DANCE PRONE

David Coventry was born in 1969 in New Zealand, where he lives with his wife, the novelist Laura Southgate. Published in over fifteen countries, Coventry's debut, *The Invisible Mile*, was hailed in the *New York Times* as a 'gorgeous . . . philosophical action-adventure', and was book of the week in the *Sydney Morning Herald*. It was described in his home country as 'one of the most gruelling novels about sport ever written', one which 'immediately places David Coventry among the elite of New Zealand authors.' He received his MA in 2010 from the International Institute of Modern Letters at Victoria University of Wellington, where he is currently completing a Ph.D.

Also by David Coventry in Picador

The Invisible Mile

DAVID COVENTRY

DANCE PRONE

PICADOR

First published 2020 by Picador

This paperback edition first published 2021 by Picador
an imprint of Pan Macmillan
The Smithson, 6 Briset Street, London EC1M 5NR
EU representative: Macmillan Publishers Ireland Ltd, Mallard Lodge,
Lansdowne Village, Dublin 4
Associated companies throughout the world
www.panmacmillan.com

ISBN 978-1-5098-3945-2

1 3 5 7 9 8 6 4 2

A CIP catalogue record for this book is available from the British Library.

Printed and bound by CPI Group (UK) Ltd, Croydon, CR0 4YY

Visit **www.picador.com** to read more about all our books
and to buy them. You will also find features, author interviews and
news of any author events, and you can sign up for e-newsletters
so that you're always first to hear about our new releases.

For Charles

1

November 1985

They punched the fat kid first. Then his skinny buddy and these two wannabe stage-divers fell off the boards before we even began. The clattered sound of bodies, knuckles and skin as the security got ugly and began tussling with each of the boys climbing the stage. Heavy men under the glower of two hundred all staring up from the blackened room. This was Nail's Mexicali down on Neves Ave., the one venue left in the middle of our damp old river town smack on the edge of reality and the west. It was a sweat-stinking dive with a makeshift bar and a rostrum lifted at one end, faces filling the floor to the back as I watched the two body-crossed divers merge with the crowd. Hair, heads and necks in that hypnotic sway and give, the stray energy of loosed teenagers all hepped up on that hell-evoking thing that kept them awake at night.

Yells, the band's name echoed into the room.

'Bauen, Bauen . . .'

Half a dozen in a pathetic mantra quickly lapsing into jeers. Then other chants, rising then falling back, dissipated into single shouts, witless, primed by recall because song is memory: assaulting, lying and always on the move and there at the front were the four of us – drums, bass, two guitars. The usual rig of pent-up souls and instrument, tuned and strung tight. Each waiting on the look, the one that'd say: *Go.* The one that would throw us, heave us into the lights and land us in a howl of distortion and distressed chord. All in a kind of joy, a sung jewel we wished for every sucker out in the pit

and beyond; friends, kin and the loves you're always trying to amaze with something you don't know the name of.

I prowled the boards, ignorant and strange for it. Spencer hunched at his drums, messing with his hi-hat, the chain assembly and how it got stuck some days. I stalked, this way then back to where my amps sat waiting and Tone stood over the kit, his face glistening, dripping with the water he'd thrown at himself backstage. 'Yo. The fuck, Spence?'

Spence Finchman shaking his round head.

'The fuck?' Tone yelled.

A kind of massing out in front as they argued, the security trying to keep the peace, but this *was* a kind of peace and they'd no idea. The sense of event and the odd talent of a crowd of punks to make a gig an issue beyond noise and physical urge. Body heat and a hunger for a kind of forced wrath, for the inducement of physical memory. I trod my distortion on, then off. The room lit by a spasm of electric noise, a kind of warped warning written in feedback.

'Hey, fuckstick,' Tone said, and Spence mumbled urgent and inaudible under the shouts from out front, the *Fuck offs* and the house music scraping through the PA like a bucket of iron. Watch me: I didn't look out, just glanced at the set list and tracked the stage, an adrenal surge and back and forth between the two idiots with their matching T-shirts boldly proclaiming their allegiance to some dead-end security firm hired for the event. I pushed my way through, my mouth dried out on nerves. Though I was never nervous; this was a state unnamed that nervousness seemed to mimic.

Tone shouting. His voice failing like it was seven hours later and he was in hospital, finally. All the world stinking like disinfectant and the impossibly clean.

'Wait man,' Spence yelled through the noise. I went to my amp, took the glass of water and threw it on my face so I looked like Tone for an instant.

'Play!' Tone yelled at Angel.

Spence's head disappeared and all I could see of him for the moment was his faint bald spot.

'Angel,' Tone said.

I saw our bass player nodding out the corner of my eye, then heard it: *Clank, clank.* The hard-trebled heft of bass as Angel started low and quick. His pick clacking away and Spence still fiddling. I couldn't wait, I screamed *Fuck it* as Spence gave in to something and sat up. He started slaying at his half-open hi-hat while shaking his head. He pumped his kick so I could hear it off the back wall. He waited on me. He waited on the stutter I gave before I jumped up sideways, twisting my torso with the neck of the guitar up by the lights – then cranked, right to the bottom of the strap's arc, my ring finger on the volume knob and I poured it all on in one flick so feedback filled the room in the instant before the beat. I unwound and put my fist into the strings; all power and chord as I landed. My face demented. Everything a crude shudder. Spence: hair and fists. Angel leaning back, his arms extended to the neck of his machine, his mouth fully open in a howl beside the deep fuck of his bass in with Spence's kick and snare.

A brute dance then as we threw ourselves at the air and every kid out front, they turned a brownish, thuggish fury. One, two. One two, and watch as our wrists, watch as they flicked open chords and our bodies lurched. Sticks through cymbals, snare and tom. The way light suddenly bounced off every corner of the room, off every shaved head and ripped shirt, every glass surface and every hidden nerd punk. The four of us. The way our wall hit, the sudden terror look on their faces as they leapt and elbowed their way into the sound, swinging and shouting and the security had no chance in the brawl of teenagers and their blunt-cut hair. Fourteen, fifteen, eighteen, because this was an all-agers and most were kids and the way they fell into a form of crippling madness as our

amps turned string sound into voltage so the air out of the speakers seemed to rip. And stacks of them. Marshall, Fender, Ampeg. Each of them tearing the air so the hit on the audience was immediate, physical, turning them into butting heads and thrown fists.

Then five of them up on the stage, shoving, jutting legs in a Hermosa strut, that crazed dance imported here from SoCal. Spasmed limbs, all clenched teeth and jerking. Bodies flung back into the audience. Back flip, caught and passed through by reaching arms; no one was left to fall there, always caught, held. And immediately the whole of us, the four of us and the room, soaked. I stood legs apart and leant back before I had to sing, to shout at the mic.

One song, two. The rush and pile of kids and the way they went at each other, the way they held each other and swung through the scrum, hitting and hugging in that punk love thing that nobody was supposed to get.

Song four and this is the room, alive and raw.

I ran in circles as Angel bounced with his bass and Tone flung his head around. The way bass shifted the harmony and you could see it on their faces, a knowing-ness, an uncoupling of something taut and near as the kids danced their spastic dance. At song five Tone stood among the divers, staring through them as they approached and fell back. We chopped into verses and out again, faces snarled and wet. He made sudden jerks in the divers' direction, stared them into stepping off the stage.

Song seven and these kids don't let up, they don't let go of this thing. Two hundred of them all ready to fight the great unnamed. The fat kid again and he didn't care about his bleeding face and flopped into the crowd on his back, shouting.

One, two. Wood on wood. Teck, teck, teck, teck.

Song slipping into song, and in each song were the fissures, atomic-level breaches in the noise and inside them I watched

for Sonya like I always looked for Sonya. For something plain and clearly sighted: a hint of eyes, a lick of mouth, a clue that she was there, keyed in, attuned to the impossible communiqués from these strange assemblies. I swung around, violently colliding with empty space, and caught a glimpse. Her hair, her brown bob bouncing beside Leo Brodkey, our pal out of Rhinosaur: legendary Louisville punkers, slow-core with drug-thirsty twin singers. They stood near Tone's amps laughing at something beyond the boards. I watched them as I stalked, one end of the stage and back till noise hit once more and I heard her scream, a snatch of delight at this.

'Hey shitballs,' she screamed out. 'Hey fucktards.' Sonya had a way of appearing wistful when all around her was tearing itself apart. She was there on the tour out of procrastination; at war with her MA, a deserter, hiding in towns far from her desk, typewriter and supervisor. She instead spent her invaluable time screaming at bands, at her brother because Tone hated any kind of heckling. That's the thing with siblings, they're always doing the opposite to stay the same. 'Con,' she yelled at me, laughing. She was laughing because by now Tone was climbing, lifting himself up his speakers like a madman.

Up his two quad boxes and the shitty Peavey he put up against the warmth of the Marshall. He stood there in the hard, invisible air. He let his guitar feedback as the audience started throwing those clear thin plastic cups. Water and whatever bursting in the lights. Tone stood utterly still as we stormed through the two-chord stab and hit of 'Pig Rental'. Spence the engine of it, clanging the rhythm while Angel and I hacked at the strings in some kinda time that wasn't four-four but fit in with it just fine. It was a build. Deliberate and manipulative, fraught and waiting on the change to come and hit, to scream the anonymous thing everyone will later claim they knew all along. That narrow point of knowing reached by the sight of

us switching key and making some new crude harmony and the way it would twist the inside of your guts and Tone. Tone, he stood there on his amp, balancing beneath the beams. He made exploratory hits on an inverted chord up by the ninth that invited us all to listen closely, exaggerating the build and threatening a change from the noise of this, the distortion, fracture and beat that put our faces into ridiculous snarls.

Then – Bang. Bang, bang.

The double snare hits that meant in eight bars we'd stop, pause in the centre of the song and switch keys, dive into the beaten wave that came rolling in after the silence. The movement to half-time. And there, at its head, Tone jumped.

He turned, leapt while hitting the chord back over Spence's kit. Tone grabbed the drapes that covered an arched alcove full of restaurant junk and swung, his guitar banging about as we swam through the outro. Then he fell, inelegant, into the kit. Right on top of Spence – and somehow we didn't stop, just kept ploughing till the last chord was reached and Tone was back on his side of the stage by Angel waiting for the next song. Kids yelling, unclaimed insults and cheers.

And all along Sonya was laughing with Leo. She tucked her hair behind her ears and laughed. She said she loved all-agers because the kids didn't know when to stop. There was no edge of the pit, just a rallying to an ever-sharpening end she couldn't get out of.

Half an hour, three quarters of an hour and then the end.

And at the end, once the seconds passed, the minutes passed, we sat out back in a blurred sway of post-exertion sweat and commotion. Friends sat with us, Vicki Mills, Leo and Leroy. We drank beer amid the insults and jokes. One of the support bands, Spurn-Cock up from Phoenix, brought in whisky and what a mess. The grind and grunt of this voice over that voice and we let the heat rise out of our bodies. Burnt off as if the

noise and shriek and lightning-crack volume breached that section of the mind trained to purify all this into the flow of believable memory. We drank and laughed, people came by and said: *What a brute fucken show, man*, and we just sat, drank all sweated-up, making jokes and letting them pass as the security shifted the kids out into the evening.

Two hours later we headed to the van, that '79 Econoline, and the five of us drove through Burstyn, through the rough streets that nerved our little town, that old college municipality 150 miles west of Chicago on Rock River jutted full of broken jetties and riverboats captured in the mud. We headed back to Tone's warehouse at dusk, inched through the wide brick entrance of the Eighty-Eight, the name we'd given the old abandoned hulk in the days after he'd taken it over. Imagine us unloading the gear in front of the building, lowering it to the forecourt floor and standing in the vague paralysis such a matinee can put on a band; the aftershock and slow emptying out. Tone stood arguing with Spence about his hi-hats – *Fuck you* – then it seemed to be over until Spence took a swing at Tone and the both of them tangled for a moment and that was it. They stood panting and then laughing and then all of us found it kind of amusing and we all stood quite exhausted. There'd been 200 at the Mexicali. Bodies and hair, each thrown against the other, the mash of teens, of denim, callow skin and lit nerve. The remainder of this sat in our bodies, Polaroidic snatches, light, sweat and eyes flinted with a kind of terror. All a-glimmer in the adrenal lag.

Watch us, all quite unaware of what was to come next and you have the scene of a clear, practised memory, a cloudless event of time and movement.

Sonya said, 'Con, I'm seeing you later?'

I said, 'Sure. You're not hanging around?'

'I gotta get a letter to my supervisor. I gotta send some words. Like every good, pretty student sends some words.'

She screwed up her face making a temporary monster out of mouth and eyes.

And again I said *sure* and watched her smile out past me. She hugged each of us and left a kiss on my cheek. Then she vanished with the evening.

Once we'd shifted the gear the four of us stood smoking cigarettes as the last of the rush burnt off and the conversation dimmed. Spence announced he was off to feed the two little pups Sonya and I had bought for his birthday and could be seen heading out to Vicki's because that was where he was keeping them while he stayed with his father. Angel and Tone also slowly dispersing. And once they'd disappeared I dragged the equipment to the basement and set things up for the following day's rehearsal before we left on the second leg of the tour. Then I vacuumed, emptied the bag, sat for an hour thinking about Sonya, and not thinking about her, then thinking about her again. Such was the intelligence of my girl: to be there when not there. I figured she'd headed to the pub over from the university library, the open-decked bar where the word-haunted sat and drank pitchers of beer looking out to the river, reading Camus, Stein and Kafka. The place we all ate dollar-fifty ribs, caught in arguments about genre and harmonic sequence, trading the names of bands and people, listed albums, notes that shaped into songs, all the epic titles we gave to scales and space. She bought bags of pot from the bartender there and liked to get blunted in the bathroom out back.

It was 7.20 p.m. by the time I heard noises. Voices chiming in and out of the building.

I abandoned the rehearsal room, went to look. I went out into the forecourt, the once roofed space in front of the warehouse all covered in yellow leaves, red and fading brown. I hunted for the voices, the creeping source of nerves heading up my neck. I stood beside the van and gazed into the various

sightlines that looked towards the entrance and alley down the side to the back of the building. People were always trying to break into the Econoline, eyeballing it for equipment and junk. I found no evidence of tampering, just felt the wind, the well-bitten howl off the river. I went back into the building, the so-called Eighty-Eight, and waited at the threshold. I moved slow, wary of who might've entered the building while I was outside. The slow creep of this foot and that foot, a kind of ambulant whisper. I looked into the ends of the halls as I went about corners. Their long shallow darkness and all the doors. I could hear footsteps, slow and uncertain, a nervous echo of my own. I decided to run, to burst into the main area off the hall and startle the lurker. I imagined some drug hunter, thin and desperate. A fuck threatening with a blunt butter knife. I ran, lurched into a gliding run, took no more than five steps before I crashed, chest and elbows into the full front of Vicki. Bones and breast and fright, our bodies colliding, rolling off into the wall. Her forehead into my shoulder and I grabbed her arm to stop her from falling.

'Fucken—'

'Oomph. Jesus, Con.'

The two of us stared at each other there in the hall, hearts thumping like this was some sudden endpoint, flexed and eyes opened in the burst of adrenal thwack. Vicki Mills, five-foot-shooting-fucking-star-nothing out of Athens, Georgia. Her face graced by green make-up-model eyes and a tilted smile. She stood there shaking in a Killing Buddha T-shirt, one that used to belong to Sonya before she'd moved back to Tempe.

'I thought you were someone else,' I said.

'Who?'

'Where's Tone?'

'Don't know. I was looking for Spence,' she said.

'Spence is – I don't know where Spence is. I thought he was feeding the dogs at yours.'

She shook her head. 'He was, then he was on the phone to Joan then—'

'You seen Sonya?' I asked.

'You scared the shit out of me, Con.'

We stood waiting in the burnt static air left over from our collision, me panting and Vicki looking at her elbows for potential bruising. Eventually she moved me into the lounge, the enormous room of old couches packed full of horsehair, the one large table, the TV and stereo Angel had pilfered from a house up on Corking Road near the hospital and lent to Spence. And Spence had left the speakers and amp here since everything with the hospice, since he'd shifted from his house on Maple and was constantly on the move between my place and his father's. I offered Vicki the bottle of whisky I'd bought before the gig and watched her swig and wince. She put a record on the player and sat with the bag of grapes. It was the Minutemen's *Double Nickels on the Dime*. Punk and jazz and funk and she held the cover over her face so the eyes of the figure on the front covered hers. She lowered it and we watched each other until we matched the looks with laughter.

'What do you know?' I asked.

'What do I know?'

'Yeah.'

'What do I really know?' Her accent and how she liked to play it up all Georgia-southern. All giddy-flirty when nothing of the sort was on the cards. Vicki'd found her way into our lives via alt-rock and shared courses, then friends and houses. She lectured and tutored, killing kids with a wayward glance here and there, a lasered thing of unintended attention. She played in another of my bands – the Ruths – and we were near enough to understand our friendship was beyond the tight corporeality of music.

I nodded. 'Sure.'

'What do I know?' She grinned at me – a challenge of sorts. 'I'll tell you, this is what I've figured out about *knowing*.'

'Give it to me.'

She frowned. 'Each time we've decided shit's being got—'

'What?'

'This is the death of many things. Many, many things.'

I laughed and watched her drink.

'Death. Finito,' she said as her face went screwy, eyebrows unevenly arched.

'Listen to you.'

'Listen to me. It's been a long week,' she said, exhausted eyes like she had an intimate sadness she suddenly wanted to share. 'Either that or everything I know is something I misremembered along the way.'

'Weeks are longest near the start of winter,' I said. 'It's a physical truth.'

'I'm sitting here watching you, wondering if that's true.'

'Most things I say are only true once you've had tea with me at three a.m. Before that – I'm all nonsense.'

She laughed, eyed me again. 'You guys were decently savage this afternoon, for an afternoon at least.'

'I had a nap for lunch, so.'

She drank, wiped at her mouth, talked on. Stories and homespun lies. Vicki could always say what she liked and I'd listen. Especially in the Ruths; that band was always hers more than mine. Voluminous, tricky. Our first album she called *Devotional: Songs of Ignorance and Intolerance*. Had four chords in total.

'Spence all right?' I asked. I was imagining him on the phone to Joan George-Warren, talking about the gig, moaning about Tone and his hi-hats. George-Warren replying in that Texas drawl, describing the sky down Arizona way, a blue full of unspeakable silences and size.

'Yeah, fuck. I don't know, Con.'

'What don't you know?'

11

'What was that about? Tone being such an asshole?'

'We don't do fucking around.'

'Spence was just sorting his shit.'

'We go on. Slam. Then off. We're talking fireworks, bang. Off.'

She poked her tongue out at me. Stared as the old Burstyn creeper entered the room, the draught that frequently broke into the warehouse and told us this was the place we were going to die just by sitting around. It ran up my trouser leg and I remembered that one time Spence'd put me on the line and I was drunk and Joan'd sounded like someone's mother.

'Why was he calling Joan?'

Vicki shrugged. 'He purports to be your closest friend, dude.'

'Nobody's friends onstage; everyone's at war.'

Vicki laughed then shut her eyes, purposely sucking the joke out of my words. She was a year older than me and I often felt it. Felt her capacity to know things. I'd watch her in the cafe where we'd sit and notice how she talked, un-abrasive, adorned with the task of listening and addressing misread things, literary and social. I often thought I was in love with her.

'Doesn't sound like a reason for being a fuck,' she said.

'Yeah, well. Fuck's a fuck. We're nerds practising like retards, so we can be as loose as the shits. On, then off.'

'So? He's your— He hasn't got anyone else. Except me. He's got me and you, Con. He was just fixing his hats.' She sounded resigned now. 'He loves you, dude. These are the things he mumbles.'

'When?'

'I don't know. When he's bitching and aching.'

Aching. I hated that word. I wanted her to use another, something more practical and precisely tuned to Spence. He was permanently miserable. Always at odds with the necessary basics for being. I wanted words that marred the clinical, words that made you clasp your hands together. 'Of course he loves me,' I said lazily. 'I'm prime love material.'

She smiled at me, looking up, gazing from eye to eye. 'Well, you know. Fuck Tone anyway. Put it in your article.'

'Sure. Fuck him.'

She laughed. I was writing a tour journal piece for *Maximumrocknroll*. It'd become a joke because I never worked on it except in splurges. Recalling things I'd no memory of, except for what was still vibrating through my body. Those hungry aftershocks of sound and dance we called music, called hardcore, then not hardcore.

Vicki and I talked on. University, our months and the empty months. The band and her tutoring, lecturing. The tour. Spence, Angel, Tone and I'd just done three weeks in the Econoline: Newport, Philadelphia, Richmond, Washington, Trenton, New York, Bridgeport, Boston, Akron, Chicago (where Sonya'd met us), Milwaukee, then Madison two days earlier. Then there in Burstyn before we were to head out the next day into the killer cold. We talked about the route we were taking; Vicki liked hearing the dates and towns as if they were artefacts of a dusty old idea she had of the country. We talked about Spence and the author Joan George-Warren, the odd rustling of their relationship. He was essaying about her and she was so often lurking in conversations, hiding behind intent and idea like a TV show, videotaped and just waiting to be watched when that specific paper had been written, when the last vestiges of idea had been reached. A woman famed and made in the south, cooked up in the north-east. Vicki'd started with Spence after they'd met at the writer's art colony in Arizona back eighteen months, an illustrious place of cactus and umber hills. Became a duo. Clothes swapping. Kissing in laundromats.

'You going to Yuma?' I asked.

'I'll meet you guys,' Vicki said. 'I'll see you in Cheyenne, then George-Warren's other place.'

I said nothing.

'The Warrenites' place outside of Boulder,' she said.

'Cheyenne?'

'It's on the way – I've friends. My old psych tutor got married and moved there with her husband. Works with young women recently released from prison. How's your Plains Sign Talk?'

'What do you know about the woman?' I asked.

'Joan?'

'Yeah.'

'Most things. Spence's overtaken me in the what-we-know stakes. By a fair chunk.'

'I spoke to her on the phone for like twenty seconds.'

'So there you go, you know everything. You'll dislike her immensely.'

'I don't dislike anyone.'

'You despise anyone who's not listening to whatever record, then you hate them for uncooling it if they do. Dick in hand.'

'And, I still don't know nothing,' I said.

'Well, nothing's something, if you want to know.' We went quiet for a moment. Faces, lips, eyes and the cold air moving between the legs of the rotted sofa she'd lain on as we talked. George-Warren had three colonies; places dotted between cities and towns where bands showed up and played, were fed. Camaraderie was expressed there in drunkenness and accompanying grief. I knew of them only in theory, but Vicki had visited each of them during the spring of the previous year and had friends in each. She named names and watched as I instantly forgot them.

Eventually we quit gabbing and she rose, stood waving from the door and moved into the long hall and I was alone with the bottle and the shell of the warehouse, the cold and shifting, daring draughts. I put on that Modern Lovers LP and went to the cooker in the kitchen area, lit each of the gas burners. I warmed myself there, clapping my hands together until I began wondering again when Sonya was about to appear.

I found myself singing random lyrics. I danced trying to keep myself warm. But instead of Sonya arriving, joining me in the kitchen, boogie-ing to that perfect rock 'n' roll, I started recalling something less perfect. The week Spence and Vicki revealed they'd got together, how it was just a short month after Spence's mother Ruth had died. Vicki had inherited a wreck and I couldn't stop feeling miserable for her, sad in the way you feel for loved ones affected by cot death or worse. The whole episode had put a hole in Spence, hurt his capacity to think so bad he had a limp for a week and a half. There was always something smartly temperate in Ruth's way, something so near to the gentle eagerness that ran in her son that it hurt in strange ways that Vicki never got to meet her. Ruth Finchman was the one to look after us when we were idiots. She was the one who gave us money for strings and fried chicken when we'd none. She made carrot cake and liked us in her kitchen, exasperating her. Putting in the dumbest questions. We love those who let us annoy and frustrate because they know there's some question in it all – and they know the only way to answer it for us is to be amidst its phrasing. She liked having us there so she could occupy time and keep her from her husband, Frasier. There was always a sense of abrasion there, of hidden events under the long shirtsleeves she used to wear. She found amusement in the things she liked to hide, revelled in her son's intellectual diversions. Then cancer and how she disappeared, how she vanished into her bones, how we were all caught, haggard on the idea of her slipping so silently out of reach.

I waited on Sonya but instead heard the familiar footsteps from earlier: Vicki reappearing in the dark space out in the hall and asking, 'You want to go down the rehearsal room?'

'Why?'

'I feel like playing drums.'

'Sure. You wanna hit things?'

'Wanna exact great revenge,' she said. A kind of vacant smile spread up her face and into her eyes.

I stood, followed her along the hall to the door that led to the stairs to the room. The whole echoic space following us as we walked to the basement. Vicki had another band with Spence on guitar and her on drums. A kind of pretty pop and jangle they played wearing matching black balaclavas. She sat behind the kit and I turned on my amps. She played in that open-hand style and I struck several chords. The room was covered in sound-limiting foam and flyers rescued from the damp walls of Burstyn's downtown. We watched each other, the incremental gathering of speed and volume. The loosening of wrists and arms, noise and chord and – as such – so began the events that ghost this story, make white its bones, make me recoil from remembering, then recall just the same.

2

Time then. Hours, four of them.

I was wrenched, torn awake. Yanked from sleep by a numb
tug and body jerk. Numb and dumb cos I'd been drinking
and beyond drunk and stoned and— *Thud* my head wanged
into something hard and a tearing as my body started to wake
and my head was thrown into the hardness of the seatback
and some fucker was thrusting himself into me. My body
chucked forward and I was trying to shout. His hands in
my hair, my head forced into the clothes bag and I gagged.
The motherfucker grunting and shoving and the nerved skin
seemed to tear and then I knew, I knew. I'm in the van and I
knew. I was in the van and this was some fucker behind me
trying to get off. My body numb from chemical and booze
and it was as if I was merely hearing all this and then my
body felt it too. I shouted, twisted, but my torso wouldn't
move, nor my legs, arms and head, they wouldn't move. I
shouted but it was all crudely muffled. All of it, tongue and
limb muted till the realization my mouth was stuffed. That
my body was waking as I was being fucked and the smell
of the van. The realization that I was hacking on sock fibres
and saliva was dripping on my chin as my ass was being torn
and my face wet. Eyes straining and tears. And the tearing.
Waking and tearing.

. . .

Then shots.

The collision sound of bullet tearing at air.

Bullet sound. A shot. Shots from somewhere outside of the van, then shouting. Voices. Voices. Then. Another shot. One shot, then my body. Hands on my neck, in my hair. Fingers in the soft part of my neck, digging in. A shadowed face because I turned and it was a shadow. Bare legs at the back of mine and that man-grunt noise as he disentangled. The sense of blood and the quick shift of bodies and rushing through the van after the fucker half-clothed with his dick still out. Then the noise of myself. A nervous, tactile whimper like wind whipping slowly through the forecourt of the Eighty-Eight. I fell outside, stumbling, and I saw him – Tone lying jerking in the forecourt, an echo of his body trying to escape his prone, haemorrhaging figure. Shouting then. Shouting, then Sonya.

3

Then. Lights. Then—

Then, the next morning, and we drove out. Headed stunned under the autumn dawn, town-hopping through the fall until, twelve days on, you could find us still in the Econoline, hidden behind the ballooning of yet-spent-time as Illinois slouched behind us. As Burstyn, Chicago, Cincinnati and Evansville over in Vanderburgh County went by. Gig by gig, town by town. Springfield, St Louis. Feedback and beer, sleet and electricity. Fort Wayne, Indianapolis. In Louisville we climbed the fire escape so the rednecks downstairs couldn't end it all before we began. Just like'd happened two years back when a fuck of truckers over the border at the Calgarian Hotel'd kicked Spence's ribs in and we'd had to scratch the rest of the shows. Which is precisely what I hoped for as we drove in the freeze. Tone'd shot himself and I'd been muted and fucked and there was no way, no way we should've been out there without him. But in the morning we'd congregated at the van as he lay in the hospital two miles to the north and someone'd just said: *Let's go*. I don't recall who, and we packed the gear into the back of the van and left. All I remember thinking was Calgary and wishing those fuckers would find us again and that'd be the end of it all. But on we went, the inexplicable all of us. I spent hours in silence. I learnt it as I drove, practised it until I understood its voice was as bright as colour and as colourless as the cold.

We drove and drove.

Two hours on from Washington U and we headed west, careening without sleep. I found myself mumbling, as if I'd just been woken again by shots and I wasn't driving at all – but I was. And then, then I felt a certain calm watching the lights peel back from the land – then the tearing and sudden panic. I twisted and writhed and it did nothing. Spencer sat shotgun endlessly unaware, the cabin glow and the dull aura of him banging about, the two of us wagged by the forces of pothole and camber as the road kept coming yard by yard, the incremental stretch of a continent giving up its span, on and on.

And on and on into venues, bars and saloons packed with students, indie-kids and punks, converted warehouses and record stores where our fists smashed at open strings and proclaimed dissonances in the name of punk, post-punk, hardcore and its descendants, antecedents. These were our points of departure and arrival. VFW halls and some kid's front lounge. Everywhere centre lines, a crude ellipsis on and on, taking us into rooms and floors and beds and sofas and halls and all the real places of the tour diary at the end of routes like these, sparked and shaped like bloodshot eyes, with Spencer stirring in the front, twisting out of dreams as the van was rocked in the wind-blast off swaying trucks.

'Hey,' he said, quietly.

'Hey.'

'You figured it?'

'Good morning, America.'

'You figured it?' he whispered.

'What?'

'When he's getting out, when Tone's getting out.'

'Of hospital?'

'Yeah.'

'I'm driving: I'm figuring out everything, dude,' I said.

'You've done the mathematics?'

I tightened my scarf. 'Sure.'

'How many days?' he asked. He'd the map on his lap, crinkled in the places his skills at folding had let him down.

'Five more,' I said.

'Five days? How'd you get that?'

Five days. This based simply on the numbers Sonya'd given the night before in St Louis. She'd been on the phone to her brother's doctor, slipping quarters in the slot, crying and straightening out her voice. She'd this thing she did when people couldn't get her accent, she'd go all mid-Atlantic. Her mouth changing its shape into something I didn't recognize. I glanced into the back of the van to make sure she was still sleeping and there she was, her eyes shut and her head on Angel's shoulder.

'We're talking muscle and teeth, right?' Spence said. 'Tone. Just muscle and teeth.'

'I don't know, man.'

'We're living in a freak show, dude.'

He listed all the things we'd imagined every night, the parts of Tone falling away. The blood out his mouth, the skin rent and terrible. I felt the psychic core of me clench. That body panic and fear. Tone'd placed the barrel in his mouth and fired. I'd heard the noise of it, the rip and tear as I was being fucked and God knows why. Then we drove and some mornings and nights I woke to the sound and I'd find myself bleeding down there till it stopped. Days and nights playing to hundreds of kids and the fear of fluids showing through as if I'd shat myself. I'd taste metal. Iron and blood. That was what I knew and Tone was now 800 miles away, a hospital bed, drip-fed as we drove. Spence, Angel, Sonya, Leo Brodkey and I. We'd been operating as a three piece with Sonya playing the occasional guitar. Then she decided couldn't anymore. Something about being a stand in for her brother, something about imitating his strum that made her pale. Half the songs were impossible, the other half stumbling and newly raw.

'What you think?' Spence said. 'We just cancel his insurance

or something?' He opened the glove compartment and closed it.

'Or something,' I said. Every mile had a kind of discrete hurt attached. My own and then I'd turn and see Sonya behind and remember her own hurt. How each night she cried and asked what the hell she was doing in the van and neither of us had an answer to that, just vodka and the odd pill popped like thought balloons in the back of our minds.

Spence opened the compartment again and took out my camera. 'You ever, ah,' he started then stopped. 'You ever had sex, Con, like in a hospital?'

'—'

'Dude, I'm serious. You like ever, porked in a hospital?' he asked. 'Like, in a ward, man.'

'Half a dozen times,' I said.

'I'm serious.' He was holding my camera now. My old '68 Canonflex.

'Maybe seven, eight times. Put that thing back, dude. You're fucking with shit.'

I had the feeling he was smiling. That he'd asked as a joke but now really wanted to know.

'Depends what counts. Three times, maybe, I think. Twice.'

'Twice?'

'I'm nineteen,' I said and shifted on the seat, moving my ass around to find some comfort. Angel'd accused me of having piles, warts or some grotesque perianal abscess, but it was just the remains of pain and with pain there's always fear, body fear, panic and the mind not functioning like the mind should.

'You're like twenty-two.'

'No, I *was* nineteen, and I'm visiting Sonya visiting a friend at the university hospital. She sits on my knee in the gardens. Later we found a cupboard with two nurses.'

'Really?'

'You asked,' I said.

'Don't be an ass-bitch.'

'To stop me being an ass-bitch, right now –'

'Yeah.'

'– at this moment –'

'Yeah,' he said.

'– it'd take brain surgery.'

He snorted. He lit another cigarette and leant against the window. His smallish head and light skin. Spence wore a scarf up to his neck that made him look fourteen. Twice the age he was when I met him in grade school. I almost felt sorry for him, that I wasn't going to tell him about what really happened to me. I realized then that he wasn't quite that person in my life, not yet. Nobody was.

He put on a tape. Some blackened LA fury and we drove silent inside their howl, silent until their noise, its violent crush of chord and coda, said this was the nature of silence, to know the destructive urge of one's own weight, when weight is measured in the things of pause, of waiting and want, of wanting and hiding until nothing else can be heard but the stern reflection of the road and the way the road is always beneath us, telling us its inaudible things.

Twelve nights earlier Sonya had found me in the front of the warehouse stumbling away from the van. It was cold and it'd been raining. There was mud under my feet and I walked in a deliberate circle around Tone. I saw his face tangled and ripped. I couldn't look at him, couldn't look at his face. I wandered in an ellipsoid around the van, looming close, drawn by the gravity well of his body, his nose in the air and the tangle of skin and blood, the hint of teeth. I came close then veered. He seemed rent. Sonya soon came running out of the alcove of the front entrance. Tone coughing and spitting blood, twisted up like Holofernes after Judith had had her way. The gun still

in his twitching fist like some inflamed nerve in his arm had been left open to the elements.

I was talking slow like a child. 'Sony. Sony.' My voice paced by my steps. I sounded high, like an adolescent near to the age he's got to be shipped off to war.

'Con?' Sonya said.

'Sony.' I sounded pathetic.

She said, calm and stern: 'Con? What'd he do?' She was staring at the firearm.

And I made a noise, panicked and petty-sounding. She was walking towards me, trying to predict my trajectory so she might intercept and grab me, shine her face into my own and ask again what'd happened. But I wasn't stopping so she went to her brother in the grass. She leant over him and started whispering, her hand on the flap of his mangled cheek.

Then ambulance and lights.

I don't recall the drive, but was soon stationed outside his hospital room with Sonya. By then the shock had drained out and she was crying, by then she was shouting at me, then calm.

Baby, she said, and apologized.

By 4 a.m. we were asleep, leaning against each other. I woke with her hand on the inside of my thigh. Her nose nuzzled into my neck. She was warm despite the cold out. Her face was beside me, the saddest eyes quite out of focus. We upped and held each other, began to walk in the halls until we came to a small room, disused and empty. It occurred to me that this was something she needed, an act specific and utterly physical to lure back a sense of normality after the sight of Tone in the grass, of him in his bed, breathing strange among tubes and nurses. But there was no normalcy, just fear. Fear and a sudden shame. A panic that rounded and pinched as she reached at me. Her hand in my fly and I was shaking and ragged. Horrified she'd see the blood in my underwear, that she'd know. Horrified she'd see the bruises on my neck and wrapped round my

collarbone. That she'd know, and suddenly everything. I was panting, certain someone was going to come and grab my hair and crack my head on the stainless-steel basin in the corner. Hurt us both, break us. I sat on a stool barely hard and crying. And she was crying, sliding my limp erection between her thighs, weeping and wiping my face.

And it wasn't sex really, it was an echo of sex. I felt her body, and felt the inside of mine, hollowed out by something furious, the flash and rush of ill-defined memory.

Early the next morning we'd driven to Spence's – his father's huge house on Jarvis and 3rd, near campus – and knocked. Spence was living on funds from his scholarship and trying to get out of the family home since he'd returned from his place on Maple, but there was something there he didn't seem to know how to leave. Frasier Finchman answered in his large robe, the heavy Prussian-blue set in place by clean, white piping. He was established in the English department, there since the early seventies and known for his calling out of students late to class with a hard, vicious wit. His large bulbously ball-like head made me think of the sound soccer balls make when tapped with a hammer. He stared at us. Said Spence'd gone out to the Eighty-Eight.

'What on earth was he doing with a gun?' he asked as we turned to leave. 'What kind of levels of idiocy are you up to now?'

'Excuse me?' Sonya said.

'What kind of levels of idiocy are you people up to?'

'Excuse me?' Sonya said.

'Look at the world.'

'Why?'

'Look at the people in the history of the world.'

'I'm looking at you,' Sonya said.

'Look at everyone.'

We stared, the shape of him framed by the house behind and I felt a tremor in my arm and Sonya walked towards him. A vibrating pulse in my forearm and down to my hand which began shaking.

'Who does guns? The drug drunk do guns, the paranoid and dull. Look at you. And thieves, and the drug-fooled. What kind of so-called musician carries a gun?'

'So-called-fucked-if-I-know, sir,' Sonya said mutely in her thickened accent as she began walking away.

'Don't you come around my house dirty-talking, Miss Seburg.' He stared at us, a rent grimace on his face as if he couldn't use the muscles with any natural aplomb.

'Sorry?' Sonya said. She turned hard and took a step towards him. They stared at each other. He always seemed apprehensive of Sonya, whether it was her voice or her lack of hesitation, I couldn't tell. When I was young Spence'd have me over and Ruth'd make jelly moulds and let us play in the back-yard, improvising various games of deep-wrought importance we'd once observed on TV and repeated in the grass cuttings and she'd watch and clap and join in if we needed a third body before going back inside to make dinner for her husband and sometimes I'd stay. Sometimes I'd watch and listen and feel that tuned elegance of family life slowly compromise itself at the fall of a discordant comment. I'd seen Spence's father turn and smack Ruth with the back of his hand, knocking off her glasses, stand and take the newspaper to the living room where he'd watch the TV with the sound turned down, furious at any noise in the house. I was terrified, but sixteen years on Sonya had an eagerness to watch his threats become babble. And as they stood considering each other on the front step Spence's father eventually gave in to her slow movement towards him and retreated into the house.

We drove across town and found Spence in the basement room. He was packing up his drums into cases, saying we had

to hit the road early. He'd been crying; there was salt in the corner of his eyes. We asked if he'd seen anything and he just said: 'Do we take his guitars? Or, what the fuck?'

'Your father's a cunt, Spencer,' Sonya said.

'Of course he's a cunt, Sonya. Why the fuck you think I'm down here and not getting a head full of him?' He was standing in his immense coat, shivering and still twitching with last night's drunk.

Spence, now he made noise like he'd just woken as we hit a cloud bank rushing out of the black and we drove momentarily inside its ghost. Angel began playing chords huddled in the black back of the van where he sat beside the nodding-out Leo and Sonya. Whenever we walked from van to venue, from bar to deli, we felt hard, equalized by intent and reason, when we merged on the stage we felt an identical force – but here we were shadows lurking, waiting. Angel stopped playing, then started again. Slow chords with the same high note ringing through. The strange fact I could hear the notes quite clearly over the charge of the vehicle as we went west through plains and rolled hills, damaged trees here and there, birch and pine and deciduous things I can't name. Angel played those few chords, the ache of notes harmonizing. And our Spence looked into the rear where Sonya was wearing his enormous coat, a shearling fur-lined leather thing almost living. He and Angel watched each other, the rumble of the van and the air on the outside. The last note Angel hit rang on, the way it vibrated and touched against the pick and the two of them watched each other as if confirming the thing they had both thought for the last ten days. Tone wasn't coming back any time soon, no matter what numbers were said. He was in hospital until we didn't know when. We passed the lit entrance to the Callaway power plant, its immense cooling tower lit up. The yellow street lamps flickered through the fence and trees and it was

as if eyes were catching us with their cameras, holding us for a moment of obscure fame, shadows coming and going. Sonya reached with her mitten and muted the strings.

Spence went back to leaning against his window with my camera in his hands, his eyes closed, the world flashing millimetres from his head.

4

We'd driven out of Burstyn ten cities earlier, following the
lines pinned to the map on the wall of our office in the Eighty-
Eight. The huge array of linked maps marked with red ink,
tacks supporting little flags. Dates, venues. I didn't like to drive
more than ten hours at a stretch, which worked out at near
seven inches on the map. I set a compass at that width, gaug-
ing the distance and planning the routes. Everywhere inside
that radius held the kind acts of friends and citizens of punk
and DIY determination, dudes deep in the scene never before
met but somehow they were people who knew us and their
willingness to feed us and house us made unknowable towns
open. Patterns of friendship and apartments, conversations
and family like gestures, offerings of drink, floor and names
– the linkages of town, road and city. We'd arrive and sit on
crates sharing these names, laughing and trading tapes among
junked sofas and the discards of takeout and other lives that
had nothing to do with music. And once there I spent hours
in strangers' bathrooms trying to see what kept bleeding, wad-
ding tissue and wedging it there before I drove us once more
because it was always I that drove.

And as I drove I was plagued by dual terrors: that what
happened could happen again, was about to happen again;
that what happened was communicable, knowable to others
by smell, smile or look. In Springfield Spence'd knocked on
the bathroom door where I sat with Sonya's mirror trying
to see. I'd been in there an hour and he was letting me

know how many minutes had passed since I'd left the couch where everyone was sitting playing *Road Runner* on Atari and drinking vodka. I came out and he was loaded up on smartass remarks, but they seemed to drift out of him when he saw my face. The tag was sticking up from the back of his shirt and I watched as he reached to tuck it in. Then he sidled past into the filthy bathroom and the smell. I'd felt sick then because I swore that by that stench he could know anything about me suddenly.

I'd never been nervous for myself before this, never shy of shouting some muscular phrase to anchor our shared anxieties to the gigs and rehearsals. I was constantly within the unconscious of us all, looking for communiqués of pain and depressed motive. I was greedy to know the force of others' torment, wanted to harness it, kill it with the noise we wished to flatten the entire country with. But here an inversion was at play: I could no longer hear the interior monologues of others, just the ever-shifting shape of my own silence.

Before the tour me and Spence had spent hours trying to find the rational route from here to there within those seven inches set on the compass, figuring support acts, available venues, and when there wasn't a venue, some crude alternative. We'd do the scheduling alone, or with Tone when he was around. We came to know our small habits in the cold dark, the things we didn't learn by playing or drinking or horsing. These were the things learnt when working exhausted. There was always something calming about the measuring. Drawing up the means of our escape by staring at something so small as a map.

Then, two days before the tour started, we completed the itinerary and the two of us celebrated by walking. We went ambling down to Neves Ave, where I'd been living for years in a shitty house with a blanket across the window. We wandered west, then north on 7th through the pitiful grey induced by

light drizzle, the two of us making a pattern in the street grid as the sun came up in the vague east. We walked, naming the cities in order, then said them in reverse, as if this reversal told us the nature of completed things. I bought cigarettes at the gas station on 4th Street, then stopped in at the next 7-Eleven to buy a box of matches because neither of us, we realized, had a light. Two chemistry students we knew from the college were hanging at the trash cans. They tried to get us to come over and smoke pot at their vaguely infamous house on Kingchester Street.

'Dudes, we don't do the pots,' Spence'd said as we headed out. 'Can't afford the hunger.'

Light banter, addressing the pussy-assed nature of our competing faculties and we were on our way through the dull lit streets with the new knowledge that Humanities could die and no one'd notice. We walked through the outlying edge of the closed business district till we rounded the corner of Delany Street. We walked on and it seemed the two of us had always been walking, since the first time he realized he could escape his house, that there was a way out and we'd be wandering. But how this was an escape was like asking me to explain a book I'd never read, a room never entered. We'd been friends since elementary school. We chewed the same gum, watched the same cartoons and learnt how to be cruel to my sister and mom. Then we didn't see each other for half a decade when his folks moved away to Evanston. Then he turned up at high school with a dog chain around his neck like the world had been suddenly rebooted in some horrific and startling error. He looked great and I got one also. We formed our first band sitting around his mother's piano, me banging on a can: The Mock Genders, which is still a great name. Then we were ExSpence & the Con. Then, at seventeen, Dick Saw, after convincing Angel to learn the bass back when he was a sophomore working at Big Tune, the record store on Neves and 7th.

Angel was book mad, music mad. Hemingway obsessed. Marlowe crazed and he'd no idea what Finchman's life was like. How Spence used to bolt as soon as he heard Ruth and Frasier start up fighting, come and creep into the shed in my parents' backyard where I'd hid a roll-up mattress. He'd throw stones at my window and I'd know he was outside. We'd hang out till morning, talking, joking. Most nights without sleep. We'd nap at recess in a closet. One day he walked in on me getting a hand job from a girl in that same little room and we didn't speak for two months. Then college and we all stayed put in Burstyn, which felt right, but in the future seems so strange. Like there was a way out and we never took it like all our friends who dispersed blindly across the country.

'It's always chemistry kids hanging out the back of garages,' Spence said. 'You notice?'

'Someone once told them that's where the girls are at. So they're still there, sniffing for evidence.'

He laughed at me then went still and quiet. A couple of cats scrapped over leftover chicken bone and meat and we heard the sound of women shooing them inside. 'Fuck this,' he said. He started walking back the other way, back towards the gas station and the guys.

'What's up, man?' I asked.

He stayed silent until we were back there beside the garbage cans and abandoned pallets. There was no one there.

'You want to get stoned?' I asked.

He looked concerned. 'No, I just . . .'

'What, man?'

He went over to the Coke machine around by the front door. He put in some quarters and listened as the coins made their way through the machine and the can fell out into the tray. He stared at it, mist rising off the cold metal. He left it there and turned around, looking for something.

'I just want someplace to stay,' he said.

'Stay at mine.'

'I'm not staying at yours. Your roommates'll burn the couch if I'm there one more night.'

'You want to stay at the chem-heads?'

He shrugged. 'I think we can define safety as the place where complexities are simplified by idiocy.'

I laughed, but he stayed plain-faced. Eyes like the deadened prose of essay and thesis, those things slowly killing him. He lugged large tomes around on tour, writing strange marginalia to the gods and wearing looks like they were talking back to him in impregnable code.

'We'll head out soon,' I said.

'Yeah, I get this. Con, here's a thing.'

'You got a thing?'

'I'd like to know what it'd be like to kill the fucker, you know? I'd like to know what it'd be like to feel the depth of that particular shock; that a human is capable of that kind of shit; that I'm a human and . . .' He spat into the gutter of the Coke machine.

'Let's get drunk someplace,' I said. 'We deserve unremitting drunkenness.'

'Just want to sleep, dude,' he said. 'I'll sleep in the van. Someone's got to watch it.'

'What about the Kingchester crowd?' I asked.

'Fuck 'em. I'd just argue with them till my brain breaks anyway,' he said. 'Then I'd know nothing.'

I went to get the can of Coke. He grabbed my arm.

'Leave it,' he said.

I left it there and we walked in the hazy dawn. The odd car now, a bus empty and dutifully waiting at a deserted stop. The windows of bedrooms sudden lightboxes, silhouettes and dogs barking at the half-state of a waking town. I went back an hour later after Spence'd crashed out in my bed and grabbed

the can. It was still cold, as though the sun hadn't yet begun creeping through the streets. I put it in the dumpster and went and slept on the couch.

Two days later we drove out for Newport on the first leg of the tour, eight hours, two tanks. Then Burstyn, then on. Ten cities and finally Springfield and Spence came out of the shitter and sat beside me amidst all the noise from the TV and all the shouting as the little roadrunner on the screen failed again and again. Spence spoke quietly, as if he knew secret things, things of domestic ritual, inward and dense.

And then, as the sun rose in Missouri three days later we took the road east from a village named Big Piney. I drove three miles of gravel feeling gracious that I could feel sorry for him instead of myself, but it didn't last long, it couldn't. Trees hung over the drive, leaning as if we were in the summer and this was the place we could stop and the boys and Sonya would jump in the water in their underwear – or in the flesh if there was no one to see. Breasts, cocks, buttocks and hair. We were a landlocked species, always on the lookout for watery space to wash out the worst of ourselves. Then I was turning to Spence to ask about where the hell we were and he banged on the dashboard as a flock of crows burst up.

I turned quick, said: 'Yeah. I got it.' I had, I saw it: a dip and a ford.

'You got it?'

My hand on the gear stick and the sound of the engine wound up as I went down into second from fourth. The physical memory of vibration and voice and I braced myself. Spence turning to the back of the van. 'Ford,' he shouted so Sonya, Angel and Leo could ready themselves. It was unexpectedly there, a cut in the bank and a rough descent to the floor of the creek. The sight of boulders and scree.

'F-Ford,' Spence said.

'We're fording!' Angel said.

'Ford!' Leo shouted out. He often rode with us to escape his brother and bandmates in the Rhinosaur van. Their specific stink and lines of verbal and personal abuse. He was using then, sticking needles in his arm and jumping in the back of the van where it was quiet.

'We're fording, fuckers. In a Ford,' Spence said and I turned, a micro glance his way and caught his grin.

'The fuck's this doing here?' Angel called out. The processes we went through were always turning to questions; their answers always a substitute for intelligence. I went down into the gears, the van and its peculiar patches of grip in the outward pull of the clutch. I let the engine slow us, then accelerate us out – revs high, water low.

'This is,' Spence said looking down at the map, 'Argot River, so we're near.'

Angel leant into the front. He had a heavy man smell about him. The kind of smell some women wanted bottled. Then he fell backwards into the rear, laughing as the bottom of the van scraped. The sump, the differential.

'That's—' he said. 'Fuck.'

'It's all right,' I said. My voice felt tired and worn.

'This had better be the fucken, I don't know –' Angel said, leaning into the front once more.

'This is the place,' Spence said.

'– Northwest Passage, El Julfar. Whatever.' Angel's hand pressed against the dashboard, his fingers spread. 'Whatever. This is whatever.' His knuckles were white like there was only bone under his skin and nothing else.

'What do we call these dudes?' Sonya asked.

'Warrenites. They're nice,' Spence said. 'Interesting at least.'

'And who are we?' Angel asked.

'You know who we are,' Spence said. 'I's at their other place last year, kiddos. They're fine.'

Sonya leant forward, pushing Spence out of the way. She roughed up my hair. It was long and heavy with ten nights of playing.

'So this one of Joan George-Warren's?' she asked.

'Which one's that?' Angel queried.

Sonya put her chin on my shoulder. She pouted, then said: 'She's the one with the whips.'

'There's no w-whips,' Spence said. He sometimes put on a stutter. Sometimes it came without thinking, like an idea or a visitor with strange intentions. We teased him about it because that's what young men do.

'She's the one with the dungeon and the iron maiden,' Sonya said.

'They make their living off selling postcards and art for Christ's sake,' Spence said. 'She's the one from down south. Beardy guys and sand. She has that big party in Phoenix every Christmas. Every dumbass band.'

'Is that in the diary?' Angel asked.

'The gig's in the book. Booked,' I said.

'Is she here?' Sonya asked. And when Spence said no, I felt a kind of relief. 'Do people still do beards?' she asked.

'Depends who they're scared of,' Angel said. 'All facial hair has something to do with fear.'

I pulled out of the creek as the road returned to dirt and it was obvious only vehicles with a high wheel base could make this journey regularly. I felt the bottom of the van scrape. We ducked under tall long-limbed trees with their arms hanging and a breeze signalling the way towards the farm whose details Vicki had passed on to Spence. My chest began thickening, a heart-grabbing panic sent from the gut. I huffed and Spence looked over.

I drove slowly up out of a gully and onto a piece of flat land, farmland and then a fence and then the signs of the commune. We only wanted to get to the Warrenites' compound so we could eat then sleep then whatever.

'Dance with that one,' Angel said.

We saw women in loose-fitting dresses, two men with beards and another with a moustache strolling rogue in the countryside, half clean-shaven, and I felt momentarily disappointed: I wanted ordinariness when I saw ordinariness; I wanted repetition when I saw belief. The sense of certainty written again and again in the look and walk and stitch. I stopped the vehicle at the gate. A man came jogging.

'You guys the sand hillers?' he asked.

'Sure,' I said.

'Which one of you's Finchman?'

'Which one of you's Joan?' Angel asked.

'I'm Spence,' Spence said.

'And Vicki?'

'We have no Vicki,' I said.

'We were expecting a Spence and a Vicki.'

'I'm Vicki,' Sonya called out from the back and poked her face through.

'What kind of band are you guys?' the man asked.

'Ecclesiastical,' Angel said. He'd usually look at the ceiling when he was joking, but this time looked straight at the guy. Beside him on the gate, handwritten in an elegant script on a split and sanded log were the words: *Be among those who renew the world, be there to make the world progress towards perfection.* The man tapped the roof of the van. Rust particles fell through the door, making a light, hollow sound.

'Hallelujah,' Angel said, and the man watched us head through into George-Warren's camp in the lowlands of the great Missourian valley.

We angled note against note, note against rhythm. This stressed beat, this flat-fifth. Played hard for forty members out of the art colony. Four amplifiers and we were really just having fun. I spread them about the stage set-up in their common area,

splitting the signal and using my echo unit on one side and Tone's amp on the other. Men danced, the older men. We hit out covers. We played Wire. Here we were, monstrous on 'A Touching Display'. Played it for ten minutes. Angel feeding back his bass on the eternal solo. Things got jammy when we stopped bothering with songs and just sat on a chord and played at being German like we did in the rehearsal room when there weren't any songs left to practise and it was midnight and we didn't feel like dispersing. We just felt like listening to the sound of amplifiers and rhythm. Krautrock. Strict beat. Homage to our name.

The crowd swayed, eyes closed and I closed mine for the moment and imagined we were somewhere else where this stuff made sense. Chicago perhaps, Cubby's, or The Channel in Boston. The kids throwing everything they had in the air, bodies and friends, raw teenagers screaming and teetering. Here it's painters, sculptors and writers and kids. Children flopping about, a toddler falling on its bulgy rump. And then slowly we weren't playing the song, I was tuning and people were clapping. A hard rain of hands in a room full of artwork, of large triptychs and desert scenes. The walls jammed tight with evidence of thought and the expanding mindscape. Vicki'd been here some months earlier; she hadn't said anything about the sheer mass of work when she told me about it during practice. Just that it was teetering somewhere between innocence and insanity, that she'd fallen in love with the place.

Teck, teck, teck, teck.

And then fuck it. Now I'm Johnny Thunders snarling at the pretty girls. I'm Greg Sage with a perfect right hand. I'm the Minutemen's D. Boon bouncing on the spot, a singular pogo amidst the ghosts of punkers lost. I'm Sterling Morrison dazed in abandoned blues runs.

'What you guys do for head around here?' Angel yelled between numbers. A woman said something back. A mild

retort, giddy-sounding, and I thought perhaps she was once a school teacher, that perhaps she still was. 'No, I mean it,' Angel said. 'What you guys do when you're sick of jerking off?'

There was a titter.

Then Spence on the kick and snare, the ping of the ride cymbal and Angel and I following each other – A and A#. People laughing and we felt easily alert. But then the chords caught. The stern groove, the brute rhythmic juxtaposition. I felt our facial expressions lock. The quickness inside the beat. Kick, kick, snare, snare, snare. And then no one was laughing because they saw our faces change as we remembered the music. The flex of muscles, firm chords and the contort under our skin and the people stared or they started to look away as we recalled the force of the song.

And Spence there at the back, hammering a kind of pattern born deep in the harmony of the whole chugging chunked sound. Kick, kick, snare. Kick, kick, snare, tom, snare. The patterned walloping of fists and hair. He used to play the piano at school, then converted to the drums when he was fourteen and his mum had moved them out of the house for a while and there was no piano to play. The whole keyboard thing my guess as to why he was so damned musical in these specific arrangements. He'd place toms like notes – rise the beat up and against the structure and hold its pressure. Angel just slipped in next to him and let the guitars be a modulating growl, a mongrel noise hinting at melody, slipping back from where it desires to careen into the obvious sentiment of fabricated key shifts we've all read somewhere. And we sang, I sang. Tone and Spence wrote the songs but I was always the singer. The one to take the blame when it all went wrong.

Each night the song altered, changed, no matter how much we desired it to remain a precise replica of the tune in our heads because each tune is the performance, the enactment of memory. And perhaps that's why there is never one tune

in our heads. On any given occasion any song could be dominated by the pull of one or other of our maladies. And with no Tone, this was all exaggerated, yanked out of place. The songs half there, staggering without him as we tried to remember their source. Each song is a ghost and there I was, against the mic, crouched. Mouth pointed upwards, eyes into the lights. Sometimes I'd howl, sometimes I'd hack, sometimes my voice went and I was mouthing utter dread because it would stretch open the eye of the Eighty-Eight and show that what happened in the back of the van wasn't larking, wasn't a prank and my voice became the explicit one-note chord, knotted by a scream.

5

On and on. Vast stretches of boredom, tedium crossed with absorption, time colliding with time. Stage, war, plotless time. On and on and I learnt new ways of evading the strew of half-seen faces, of movements. I'd remember books I'd read, mime passages back at myself. V. Woolf, T. Pynchon, Greene, Céline. I'd listen to albums on the stereo and in my head. Sing with my mouth closed so nothing could enter. Silently list songs I wanted to hear, list them in my thoughts and watch the figures retreat. Make playlists, indexes of singers and players, guitarists and drummers so the towns shot by uncounted and hazed. Make stuff out of Tone's collection, the two duct-taped shoe boxes I'd made sure I'd pilfered before we left. His obsession with New York no-wave, with northern post-punk. Scottish stuff, Manc stuff. Tapes dubbed a dozen times, mailed across the Atlantic. Dubbed again. Demo tapes, rehearsal tapes and actual albums. Deadly angular stuff from Hertfordshire, from the goth-heavy territory of Leeds. New Zealand stuff, too. Strange harmonies in the top end and somehow motorik. Deeply owned and necessary. Timbre, beat and that perfect immediate distance. Anything on SST. Anything on Homestead, Discord and Touch and Go. Any shitty little labels run by bands like us. The glorious on and on of Tone's tape collection as I secretly checked myself, reaching my hand behind into my jeans and into my boxers while jokes banged about the van, the hee-haws of appalling humour, sex jokes and shit jokes and piss jokes and Leo jumping into the front of the van and sticking his tongue in my ear.

I feared infection though all that remained now was the deep, heavy bruising and the desire to play, to play and play on and on.

And on and out of the mud of George-Warren's northernmost camp. North, west, then Columbia, Missouri. A city of students, of campus not far from the hills forested among the prairies mid-state. The road in and I went this way and got lost near the university in the late dusk where a large field sat looking straight towards us. A kind of sacred plane, mowed green with a huge marble structure at its centre. I put on the emergency brake and we sat staring as Angel looked at the map, trying to relocate ourselves. These seven enormous Greek columns rose to announce the campus. We ogled these things, confused at their provenance and how the hell they'd ended up there in this particular centre in the heart of the country.

'The fuck?' Spencer said.

Seven colossal columns in a line in the centre of the field as the first snows fell, all neo-classical and scintillated by la luna and our gawking headlights.

'You back up and hang right,' Angel said.

'But hang on, what the fuck?' Spence said.

They seemed to glow, talking back to the moon.

'This is East Groove,' Angel said. 'We're supposed to be on West.'

Spence continued swearing at the thing as we tried to figure out where we were.

'No, we're on West,' Angel said. 'How about you just back up?'

And I did. Turned and came off North Province and then East Walnut to the venue. There was a van outside. Rhinosaur. They'd been on the tour with us since Madison and the night before all this began, Leo and Leroy Brodkey. We'd had a gig with them in the downtown, then showed up at a party

in west Madison where we played in the lounge to students and badass scene kids crazed on trucker speed and bourbon. I loved Rhinosaur, they were boys full of beer and their own clanging in-speak. Leo's brother and the others didn't seem to be around, at least not on the street. Which didn't surprise me. I'd seen them survive on the sweat of two large pizzas for the entirety of a three-night tour, watched each of them sleep in the same bed.

Now there was no sign of them, just the hall swarmed with kids in their serious clothes, decals and buttons. They turned and kept up their talk, shoving each other and sharing cigarettes beside the stern look of our flyers on the wall behind

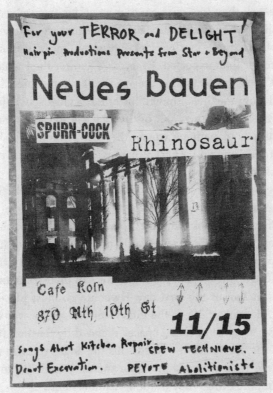

them. I went for the font we'd named the band after for our logo, the same font as on George-Warren's first book, that collection of essays on various American occurrences and phenomena – sixties and early seventies stuff. Stories of corporate- and street-level violence and their antithesis. Stories and on. Some kid from this Columbia scene photocopied it into existence.

I spotted three skinheads leaning by the bus shelter. They moved off when we got out of the van and the other kids continued to watch, because that is what people do when they think they know your name. They look at your hair, they look at your height, they look at your clothes, they look at your sunglasses, they look and try and judge for themselves what we will be when we hit the stage. What songs we'll play by the look of our mood. I'm five foot eleven but know in their eyes I'm shorter than expected. Everyone's shorter than what they expect when expectations are made off photocopied images ripped from fanzines, drawn out of hazy videos swapped on weekends out of town, out of the fact we played guitars and they didn't, or perhaps worse, they did. Everyone's shorter, except for Tone and Angel. Angel was six-six and is always six-six. Tone just two inches below.

Angel watched some more blue-jeaned boys and their suspenders move away up the street. He followed them a few feet. They had a look that said they were about to double their numbers in the alley thirty yards up. The last time through we'd played in Joplin just to the south. The crowd drinking and hitting. Angel spent the night there in their company and met us in Kansas the next day. He could go most places and return. He had a faith in the tune of his voice, the way it was tweaked to move in social spaces dictated by tension. It's not the words, rarely it's the words. It's the angle you use to pry and stalk. He'd returned this time and only said: 'It's incredible, Con, the things they think they understand.'

Nazi fucks seemed to follow us around for a time and I could never get my head around it. Blue jeans and suspenders, kids who sought some kind of security in violence.

The things they *think* they understand.

And I could only agree with Angel. Across in St Louis three nights back I'd had that freshman with his precious Nagra trying to recall for me how Tone was no longer in the band. Saying how he knew I'd held him up at gunpoint.

'No part of this is true,' I'd said. Then some part of me started to threaten and stalk the kid's face, wanting to flick something at his eyes. 'You're a fucken liar,' I said.

'Who shot him?' the kid had asked.

'Nobody shoots anyone,' I said, 'you fucken pantywaist.'

'He's in hospital,' he'd said with his microphone. 'Gunshot wound. This involves volition. This involves fingers on triggers. Aha?'

He wore a Morrissey quiff and had small, tight features. The kind of weakling-fuck who performs lame judgements on books and albums without listening or reading. I stared him silent, stared until I felt a new rumour arise in his face. Finally, I said: 'And how is it you know this? How is it you understand this?' He'd reddened, sweated. 'How?' My voice all over his face. I got in close, spat. Ten minutes earlier I'd vomited involuntarily like I had routinely since the day after Burstyn – or not routinely. I tasted of bile and smelt it as my spit globbed on his face. He looked pathetic and I felt myself willing to headbutt the maladroit. He grabbed at my scarf in some strange manoeuvre and I pushed him across the room, shouting at him. I followed him out to the car park, screaming: 'How is it you know this?' Words I'd read in a book. 'Cunt,' I shouted after him. 'How the fuck is it?' Words from a book Spence'd lent me months ago in the summer before I went north to Canada for school and wrote letters to Sonya from the trees. I'd written this same question in a note sent to her

from Vancouver, hoping she'd know what the next words were. They were originally inscribed by Joan George-Warren, of course, in her first book and I'd no idea what part she'd play in my life. There's no simple way of knowing and all I could think of at the time was one of her essays. The history of a Hungarian family who'd lived in the same home for generations in New York, who'd subconsciously learnt to walk the stairs and halls of the house in a way that made the brownstone creak in harmonically pleasing sequences. After they'd had to pull up the floorboards to rewire in 1969 and hammered them down once more they all, the entire family, became sick, mentally and physically.

And all Sonya'd said in reply to the question was: 'If we say we don't know, the question then becomes: *What do we know, if we don't know?*'

We eventually found the rest of Rhinosaur in a bar and packed into the venue. We sound-checked and sat around and with us all suddenly hungry Sonya and I went out to get supplies. The two of us in shitty shirts grabbed from the clothes bag. She wore Spence's coat and I had my leather jacket zipped up to my chin as we wandered in the dark. We held hands as we went hunting cheap bread and massively processed protein. Half the places wouldn't serve us, half told us we had to eat outside. We went past an aged red-brick library packed full of musty awe beside a church with signs warning of sin and death, a place for impossible memories of biblical event and martyrdom. Sonya posed as I took a photo of her and the chapel all lit up by foot lights, beams casting cruel shadows on the walls. It was good to be alone; I felt something prosper and wake inside.

'You know the rumour I like about the afterlife, honey?' she asked as I had her shift her torso into various angles. 'It's the vast fields of fancy cheeses.'

I nodded, clicked.

'Like brie and blue and, whatever,' she said. 'Rivers of slow-moving camembert.'

'What else you got?' I asked.

'For the afterlife?'

I nodded. I loved taking pictures of her, the way she thought she should pose and how it wasn't about the pictures but about her knowing I loved having her in my frame.

'Clean clothes, for a start,' she said.

'That'd be a start,' I said.

'Clean clothes. Like, silk pyjamas. I'm rich when I fantasize.'

'Socks,' I said as she took the camera from me and handed it back.

'Fresh socks.'

'Two apples, smoked cheese.'

'Back to cheese. A world without thrush, or BO,' she said. I motioned that she should step away and we continued walking. It often appeared she became someone else when it was just the two of us. Someone she was determined to be that belonged not to her family or what her studies asked of her, but a woman alert to the things that made her feel close to her own recollections of life.

'Thought you liked the way I smell.'

'Not so much.'

We wandered west on East Broadway, down past a squat stone building. Sonya pointed at the inscribed lettering above the entrance barely visible in the cold street lights: *Central Dairy*. She wondered aloud if it were the implied milk that was central or the place. She stood frowning like this were a question that would solve a thousand problems, then laughed. I needed these moments with her. They had the effect of making the vile seem old, tired and shy. Before elementary school my family moved a lot and when, after years of shifting, packing, we finally found our family home, the effects of this vagrancy set in me a sense of desolation. An echo of which cursed my

first moments with anyone, and in particular, Sonya. She was from a country clinging to the edge of the ocean; this was her part in our mutual suspicion of space. Something I suspect we exploited into our own form of attraction, of hots and lust. The channelled path of our interiors always on the lookout for love.

'Vicki said you and her were down making a hell of a racket before he shot himself.'

'—'

'You were jamming.'

'Yeah, so.'

She squinted. 'Vick just said is all.'

'Yeah, we were.'

'After that she lost track of you.'

'Why?'

'I just want to know where you were when he shot himself.'

'I was warming myself in the kitchen after smoking your pot,' I said, kind of hard. She watched me.

'I don't want to call bullshit on that,' she said.

'You hungry?' I asked.

'Not really.' Her eyes gentle, love-bright despite everything. 'It's OK, baby. Just trying to understand.'

'OK, hon.'

'Who else was around?'

'I don't know.'

'Vicki said Frasier.'

'Yeah, the last person I saw was Frasier Finchman. He came into the practice room while we were playing. Then he fucked off. When did we last eat?' I asked.

'Dunno,' she said and I caught myself re-seeing Spence's father standing in the rehearsal room. That bloodshot figure, a drunk whose only kink seemed blithely aligned to aged jazz. The cat-gut vibrations of old recordings seemed the closest thing he knew to experiencing emotive distress. He was old

rust money from Pennsylvania, imputing blame on all others for ending up at our nervously liberal arts college so near the Mississippi. I'd once had a class with him. DeLillo's *The Names* was the text, something Sonya'd turned me on to. *What is it we ask of history when we read this novel?* he'd put to the room, and nobody gave the right answer. We were all wrong until we repeated word for word what we'd been told at the start of the lecture. History was the battle between the language forms of conflicting epochs, of flowed technologies of thought. I hated him for the way he treated the class. But I hated him even more for the fact that what he'd said had stuck with me longer than any thought I'd come up with myself. History is the war of technologies of understanding, of truth. What an asshole for knowing such a thing.

Sonya shook her head and stared at me for a long moment. 'You know when we eat sometimes and you don't ever talk until you've swallowed?'

'Yeah.'

'And how I get irritated you won't answer a question?'

I nodded.

'I like that – but it's a secret like. That you don't talk.' She looked solemn then, like her brother had just whispered in her ear the truth and this truth ran through her, vibrating a last long chord.

We found a deli and walked slowly about the aisles, picking things up and putting them back. She sidled up to a young couple, saying: 'Who killed the pork chops?'

'Sorry?' the woman asked, recoiling.

'I won't eat 'em till I know who. It's the least I can do.'

She smiled gently for me, and the rest of her question seemed to evaporate. We walked back past the church, its four columns holding the portico in place. We found ourselves standing there once more. We talked about her brother. Repeated details.

'Things are appalling, Con. I spoke to my mother while you were loading in. I spent the entire call imploring her not to fly to Chicago and over to Burstyn.'

'Why?'

'I don't actually know. And she kept calling me, *love*. You know? The whole call and she's never used that word as a noun before. Not like that.'

I huddled her in close, her arms around my middle.

'What is it when we say we love, Con? What is it that's so abysmal and I just can't give in and I give in? Why is that?'

Twenty minutes later at the back of the van she was crying. A kind of body shock of tears and nervous undoing, snot and unretractable weeping, trembling face and body and salty eyes. We stayed there for hours, the lulls and the outsider stories we told each other, these were a whole other part of the silence.

Then it was 8 p.m. and though we put our gear on stage, though we sound-checked and sat waiting with two six-packs, we never played Columbia. A crowd of keen and beefed football players had taken the venue apart, smashed windows and broken up the stage as Spurn-Cock went through their set. Sonya and I'd watched from the back. Kids smashing each other, blood-wet and eager. Faces raged by unspoken elements of this desire and that hunger. Virulent things, habitual and everyone seemed as happy as pie. We watched two kids punching and throwing themselves into a pile of stacked chairs at the back of the room. And just as Angel tried to separate them Sonya said: 'God, Tone would've loved this.'

6

October 2004

And in another now, in another moment lurking during the autumn of 2004, her brother found me in New York. It was a time during which I was struggling to get my head around work, uncertain how jobs might find me after a time away. I'd married Barbara, my first wife, in the mid-nineties, then shifted to Canarsie in Brooklyn with her kids and our greyhounds a few years later, from Oberlin. That cold little Ohio college town I moved to a week after the tour finished, retired and watched bands like Bitch Magnet come of age, Slint, Codeine and Come. Post-hardcore. Post-rock. Men just a few years younger than me understanding things that I hadn't. At first, we tried not to say we were in Brooklyn. What that word meant was unclear to us, as if we'd arrived 200 years earlier in a haze of smoke and fog looking for a place to live and found only hills, wharves and mud. We got a house not far from a park and I found a job at the postal service once my attempts to find work as a cameraman fell into abeyance. But over the months the word *Brooklyn* summoned then irked the small-town parts of us that sought relief in known borders. In New York, there was no such thing; the hiss of open streets and whole neighbourhoods massed by unknown dialects. Barbara left me two years later for Richmond, Virginia. It was then I found myself in a deep habit of walking. Ambling the twitch and lattice of neighbourhoods I'd no right to be seen in.

I'd head north on East 42nd, where I lived for a time, drift in amplified heat until I hit Rockaway, then New York Ave., west until Jamaica and then anywhere. Three hours, four. I

was a wanderer sparring with moods that never quite became thoughts. I walked because I desired to maintain some kind of intrigue with my body. It'd become haggard, tuned to the provocations of drink and pizza. I continued to walk because I believed there was a question at the end of it all I could answer swiftly and simply by returning home and staring at the books on my shelves.

Then on a Thursday in late July I was over near Queens, past the little Gnawa joint with the afro-trance tunes caught between the buses and the balcony beatbox, past where the road started to feel like it should have a new name, and I took a right in an attempt to swing myself back home via Liberty. Found myself standing on 183rd where a squat, nineteenth-century brick construction caught my eye. It said *ICE* in large flaking letters, quietly going about their doom. I was drawn for obvious reasons: it was hot and all I had was the heated dregs of my water bottle. Everything felt burnt off, the colours, the humidity, the aura of street sound and garbage stench. Everything lifted, ghosted in the warbled air. It was also the age of the lettering, the pleading intent still extant in the word. ICE.

I walked on, imagining the building housing just one colossal hunk of frozen water from which all ice came, desperately imagining that it was always ice and there was nothing else it could be. The road dipped and tunnelled under railway land where lines branched into workshops and the sound of great machinery. Then the dim trudge towards the tunnel's eye at the other end. No cars but abandoned shopping trolleys, no sounds but the trembling from up above as the trains lugged themselves to a standstill. Dim daylight filtered through from a grill and that was it, the arbitrary pooling of light. I found myself in a daydream contemplating the patches of frozen asphalt we would sometimes encounter as we splintered the hinterland in the van. A bridge, perhaps, where there was

no residual heat from the earth to keep the fallen rain from turning to ice. The places in my mind where the blacktop is forever frozen over, forever seeing us slide, the trajectory of the oil-hungry van no longer attached to my hands and off we'd go, sliding, the four of us whooping, laughing and waiting for the hit. But there never was a hit, just the sensation of waiting, on and on and how we became silent.

And in that relearnt silence I thought of the places we'd end up, the how and why. The bars and improvisations turning backrooms and stores into venues. The madness of our appearances, state after state, house after house. And then the four of us at the camps, Joan George-Warren's anomalous places of experimental living – that they existed at all, that we were there, odd participants. I gradually learnt about their purpose along the way, but this didn't change the oddity of our involvement.

In fact that was the second time I recalled thinking there was something to remember in the past that wasn't simple, that wasn't easy. A realization I'd buried empathy, grief and passion but not so they were forgotten but rather blurred into a form of misremembering that made it easier to keep things un-thought of. What I recalled then was an echo, the haunch of forgetfulness. I kept walking, wanting to find the edge of the great thing, of the city and all its roads, rogue taxis and voices and men calling me out, the abuse and courting cries. But with a place like New York there's no such thing, just outwards and onwards.

After a year of postgrad trying to write on the Maysles brothers and Errol Morris at my new college, I found work at a production company. Run of the mill AD stuff. Then shooting commercials in Cleveland for a director who came over from Chicago in an office dank and rat-run. He liked me, liked the pictures I took. I thought I'd easily find work in New York for some low-down corporate video outfit. But nothing came. A week as a taxi driver. Days cleaning at a McDonald's. Then the postal service until I

stopped being able to recall my route. Stopped being able to recall which buildings and which streets. I could be seen standing at street corners staring at the mail in my hands.

When they fired me, my sister helped out: every few months she came to town on business and took me for a drink and most every time I'd find a cheque in my wallet for $500. I was effective at eating out of cans. I wrote music reviews of local shows. Every now and then I was able to pick up mixing gigs at places like Issue Project, Tonic or the House of Nails. Ensembles of freak noise and post-rock disintegration, of isolation and post-noise pop. Of protest and statement, of non-statement and just the raw remains of all the words we used for funnelling punk. Laptop aberrations, percussion and glitch. Circuit benders and guitars without strings. But gigs were seldom and I wasn't that excited by hanging out with musicians when I didn't get to play myself.

Then I entered the fuss and glamour of home staging. I loved that job, loved moving furniture around until the dim and grimy felt like home. Queens, Staten Island, the Bronx. Even over in Newark we had jobs turning homes into the kinds of places anyone would want to live. We'd take the truck through the Holland Tunnel and across the Hackensack towards the city. The enormous factories and warehouses from the previous century. The glass-panelled walls, the cracked vistas and the thought that surely someone would take responsibility someday and smash them all to vacant lots.

But they stayed, they stayed through economic revival and retreat. And the same could be said for some people. I'd gained fifty pounds in the 1990s, sustained this through into the 2000s. Sidling past people had become one of my new life's pastimes. Then I lost it all in the Great Fight around 2003. I use capitals because it would make Spencer happy. That was the name he gave the nick of skin cancer under my right eye after he came and visited for the first time since I saw him in Oregon that day. Minuscule, a baby rash of deadly cells. In my lesser

moments I was more thrilled to be losing the weight than I was to be going on living. The pain non-discreet. For years I was the worst companion to be around a meal. I talked of this pain and this strand of nausea. People came and went, eager to stay a little while in my apartment with its old mottled wallpaper that made the place look like it was carved from some kind of rock, then leave for the subway. Then, to my surprise, Tone was standing at my front door. He was the most recognizable man on the planet, if you were me. It was his face I would see enhanced in the background on the entertainment section of the news. It was his video I saw if I caught a flash of MTV. Fame is what old friends and bandmates see when the rest of the world is drinking coffee and waiting to sleep.

But this was October 2004. He was in his mid-forties when he came to visit in New York, the small apartment on Grand Street near the Knitting Factory. We stared at each other sitting in my deep brown chairs, things I couldn't afford ordered from a magazine. We'd seen each other a couple of years earlier in Chicago, just before Barbara and I'd moved to Brooklyn. Played a surprise festival show together in front of glinting thousands, but this felt different.

Tone wore a white cotton shirt over a slight belly, white loose-fitting pants, white Doc Martens and a white coat that went to his knees. Even his beard was showing signs of silver. I watched him, trying to understand who was sitting opposite me in the lounge. He looked like a new set of teeth, brushed, fluoride and zing. The bright halo of dental reverie. He watched me watching him and finally said: 'I feel we should – like – hug, Conrad.'

Even his sunglasses had white rims. They seemed to dim the effect of the scar in his dark skin, star-shaped where they'd stitched his cheek back in place and let it form into a glossy rumple of turned skin.

'Sure.'

And we stood and embraced. It was odd, over-long and he smelt of day-old wine. Finally, I stood back from him, gathering in his glow. He started smiling and I remembered how I always liked it when he said my name, even from back when we were young. It always made me feel connected to whatever was going on in his mind, whether it be about music or art or people or what we were going to have for lunch, I didn't care. I just felt slightly bigger each time he said *Conrad*.

He watched me staring at him. His skin glowing against the white. 'So, I've this trick,' he said.

I found myself smiling.

'For killing hangovers. Learnt it in Amsterdam from Nikko Spurn-Cock, if you remember him. So, you're hungover, right, you're quivering and sweating. You know the deal. So, you go to your wardrobe, search around for anything white. Put it on. White socks. White boxers. White wife-beater. You feel amazing. All vigour times vim.'

I laughed.

'You feel like the freaking sun,' he said. His large eyes expanding with the words.

'The sun?'

'You feel amazing.'

We talked of his life in Germany, the ruin of my marriage, that other life lived under martial law. We talked about how drunk we used to get and how it didn't seem possible now to do what we used to do. How we'd sit for hours and let the talk be about anything: fried chicken, ice-cream sandwiches. Lost kids on milk cartons or the mere fact we were sitting in the hall of the Eighty-Eight where we'd moved all the furniture, just to see how it felt. The ritualization of adolescence so we might have its illusion to hold on to, that stem of youth whose loss we always feared until it was gone. I put on that Annette Peacock compilation and watched him sway. We listened to

Trans Am and Shellac, Peaches, fIREHOSE and Judee Sill. After two hours he switched the television on and muted the volume, we conversed over serious faces talking news. Iraq. Bush. Mrs Bush. Missiles. Local murders and robberies. The NASDAQ and its holy war.

I brought us tea, a nice bluebird set I'd purchased in California, and we watched an article on the ancient Bamiyan Buddhas in Afghanistan. Those monstrous figures blown from the rock seven months before 9/11. Here people were discussing rebuilding the things out of the rubble strewn at the remains of the Buddhas' feet. The UN's International Council on Monuments and Sites. These words scrolling under the images of women and men in the dust.

'How long you been here?' he asked.

'Fourteen months.'

He looked at the images on the screen, calculating the number into years. He'd a habit of pushing his tongue into his damaged cheek, still feeling for something, and his beard shifted.

'I'm fascinated by these things,' he said, nodding at the Buddhas and rubble. 'Can't decide what's more interesting though, the empty niches or the pictures of the actual things.'

I laughed.

'I'm serious. I feel like I'm supposed to have an answer, but I'm vacillating.'

'I like the holes,' I said.

'I like the holes. That's all I've come up with.' He stared and glanced back at me, then looked away.

'What?' I asked when he didn't say anything.

'What do we – do we have a name for this?' He swung his arm around at the television. The greenish tinge and mutant reds.

'We have no names for this,' I said.

He chortled. 'We have a name for this.' Then he went quiet and I remembered how when I first met him, the day after I met Sonya, I was struck how he didn't have an accent. He'd

moved to the US two years before his sister, lived in Phoenix before moving to Burstyn after joining the band in a moment he later described as *obliquely visionary*. For reasons of time, that was enough for him to lose his New Zealand voice, but he didn't lose those things in his persona that were impossibly different to his friends and bandmates. Which, of course, made him oddly more enigmatic than Sonya, unwilling in some exchanges, extravagant in others.

'What godforsaken gets you to Brooklyn?' I asked.

He sat still with his cup. 'You know, people. Producers, magazines. I'm prime property to the age group just outside of Who's-Fucking-Pirating-Every-Fucking-Thing. They're the last of the non-static buyers. Which is a term they came up with last week to get me here from Germany.'

We found ourselves watching the screen in silence, the mystic of futures and pasts played out in pastel and misty blues. 'This is TV paying for itself,' I said eventually.

'Really?'

'How's your sister?' I asked.

He told me she was living back in New Zealand and I felt an unexpected twang, a jealousy that he knew this and I didn't.

'She's become a consistently nervous woman,' he said. 'You should write to her.'

'I don't think so.'

'Have another go, have a better go,' he said, pointing at the TV, imploring me to describe what it was we were seeing. He blew steam off the tea. 'Plus, I'm scoping studios. Have a go, I'm interested.' I watched him stand and look at my bookshelves and photos. The framed and not framed. 'There's a name for all this.'

'Sit down, you're making me want to shit.'

'Have a go,' he said.

'This is, this is society tallying its sorrows,' I said.

He laughed, coughing up air. He leant towards the screen like he would if watching the Packers, Yankees, or whatever might

be on. Instead it was members of the International Council on Monuments and Sites holding up hunks of rock to the cameras with the scaffolding lurking behind. 'This is TV,' he said. 'And the thing to remember about TV is it's always hungry.'

We chortled, the two of us, said some more grand summarizing, unifying statements, like old men at a well. His hair stood up like a headdress, combed there in some morning ritual. In the nineties he'd had a string of successful albums, each paving the way for five-, then ten-thousand seaters, then stadium tours on the support for Neil Young, the festival circuit playing the evening set before the likes of Soundgarden, Foo Fighters and whatever awful. Then one song. One huge song that led to a huge album that sold his back catalogue, and ours. 'Brevima Dies'. The single that sold to the world when the world still bought singles. Money had become a topic of conversation, it'd also led to a preoccupation with his hair.

'It's how a culture remembers its burdens,' I said, then changed tack. 'I'm imagining, like. I imagine you travelling with a set of lackeys in uniforms, Tone. I imagine you with stockbrokers at your side. Email and SMS,' I said.

'Not quite.'

'Wild investment schemes.'

'Not quite,' he said.

'I'm imagining you with a laptop, only you never touch it. There's a young person whose sole responsibility is to tap into this thing. Find data ports and modem access.'

'I have a fleet of minnows who watch numbers. Daily updates. They buy and sell. I don't know.'

'You don't know?' I asked.

'They message me, I send back cryptic answers and await the outcome,' Tone said. He turned the sound up on the figures and chunks of rock and Buddhas. The poor 1,500-year-old statues had been destroyed by dynamite during a month of festivity and obliteration. They were fired at by Taliban

anti-aircraft guns and artillery in the name of iconoclasm. Military men placing anti-tank mines at their colossal feet so they might detonate with the falling debris. The lamenting Taliban Information Minister was on the screen saying: *This work of destruction is not as simple as people might think.* Then Tone muted the whole thing as we watched the final act of dynamite and rocket fire.

'You remember Spence, him saying about the TV, back like?' Tone asked.

'When?'

'You remember?'

I did, but he reminded me. Every time Spence saw a murder reported on the TV he'd watch real close. The news presenter and Spence'd lean in as they named names. He'd joke how he used to hope it was his dad. That his dad was the murderer and he was in custody. Or he was dead, the murdered. How he always wanted his dad to be the killer, and life would've made a whole lotta sense. His picture on the TV. And they'd use his entire name. Frasier Preston Finchman, the way they do.

I laughed, then he laughed.

'I think I saw him one time, Spence's dad,' he said suddenly. 'I was at a supermarket in Chicago on tour and this poor woman was buying her groceries with food stamps and this guy, this fucker, he started yelling at this woman. It was horrible. This guy just yelling at this poor woman and I went – *Fuck! Spence's dad!* It was quite strange, to see him there among everyone at the supermarket. It was horrible actually.'

'Jesus. Was that after he was fired from Burstyn?'

'He was fired?'

'Yeah. He embezzled funds from the English department and got biffed.'

'Right. Good for Spence's dad. And then I just went to the hotel, depressed as all hell.'

I changed channels twice. A rerun of *Friends*, then *The*

Sopranos. Tone pointed, a little adultescent excitement, and gave a rundown of the series so far when I said I'd never watched it. Imagine Tone leaning back, gesturing each time a new character came onscreen. It reminded me of when we used to hang at the Eighty-Eight and watch late-night TV until we were asleep. We'd sit with guitars pretending to be writing and we'd watch and just drift and he'd tell me about New Zealand when he was triggered to do so. Growing up in Wellington where there was little to do but walk in the forested hills and swim in the harbour when the summer came around, or down on the rough south coast full of seals and murderous sea. I'd always wake after him and I'd hear him in the upper halls of the warehouse, looking through the rooms we'd never been into and it always made me think he was ahead of us, always finding ways through things we didn't yet know were there.

'Paloma,' he said.

'Sorry?'

'Look. On the telly. Paloma Mrabet.' He pointed at the screen. A massive mural in Marseille. Scum-rocker GG Allin. Black blood streaming down the side of the building from the back of his head. An interview then with the artist. She looked leaner than she had years earlier and it took me a moment to see her young face among the gaunt features.

'I don't remember you meeting her,' I said.

'I met her all right.'

'I know. I just don't remember it. I remember so much, Tone. So much. But then there's whole years, towns and spaces gone.'

'I met her in Yuma. What don't you remember?'

'If I knew, then I'd have remembered it, wouldn't I? I mean I say years, but maybe I'm only forgetting days. I just can't tell.'

He laughed. A specific laugh that seemed designed to station a curse on all the things he didn't have answers for.

''Bout you?' I asked.

'What?'

'What do you remember?'

'Well. I *don't* remember playing. Not really,' he said. 'I remember haze. I remember stages, venues and bars, people. But I don't remember the actual, the event of playing. The event has vanished. I've a theory about it. Actually, it's Sonya's, but what the fuck.'

'I remember just a few gigs. But the others—'

'She said we're talking, like, excess. Like – fog of war. Right? It's the prodigality of excess. The physical and mental excess. Your body's at full power. You're screaming your throat raw. You're yelling like, this is like you're under attack. You put yourself into a state of immense adrenal overload. This is flight or fight and you're there for the fight. The brain tasks itself with the problematic things of survival; memorizing isn't one of its tasks. We're talking self-administered PTSD.'

'This is her theory?'

'Aha.'

'So why do I remember some gigs?'

'Because you were playing like a pussy. Leo remembers every gig cos he's always played like a pussy.'

We laughed.

I wanted him to say there was a precision to memory, an exactness that comes with time. I wanted for him to say a name, then almost the same desire to never say it. He stayed silent. We watched Paloma on the TV, the concentration on her brow. A record of her work, record sleeves and sculptures. Her desert-land punk exhibition at the Brooklyn Museum of Art: photographic anarchy, large format, rock and noise carnage, German industrial, metal grinders and burning debris, fallen luminaries, all snapped during her time at punk's Desolation Center, the festival of freak-core which Tone made claims of attending multiple times. Then back to GG.

'What do you think?' Tone asked.

'I think if anyone calls GG a punk they're just confused.'

'Bullshit. I miss dicks like him.'

'Come on.'

'The guy promises to blow his head off on stage. Instead he overdoses at the house of a guy named Johnny Puke. There's something deeply poetic in this. This is a guy who ate his own shit for our entertainment. People go to his gravestone to pee and defecate. He's far more successful than me, or anyone from then.'

'You spend too much time alone, huh?' I said.

He blew air out the side of his mouth and asked: 'You still take photos?'

I shook my head. 'You spend millions on being alone, don't you? I've always been fascinated by what money can bring.'

'I don't have millions, so straight away you're lying,' he said.

'Thousands.'

'I pay people thousands just to say I'm unavailable,' he said.

'I request on my answerphone that people don't leave a message,' I said. 'Seems to do the trick.'

Tone bobbled his head and looked out the window, almost winsome, almost coy. He was the quieter of the two Seburgs. Sonya could shout, though wouldn't; she could be there with a filthy joke, but rarely saw its opening. Tone was somewhat more hidden, and I remembered that as we made faces at the talking heads. Joked about the eyes and hair, the teeth planned in some dental surgeon's office. An advert for hair-loss replacement therapy. We skipped around subjects as we banged buttons on the remote.

'You know in the sixties they did experiments trying to reanimate cells in hair that'd been dead for decades?' I said.

'That's nicely insane.'

'I shrug emphatically. All in honour of hair loss.'

'Are you going bald? I'm going a little.'

I shook my head. 'I'm fine. I look at Spence and think: *That's one balding motherfucker.*'

'Yeah, well, fuck Spence. Speaking of reanimation, you like ever opened a defibrillation kit and zapped the wall, a plant or something. A small dog? You ever been tempted?'

'Sure,' I said.

'A small dog?'

'No. Not a dog,' I said. 'Tempted, maybe. Put it on my leg and wham.'

'There's one at my grandmother's house. I visit and look at it and go, *Come on, let's get some action here.* She's eighty-nine and I'm insufferable sitting around watching her.'

'So, you search defibrillators out.'

'They're locked in memory,' he said. 'Across Europe and the deepest Midwest.' He went quiet, and for a moment I found myself caught. I hadn't been anywhere near the area since our final tour in '85, not since I'd moved my shit from Burstyn. He nodded, as if to encourage my next thought into words. 'You were drunk,' he said. 'If you remember. Nearby. Or you weren't drunk.'

'Which narrows things down.'

'And I woke in the ambulance. Gauze over my face.'

'Yes,' I said, 'fuck.' And I felt the blood-rush of detuned memory trying to make itself real. Awake.

'They turned the siren on, but there was no need.'

I felt my mouth open, the weight of my bottom lip. I bit it. We continued to watch TV. Weather and the whole thing of mimicking isobars. The presenter gesturing off-screen. Tone'd never mentioned the night in Burstyn, not in twenty years. Not since we were alone at his parents' house in the Santa Maria mountains six weeks after he shot himself, not since then. It would've been simple to turn to him in my lounge and say that sometimes the event returned. Tell him that the sound of the gunshot out the front of the Eighty-Eight still did its thing and

woke me, dinged imagined air. But I said nothing, because at that point I still wasn't sure what sections of the past I'd lost. I knew my past was in my body and my body was always trying to codify loose sensations into a kind of narrative core. My mind was always trying to forget and there was pain, psychic pain and the rapturously real. There was incompetence, there was near poverty. This was the conflict, skirmish and the tussling of various demonstrating demons. Years later, as others close to me had their capacities failing, a sudden definition around all the changeable data began, but in that room with Tone it was still a cloud of personal ambience shifting in and out of whatever story was being told.

'The sound of charging electronic equipment,' he said. 'Capacitors thickening with the stuff. Lights. Men discussing my body in terms I hadn't heard before. The sense that outside the vehicle lights were flashing.'

'So, fuck.'

'A slight strobe of blue and red in the corner of my eye.'

'So, fuck. Did they, did they use it?'

'No. It was all powered up and my lungs came back and my heart came back and they were counting down. That's my memory, but they might easily have been saying other words.'

'In Burstyn?'

'In Burstyn.'

I looked up at the ceiling as if that were a direct link to something eternal, to memory, as if its hiding place among the perforated tiles and lights was the always-settling dust beyond. He looked up into the same place and I remembered Angel making that joke in the van about the band being ecclesiastical. I found myself laughing for a moment. The recessed light bracket with a bulb faintly brighter than the others.

'Have you ever?' I asked.

'I've never known.'

'Never?'

'What had me – with the barrel in my mouth?'

I nodded.

'I've never known.'

'But you know something. Everyone knows something.'

'As I was saying,' he said.

'What?'

'We put ourselves in situations of forced trauma. The mind isn't so worried about retaining the information.'

'Frasier Finchman,' I said.

He took his time, waited for the heavy wheel sound of a passing truck out on the road to run on out of earshot. 'It's a name with resonance,' he said.

We played guitars and lit up the piano his mother had lent me twenty years earlier. A kind of circular music based on two gonging chords on the keyboard which we'd looped with the Boss pedal I'd bought on the web so I wouldn't have to walk into the music store and be asked what guitar I played, what kind of music. A heavy bell sound donging in the room via digital memory. It was the first thing I'd purchased on the internet, and this was the first time I'd used it. Tone showed me what to do. We played for three hours, recording on his little digital Dictaphone. Hypno-lit, hints of the phrases played so easily twenty years earlier, the strange conversation between the musical mind-tech of competing nows. Then the two of us lying on the couch, in an unexpected sweat. I handed him some of my painkillers and we were there for hours. Eventually he told me to get well, and he left before I could ask him about Boulder, about why I had so little of what came between my rape and my remembering, my head jacked up on Demerol, quietly exchanging pain for dreams.

He called two months on from LA and I went to him, across the continent.

7

November 1985

In Columbia we'd abandoned the gig, left it to ruin and found the band's house out on Locust Street not far from the university, shifted the guitars inside the low-rise and started drinking with the guys out of Spurn-Cock and Rhinosaur. Cozen Jantes had a box of long-necks he shared with me, the two of us laughing and Spence sipping ginger wine. The place was a terrible junker with the piles gone in the south-east corner, so each time Jantes put a bottle on its side, it roamed towards the hall. He did it with the purpose of noise, as we did most things. He sung out of Spurn-Cock, wore ripped black denim like the rest of the band, safety pins like it was '76. Spence watched the bottles groaning across the wood then banging against the door frame.

'Hey f-fuck-o,' Spence said.

'Whatcha drinking, Spencey?'

Spencer held up the green bottle. 'I'm drinking what I'm drinking.'

Our drummer never drank what we drank, always had it that there was a different idea at the bottom of every drink, and as long as he was consuming something other, his thoughts were his own. Angel once made the claim to his mother when she'd found us drunk on her doorstep during school time that he drank to forget. It sounded like something he might've heard once from some addled hipster or starred-up drunk, imbibed and kept for himself. But I was never convinced and in my late thirties and drinking a lot in New York, around the

time Tone came to visit, I came upon the idea that I was drink-
ing to *remember*, that there was an idea or thought or question
that I was trying to rediscover, deep in the drunk. This, I real-
ized, was possibly what Spencer'd been on about twenty years
earlier. In among the molecules of ethanol and sugar was a
specific memory he was trying to rescue, let rise to the surface
and inform whoever was around he'd found some truth.

'Hey, arsehole,' Spence said at the singer in Columbia.

'It's the h-house,' Jantes said.

'It's the house, bullshit.'

'It's the house.'

'*It's the house*. You know who your band sounds like?'
Spence said.

'Fuck off.'

'You sound like a poor jack-off shit.'

'Oh, fuck you.'

'We can give you chord charts if you just want to, you know.
Go whole-fucking-hog.'

They went on like that until a local band started playing
in the hall. Kids leaning in watching. A whole party came
and went. I found myself in the bathroom telling two girls I'd
stopped bleeding. I don't know why and I didn't say where but
they were just laughing, saying: *I know, I know.* One of them
hooked up with Jantes and I drank until Sonya was telling me
things I'd never heard before, like she knew I'd forget.

And then we played. A zillion watts of us quaking the
house. We played until I had no voice and was on the floor
among the discarded bottles with the mic, improvising mock
languages and pronouncing sentences for the rich and vain.
I crawled through the house, grunting and cursing, between
people's legs until I was in the kitchen and I ran out of cable.
I humped the floor as the band crashed and stomped on the
other side of the house. Noise through the rooms and a woman
in a sixties-style dress handed me things from the drawers

and added percussion to the racket. Serving spoons, ceramic-coated mugs, cutlery and plates. She handed down a long sharp boning knife which I slammed into the mic cable and that, that was the end.

And then later still once all were sleeping, once the last of them stopped shouting and replaying the same side of the same record over and over, I took Sonya's arm from my chest where we'd fallen asleep on an ancient divan. Her fingers had been resting on the bruising and she'd no idea they hurt. The marks were still blue, and I tried to hide them the best I could. When we had sex I kept my shirt on. When she kissed my neck I pulled her mouth up to mine. And now I shifted her off me and headed out. I found Spence's coat near the door and went into the black-cold. I walked Locust Street till South 8th. Then in the direction of the university. I walked because I'd lain there listening to side one of that first Sonic Youth EP over and over and as it played out again and again I remembered something. I recalled a photo, a Polaroid I once saw in Louis-ville while staying at Leo and Leroy Brodkey's. The Rhinosaur house. We loved those guys and would play with them as much as we could. Spence even played for them on occasion, recording and touring. He'd spent a month on a tour of the south-west back about twenty months. Texas, New Mexico, Arizona and California. That was when he first came across George-Warren in person, her compound in Yuma where Vicki was visiting on some kind of furlough.

If we ever ended up in Kentucky we'd crash at Rhino's house and drink and kill one another with stupidness. The pic-ture I'm thinking of was taken at a party at some shitty duplex where they used to practise along with a few other bands. It was summer, out in the backyard. Leo lying rump-up in the grass. Their bass player, Glenn Brotius, was kneeling behind him. Leo's pants were down and Glenn had his finger in his

friend's ass. He was laughing, pointing with his other hand towards the camera like David Lee Roth, like – *This be rock 'n' roll, motherfuckers.* Leo had the picture on the fridge among takeout menus and drawings by his little niece. I thought: *Yeah. Maybe that's it.* Maybe it was Glenn and Leo playing at being jock-cocks. But Glenn wasn't in their band anymore, and nor was Leo ever likely to be sticking anything anywhere since he'd come down all rumoured with girlfriend none of us ever saw. I'd never in my life thought that photo, any such photo, could suggest hope. I never believed any such thing could suggest anything beyond idiocy.

I found myself walking the snowed-on field, the Francis Quadrangle where I'd earlier put the van so we were staring at the same space. There at the centre I found the strange array of columns once more, seven lined across the centre of the field. Thirty feet high and waiting on something. We'd earlier taken that wrong turn and found ourselves face to face with these luminous chunks of marble, stared for a moment before reversing out and away. Now I walked towards them. I thought: *Why six? Why here?*

I walked to their foundations, lifted myself up and sat in the heavy air. And as I sat under the marble I started to feel the returning anger. The mangle of heat and blood, lateritious and ridden by cold panic. I stood up on the white stone and tried to jump and kick the returning terror out of my legs. I shouted and found myself thinking of the fuckers back at the gig who'd made such a mess. I remembered their faces, something compelling them to explore the output of violence and stupidity. I felt my skin in the hard cold. I felt like knocking them sideways and standing over them in my boots. I started to imagine kicking them. The bruise and hurt and slop as my boot made swill out of their faces. I imagined them hollering through damaged mouths, beckoning sympathy and relief. Then the brute fact I couldn't hear them and the way they

moaned, the way their mashed mouths were moving with no sound rising forth. How I tried to shut them out with one last thrust of the thick heel. How I found myself imagining Sonya at the side of the street. Her eyes reddened and wet, but not out of pity; it seemed she was crying for the sake of all the other things I couldn't tell her.

All the things.

I wanted her to know nothing of the reasons that had put her brother in hospital. I wanted her to know nothing of impossible variances of truth I suspected and feared. That the gun was fired because he saw. Because he knew, that was my certainty, even if years later he couldn't admit it. I'd said Frasier Finchman's name and all sorts of fear came with that, that it was him and I suddenly feared for all of us. I stayed that way until dawn came. The sun hit on the columns, the faux wreckage of a culture so eager for a past and I couldn't back away from the idea of it, of Frasier's body, old and angry. I walked brisk and determined back to the house, amazed at the depth of the cold.

8

So many voices, so many shouts as Rhinosaur played out. The immense volume of Leo and all as I wrote up our setlist, four chronic weaklings manning chimed guitars and wide, slow drums. They were simple, thin guitary sounds made by the two brothers and a splashing bottom end from the rack tom, floor tom and ride. Bass played Peter Hook-like, fingers high up on the fretboard. The odd legacy of Glenn Brotius's gift to the band. Something distantly heavy about them, a kind of weighted diapason that grows and ebbs. Dreamt harmonies, not Beach Boys perfect, but dusted up by an out-of-tune-ness dissonant enough to wound the songs and make them that other kind of perfect. A vast harkening of irreverent angels. Simple chords over and over. A, D minor. That's their verse. Then an F for a chorus, and that, God, that was when everyone died. They weren't characteristic of any town, certainly not Louisville. Any town that could produce Squirrel Bait and Maurice at the same time, then Slint and Palace Brothers and Bastro out of the same souls: there was no such thing as archetypal when it came to that city. It was an asylum with all the wrong kind of medication and here they were playing to the milling crowd on a stage built back in the late forties, a curtain behind and the green glow of a television that someone forgot to turn off hung up to the right. Leo and Leroy wearing matching T-shirts that read: *I might be ugly, but I'll make you happy.*

Angel, Sonya and I sat in a booth with Spence, the thing walled by a large mirror someone thought to be a good look

ten years earlier. Angel tagged the glass with Sonya's lipstick as we considered its extent and the cracks spreading out from the corners.

'What I want to know,' she said as Angel and I went through the songs, considering their mood against our own and so on. And what she wanted to know was how this wall of glass hadn't been shattered by a bottle or fist or stone long ago. It'd been keyed, sure, but how hadn't a brick been put through its panes? Angel and I said the names of songs as she gauged the width of the thing running the length of the bar. Spence was silent, his head buried in his arms, resting on the beery tabletop.

'I mean, really,' Sonya said. 'How does this mirror exist. Here. Not in a thousand lifetimes.'

'Someone's idea of fucking,' Spence said, sounding like old oil from the folds of his jacket. 'Some archaic fucker. He sees a chick's snatch, she's getting pounded in some flickery dick-flick under a mirror and this becomes, this is the sex act.' He looked up then put his head back down.

'Snatch,' Sonya said. She started laughing.

'Snatch. It's a good word,' Angel said. 'Potang. Vag. These are lesser terms.'

'Twat. Pudenda. Merkin,' Spence said. He was riding his pre-show fug, not nervous, just eager, and when he was eager the anxiety whacked him like a plague of eyes.

'Merkin. Jesus,' she said.

'Snatch. Beaver. Muff,' Angel said.

'Gash. Box. Bitch,' Sonya said.

'Bitch?' Angel asked.

'It's a synonym,' Sonya said.

'For snatch?'

'I think so.'

'Women are so, you're so goddamned lucky,' Spence said. 'All we've got is cock and dick.'

'Beaver-pussy,' Sonya said at him. He looked up and smiled for the first time since we'd left Columbia.

'Beaver pussy,' he said.

'No. Beaver-pussy. It's a thing, like a jack-o-lope.'

'Prick. There's another word.'

'Prick's an ugly word.'

We went silent, letting Rhinosaur finish their second song and we clapped and the crowd noise was yanked by the jeering of four Spurn-Cock fans dressed like spooks. Denim jackets cut off at the shoulders. A Mohican and a skin. Death-like make-up, à la the Misfits, à la the horror punk of New Jersey.

'When'd you guys discover ugliness, like true-unbridled-ugly?' Angel asked.

'Don't know about ugly, but commercials for dental floss give me the shivers, like for hours,' Sonya said as the band lurched into an incredibly unhurried number, accented on a half-beat of a rhythm I couldn't name. I'd once watched an elderly woman in Burstyn struggling to stand in the wind. She was out on the edge of the jetty. I was with Angel, just wandering around. Two hunchy kids bumming it. Angel, back then he was an out-and-out thief with inclinations I'd little understanding of. I'd skulk the streets up near the hospital while he entered houses through back doors, slipping coins from key bowls, a cheque from a book of the things, repugnantly full of the unspent, un-fated dollars of this architect, of this fund manager, of this son-of-a-bitch commuting professor and his pet spaniel. He only took things people wouldn't notice. A screwdriver, a box of toothpicks, a wooden chopping board, a single fork. This one night, Angel came running out of a three-storey villa with a two-inch-high plastic Buddha with two wind-up legs. We ran down into the city below, mapped in circuit board precision, streets as if pure digital thought, unimpeachable memory in the hard dark. A series of hairpin paths that took you through the scattered jumble of villas and wisteria. Then we walked: the abandoned

business district, the sixty-foot wharf jutting into Rock River like a reminder you forgot to forget, collapsing on its piles, prohibited and alluring. And on this night there was this old girl and we went near, intrigued and partly concerned. Angel crept up behind her and I thought he was going to do something awful, like shout in the woman's ear. But instead he put a hand on the old girl's shoulder. She turned and looked terrified, like there was nothing left in the world that she recognized. Angel said some words out of earshot and I watched as the woman shook her head, so slowly that I wondered if there were any thoughts behind her eyes as they went back and forth, back and forth trying to recognize the boy in front of her. Angel took her arm and started her walking. She stumbled on each second step, her right knee giving and recovering. *We take you home, smelly old dudess*, Angel said as they went past in a strange stumbling rhythm. The same rhythm I felt as Rhino fell forward on an unidentified beat, lurching and recovering before the fall.

'When we first moved to this country I used to be followed by these boys, right? Who liked to call me ugly and simple,' Sonya said.

'I used to have a thing for girls people said were ugly and stupid,' Angel said as some kids came into the bar. Lording it. We all watched them, that kinda stumbling youth thing, falling over each other and leaning this way then that.

'Simple, not stupid,' Sonya said.

'Yeah, but I always fancied ugly and stupid.'

'Ugly's like people on the news,' Spence said. 'Stupid's like all the people you've ever hated. Except for my father, who's ugly and ridiculously stupid. Ugly's like, it's like the swarm on the news. People swarming on the box. Spain. Paris. People in their thousands swarming around something.'

'Listen to him,' Sonya said. 'He's so sweet when he's all conceptual.'

'We live in a world whose entire mistrust of outsiders is

based on foreign video formats,' Spence said. 'Ageing is just bad resolution.'

'If I ever hit fifty I'll come to you for a check-up,' Sonya said. She took the money box out of her bag and put it on the table with the key. 'Anyone want to count this?'

I started writing the songs out fresh, the numbers that could be done without her brother.

We listened to Rhino and put in names, took them out. The strange melancholy knowledge that none of the tunes were anything as hobblingly good as Rhino's. All they seemed to do was play chords and sing under that strange melancholy light of the TV, but they were able to make a choir out of two guitars and simple banging. And people danced to them. They didn't kill themselves, they danced, swayed one foot to the other. People falling in love because you fall in love when all about you is new but comforting, as if old familiarity were a ruse and only the new, only the new. My favourite gigs were those played with these slow-song punkers. Watching them swap instruments eight songs in, strip, swap clothes and underwear and boots and they're falling over amongst the drums then up again, gleaming and ridiculous until they started strumming once more. The music always felt just as hard as the nails we tried to hammer into people's skulls. It was a music that pierced the DNA, traded sensible genes for rogue molecules. And Spence'll play drums on their most loved album two years later, *This is the Sun*, because their drummer will be incapacitated by Hep C and trying to recover on a caravan holiday in the Ozarks.

'Hey.'

I didn't look up. The sound felt angled at me but I ignored it.

'Hey, dicks.'

Two kids coming at us from across the room as a streak of coil-feedback rang out: pickup, electron, air, skin.

'Hey, Neues. You fucks're playing with us, in Denver.'

Two eighteen-year-olds, pushing folk out of the way.

'You fucks going to show up or do we have to cancel?'

'Yeah,' I said. I didn't look up. Sonya indicating to swap this song with that.

'Yeah? We'll make you look like tofu,' the kid said.

'What's your band?' I asked.

'The fuck's yours?' A chubby kid with a fuzzy moustache. I stared at him for a time, waiting for it to become obvious why I was staring at him. It took me a moment, but I saw it: the leery harelipped grin and long hair. I stared until he looked away.

I said to him: 'You want to write out our setlist?'

'Lemme—'

I passed over the piece of paper. He studied it. Said: 'You suck so much.' This twist in the red line of his mouth, partly obscured by his downy moustache and beard.

'We suck so much?' I asked.

'No, you. Why do *you* suck so much?'

'I learnt from watching your mom, fuck-o.'

His companion laughed. Sonya beamed at the kid. The deep brown of her eyes making the room seem well lit. They sat with us, making it eight souls if you counted the figures in the mirror.

'You're a piss-stick, aren't ya,' he said.

'You should see what I do with balls,' I said. 'What's your fucking band?'

'Typocaust.'

I repeated it. It didn't quite work, but I liked its irretrievable potential. I remembered them, their demo. They sounded a little like Minutemen. A little like Hüsker Dü playing jazz chords. Immense distortion with sevenths and diminished twelfths all layered up.

'Great name,' I said. I tightened my scarf as it started to loosen from my neck.

'Doesn't quite work,' the kid's companion said. A taut-faced figure with a thick torso. I recognized them suddenly, the two of them. They were the ones on the stage back in Burstyn getting banged up by security.

'Nope, no it doesn't,' I said, and he nodded at the pause I put in the sentence. 'So, buster, you going to write out our setlist?'

'Only if you stop the pretence and change your name to Mission of Burma.' He spoke with a slight affect, purposeful, designed to irritate. He had seven small dots tattooed on his ankle, and a stick figure on his wrist.

I laughed, said: 'I'm agitating for a spot in Big Black. So fuck you.'

'Just fucken, just fucken play "Dance Prone",' he said. 'Play it good or I'll send some ugly mole to lick you out and your girlfriend will be damned pissed.'

'OK then, whoever you are.' I leant against the mirror.

'What's that on your wrist?' Sonya asked.

'It's just a hangman, dude,' he said, protective of the little figure. 'What's with the scarf? It's like seventy degrees in here.' He nodded at the thing around my neck.

'Let me see,' Sonya said.

'Where you from, lady?'

'My mother's country,' Sonya said.

The fat kid turned away and started to wander into the crowd. Sonya leant into me as they went off. The way we blended our shapes as I squished against the mirror with her under my arm. Something so near about glass, and something so distant about ink when it's under your skin.

'That's Blair Potaski,' she said. 'The fat one.'

'*That's* Blair Potaski? We're putting out their single. Is that right?'

'I think so, yeah. Blair.'

'Tone says he's going to record them,' I said.

'Yeah. Things you do. Blair Potaski.'

'Hideous boys.'

Sonya laughed, she rubbed her arm and sat saying nothing for a time, then: 'I swear, three days of not showering and my IQ drops twenty points.'

'Have a shower, at the support band's house,' I said. 'There's taps and towels.'

'It's not as simple as that,' she said. And there seemed something so true in this, as if there was nothing but complexity outside of that booth with her. For the outside is always the nearest to our skin, but the hardest to feel and recognize.

'Nothing's simple,' I said.

'You going to be OK?' she asked. 'Without me.'

'Why wouldn't I be?'

'I'll meet up with you in Phoenix. I'll try to get him out of hospital and meet you there.'

'Yep.'

'Con?'

'It's all right,' I said.

'Why the fuck did I leave him in Burstyn anyway?'

'I don't know. This is something people do,' I said quietly. 'They carry on.'

'—'

'People in shock. They just carry on like everything's the same and all.'

She leant over and tried to loosen my scarf. I was sweating and the thing wasn't helping but I pulled it back tight.

'Hey, it's OK,' she said and I made to kiss her. Opened my mouth and put my hand between her legs and she said, 'It's our world isn't it? This whole, thing. It's ours, right? Isn't it?'

9

And then I crashed, one wall to the other after Rhinosaur'd done their thing. Threw myself at a beam off to stage left where a TV was attached to the wall in Kansas City, blaring images across the stage, my shoulder shunted sideways so I fell into the amps with my guitar hailing up a whole wash of noise. I lay among the microphones listening to the feedback zinging away between the kick and snare and Angel's bass still in the song. The beauteous arrangement, this shriek amidst the rhythm and throb. The fellow running the monitors pulled me up and reset the mics and I was back across the other side choking the neck of the guitar. Queues of army jackets arguing to leap the stage first. One stood arms out on the monitor, Blair Potaski with his mouth bleeding. He spun and I watched him shut his eyes as he flung around backwards and jumped sightless into the pulse and skin. He fell on his back. The thrashers handing him down through their bodies, the calm and ease at the heart of a human bomb.

Four songs.

Five.

This wasn't hardcore, not anymore, but they kept coming, hoping on collision and fight.

Seven.

And we could still play quick, do it at a million miles an hour if we had to. Violence as non-violence. Contradiction as the great calm. A kind of trance in the haze of brute force.

Then a Hispanic kid out of the crowd at the mic and he

started to scream, four syllables like a gun over and over, over and over. The kid yelling so the wet veins of his neck stood up and slithered, temporary cables linking the wreck of his day to this moment when he's right there and he's got a hundred punters listening to his voice breaking across the PA. He's shouting: 'It's ma birthday! It's ma birthday!' He was jumping, shouting out any note that wasn't in the key we were fucking up anyway. He was shouting and I was playing high up, scrubbing the strings. Screeding and roar. 'It's ma birthday! It's ma birthday!'

I watched as Blair Potaski hauled himself up on stage again and shoved the guy. The two of them giddy about it all, laughing with the shouts from the sweet-looking arts kids at the front all gooey with sweat and rare rage.

My hand started to ache so I just banged away on the open E as one of the security guys came across the stage and threw the shouting kid, mic and all, into the crowd. Blair screamed at the guard, tussled with him and oh and oh. I ran at the two of them, put my headstock into the security guy's stomach. Spence kept pounding but Angel had thrown his bass into the cymbals and was soon pulling the guard off Blair and me. My shirt went up around my head and I was flailing like a boxer with bloodied eyes, except the blood was coming from other places, from where the bandages had fallen off, and was dripping down my belly. All about me the rampage of raw feedback, my guitar screaming and clanging as I fought the shirt and the guard. But it must've still been music because the crowd was throwing coins. I felt the hit of metal and Blair was laughing as my shirt was finally off.

I stood, my guitar confused in the fabric I didn't want anymore, and let Potaski tear it and throw it back at me. Everything heaving into a glow. I swiped the sweat off my face and threw it back into the audience all bloodied. And then quite calmly and despite the noise, despite the security

guy trying to kick Blair who'd slipped and grabbed the guy's bootlaces and the milieu turning to elbows and fists, despite all this, my attention was neatly swung around to a new threat blinking ten feet away. I watched the calm descent of it on the TV bolted to the wall at the edge of the stage. The screen hung in a frame near the ceiling emitting an NFL game to where it imagined the old-boy regulars sat and watched and drank and talked about things I can't know for they only spoke of it when this room was less contaminated by young men. I looked at the screen and saw the stadium ten blocks from the hall, the game and it's the Kansas City Chiefs and the crowd was standing looking upwards – I watched them all watching the players watching the weather.

Feedback and snow, quite a fancy show in flight. The soundtrack to delicate things should always be the young and their noise. The waft into and out of the lights shafting across the stadium on the TV, each infinitely different to the infinite flakes that came before. All on the screen looking up and it was as if a new kind of light had descended. Large men sealed in their suits blinked in the beams. My guitar banging out random noise and my chest glinting in the house lights as I watched the snow fall and fall. Flutter and fall, each leaf lingering uncertain, as if held too long in the stadium light. The crowd in the stands, all watching the drift, watching the weather, watching the stuff as it fell, lighting on their cheeks, mounding in corners. All the noise. I was thinking then how when we got out of there, how when all the guitars and drums and amps were moved and stowed, how I'd have to drive without knowing how long the night might last, how long the lights might be maintained, how long it might take us to freeze among the scatter of cars left on the highway by the storm's release. I wondered because Sonya would be heading back to Tone to see if she could get him on a bus and it'd be just us amidst the living wondering just how long the living can last.

I didn't think she'd return. Believed I'd never play with Tone again. I thought every instant was a version of the end. Every snowflake a part of the past ganging up on the present in order to white it out and kill, kill, kill.

Soon enough Potaski was shoving my back, but by then I was just kicking my guitar around on the floor, watching it bang and clatter, how the strings were always hunting out harmony and how harmony happens to change its rules at the highest volumes. Feedback and flight: the great gifts of the twentieth century.

10

February 2002

I owned a fax machine, a Canon 705, and it would come into life every few weeks when my mother sent through her handwritten letter to our house in Oberlin. She'd given up on the post and embraced the oddest of the mechanisms slowly replacing speech. The dirty grey of faxed text and all its heartless misgivings. Then, a few months before we moved to Brooklyn, on one cool summer morning, the sound of my wife's children playing was split by the fax's cogs and rollers sucking up paper and ink. It was Tone, he'd flown in from Germany for a festival. It said to meet him at *Looma Grand*, held at Grant Park over in Chicago. The first time I believed I'd heard from him directly since 23 December 1985. *Bring Jazz Master,* it said. *You have it?* This was two and a half years before he came to New York and my shock at seeing his name on the paper printout did strange things to my eyesight, sharpening it, making me see every word on the page in odd syncopation.

I told my wife, Barbara, I was going to Cleveland to spend the night with a buddy, which I sometimes did. I'd drink and drink, black out. Told her I'd be back in the morning. Barbara was hazy on my time in Burstyn. We'd met at the tiny television station where I'd been working. She'd come in to do some ad work two years earlier. We'd married, bought a section and a two-storey thing we filled with her children and my books. Something in us became nervous and failed quickly. She knew nothing of the band, and had no idea about the kind of fated dreams I had in the dim hours of morning. The night terrors.

Those sightlines piercing the hibernal waste of my sleep to a disguised figure, lurking, moving, always moving towards me. The unreportable truths of trauma and its greed. She just described it as my numb-man disconnect.

On that summer afternoon I felt Barbara watch me as I took my old pickup down the drive and out through the green summer airs, the jumbled vines hanging through the street and the tunnel it made out of town.

And of course, instead of heading to Cleveland I drove five hours west to Chicago and put the van in a parking building, collected a backstage pass from the gate and went through. How *simple*. He'd faxed and I'd replied and I saw him for the first time in person for seventeen years. The unique terror of spotting his shape across the green room, which was a large white tent fifty metres from the stage. He looked younger, as if there'd been something heavy in his youth that'd now given way and lifted everything. He was clean and showered and smelt of white wine. We sat and eventually talked, quietly detailing our lives. The cities and albums. Life in Europe, where most of his success could be charted from a flat in Düsseldorf.

'Does anyone still call you Brother Jean?'

'Only you called me Brother Jean. And assholes.'

'I can't document it but there's plenty of evidence in my head, people calling you Brother Jean.'

'They're all liars,' I said. 'Life teaches this.'

'Life's a murderous fuck. That's what it teaches you.'

Then he smiled. There was a time early on in which he'd worn a mask over his left cheek. An interview had told me he'd found it in a private military museum in Vermont; it had belonged to a World War One veteran who'd lost part of his jaw and Tone bought it from the museum owner. I was amazed that this was my memory of him, magazine pictures and words.

'What am I doing here, Tone?'

'In Chicago?'

'What am I doing with my guitar? Yeah.'

'You're about to go out on the stage, with me,' he said.

'For fuck's sake.'

'Uncounted thousands. Jig-a-dee-jig thousands.'

'Bullshit,' I said.

'They're counted. Someone knows.'

'Fuck you, Tone.'

'Yeah, fuck me.' He murmured something else, but it went unheard. 'But you brought your guitar, so—'

'Yeah, you told me to.' My cheeks filled with air and my eyes bulged a little. I started chortling, the slight laugh of nervousness and confusion. He looked at me, peering in.

'Because,' he said. 'Because Sonya said to call you. She said to call.'

'So – you faxed?'

'I only found a fax number.'

'I don't list my phone,' I said.

'But your fax?'

'It's my wife's,' I said. 'She invoices. She sends samples. These are the things of ordinary lives.'

'Ordinary lives.'

'It's this thing I'm doing,' I said as a photographer came by and sidled to Tone's right and clicked away. All photos of Tone reveal his right side, as if the left were merely a rumour.

'Ordinary lives,' he repeated.

'These are things some of us live,' I said. 'We do OK at it, sometimes.'

'What do you do?' he asked, scratching at his beard. The thing he'd been lugging around since that singular date in the late eighties no one remembers.

'For a job? Not a lot. I'm a cameraman.'

'What do you shoot?'

'Commercials. Local TV. Nothing much. Restaurants and car dealerships.'

'*These* are the things of ordinary lives, Conrad? Screw your little, you know, life.'

I laughed. I liked this conversation, it had the lightness flecked with distrust. 'You have defiance in your eye, Tone,' I said.

Then imagine us in a corner, fiddling with unamplified guitars next to a pair of cacti. His bass player and then Leo Brodkey leaning in, joking and saying: *Is that it? Is that how you play it?* Old songs, songs dusted by years of silence and rare plays on college radio and dorm rooms of eighteen-year-old seekers, bespectacled and punk. I hadn't seen Leo since I didn't know when. He was clean, despite years of smack and speed. Players walked by and smiled, people from record sleeves imported and local.

We went out in the fall of eager rain, its plummet through the early evening. Tone'd organized it that Laurie Andersen's 'O Superman' played out of the PA over the crowd as we walked on through scaffold towers. Ah-ah-ah-ah-ah-ah-ah-ah-ah. We stepped on the stage through the ripple of shouts then bellows, the beautiful haze of voices calling with one purpose. Jig-a-dee-jig thousand, and all their eyes. He sang and it always surprised me when I heard him sing and it was so clear. He'd had problems with talking for a few years according to an interview. He had just a mumble, like his tongue was too thick. The issues had nothing to do with the physical shot; it was a psychic impairment. A mental replay of the instant the gun was fired, the flash and singe and rip that came in after the tour. I stood and played and watched him, imagining Sonya and Vicki out in the audience, waiting at the end of some kind of trick, that they were there, waiting on something I'd yet to recognize in myself. We played 'Dance Prone', 'Pig Rental' then 'Brevima Dies'. The one about Minutemen and D. Boon. As we played I realized he'd stolen the entire structure from Boon's

'World According to Nouns'. There's a video of the show and I'm laughing, shaking my head, right there on YouTube.

We ambled backstage amidst the fused shouts of thousands. We ate specialist breads and cheese, dripped stage sweat off our faces and clothes. The adrenalin still rogue as I tried to hold conversations. A support band threw cake at their A&R guy. Immoderate chaos as managers talked on cell phones and ran back and forth. The haunted aura of bands loved and longed for. Sonic Youth. Patti Smith. Missy Elliot. The Meat Puppets. Mike Watt, who'd watched from the side of the stage, deep in the war of thought and precision articulation. David Yow. Thalia Zedek. Ice Cube. Bob Mould talking with the bass player from Led Zep because God knows. Leroy Brodkey with a guitarist half his age on his knee, his hand on her upper thigh, hunting out her panty line. Which must have been a joke, right? She was nineteen and about to go on stage before the Beastie Boys hit up and closed out the night. The famous and renowned, the sense they were all about to evaporate, vanish in the vapour and vim of fame.

Afterwards, Tone and I went to a Chinese restaurant on North Clark with his crew and players out of bands whose albums I owned. The guitar tech from Chan Marshall's group with her eight-month-old and Tone bouncing it on his knee. Something about Tone and babies. The rhythmic banter of road story and battlements. War stories and the lame casualties. Tone told the story of his first solo tour of Europe in '87. Paloma Mrabet travelling alongside him, screening films over the top of his stage performances. *The Thousand Small Cuts Tour*. The horror of busing and training with guitar and amp, of surviving on kebabs and hummus, of gigs played out on someone's back porch, under a bridge, in a laundry, in bars with shouting beer boys. He said: 'I learnt playing should never be easy, it

should be hard as hell. If it's not, you're cheating yourself and the audience of the self you don't already know.' He told how he refused to practise after that, invented ways to force difficulty upon the situation so each performance was unique and stalked by the unpredictable and raw.

I listened to Tone jabber. The way he seemed so easy with it, with people and questions. Heard him talk with a kid, a one-sucker band named Dylan Sluts out of Queens with a savagely well-selling album who reminded me of entities like Fennesz, like Double Leopards, Minit, Parmentier, Jim O'Rourke, Pansonic and Mattin – stressed laptops and circuitry, glorious collisions of electronic violence. I missed bands whose existence spanned two gigs then vanished into caustic rumour, and he seemed to have that quality of instant exploration. Sluts asked about 'Brevima Dies' and I watched Tone nod slowly before giving in to the question. It was a song wracked by fascinating disturbances, images of vehicular violence, shattered cars and bodies. Loved ones wrecked in the desert cold. A song understood by those who knew the story of the Minutemen's demise, who knew to read into all the carnage and delicately whispered howl of the chorus that it was about the 1985 death of D. Boon. The second verse straight ahead as it clocked elements of punk's lost love story, the guitarist's van flipping in Arizona, how he was thrown from the rear door, breaking his neck. It was a kind of heart-breaking piece of poetic loud-quiet-loud. But it contained further layers of loss: both Tone and I knew it was also about someone else, another death, a young woman who died that same winter day, hit by another van in the same border state in December '85.

Tone sounded rehearsed but truthful telling this story, believable but fearful of something he didn't quite know how to voice. He was forty-one then and mostly irrelevant, a man making rogue attempts at articulating the impossible, a unifying description of punk, and punk rock. All I could think was

that nobody had a right to claim what this music was, except in order to make you extraneous. Sluts finished the conversation, saying, all dumb-looking: 'I just do this to save the kids, dude. All these dudes going to malls to kill them all. This is the pressure modern pop operates under.' He had a face that could have been smiling, or simply stuck in an ironic pose born in the womb along with his dutifully damaged voice.

Later, some headed up the hundred yards to Cubby Bear and soon it was just the three of us and the large chap who'd been in charge of monitors. He was sitting with us talking in incomplete sentences. He was familiar, until it became apparent he knew me. He started talking like we'd been in conversation for months. The guy turned to Tone, said: 'Look at this pissy mouth-breather,' as he nodded at me.

The world was full of inch-deep theories of who I was, a crawl of sods who wanted me to remember the name of my old band for them. To say it so they could judge me on the way I sounded when I spoke of older things, of my connect to Tone. Who wanted me to say something that equalized their own jealousies at what the world had given to him.

'*Prissy* mouth-breather,' the man said. 'One or the other.'

I watched him. The mouth behind the beard, the harelip and bent mouth.

'Pissy; prissy,' the fat-ass said as Sluts stood and made his departure, hands waving like puppets.

Then I saw his eyes among all the pudgy-ness.

'I'm talking to Blair Potaski,' I said suddenly. I looked at Tone then back at the figure. 'Blair lives in Colorado.'

'Not quite,' Blair said.

'Blair's a shit who works in an office pinching girl's asses,' I improvised. 'He plays bass in his brother's covers band.'

'I'm thinking maybe it's prissy?' he said.

'He's still a shit,' Tone said.

'I'm still a shit,' Blair said.

'Yeah,' I said.

'How are ya?' he asked.

'OK. OK,' I said.

'OK.'

'OK,' I said. I stared at him.

'And here we are,' he said. 'Shits passing in the night.'

The studio's expanse filled the back of a low-rise warehouse, something added on to in the years since Blair'd moved it to South Deering from down in Colorado where he'd built it in Boulder. Blair showed the rooms, isolation booths and connecting halls all inside a turn-of-the-century warehouse beside the river. He showed me the collection of microphones. Vintage, East German Neumann. The Gefell factory. Electrovoice.

'How long's all this been here?' I asked.

'I've always been building it,' Blair said. 'Since I was a little prick.'

The control room crowded and fed by wire and lines drawn by the eye of the speakers straight to the centre of our hearing. He took a two-inch tape and placed it on the reel-to-reel. Hit the white play button and the room became animated with amber, red, green, blue light. Every track in every module in every channel on the desk and compressors and the wave forms forming on the monitor above showing the capture by Pro Tools. Sound and light.

I said: *Oh*. A small, involuntary opening in my voice. Blair explained he was digitally preserving old tape, a money-spinner based on those who feared their musical pasts were decaying in mouldy boxes. I wanted to play a guitar suddenly, bang it until something broke and it sounded the way all my guitars sounded, so it sounded like me playing the guitar.

We left the room and headed to the balcony. Wicker chairs, and I watched birds laze on the river. We drank. The late

night came to be early morning, and even that went by. Tone and I watching each other, talking of Europe, talking of India. Places we'd both been. He asked about Spence, I said as little as I knew. After the band he'd retreated into that rank pit of depression, that deep-wound state that went on for years. It'd always been there, always embedded in-country, and then staged its coup. He ended up in a respite centre on the coast of Oregon for a year after a short stint in prison. I'd visited him there after he'd written to me, the first contact in fifteen years, in 2001. He seemed shy at my presence there, almost shocked that I'd bothered to make my way up from Portland, where I lived for a brief time while working on a TV show. He greeted me in a bathrobe, his hair was long and his beard had grown out. We sat together quietly in the garden in the front drinking rough coffee and watching seals slip in and out of the water like there was no border between sea and sky. He said nothing for a long time, just stared into the building behind me. He stayed that way until I started sharing things, episodes from my life, and he sluggishly seemed to wake. A vague smile appeared, then words and passages and descriptions covering the length of time since 1985. That was the first time we'd used the word – *disorder*. Bipolar disorder. It sounded like a curse, a physical collision with word and thought boring out a great chasm in some part of his mind. He worked among beehives, his mind turning in on himself, begging he might die. But then something worked and he went home, some trick of chemical and thought and how they trade places.

'He's in Burstyn still,' I said. 'He's got a place downtown. He writes me postcards now and then. Angel is regularly sending emails.'

'People still live there?' Blair said.

'He says the Eighty-Eight's been turned into apartments, Tone. Views over the river and all the rest.'

'What else we got except beer?' Tone asked.

'There's some Scotch somewhere, sugar tits,' Blair said. 'Made by real Scots with haggis between their teeth, balls-a-swinging. You ever hear what happened to George-Warren?'

I shook my head.

'She was arrested, down in Waco, Texas. That shitstorm there in '93.'

'Really?'

'In lock-up for a month till some judge let her out. She was protesting the use of tanks and the deployment of Slayer as a weaponized noise. I don't know, if I was in a cult and someone's coming to liberate us with Slayer, I'd be all: *Hallelujah!*'

We drank on, dire quantities.

Eventually I lay on Blair's deck as the other two talked. Out on the highway trucks honked in a series of accusations then drove on. A dredge settling down by the pylons looping their lines to the west over the river. I felt a kind of old nausea. My breath fading till my chest was barely rising. I heard people speak, but they weren't near. I faded in and out. People came and went. The forgotten sounds of them. Vicki, Miriam and Sonya. Joan George-Warren and Paloma. The elegiac soul-seeker in the hills in west Arizona. I thought of the stories Vicki and Spence'd told of her. The places George-Warren had visited and fought to understand because she was a woman who fought to understand many things. Many years before Spence and Vicki'd heard of her, before we visited her camps, Joan had visited the Christian cults of Texas, halidoms of Alabama and Montana. Visited Rajneeshpuram in Wasco County, Oregon. Collected stories and the sacred measures that set them all separate. This was a woman who'd made her money in property investments while teaching and then sold a shitpile of books before the artists' colonies became Spence's strange obsession. She travelled to India, Rajasthan and Jaisalmer. She grew her hair into a tangle of immense proportions. Bamiyan

Afghanistan, the Buddhas before they were destroyed and rebuilt on my TV. She travelled into Iran, Spence'd told me when I went to visit him in Oregon, the site of the Alamut Castle. The sacred grotto-shrine at Pir-e Sabz and the flame lit by Zoroaster three millennia ago. I remembered the story of how she'd pilfered a branch of it from the temple in Çäkçäk, lit two oil-fed lanterns and brought them out of the country in late '78 without any questions being asked. Drove them north, up through Turkey where she sailed from Istanbul to Spain, then a liner to Miami. She drove the flames to the artists' colonies in Yuma. They had been burning in a pit for five and a half years by the time Vicki and Spence'd first visited, a makeshift brick temple blackened and always hot. A 3,000-year-old flame, I'd watched it reaching and flicking at sky. An act of deep cultural appropriation, but what the hell. I lay thinking how strange it was that I desired to visit there, to see. It was the first time I recalled remembering her, Miriam.

There was noise then, footsteps on the wood. I couldn't open my eyes. I couldn't roll over. I think I spoke but I couldn't hear the words. A voice. Christ. He said my name. Said it over and over. My heart kicked against my lungs and I woke proper. Breathing hard. He was standing over me. He had his mouth open and it looked like he wanted to talk.

'Blair? Fuck,' I said.

'You been sleeping, Brother Jean?'

'I don't know. I—'

'You look like you were sleeping.'

He offered me his hand, pulled me up. 'Shh. Tone's asleep.'

'What's going on?'

He guided me back into the control room, the closet where he stored the tapes he was currently working on. He retrieved a box from the shelf and put its tape on the machine, winding it through the rollers and the capstan.

'This is – listen to this,' he whispered. He dialled in a quick mix on the console. He nodded at me, then it began. He watched, he watched my face, how it responded to my body because that's where I heard the sound first. He watched me as it became apparent I knew. The rise of guitars and the fade and the opening of a space in the song. The flicker effect of two guitars playing a different rhythm in the same eight bars of simple drums, crossing over each other, phasing and hooking then going out of sync. And then a break and a breathing sound. A set of lungs sucking in and out, kind of playful, kind of intense. Then the sound of someone plugging their guitar in and a squeal of feedback and the kick hammered hard, then the snare in double-time on the three and four and the whole band in a shredded chord. A scream, a woman, high-pitched and life-threatening. The guitars were Tone, they could have been me and Tone but I swore they were just Tone. A woman with her voice like a lance, thrusting it through the eye of the song so it hung out the back of its head. But then the scream slowly undid itself and it became a note, long and soon so pretty, like a sheath of ivory pulled from meat. It was Sonya – it was Sonya and she'd been here before, that was what I knew suddenly. Here, or wherever she'd recorded it. She'd been here before and now she'd found me in the lowlands of south Chicago, fourteen years since we'd last spoke.

'Oh God,' I said.

The album was lost music, *Titles of Great Books*. Tone's band with the Rhino guys from after Neues Bauen. Never released. I hardly listened to music for four, five years after I'd quit all my bands and knew little of his early stuff. But there I was, listening. I sat up, I felt hit. I said: 'Oh fuck.' As if I'd been found out. That Sonya'd found out something awful about me and it'd taken this long for her to locate me and tell me.

'Do you remember this?' Blair asked.

'What?' I said.

'Do you remember this?' he asked again.

'This is Tone and the Rhino guys,' I said, guessing. 'They recorded this here?'

'Same studio, different locale.'

'Where?'

'Boulder,' he said.

'This was recorded in Boulder?' I asked.

'You don't remember?'

'What?'

'You don't recall recording this?' he said.

'What? I wasn't there. That's just Tone, double-tracked.'

'You don't remember?' he said and looked at me as guitars did that thing we used to make them do. 'You stayed the week.'

'What? When?'

'This is 1989.'

'I haven't seen Tone since—' I said. 'You know when I last saw Tone. Today's the first time I've seen him since '85.'

'You stayed the week. We recorded this,' he said. 'The first thing recorded on that machine. My first twenty-four-track recording. You, Leo, Tone and some drummer.'

'Bullshit,' I said. It seemed impossible I could have forgotten such detail. You don't just lose detail to this degree.

'Listen.'

'Fuck off.'

He isolated a guitar track. All else disappeared but a guitar, the strum and accent, the curious manner in which the player always landed slightly after the beat. The way his middle finger seemed to bend the G-string, all faults of technique, all a part of the discreet charm of this player who was no one but me.

'How the fuck?' I said.

'This is you.'

'I wasn't, not here, there. Not wherever,' I said.

'This was you, Brother Jean. Nobody plays this bad, nobody stinks up a recording like Brother Jean.'

11

November 1985

We drove south out of Cheyenne on I25 towards the second art colony. This info rests in the old tour book I've recently scavenged for parts, an old diary stolen from somewhere and held together with two rubber bands. It held all the addresses and numbers of venue and promoter, friends and bands. Blair Potaski was in there and I never knew. That name somehow brutal and vague like the received memory of someone else's pain and torment. The diary was always falling apart and lived in a series of Ziploc bags which Leo seemed to have an endless supply of. He was in the back on another sabbatical from the Rhinosaur van. He regaled us, fed us. In Cheyenne he bought four bags of clothes for a dollar each at the thrift store on Decan and Smart, where we'd met up with Vicki again after Sonya had headed back to Burstyn to look after her brother. Shirts and jeans and slacks. The five of us sorting through garments, the cloying pong of mothballs. Leo holding up a paisley shirt from the turn of the seventies. Unnameable chemicals and cotton.

Spence from across the van: 'Lemme wear that,' he'd said.

'No,' Leo said.

'Lemme wear it.'

And Vicki saying: 'Who's got a belt?'

'Why?'

'I'm going to hang myself if Spence ever wears anything with green and yellow in it.'

'We need a sewing kit,' Angel said. 'We say this every month.'

'Need a girl with a needle and pricked fingers,' Leo said.

'Someone send Vick out for cigarettes and needles,' Spence said.

'And everyone can fuck themselves,' Vicki said.

'Yeah, you,' Spence was saying. 'You're kinda cute with a bit of thread 'tween your teeth.'

'Whatever that means,' she said. She'd been in Cheyanne two weeks and was desperate to escape. She told me there was a cruel glare in her friendships there, elements of love that seemed to be asking intimate things of herself she wasn't sure of. She'd spent the last nights in a motel drinking and reading Proust.

'Cute. It means pleasingly pretty,' Leo said. 'In a dainty way.'

'Or: ugly but interesting,' Vicki said. 'Depends on the dictionary. I'll go out if someone gives me money for gin. I'll sew if you let me get drunk.'

'You can get drunk, whatever. Just don't cut yourself. Blood's bad for cotton,' Leo said.

'And if Brother drinks with me,' she said, 'I'll cut and sew. Anything but denim. Or corduroy.'

'Check these. I've trousers,' Leo said. 'Check the belt loops. I just have to lose the extreme nature of the bottom half. There's a lot of material to cut away. Survival is the key question for these pants.'

'It's a risk,' Vicki said.

'Show me,' Spence said. He tore them from Leo's grip.

'Let's be careful with the threads. Let's have some gentle behaviour around our new friends,' Angel said. He wasn't looking at anyone, just pulling a sweater over his head. Black and red, perfumed by hours among doped-out frocks and lingerie.

'You can't have these,' Spence started. 'You can't alter these. They'd still be flares. They'd still look like flares and you'd still look like a rapist.'

'I like the belt loops,' Leo said.

'You'd start growing a beard,' Spence said.

98

'They're innocent trousers. Cotton, for Lord's sake.'

'Pass them here,' Vicki started.

'We'd all become subservient to your ridiculous dong,' Spence said. 'It'd develop an unnatural growth. You'd start doing underage girls dressed in cheesecloth. You'd be this grotesque creature in flares. You'll be immoral to the point you'd gain followers once they let you out of prison.'

'They can be rescued. They're a good pant,' Leo complained.

'Go to California, you fuck,' Spence said. 'Go and find some desperate harem, desperate for your grotesque foot-long dick meat.'

'Pass them back,' Leo said.

Spence put them between his legs. He undid the fly of his jeans.

'Oh fuck no.'

He started peeing into the rumpled fabric. 'I'll be done in a minute.'

We never washed our clothes, just sought a new garment from the bags. Vicki threw the trousers out as we went through the McDonald's at Fort Collins. Then we arrived at the camp fifty miles north-west of Boulder an hour later, drove in past a sculpture made from seven wrecked sedans at the entrance to the compound, spray-painted into weaponized non-colour. Some strange arrangements of thought and waste. We decamped and set up to play in an old hall under the haunt of Longs Peak. The Rocky Mountain National Park yards to the west and snow slowly weighing on the roof.

We played. Twenty minutes in, the power stammered and went mute. Guitars suddenly empty without electricity. A din of drums as Spence careened off into a chorus without us, brutal on the ride. A band reduced to a drummer pounding in the sun pouring from the west-facing door despite the snow on the other side of the building. He kept hitting, as if summoning the song

back to life despite sudden respiratory failure. A young woman with a marvellous Mohican twisted acutely at the song's end, danced and hurled herself in the kick and bash of the careering drums. I'd nothing else to do so I watched her fling and catch her balance as she threw herself through to a frenzy in front of the stage. The drums banged along on their own, her arms flung out like a dervish. Thrashing and spiralling. Slowly Spence too turned himself off until it was just the kick drum nagging in the room. *Boom, boom. Boom, boom.* The woman slowed and edged and stopped, she'd a dark complexion close to Sonya and Tone's, sweated and damp with exertion. She'd a dripping nose attended to by a black rag. The other thirty or so stood compliantly erect, expectant, as if it were their duty to be expectant of these last beats. We eyed each other, realized that this is what we'd been waiting on, the cut-off so we could eat and leave. I winked at Leo. He gave back a quiet smile, secretive amongst the onlookers and the rest.

All the way down I25 we'd done that kid-rocker thing that made us feel rescued and half human. Leo accessed Angel's deep carton of tapes. His strange mixes. Romanian gypsy music and Chinese opera. Branca, Reich and Stockhausen. A cassette with songs organized by the fact they had *Woman* in the title. Then one tape, with one song: 'What Goes On'. The live version from the Velvet's *1969*. Just that one song, looped for ninety minutes. And then you can't listen to anything else. It's as if there's just one song in the universe, rhythm and drum. And then, just as if there would never be any other music, Angel had slipped in another bootlegged version of the same track, recorded out of Cleveland, Lou Reed's brutal feedback before his odd run-up into his solo. Leo played the tape twice, sung the same words, mimed the same tranced rhythmic excursion into E major.

Then as we finished our show he took my guitar, gave it a quick tune and played Reed's riff. The young woman went to

him and said in a French accent: 'My cousin once kissed Lewis Allen Reed.'

'What? When?'

'Paris. 1972. My cousin. She's a suchness, yes?'

'Well, that's bullshit. What was he eating? I'll let you tell me more if you can say what his breath tasted of. What was in his teeth?'

Before she could answer, a man of immense dundrearies called out from the dance floor: 'Damned mountain folk. Ain't what they used to be, man. Apologies.'

His friends laughing. Someone else called something, but it died on our ears as plate and cutlery noise echoed out from other rooms.

He came to us, the organizer. He was a wide man, those sideburns ginger in the afternoon. He took us outside to a tent, a large party marquee that'd obviously been hammered into place many years earlier. We stood waiting on instruction beside a massive stainless-steel sculpture at the entrance, once again seven-sided and pendulous. We had to duck in order to pass through the front door as Leo tidied up our gear. Ginger introduced us to his wife helping with lunch. They were both new to the compound, taking over the day-to-day after the last leader fell out with George-Warren. We heard the story, the compression and expansion of other people's tales. Fourteen or fifteen other couples came in and were seated. A uniformity to their clothes, but nothing exactly matched. Mostly they were white and in their thirties, some attractive, some just made ugly by the clothes that seemed completed in a rush by unskilled hands. And some just staring into the space where thought exists, mutating, claiming.

'Bernard,' the man said, shaking our hands.

'Your mom lets you get away with that, huh?' Angel said. 'Calling yourself Bernard?'

Dundrearies smiled. 'Call me Bern. Seems to be the

consensus around here, to call me Bern. Let's get some lunch into you. You played over at the camp in Missouri?'

'Aha,' Spence said.

'They've been there fourteen months and fuck knows what they're up to.'

'And you guys have been here five years?'

'Sounds right. Then again I get nervous when I count. What's your dig with her? With Joan?' Bernard asked.

'Dig?' Spence asked, kind of aggravated.

'What got you into her.'

Spence frowned. 'I'm not into her. I'm studying her.'

'You're studying; she's studying. I'm comfortable announcing this as a kind of into.'

Spence went quiet for a time, turned to me and Angel like he wanted us to find a fire extinguisher and do something stupid with it. Fill the room with foam and dumb guffaws. But then Bern was asking something else and they were talking again. He asked what Spence knew of George-Warren.

'The usual,' Spence said. 'I'm guessing the usual. Her books were all through in the house when I was growing up. My mother had the first two. I read them and just kept reading.'

'You meet her?'

'I went and visited Yuma about a year and a half ago, last April when I went through with Leo's band.' He nodded back to where Leo was organizing our gear talking to Vicki and the French woman with the vertical hair. 'I got this notion to write about her when I saw what she was doing. I know background,' he said. He described details of location, of developing intents. They talked on, the two of them, while Angel and I shared a cigarette. We heard old history like they were shaking out the can of Joan George-Warren. How she started out in Austin. Went to New York. East Village and a thing with Douglas Colvin. Wrote for the *New Yorker*. The *Times*. Three books. Headed back south and started her colony.

'Then she gets her idea in Yuma,' Bern said, looking out the window where hardy birds struggled in the cold.

'Then she gets her idea.'

'This is your dissertation, huh?'

Spence shrugged.

Bern looked back from the window and frowned seriously, as if looking for previously practised sentences. 'She's basically a pain in the ass,' he said. 'She's a son-of-a-bitch, but we get work done.'

'Her pain-in-the-ass-ness is why I'm here,' Spence said. 'And she's got you guys doing what?'

'Numerology. That and Jain Dharma. We're talking fasting and meditation.'

'__'

'I'm a painter and she has me obsessing over numbers. She bought the land and built this up, now we're dealing with concepts of religious death.' He laughed. 'We're vainglorious in the abandonment of food and drink. We're talking unenviable chaos,' Bern said, continuing to laugh. 'But let's eat,' he said. 'We quit the fasting a week ago.'

We were hungry and eager to get to that part of the day. In Cheyenne we'd discovered we no longer had the money box. We'd argued about it, pointed and shouted various combinations of accusatory phrases, petty and derived from lives lived under the roofs of parents we barely understood. Then gave in to the fact it'd been stolen. Or left back in Kansas. We'd lived off Slim Jims ever since. Stale bread. Bern had us sit at a rough wooden table, half starving. He nodded at it and said: 'We all turn up here, we have to learn on the job. Carpentry's one of those things we practise but haven't perfected. Most of these folk turn up and want to make art. Our instincts don't seem terribly aligned to practical matters.'

'We saw your cars.'

'Case in point. Put together by my brother and his girlfriend.

I think she's his girlfriend. I didn't meet her. They built it, went back to Denver just before I arrived.'

'Aha.'

'It's a stinking mess if you ask me.'

'What about the other sculpture. The one at the –' and Spence nodded back at the entrance, at the other seven-sided beast hanging over the front door we'd ducked on our way in.

'Yeah.'

'What's that?'

'Heptagonic, et cetera.'

'Right. Who made it?'

'Same girl. Just before I arrived. It's a strange thing, for certain.'

Spence nodded in a way that made it seem the man had more to say on the issue, whether he knew it or desired it. 'And she just left?'

'She was here awhile,' Bern said. 'Came in with Joan when she was settling things down before my time, stayed the best part of a year. People come, they hang and drift off.' The man looked as if he once had a girth, something of bearing, but out here it had been evaporated by work and the need to be a more practical size. By fasting and hunger. He wore dungarees, seemingly to match his sideburns.

'Who was she?' Spence asked.

He shrugged. 'She left before my wife and I got here. She just disappeared with my brother. Hey, Paloma,' Bern called out across the room to where the black haired dancer from earlier was sitting down to eat. The woman was carrying a basket with the small face of a baby glowing between folds of a blanket. She placed the infant on the table beside her and was quickly bent over her bowl as again Bern called out. 'What's that chick's name?'

The woman finished chewing and looked up at the ceiling. 'Which chick?'

'The chick who did the sign by the entrance.'

She mumbled something in French then said: 'Got no idea who did that shit.'

'The one with my dumbass brother.'

Paloma didn't reply and tended to the baby, offering a bottle while making soft noises.

Bern had a dense grin. 'We make a habit out of talking dick here. It's like it gets us out of dishes detail or something. I think her name was Miriam.'

'Miriam?' Spence asked. His eyes remained on the woman as he said this name and then quickly turned back to Bern.

'Aha. She was going out with my brother. Or was friends with my brother. Hard to know these things when you haven't actually seen them together.'

Spence stopped talking for a while and went looking for cigarettes in the inside pocket of his coat. He lit up and looked back out to the entrance. 'Does it do anything?' he asked suddenly. He nodded at the visible edge of the construction over the door. Metal welded together into a rough-sung harmony.

'Sure. We give things a chance to mean here. That's part of the experiment. We see seven sides, see equality of seven. We look it up. Turns out its biblical. Turns out its Koranic.'

'Is that of interest?'

'Yeah, sure, man. Of course it is.'

'So?'

'We looked it up. It's a habit. We look up everything. Joan says, you know she says the point of art's not to describe knowledge, rather art is the act of intellection. Which is some malarkey but might even be true.'

'She says this,' Angel interjected as food arrived.

'She says its function's not to describe the onset of knowledge, it *is* its onset. It's coming into actuality. This is Joan's mantra. It's enacted with each new observation. It's a paranoid process. We don't expect anything out of this. We just

investigate it because it's there. Hey, Paloma. What was her name?'

'Fuck a dog, Bernard.'

And Bern started chuckling as he spooned potatoes and casserole.

'Fuck a dog,' I heard Paloma say to herself.

Her name was Miriam and that was the first time I'd heard it, just moments after hearing Paloma's. Two names, one each. We ate and Bern interrupted constantly, delivering versions of what he believed they were doing there. He lit cigarettes mid-mouthful and called over for more peas or water.

'At college I majored in humiliation,' he said. 'Then I had a career in despair and disappointment. Coming here made sense.'

Angel was the only one who laughed.

'How many of you now?' Spence asked eventually.

'I don't know. Thirty?' The man shrugged and tugged at his sleeve. The arm of his shirt pulled up over his wrist and I saw the same tattoo Blair Potaski sported back in Kansas on his ankle, rudimentary dots in a pattern, the same as I saw on Leo still out loading the van. I watched them until they slowly disappeared back into his shirt.

'Your brother's Blair?' I asked.

'Yeah, did I say that?' Bernard Potaski said.

I shook my head.

'Well, don't blame me.'

The biggest obstacle of a touring musician is time. The way it forms in strange places like a creeping mould. We practised wasting it like a game we needed to master in order to shift through life. We practised passing it, hitting it, tackling side-on, front on. We're the scrimmage line, banging heads. We're the glide of a running back heading for the light. And as such, once we'd eaten, helped with the dishes and shat, Leo,

Angel and I walked the grounds, followed by three dogs at our ankles. We sat waiting at a picnic table with our tape deck beneath the relief of four flatirons just to the east and played cards, three hands then something else. Leo was a chronic cheat. Hiding cards, slipping them into his hand. Jokes and abuse. He played his set and talked music.

We traded band names and singles. We went through whole worlds in lists, whole ranges and straits and paths through mountains, caches of cures for sadness and dreams and love-ache. *What about? What about?* Wipers. Debris' *Static Disposal.* Obscurity often equals vanity. *Nite Flights.* Then we were listening to the Raincoats, the English group of girl-punks and killer hits because Leo'd never heard them. Then a track by Kevin Coyne. Monks, then named every Suicide song. Then the Avengers and we were all trying to get at the machine to play what we believed came next, as if the lost element in the last great chord progression. The number triggered by the tune in the speakers we had to hear. They went over their obsessions with Siege, Scratch Acid and Mission of Burma, Naked Raygun and pretty much anything Tone brought back from New Zealand. Scorched Earth Policy, Nocturnal Projections. The Pin Group. Labels and cities. We overcame immediate experience via this verification. Song, song, album. Check the name, move on. The pattern of names so we could confirm presence, that we were all there, as if checking for keys, for cigarettes and matches, checking all the things that kept us upright and animated, stinking and grotesque.

'"Adults and Children",' Leo said. 'You heard that?'

Angel dealt, seven cards here, seven there.

'How'd you hear that?' I asked.

'It's like – it's like – massive saws fucking,' Leo said.

'How'd the fuck you hear it?' I asked.

'Dunno. How'd you?'

'Sone and Tony. Tone brought it back from New Zealand.'

'Yeah well, they're using it to kill any remaining freaks stalking East Village.'

'"Midget Submarines",' Angel said. '"Holocaust". "This Perfect Day". "Third Uncle". "Nervous Breakdown". These are the songs to go to war for. These are songs to kill your neighbour over. "Sonic Reducer".'

'Sure. "Don't Hide Your Hate".'

'Fuck-a-mighty,' I said.

'Yeah.'

'Cos it's the greatest title in the history of titles.'

'"Don't Hide Your Hate".'

'"Don't Hide Your Hate".'

At the end of the hour Vicki and the dancing woman, Paloma, came and sat with us at a picnic table with the baby while Spence talked with Bern about all the stuff he came here to talk about. I quickly understood that Paloma had learnt her English in America when a teenager. Her father, a French-Moroccan, and her Berber stepmother moved from Cadi Ayyad in Marrakech to Boulder for jobs at the university in the late seventies. Paloma and Vicki traded sentences in French, a tentative non-conversation of verb and noun describing little other than a street in Rome Vicki recalled from her time on a student exchange. Paloma seemed our age, maybe a year or two older. She wore kit from the seventies, a kind of unintentional retro with hair hoisted up. Vicki in flares. The kind that made Spence furious. But Spence wasn't there, he was talking to Bern in the admin tent.

'How'd you punkers find your way here?' the Moroccan asked, wiping at her nose with her jacket sleeve. She squinted at me, then Angel. And after we shrugged she said: 'Because there's not so many visitors to this place. Not so near winter. Not dressed like you.'

'Our drummer,' I said. 'Got a thing for mountain folk.'

Vicki leant in towards her: 'You're mountain folk now, Paloma.'

'Yes. Mountain folk.'

'I'd say you're the replication of the idea of mountain folk,' Vicki said.

'But sure.'

''Bout you?' Angel asked Paloma. 'How'd ya get involved in this shit?'

Paloma laughed and jostled her body. 'There, that's a finely executed question.'

'Yeah, and *sorry*'s the noise I make telling my non-existent wife I'm shitting on the bed.'

Paloma's grin filled up her face, her eyes squeezed like she'd just learnt the final great thing of the universe. 'My mother. Long lost. Found her in a dumpster and followed her here because my half-sister was here, and . . .'

'Right,' Angel said. 'Right, right.'

Paloma blew her nose on her sleeve again. 'I'm not kidding, except the dumpster was my parents' house.'

'Right. Who's your mother?'

'Joan.'

'George-Warren?'

'Apparently,' Paloma said.

'How's that work?'

'Just like, like I don't know. She visited, a few times. My mother, she visited my father and stepmother. She has this idea I think sounds loony, so I join in after I came back from Rome a year ago. I met her when I was eight, then again at sixteen. But eleven months ago was when I started helping her out. I help Joan out with family things, too. Here and in Yuma.' She told us she'd always lived with her father. Joan was permanently in another part of the world, drifting towards now.

'She keeps turning up,' Angel said. 'What's her real name?'

I laughed and smiled at him. I loved the lug even if I'd hit

him once, once, after he'd hit me on a short tour around the east coast, Trenton, Brooklyn, Boston, and we were tired and cold and playing like assholes and—

'Ha. Yes,' Paloma said. 'But, here's this woman in a cowboy hat and a Black Flag T-shirt,' she said.

'You knew she was your mom, because of her T-shirt?' Angel asked, smiling. His obsession with Black Flag was immense. For an entire year all he listened to was *Damaged*, it was like an illness. Then *My War* and that was it, he became obsessed with slow and we trained ourselves to play slow, which was just another kind of fast. I think that's why he might have hit me. I told him he couldn't play that tempo for shit and he was hungry and cold and he whacked me then we didn't talk for days. Then I'd hid his pants.

'Yes, I knew, I knew,' Paloma goes on. 'I've always been half Moroccan and half ex-hippy mad person. So I like her and listened to what she said. Amazing how simple some things are. The universe is full of lost simple things. She says she has this idea, and it intrigues me. This is a woman who believes in nothing but the output of logical positivism until she starts getting excited about the French and *zam*. But she also believed in joy and she wants to know about joy.' Paloma nodded at that. She talked on, describing her mother. Taking cigarettes from each of us and laughing. Taking our lighters and putting them in her pocket and taking them out again and putting them on the picnic table like it was all part of the conversation. Paloma was a student at the Lorenzo de' Medici Art School in Rome for a few years while her parents remained in Boulder. Then she moved to Colorado to teach about a year ago so she could be nearer her estranged mother and half-sister.

'And Mother has this notion,' she continued, 'that on each sparkling new year, yes? she starts practising the thingama-jigs of this pre-determined religion. Crazy, stupid. This is her

idea. But then she examines herself for change, for alterations to logic and modes of communication. She wants to know the physical effects, cultural effects. What are the effects of different modes of prayer on the mind and its output? I like this idea. I find it – hmm.' Her eyebrows lifted, opening up her entire face. 'So she says: *Look into numerology.* So here I am. But I'm mostly in Yuma. The dumb-assed things you learn. Before that we were learning to pray like Catholic nuns. Which turns out to have much the same effect as the practices of Buddhist monks.'

'I've never met her,' I said. 'I've no proper idea.'

'She's, what is she? She's charming,' Leo said. 'I'll say that for the woman. Overly curious. She used to go out with fucking Richard Hell.'

'That may or may not be true. Believe me, we're a rogue species,' Paloma said. 'We're divined to be overly curious.' They looked at each other, eyes intersecting, and I realized they'd met before.

'A forceful statement,' Angel said.

'Well, yes. But I swear on somebody else's god, there's messages in our DNA telling us to go looking for every hint of origin available. It says: *Spy under rocks.* So we sniff the damp, all for evidences of ourselves. Climb mountains, cliffs.'

'Paloma's main interest is spelunking,' Vicki said.

'I like that word, but I've no idea what it means.' Paloma laughed and smiled as a crawl of sentences transited her thoughts. 'We like to scare ourselves. Mmhm. What terrible vistas, what traces of our future.'

'This is what we learn,' Vicki said. 'Life's about living with entire histories of terrible things.'

'Yes. And I am the sound of the last great sigh.' Paloma laughed once more. She'd a brilliant smile, ebullient – a face stuffed full of irony. Of contradiction and hope. I listened to her talk on. She wiped her nose and sneezed. 'Apologies,

signori, I get here in June and ever since I've had a damn cold. You boys headed for Yuma? Maybe, maybe I get a lift.'

'Eventually,' I said.

''Bout you?' Paloma asked Leo. And there, yes: they knew each other.

Leo nodded, a little unsure. 'I've got my own band of idiots.'

Paloma smiled. 'So. Tell Joan she's a fool from me. No, tell her she is a virus and we all hail. Explain there's no actual system, if that's what she's trying to understand. First I go to LA, then Yuma.'

'Nobody goes to LA. You just end up there,' I said.

'I go. I meet with Mike Watt. Tell him I'm doing the next Minutemen cover. You saw their last one? This, *Double Nickels on the Dime*.'

'It's the second greatest cover of all time,' I said.

'Yes. Yes, it is.'

'You need to talk to Tone. Listens to nothing else.'

'This Tone, is?'

'A hardcore shit shitting.'

'Mm. This is this,' she said

'What?'

'This hardcore.'

'What hardcore?' Angel asked.

'No. I mean. It's the – do we have the word? It's the pure reduction. I like it very much.' She laughed. 'You reduce and you reduce, correct? This is the attraction of, hardcore.' A little pause before the last word of most of her sentences, like a loose thought. 'This is right, yes? Diminish till it's a set of tight rules, but beyond rules. This is what you do? It's speed, distortion and – ah – fury. I like it very much. It's all the annihilation of music. I like it very, very much. And of course what do you get when you remove all music? You get another kind of music. This is the music after music. This fascinates.'

'The teenage versions of us used to be hardcore. Now we're something else,' Angel said.

'But yes. This is the music after music after music.' She looked at the baby lying in the basket. She made cooing sounds and said: 'Gotta keep feeding these things or they don't keep.'

'And who's your sister?' Angel asked.

'Ah. Her name's Miriam, but she's not here right now.'

12

Late the following afternoon we stepped out of the van at an old garage hunkered down on the outskirts of Denver. Snow drifting, signs advertising the price of fuel from six years earlier. There were two young women smoking cigarettes saying, *Hey, hey* beside a phone booth. Angel and I with our hands up waving, simultaneous in a strange twin act. They wore matching footwear and could have been sisters for the familiarity of their movements. Intimate and calmed by the other's slightest shuffle. Kiss-me mouths and boots, black lipstick and a kind of low-core goth. Death chicks at a safe distance from the gallows. They watched until one of them said: 'The band! The band!'

Her friend laughing and they huddled as the snow blinked. They seemed to watch, waiting for our censure. A quick: *Fuck you*, or *Piss on a stick*. Instead, Angel smirked and they were waving and calling him over. They talked, round and round. Taking hits off a single cigarette and one of them saying she was growing up to be a librarian so she could get the glasses. The other purposefully detached, blinking and persuading us nothing we said was true.

They pretended to kiss because it was Saturday night.

On the inside four boys, army jackets, rough leather at the mixing desk. I watched the change in their faces, the second it took to retrieve us out of some grazed space they reserved for bands they liked or despised. The pathetic and the adored. The

mental corner where the noise of us lurked with the patterns they linked to the things of art. The smashed particulars that said: *Yeah – fucken punk, all right.*

They seemed to say our name in unison, our band name, our Christian names, fake names, noms de plume. Even called Angel Angus, which was right but wrong. Kids joshing and punching the rounded muscle of one another's shoulders, all of them trying to be quiet as Buzzcocks sweetened the room. Blair, standing there in army shorts, called out and came forward with a complicated limp like he'd borrowed it from somewhere with the members of his band. The band we wanted to release on Eighty-Eight Records, the thing we did from our office in Burstyn. We'd put out ten singles by eight bands. Noisecore, hardcore, post-hardcore, post-no-wave: all kinds of hatred and love. Typocaust were going to be next.

Blair had a grin up the side of his face, the other side passive.

The cluttered swearing as we greeted one another. Angel peering off into the corners. The stage festooned by chicken feet all strung up on the mic stands.

We sat where the office used to be. The boys sharing cigarettes. One had a bag of sandwiches and I ate out of it. Wonder Bread and peanut butter. They'd been drinking and it felt like their plans to show us a good time were on the decline. They spoke, eager to hear where we'd been, other towns and the names they'd heard from other towns. At times it felt as if they knew the people we knew, had friendships with people they'd never seen, never spoken with. Blair was the youngest, he popped gum and said he was trying to give up smoking. He was chubby and eager, forcing us to answer questions with a quick peck of his nose if ever we fell quiet.

Spence mentioned Blair's brother and Blair said: 'Yeah, well, fuck.'

They stared at us. Rough skin, the remarks left by pimples. There was a mute kind of violence about them, as if ready to take us out on a run shooting at prairie dogs from a pick-up. Blair nodded to the corner where four six-packs sat one on top of the other. He was kid with serious wide-eyes. Almost believable in his excellent T-shirt with *PEACE & HATE* capitalled across his chest under his leather jacket. That was the name of Neues Bauen's first EP. *Peace & Hate.* Now it was a confused knock-off T-shirt.

'Any of you guys know our album?' I asked. 'The guitar parts? Cos I can't figure them out.'

'We had the Meatmen two months back,' the drummer, Amerighi, said. 'We had Redd Kross. Minutemen. Blair played with D. Boon for three songs before Watt and Hurley kicked in. Then Spurn-Cock two nights ago before Big Black.'

'Nice.'

'Blair could probably play some of your songs.'

'You're fucking kidding me,' Blair said.

'One or two songs,' Angel said.

'You got to be shitting me. I know diddly-squat-fuck. Nothing,' he said. And he showed his teeth, all uneven in the grit of a smile he didn't seem to intend.

Vicki stood and it only took a moment before everyone was looking at her. She said: 'You guys hear about Cozen Jantes?'

'Spurn-Cock dude?' Amerighi asked.

'Aha.'

'Fucken-goat-boy-hardcore-fucks,' Blair said.

'But you hear?' Vicki asked, kinda luminous in the low light. I stood also because I realized I didn't want to be in there. I wanted to head back to the phone booth and call Sonya in Burstyn.

'They're museum dongs playing sped-up Beatles tunes,' Blair said.

'What about him?' Leo asked.

'He was handing out beer to any kids who'd watch him jerk off,' Vicki said. 'The night that girl was molested at that party in Madison a couple of nights before Burstyn.'

'What girl?'

'Just a rumour I heard. Someone was fucked with. And Cozen's handing out beer with his dick out.'

'Like, what? What aged kids?'

I stood by the window through to the main room and peeled a strip of veneer off the framing. I felt drunk after two cans. The altitude. The 5,430 feet and the whole deal with oxygen, how the blood vessels squeeze and getting drunk is as simple as opening the can.

'Up in Madison. Thirteen, fourteen-year-olds at that party. I heard from Nikko. Same night.'

Amerighi laughed and Blair screwed up his face.

'So, the fucker gives out beer?' Angel said. 'I line up, I say: *Show us that thing.*'

'They were here the first week we opened,' Amerighi said. 'They just sound like Dick Saw.'

'That's what I told 'em,' Spence said. 'I said: *You hate us cos you anus.*'

'Really?'

'Anyway, that's a whole lotta shit, right there,' Vicki said. 'They sound like the Monkees.'

Which was near true: they had as much marrow as a shopping bag caught in the tines of a fence. Quick like the Dickies, pop like a jack-in-the-box.

'I like them,' Leo said. 'Do a great version of "Kids in America".'

'Their drummer's a sweetie,' Angel said. 'Nikko, from Spurn-Cock, he's a sweetheart.'

Blair stared up at Angel, our twenty-one-year-old leviathan.

'What'd you call their guitarist?' Amerighi asked, turning to the still-staring Blair.

'I said: motherfuskers, you're four-day-old cum coming out my ass.'

'Did they break your neck?' Angel asked.

'They're OK,' I said. 'The drummer at least.'

'If they play shit, if they sound shit; they're not good people,' Blair said and went kinda quiet. 'Not good people.' He pinched his eyes so they were almost shut. He had the sudden look that suggested he knew the dubiousness of his logic. That the entirety of his intellect was based on knowing the weakness of his own words. 'So – what the fuck's with your Tony Tone?' he said, belching beer.

'Nothing,' I said from the window.

'We left him on a park bench,' Angel said.

'But he'll never play again, right?' Blair said, looking straight at me. 'When I saw him, I thought: this guy's fucked.'

'You what?' Angel said.

'When I saw him, he was just blood and gore.'

'You weren't there,' Angel said.

'The fuck I was. I came over to crash at the Eighty-Eight and found his mess.'

Vicki was suddenly watching me and I began staring at Blair, trying to recognize something in his tight eyes. The element I scanned everyone for. Those with eyes that sought mine. The remorseless, beaten article of knowledge, spoken in seeing and saying: *I know, I know. And it's going to happen again, because I know and everyone knows.* The heart-fucking, cold glance.

'His face was, like, blown out,' Blair said. 'Flapping.'

You weren't there, someone else said in my head. Someone reeking of piss and anger.

'He was on his haunches and which one of you was in the Eighty-Eight calling an ambulance? Huh? Because I wasn't calling one and which one of you fuckers was running away? Have reservations about what I'm saying, motherfuckers,' Blair

said. He grunted, 'Emph.' He whammed a karate chop near Spence's ear. A drunk kid forgetting his manners.

'Your pal, here,' Spence said towards the drummer. 'He's a bit-part bitch, isn't he?'

Blair made the same move again. Spence grabbed his lardy hand.

'He's a bit-part bitch, isn't he? This one.'

'Cut it, Blair,' Amerighi said.

But Blair was twisting this way and that, his language ineffectual, crude. Spence half his size, his pale balding hair. 'Nobody saw nothing,' Spence said and threw Blair's wrist back at him and I found the panicked part of myself moving towards him from the window.

'We ignore him most of the time,' Amerighi said.

Blair remained standing. Everything about him made it seem like he was bluffing, that all this, and all his anxieties, were simplified versions of others' problems. 'Some guy gets his dick out and starts putting it in faces. Fuck you, I say what I like,' he said and karate-chopped the air near Spence's head again. I stepped in close.

'This dude's the guitarist?' Spence said at Amerighi. 'I'll break his fucking wrist if he says another word.'

Vicki raised her eyebrows and Amerighi said, 'Blair, you're being a ding-a-ling.'

'Howdy cock smokers,' he said and it was obvious he was drunk, but beer only makes a person half of what they become when they decide attention is the most vital ingredient in being themselves. He shoved the back of Spence's coat. 'Hehe, motherfucker,' he said. 'You fuckers in your faggot leather. You precious little punkers,' he said.

Spence stood and put the heel of his hand into the fat kid's shoulder, shoving him so he stumbled backwards. Blair tried to come at him but tripped over the chair he was sitting on and Vicki was at them both suddenly, her tiny figure between them,

swearing at them. Telling them to cool off. But then Blair went out the back, pushing past me. He kicked a door. The sound of glass and bottles.

One of the support bands started banging their songs, three chords and a synth. Five people out in the garage. The chicken feet swaying on the mic stands, the echo and thud.

Then there were twenty of them as we played. They smashed out the remaining windows, kids cut with airborne glass. I watched them dance on the stuff, slipping, falling hands out, blood wiped on their clothes and skin as the snow started again and fell into the room. I stood one foot in front of the other, knees bent braced, screaming words up into the microphone as Spencer pounded behind me in a kind of rage, his face covered in saliva. We watched boys fight and slip and throw the snow and glass so it grazed and bruised. We played again, old songs, songs cut to pieces and at the end Spence stood drunk and raw throwing bottles from the stage, trading cold glass for broken light.

13

May 2019

And now, right now with these days well past, I watch the evening enervate and gather then slowly spread as this ancient 737 flares in the light over Marrakech, floating down into the south-west of the old city. We land softly, cloth the earth and merge with the other aircraft roaming the taxiways, each of them clumsy on the asphalt after hours of transecting time and geometry with such delicacy. All of it so peculiar, so strange because I sit in what was once Sonya's seat as the aircraft queues with other aircraft trying to get to the gate and she's not here but so discretely here I want to turn and whisper at her something stupid and amused. A nervousness in the passengers around me whose first time it is in North Africa. I like this, there's a certain lack of predictability. They look about and I avoid their eyes as if this lack of connect will allow them a somewhat more fulsome experience of what awaits them outside the door. I avoid the questions they ask among themselves regarding the Arabic and French immigration cards.

I avoid this and I avoid that. I'm well practised at it. There are multiple keening elements within the events of living I've avoided for most of the last thirty-four years. The most elusive, the hardest to distract being the consciousness of others, the potential of their knowing. A game whose foolishness is exaggerated when arriving in a country where the apparatus of intelligence and memory is defiantly foreign to myself and those around me. But foolish is as foolish does. For thirty-four years I've railed against the frailty of various instincts, the

inclination to remember being chief among them. For some time I've preferred compliance with the remnants of the here, with the trivial narratives that hold the now in place. Here is simple, here is exact. Here keeps Burstyn, the van and that stinking bag of clothes my face was shoved and thrust into locked behind the eyes of others.

And here, if you want to know, is a deep Moroccan evening. One of warm rain and simple patience. And here I am, amidst the confusion as the flight attendants busy themselves, directing, shuffling oversized luggage out of lockers. The music in the speakers interrupted by the static ruin of the flight director's voice, coded instructions to the crew, and I wait patiently as the others stand, desperate to exit this machine and get to the terminal where Sonya's ticket had aimed her several weeks ago. But now it's just me, hunched down among the rows of mingled misery, the vastly uncomfortable.

Eventually I'm down on the tarmac wandering past the facade of the new terminal into the old, vastly seventies concourse. I brandish my passport, cash up, head to my rental car. The office has the TV on, news. A bus crash in Paris. IT stocks in crisis. Real-time shots of the medina, strange goings-on in Jemaa el-Fnaa. Men in black cargo pants, bomber jackets and balaclavas shoving people in the great square. The woman waving from the counter, keys, a smile and pamphlet.

I spend a few hours in the city before I'm driving out on the N8 towards the Atlantic coast through the hard desert. I navigate by memory out and away from Marrakech, its bright casinos and clay-clad medina, out through the shift and lift of dust. I watch the rise of an enormous ridge grey on the horizon in the moonlight. The whole mass of it, it seems a wedge lifting the sky, tilting it above the road signs for Chichaoua, Casablanca, Agadir, Essaouira. Desert and the black asphalt piecing to the end.

For a long stretch I'm the only car, the only source of light. I remember how I once thought that this was the place of things

not yet heard. Once thought: this is the place where nothing's yet been said, this is the territory between the names. I was twenty-two and thought: this was the place before the saying, before it comes to mind, the darkened desert. I drive west in the beams coming off trucks and cars. Dust holding its shape in the headlights and I'm uncertain what I think now. Perhaps the same, perhaps something less loud but not as quiet. Most of the traffic keeps humming straight but at Ghazoua I head left and south towards Spencer and Juliette's house in Tafedna. A multi-roomed pisé space where he has set aside a series of photographs he recently sent through while I was in transit in Doha from Auckland to London. A rough scan of a series featuring Tone and Paloma beneath triangular hills from the late eighties when people still fed their cameras with film. I know the hills, I know their location in Colorado. He'd also sent through a screengrab of a video, recognizable and so late to the party.

Look familiar? he'd written.

It had pushed a fear through me like coming upon a land peopled by twenty million speaking a language you've never heard of before.

I turn off at Douar Tisgharin, an unadvertised junction that I only know to take because I'd asked my phone to warn me when it was coming up. Ten kilometres later I head up the cracked mountain to Igarsouss, the mute settlement on the hill looking down into Tafedna, the expanse of beach, of torched land and fog well settled and I'm sitting on Spencer's deck, drifting out of wakefulness. It's 11 p.m. and God knows why it seems such a good idea sitting out like this, but I don't want to wake Juliette or Celine, not yet.

We'd come here before, Sonya and I, three years prior to the band getting back together for the four gigs. It was a holiday for the two of us. A vacation in the vast heat. We'd wanted the medieval and desolate, the red clay city and Amazigh

tribesman. The prayer call and we wanted to be those ruinous tourists just for a day or week. Of course we couldn't go through with it and watched the vacationers instead. Their slow reinvention of mystic lives.

I've no desire to wake Juliette and instead skype Sonya, listen to her as she shifts through various stages of wakefulness. It's eleven hours ahead in Wellington, plus a whole wet and rainy season. Her face moves in and out of my screen and she's concentrating on a fresh cup of tea rather than my eyes or anything I have to say. I speak softly, carefully, because that's how you talk to the sick. Because she is sick, despite her delicate features saying how she's always looked after herself, maintained that complex arrangement of allure with a wry humour about age. At the shoreline the sea is lit by a three-quarter moon. And then the sea vanishes with the terrible fog closing in, then pulls back in a motion seemingly designed to counteract every other action in the universe. I wet the cuff of my shirt with saliva and wipe at a mark on the screen as donkeys start up and dogs too let their presence be known in the gullies and villages of blue-wash mud-brick and narrow lanes below. These are the voices of the landscape, an unruly choir of animal echo and sea-white noise that Spence says he never quite gets used to. He's here maybe a week out of six, he told us when we visited in 2014. The rest of the time he's among Kurds and combatant factions of ISIS, among obscure, endangered Nestorians living desert lives in the bloodshot east. Or he's photographing gun-slung Georgian nationalists in the Carpathian foothills, kids posing with weapons and women. The eagerness of newspapers. Of *Paris Match*, the *Times*, of aggregating websites, of Getty Images and *Vice* to pay him by image. I realize quickly that I'm relieved he's not home yet, that I don't immediately have to fall compliant into our specific conversation, the one we've been having for near forty years. The land and sky need to do their thing, I tell myself,

settle me into the rogue consciousness of this place before I spoil it with our mode of back and forth until one of us starts to recall how miserable we can be. Instead I listen to Sonya's voice, so eternally near it never quite vanishes.

She says: 'I'm trying to picture you there without me. I'm trying to remember all the rooms.'

She says: 'When you see Juliette remember to smile, to say hi. Remember to tell yourself that it wasn't her idea.'

She says: 'Call me back in a few hours, when I'm proper awake. I promise to be interesting.' I find myself staring at the screen smudge distorting her left eye. She's no idea how it looks on my laptop, but touches there anyway as if there's no such thing as 11,000 miles, as if they disappear in the wish for the unnaming of borders, that they vanish in the onslaught of a look.

14

November 1985

'Con, Con, who's never wrong,' Sonya said down the line. 'Where're you?'

'It's a phone booth,' I said. 'I'm in Denver.'

'What's it beside? You beside a highway?'

'No. Outside this garage.'

'The Garage.'

'If that's what they're calling it. One of those kids set the place up. You at the Eighty-Eight?'

'I heard the phone ring and I got out of bed. It rings so loud when it's you.'

'It's this thing I do with my mouth,' I said.

'Can you lie down, Con?'

'Maybe. Hold on.'

'What card are you using?' she asked.

'The Diners Club,' I said. 'International. They smashed out the glass as we played. Like, all of it.'

She moved around so there was excessive background noise. 'I like that you say, *International*. You're suddenly George Lazenby. Or James Mason. Makes me swoony. Is there enough space for you to lie down?'

'Why?'

'I want you to lie down,' she said.

I said nothing for a time. Just listened to the shape of the noise on the other end of the phone. Near, comforting. People outside the booth leaving the venue. Whoops and screams. Girls riding on the back of their boys. Their breath following

them into the street light. Everyone is beautiful in the raw of winter. I listened to Sonya breathing, I found myself thinking of her underwear. How full they were of her, the line and hair and everything else.

'Honey,' she said.

'Yeah.'

'I'm on the floor in the kitchen. I can get to the couch if I lift the phone off the wall.'

'You want to?' I felt myself getting hard there in the frigid phone booth. Distance and voice. The same erotic measure of nearness and touch.

'No worries. You want me to?'

'Yes,' I said. 'Sonya?'

'Yes.'

'Do you have the money box? Because we don't have the box.'

Silence, or near silence; I could hear 'Marquee Moon' playing in the faint background. Tom Verlaine's incessant two chords before the paranoid mixolydian whip of his solo. I slouched on the floor and a lone girl walked past the booth. Her gaze down under the hood of her army jacket. She stopped and turned. She looked at the phone booth as Sonya remained quiet. The girl didn't seem to see me because she came towards the little structure, reaching out for the door. As she pulled it open I recognized her from earlier. She'd sat briefly on Blair's knee while he was rolling a cigarette after we'd played. She'd buried her head in his neck and stayed that way for whole minutes. I'd thought: *Jesus, what kinda girl goes near that?* She opened the booth door and I covered the mouth piece.

'Sorry,' I said.

'Oh.' She laughed, a little nervous. 'I'd no idea.'

'That's fine. Just talking to Illinois.'

She put her gloved hands on her small, wide face and rubbed; her skin seemed to warm, pinkening as she squinted

at me, secretly amused by something. 'What you doing sitting down there? You look like a filthy hermit.'

'I'm just talking to my girlfriend.'

'Nice. You should, you know. Say hi from me.'

'Who's you?'

'Call me Miriam. My mom gave that name, so.'

'Sonya?' I said into the receiver.

'Let's sleep here then, on the phone,' Sonya said suddenly. 'We'll sleep here.'

'Hold on, someone's . . .' I said and looked up at the young woman, putting my hand over the mouthpiece. 'Am I supposed to know you?' I asked.

'Maybe. No. I liked your show by the way.'

'Thanks.'

'Vicious, but giving. Two words I've never put together before. Which I guess is the point.' She'd a mouth that seemed tilted, permanently lifted on one side, giving the strange illusion of an ongoing thought.

'I guess.'

She looked at me for a moment longer and put up a hand to say goodbye and that was it. I returned to Sonya and my silence.

'Who was that?' she asked after a time.

'Some chick,' I said.

'Should I be jealous?'

'Always.'

I felt her smile at the other end of the line. 'Let's sleep here, on the phone,' Sonya said again. 'Let's sleep here.'

'Sonya?'

'We'll lie and wait for the morning.'

I felt myself get ready for her to say something else, something involving the words snatch and pussy and cock and tit. I could hear her taking off her jumper. We'd come to know each other through phones and this stolen credit card. Learnt details

of the other. Mapped each other's bodies by the sounds they made. But when there was nothing I said: 'The money box?'

She said nothing for a moment.

'Sony?'

'Yeah. I didn't mean to.'

'Oh God.'

'Yeah. I'm sorry. I just, it just ended up in my bag and I left and. Can you stay with me, baby?'

'I might need my coat. Or Spence's. We're kinda hungry,' I said.

'I love Spence's coat,' she said. 'I miss Spence's coat. If I die today and come back, I want to come back as Spence's coat.'

'Sonya.'

'I'm sorry. I didn't know what to do when I saw I had it.'

I sat down on the floor of the phone booth, the cable taut.

She whispered: 'Tell me something you've told me before, Brother Jean. Something secret,' she said.

'That prick from the band, he was fucking with Spence.'

'Blair?'

'Aha,' I said. 'What do you know about him?' I asked. 'He was messing with Spence and, I don't know.'

'People should just leave Spence alone.'

'What do you know about him – Blair?'

'Me? I know he wants to fuck Vicki,' she said. 'I know he was here that night.'

'Everyone wants to fuck Vicki. It's her twisty smile. What night?' I asked.

'He was here in Burstyn. His band were on the bill with you at the all-agers.'

'Really?' I said.

'Aha. That was when he said he wanted to fuck her.'

'Dear God,' I said, and laughed after a pause. 'I wonder how it is to go through life with every dumb dick wanting to screw you.'

'Tell me something you've told me before,' she said suddenly.

'What like?'

'Tell me something you've told me before, but was a lie,' she said.

'How do we know him?'

'Which one?'

'Blair,' I said. I knew how we knew him. We were going to put out a Typocaust single, but I felt there was something else.

'Oh, he's just a little fucker. Tell me something.'

'No.'

'Something that was a lie,' she said.

'Oh no. No, no,' I said.

'It's a good game,' she said.

'I'm not—'

'Tell me something that you told to me in the confidence of truth, that was untrue,' she said.

'*The confidence of truth*. No,' I said.

'You'll be good.'

'Not this game,' I said. 'How do we know him?' I punched my limbs and tried to fight the freeze.

'You haven't ever played it.'

'Everyone's playing it,' I said. I looked back at the garage, I felt my hand shaking, my face tighten.

'No. No they aren't,' she said. 'Not with these rules. Just tell me something, Con. An old lie. Or, like, what's the story with the bruises below your neck?'

I said nothing. Until I said: 'I'll stay with you. Just tell me how you're going to get the money back to us. We don't make money on these gigs, baby.'

'You stay with me here, Con, Con. We'll sleep and burn off my fat to keep us warm. That'll be my recompense.'

'Your fat?'

'Yeah,' she said. 'You'll hold me and we'll burn off my fat.'

'Aha.'

'Because I'm getting kinda chubby.'

Then the two girls Angel and I had greeted on first arrival were outside the garage, stepping away and leaving. Blood on their clothes and the same dripping on the snow. I twisted in the cold.

'I'm like, puffy in places,' she said.

And then I saw him, Leroy, he was following on after them. He'd a habit of following women home. Of intrusions into lounges hoping for invites into bedrooms. Habits are ruinous things, half wanted, always denied. Imagine the dude sitting on couches, miserable and terminally unlaid.

'Sounds like, what?' I said. 'You've gone and got a cold or something while I'm gone.'

'No.'

'You've picked something up in the ward. Something roving,' I said. 'Joan George-Warren says that fifty-nine per cent of illnesses are best cured by doing nothing. I don't know where she gets her numbers.'

'Yeah, well, screw Joan George-Warren, Con. I'm pregnant,' she said. 'This is what happens, you know, to the expectant.'

15

Twenty people punctuating the couches and floor. Army jackets and combat boots. Split stockings and knees and, and a baby in Sonya's belly. Jesus Christ. A haze of smoke from the kitchen where Angel was baking. He'd show up at people's houses and start baking in the middle of the night. Biscuits and cakes. A party blazing, one band playing in the stairwell and another in the basement and Angel baking cookies and talking out loud about his love for bagpipes as the gathering went on in its own hellish way. That was how we'd met, Angel and I, talking about bagpipes at a party, how anything with a propensity to drone and be that out of tune had to be king. I started drinking with the rest and quickly we were the people we became when we weren't in our homes, we were the people we became when sleep was traded for van noise and floors; there was often nothing but the things others offered. It was one o'clock. It was 2 a.m. and something was growing in my girl's womb. It was 3.30 and the others slept in a heap on Blair's floor, a membrane stretched about us, a skin made of breathing and beer and the fact we'd been here, talking and half high. I'd open my eyes and see legs strutting by. They were all jeans and dresses and boots. Sixteen-year-olds, seventeen, twenty, twenty-five. Hand-me-down pea coats and beer. Spence lay in the corner with Vicki on his lap as he slipped in and out of sleep and Sonya was pregnant.

Some shouted our names, some just stared. People anywhere. We lay among them as they drank and talked, sharing Angel's chocolate cake. People shouting. The yelled revelries.

'Hey, you fucks.'

'Piss up your ass, I'm sleeping.'

All at the hilt of the craic.

All mixed in with the impossible thoughts of what was happening back in Burstyn in Sonya's perfect, river-stone round of a belly. Panic-driven thoughts. The impossible question of when. Or if, whether it was that night, or another night. My room on Neves Ave. The hospital. The storeroom and that numb ejaculation as I bled. I sought out images of her, suddenly circular, a massive stomach. I tried to see her face and see the questions in her eyes, the answers in her eyes. What did she know? There was no sleeping, just the want to call and call her again. To say: *Honey, honey.* To say there was fear and it was everywhere.

Blair was dancing with Miriam. The room lit by Bad Brains, by Crime, then Neu!, then Joy Division.

Light flinched and I looked to the other corner of the room. Spence was lifting his girl off his lap and unzipping his sleeping bag. He started hustling through the remainders. I sat up and saw him run past the window outside.

I found him in the van.

'You chilly in here?'

He was lying on the speaker cabinets. We'd stack the amps and put a thin mattress there above the sabulous floor of the van for when we needed escape. Two feet between the roof and sleeping bags laid out in the hope of comfort. It smelt of oil, body odour, pee, pizza, cum and beer, the stale leftovers of road life and its habits. He shrugged and looked up at the roof, the steel separating him from the falling cold.

'You know there's dinosaur footprints in a river bed just south of here,' he said suddenly. 'Hundreds of them, just out for a stroll.'

'Sonya's pregnant,' I said.

'Huh. When?'

'Now.'

'No, I mean: When she get pregnant?'

'Not long ago.'

'So it's not too late,' he said.

'For what?' I asked, but I immediately knew what and we both went quiet.

'What are you going to do?'

'We haven't talked about it.'

'Fuck, talk about it. Vicki'd had an abortion,' he said. 'Before me.'

'Yeah?'

'Some dude when she was a sophomore. She can't remember his name.'

'Poor Vicki.'

'I got real angry, but I didn't know why.'

'When?'

'When? When she told me. I got really angry and busted a curtain and rail. Bit pathetic, but that was all that was on hand.'

'What an asshole,' I said.

'Yeah, what an asshole. She forgave me cos that's Vicki.'

'Why'd you get so assholey?'

He rolled over onto his side. I could smell his breath, it tasted of ginger wine.

'I'm being nosey?' I asked.

'Not sure. What's your motivation?' His face twisted into what eventually became a kind of marred smile. 'Everyone says: *Go see the dino prints.* But I don't know what my motivation would be. That'd be being nosey.'

'You're the first person I've told,' I said, confirming something. I felt nervous again, like I might once more vomit like I had in Springfield, in Evansville, in St Louis and among the pines at Bern's camp after watching Leo shoot up. That it might come and not stop.

134

'I just think if someone's producing kids and they aren't saying what they're going to do about it, they're gonna mess it all up,' he said – and then neither of us seemed to know what he meant, not exactly because we went silent like a secret, listening to the nothing, then listening to the rain that started up the street, shattering gallons banging on car roofs, on garbage cans and stoops. A hard shower coming at us along the sidewalk, making holes in the snow, drumming the van in a hail. Then stopping, like the sky had remembered other things.

'She's been talking to Tone's doctor again,' I said. 'The dude said the bullet was fired from inside his mouth, exited through his cheek. The angle of the shot, the trajectory. He says Tone could only have been aiming that way.' I put my fingers into my mouth, barrel and thumb-cock. 'His intent was just to blow out his cheek. That's all.'

'That's ridiculous.'

'Everything's ridiculous,' I said. 'Pretty much the entire universe.'

'My mum. She had an abortion at twenty-six weeks, you know that? She was as round as a melon.'

'Jesus. Ruth?'

'—'

'Fuck, dude.'

'My father had a moustache and he wouldn't ever wash it when he went out. He'd come back and grab me and kiss my face. That's how I knew what women smelt of when they're – when they're sexed up and . . .' He stared at me, at my eyes. It was the nearest I'd voluntarily been to a man, staring like that. I could see other parts of him, his mouth shaped like a girl's and his slight beard lifting his cheekbones. His mother used to tease him about his stubble when he was the first to grow it. It showed up in a strange month in which both of our voices broke and his skin seemed to erupt while we tried to write our first songs with a screwdriver jammed in the strings of their

family piano. We'd stick it in there so it sounded out broken notes and made a noise like a broken gamelan. Ruth'd taught him the piano since he was small, she then taught me in bursts. Spence laughing at my lack of ear and care from the other side of the room. Ruth used to stand behind me and I could feel her body willing the notes to fall into place. She was always happy to have us around. She liked to tell stories and pull books off her shelves and point at the text and have us try and explain to her what it all meant, this look in her eye that said it was all worth it. Now her son and I stared and waited on something.

We waited until I thought I should talk to him about her because dead mothers are dead mothers, but instead we waited until they came, until they came running. Until the noise of how many kids hit the van. Their feet on the concrete sprinting from a block away, then their shouts and they're jumping on top of the roof, yelling.

'Fuck,' Spence said, panicked.

Kids rocking the van, two on the roof. The dents of boots above us. In St Louis two art students had stencilled *Neues Bauen* on the side so it now had a skin and now we attracted the unfortunate and vain. They started yelling my name, then Tone's. There were five of them. Spence sat up. He hit his head on the roof.

I shouted out. I banged on the side of the van with my fist.

'Brother Jean,' Spence said.

'It's just shitters,' I said.

He rolled off the amplifiers and onto the bench seat Angel sat or lay on during our long hours. I was yelling by then and Spence was with me, shouting. I sprung the lock on the door and we were out on the street. Three boys in their army jackets, each inked-up in various band names and logos. Spence pushed past me, he had something in his hand, a piece of drum hardware, a cymbal stand and he had it above his head. The street light danced off the chrome.

'Cock shit!' he was yelling.

'Hey, dudes,' one of the kids shouted.

Spence's face'd crumpled and he was near tears. I took the hardware from him and swung it at the first boy. Just a guy, sixteen, seventeen. He was panting, as if rocking a van took energy beyond being a fool. I turned to look at the roof; the two stompers were standing still looking down at us. I recognized them from the gig.

'You dumb fucks,' I said, though I was almost laughing. That was all I had. *Dumb fucks.* But they weren't looking at me. They were looking at Spence. He was crying, his face furious and wet.

'Oh, dude,' one said, almost softly, almost concerned.

'Someone's calling the cops,' Spence said at the shits. 'That's what someone's doing right now.' His hands were shaking.

'Come on, dudes,' the first guy said. 'We're just fucking around.'

They let themselves down, hanging then falling the last foot to the pavement. They said nothing and started walking away. Then one of them turned and said: 'I ain't going to the pigs for liking your old band.'

'Nobody's going to jail for shit,' I shouted.

'Dunces,' he called back. He had on a Denver Broncos T-shirt. He looked shat upon, reduced by some part of his life he'd claim to be a tragic failure if it weren't for days like these. I said something forgettable. Their leers and backwoods accents. Never before has an art form attracted the lowest to the worst intellectuals. Punk pulls all in, makes geniuses and thugs out of the rich and poor, dumb and smart.

Then Spence shouting: 'Who loved you boys? Who's gonna love for you?'

'What the fuck, dude? I just liked your old band. I liked Dick Saw.'

'Who's going to love for you?' Spence was crying and I

didn't know from where those words came, from whose mouth they might've originally been pitched. They yelled shit back as they went off, repeating their point: Our band sucked. Tone sucked. We were the sell-off of any good idea we'd ever had. Et cetera. I looked at Spence, his face smudged, the indelicate reduction of his mouth turned down at the corners. And then I thought of Sonya's brother, how if Tone were there what would be done. What pursuit through the streets would've ensued, him ready to trip one and spit slowly in his face. It started to snow then, and then it stopped, as if any idea the sky wanted to put in our minds could be ruined with a flick of temperament. First comes the cold, then comes the rest, the remembering of this, the slow turn of the anonymous and undiscerned.

16

December 1985

Oklahoma City, Fort Worth, Dallas, San Antonio. Each a ragged mess of song and half songs. In Oklahoma I'd stood on the stage, frozen mid-set. Forgotten lines and lyrics, whole worlds passing through. In Dallas it was the same until Spence threw a stick and it collided with the back of my head. Then in Austin, Angel scored acid from a couple of mad men and we bruised the air in fantasized rage. We ate when there was leftover change or we found ourselves in the kitchen of a kind-hearted soul and we filled up on peanut butter and sardines. Or we starved.

Then Houston and blood. We smashed through eight songs, wrecked them then packed out the equipment from the International as Rhinosaur hit the stage under the strange arched ceilings. Lugging and swearing. In the after I spent time in the cool talking with Nikko about fishing and Sonya. He worked for a time at Roads to Moscow, a record store on Mills Avenue, and that's where he'd meet Sonya. I was bleeding from the head and he kept asking if I was all right. I'd split my brow on a par can and spent the last three songs wiping blood from my eyes. Nikko knew Sonya, played bass in her band in Phoenix and they'd shared an apartment for a time too. He was asking if I was OK and I said: *Yeah, yeah.* The ooze stopped when I pulled a woollen hat down across my forehead but it still dripped. He asked if I'd seen Cozen, I told him the last time I saw him he was feeling some girl up in the backstage area.

'Fuck him,' he said.

'And fuck all the girls who'd fuck him,' I said.

He smiled with one side of his face. He was a southern kid in leather who always seemed at odds with the punk and grind of all this. All as if he'd been kidnapped by a cult of Ramones devotees and this was his life now.

'And fuck all the girls who'd fuck him,' he repeated. 'I like that.'

And I liked Nikko, despite the fact he played drums for Spurn-Cock and they'd ripped us no end. That night they'd played a song that had a beat almost identical to a track from the *Peace & Hate* EP. A song recorded barely two weeks after our first rehearsal with Tone. Spence found himself playing a rhythm that couldn't have been possible just a month before. The way the four of us now played was shifted, rhythms formed and shot through with the new. It was a moment and that was when we changed our name from Dick Saw. And here Spurn-Cock, in their near matching black uniforms, thought it'd be OK to just mimic it for a time. I enjoyed the simplicity of Nikko and our conversations, the singular stabs at sentences. I suspected there was something cracked inside his processes that didn't allow for complex speech. He was a slight bit dim, sure, but it seemed at the time there was always something to learn from those who desired to understand what they never would. I liked him, also, because he played in another band, the one with Sonya, and that warmed me to him simply. This is the thing about punk rock, it can have intellectuals and mental defects, criminal, upper-class toffs and working-class pugilists on the same stage, hunting down that one elusive spark amongst the violence. That one thing that said out loud and right into the world's face: *There is a way beyond this.*

'You OK? It's your blood, right?' he asked. At first I didn't hear him, or thought he was talking about somebody else. 'On your face?'

I paused for a long moment before shrugging as some scene

kid took our photo, my face dripping with the stuff out of the cut on my head. The way it clung to my nose, how a slash of it crossed my cheek. The flash and blink that later found its way to *Sub Pop* and on and on, into a book I wrote a chapter for in 1998. A moment of unintended permanence. 'Yeah,' I said. 'Of course it's mine.'

I went outside looking for a phone booth because I'd decided I had to call Sonya. I tried to ring her every night but didn't always get through; it'd been three days since we last talked and I was nervous, pained in ways I hated to explore like this. I went through a flock of punkers all gathered around in a circle in the car park. I watched Cozen Jantes and two others standing pants down. Watched them piss on two teenaged boys and a girl all suited up with eyeliner and furs, the shaved lines through their hair, safety pins and words written in. Everyone giggling and spitting and swearing like this was a good idea. People suddenly produced in a moment of new ritual and in the next, vanished. Revolting but something almost beautiful in acts of the young when the young are trying to forget. Something spirit-haunted and bright. I looked on and had the thought that we gather in circles when we want to understand our desire to avenge what we can't control.

Jantes yelled out at me, drunken and roaring.

I soon started walking, looking for a booth. I walked the block. My head ringing, a kind of shattered headache as if all my life I'd been hunting out the furthest light and suddenly found it, there, all at once. Had I known that picture in *Sub Pop* would've become such a thing I'd have taken an aspirin or two.

I went past a pack of oil riggers on their week off, men smoking beside a trash compactor in a round. They called me an asshole and then a faggot and I smiled like I thought might've been appropriate in the moment, some ironic grin. I've never

been certain how to react to these moments. One lunged at me in an Aerosmith T-shirt and laughed when I flinched, a paunchy dude wrecked on amphetamines, eyes like split diamonds.

'Hey Turtledove,' the first rigger said.

'Look at this puppy.'

'You wanna get nailed, puppy?'

'Puppy, puppy punk,' the Aerosmith fucker said. Hair parted in the middle and thick over his ears. The faint moustache of some bad idea.

'Fuck off,' I grunted and felt weak.

'You walk here dude. Fucken faggot kill capital.'

I headed south. Strode out but each word came at me as they laughed, a thump in the small of my back. An elbow, a kinda physical taunt and hit. I saw, smelt. The neural lightning burst of corporeal memory.

I felt weak and sick and panicked.

'Look at this fucken fag puppy.'

The physical recall.

'Yo, puppy punk.'

My mouth, stuffed full of something and something.

Then the shot.

'Yo, fuckhead.'

The second shot.

'Hey, faggot.'

My jeans between my boots. The area between skin and tissue.

'Faggot.'

Bodies crashing through the back of the van.

'We'll piss in your pussy hole, fag.'

Shadowed face. Then Tone, Tone balled up on the ground, blood and skin and firearm calmly in the grass.

'Yo, fuckhead. You wanna suck dick?'

I ran.

• • •

I jogged south then back around to the east towards midtown, away from the International with my blood running thick with whatever hateful chemicals. We'd seen Minutemen at the same venue the previous April. D. Boon with his belly tucked into his shorts. Treble and bass, nothing in between but a snare drum rolled through the riffs. A strange democracy of frequency and instrument. Christ, they could play and we'd limped on one leg on the same stage. Tone's neat obsession with them. With Boon's tight riffing and sequences of chord to last chord. He'd make me sit in close to the speakers, point at certain chords, saying: *See?* See. *See.* The word I kept hearing as I ran. *See.*

The city rose up, the suburbs fading in the distance where the skyscrapers leant and I slowed and tried to walk the sensation out, kill it in long strides. *Puppy punk.* I walked until I saw the houses give way to parking, until the lights in the distant city blocks felt immaculately precise. I walked until I thought, *God, America looks like America.* The restaurants and dry cleaners set back from the road, the drugstores, the closed-up garages and lines of cars and the parking spaces for each cookie-cut business and their clientele who drive from store to home to store to work to coffee to places in their minds I've never seen. On each step I expected those riggers to reappear, to show and step out of a shadow and the Aerosmith dude to grab my hair, punch me in the throat. Each turn of every corner. The panicked heartbeats and certainty of coming pain, but instead of heading back I walked on.

At Elgin and Brazos new voices shouted out, reaching across a car park. A lot all cracked and half gravel. I looked without intention; the voices called again. I walked on and looked back. One of them was standing, one of them coming at me. I hustled, hunched to make myself small. My heart twitched till it was hard in my chest. I quickened and the man said my

name and I glanced back. I looked back. A stoop lit by lousy electricity. He said my name again. I stopped. He said our band name. He said: 'Neues Bauen. Neues.'

I stopped again. I turned and he was gambolling towards me, saying: 'You have a lighter, man?' He was tall, pale with blue jeans detailed in whiteout and torn at the cuffs.

'Yup.'

'We're waiting to be let in and no one's answering the door, so.' His jacket was torn and underneath he wore a hand-stencilled Nurse with Wound T-shirt. 'It's Brother Jean, right? Yeah? That's Billow. My name's Jackson. He's called Billow, but his real name's Bill Oskar.' He nodded at his friend, a slight black kid wincing as he looked up.

I walked to Jackson. He lit his cigarette off the glow of my own that I'd been hiding in the cup of my hand. He was dirty and his face was unshaven, not so he'd a beard, but just unshaven and it looked itchy. There were tattoos on his arms and one on his neck.

'Brother Jean,' Billow said with a grated voice. 'Brother Jean. Excuse me,' he said and he coughed a luggy into the gravel drive leading to the back of the building. He was much shorter than his friend and his dark face looked ill.

'Don't mind him if he can't get up,' Jackson said.

'Don't mind me,' Billow said. 'How'd you get this far without running into assholes? Your head OK?'

'I've just been walking.' I touched my head, beside where it throbbed and kicked. I wanted to call Sonya back at the Eighty-Eight. I wanted to hear her voice, to listen and see how it'd changed, if it'd changed.

'From the International?' Jackson asked. He looked at me like I were some grand explorer.

'From the club, yeah. I went in a circle. I thought: *How can I get lost?*'

'And now you're lost, dude,' Billow said. He had a marker

in his hand. He was taking the top on and off, twisting it unconsciously.

They traded the cigarette back and forth.

'I'm lost.'

'Yeah.' Jackson scratched at his knee. I looked down at where his jeans had risen up. A blue mark, a rudimentary tattoo, the same as I'd seen on Blair's leg and on Bern's wrist. Three dots, then another four. 'Great gig, man.'

'Thanks. Come to El Paso,' I said. 'I'll put your names on the door list.'

'Thanks, dude,' Jackson said. Three dots. And then another four. The same formation as that car sculpture back in Colorado, obscure for the sake of obscurity. 'We were outside, most of the night,' he said. 'Billow's foot: he can't really go in. I went in and out – I gave reports. It's a mess.'

'It's – ah – kind of infected,' Billow said. 'If it gets trod on I'm fucked. I'm kinda afraid it'll come off.' He laughed but then put his hands at his side and pushed himself up a little. His friend winced for him, putting a hand behind Billow's back, but not touching. 'It sounded good, though. Like, yeah, I put one foot in that room and I'll never walk again.'

'Show him,' Jackson said.

'He didn't come here to see my foot,' Billow said.

'Come on, dude.'

'Did you come here to see my foot?'

I laughed. The longer I sat with Jackson the more I saw of his multiple and often magnificent tattoos, figures and isolated words.

'We're feeding it to maggots,' Jackson said. 'You can look,' he said. 'It's all right.'

'Show him your own white-assed foot. He doesn't want to see my foot,' Billow said and he looked up at his friend.

'It's OK, it's OK,' Jackson said. 'It's OK. How's that guitarist of yours?'

'He's a pain in the ass.'

'We hear shit,' Billow said.

'There's only shit to hear.'

'We hear like he shot himself because some girl was getting molested up the line,' Jackson said.

'Haven't heard that before.'

'Girl up in Wisconsin,' Jackson said.

'That there's pigs on the hunt,' Billow said, taking over. 'Not just some girl. She's from down this-a-ways.'

'I heard she was from Iowa,' Jackson said. 'Or Colorado.'

'Bullshit Iowa. She's from Texas, or something nearby,' Billow said.

'Nothing's nearby to Texas,' I said. 'That's why we have Texas. Nothing's nearby.'

'But, right, she's from down here-a-ways,' Billow said.

'How the fuck you guys know everything?' I asked.

'We're the end of the line, dude,' Billow said. 'We're the niggers at the precise point where things stop. And when things stop, motherfucker, they start to gather all their shit and mean what they're gonna mean.'

I snorted and Billow laughed in the time lag that followed.

'He's, ah, he's,' I said.

'He try to kill himself?' Billow asked.

I started laughing and quickly stopped, the rapier repetition of the question about the events at the Eighty-Eight. I told them what Sonya had told me. Tone was back at the Eighty-Eight now. Eating and drinking through a straw, walking its halls playing his guitar through every amplifier in the building, speakers in every room, distortion and this squall of noise. I listened then for an enquiry about me, about my part in all that'd put the wrecking ball through the tour. I was eyeing them like they were used to this conversation, that they'd had it many times on these steps, that the repetition meant something, something I understood and could only undo by means of this stare I held in my eyes.

'What do you know about this girl?' I asked.

'She's just some chick,' Billow said, his mouth kind of crimson in the dark. 'She's up in Madison because this is a girl who gets around the place. She's living in Colorado. She's living in Texas and Arizona. Then we hear she's up in Madison and she's getting molested by some fuck. She's fucking done by some asshole.'

'Who is she?' I asked.

He shrugged and I shrugged, but something inside of me shifted. I felt myself trying to picture all the souls at the party in Madison two nights before I was fucked over. The girls and their clothes and hair and the boys and their bands. I remembered the party clearly, we played in the lounge and kids were all over the floor, swinging drunk. You can tell a prick by the way they dress, the way they show up at a gig and they're all in your face because they believe punk's about smashing someone for the sake of the brawl. But punk has nothing to do with fighting. I mean, look at us. Nerds lost on the way to class, scoundrels with fast fingers. Skinny butts and weak arms. But we're also liable to fuck anyone that'll have us. Punk was never about destruction, it was about reconstruction. The destruction had already taken place. It was all around us. This was us in the aftermath, conforming in the way that seemed right.

'What happened to your leg?' I asked.

Billow spoke, he told me about the two of them running with three of their friends, car dodging across Sam Houston Tollway after getting into a scrap with a dozen U of H jocks. The five of them trying to get back to Jackson's mum's, all hopped up on adrenalin urge and the want of a hard fight. Then Billow was hit. Nipped, clipped, whatever small word they came up with each time they tried to tell the story, because it took them several attempts.

'I think it was a Dodge,' Jackson said. 'So, we say Dodge.'

'I didn't even notice it hit me. But then there was bruising,

and then swelling. That was three weeks ago. Sometimes I'm not even sure if the car touched me, that's the thing, man. It was the nearness of the thing. Just prox-fucken-imity.'

They were quiet for a moment.

'But I think: *How many things just happen in the air?*' Billow asked. 'You know? I keep trying to recall but can't. Then this bruising. It stinks, right?'

'You go to emergency?'

'They ain't going to see a black kid unless he's spraying arterial,' Billow said. I watched him writing on the steps in his army jacket and the slow way he formed his words with the wide end of his pen. His ache in the air all around us, as if all around us were the full blood of his hurt and for that reason it was thick and we couldn't move. I had to call Sonya but I just sat there, waiting. Eventually I asked Jackson about his tattoos. He told me his family had moved around a lot when he was a kid. Said he never got to put posters up in a room before taking them down. 'So, I just kinda started decorating the walls myself,' he said. 'Reminders, past glances and now.'

I stared at him, a strange urge to tell him everything. About Burstyn and the van and the bruises still in my skin.

'Do me,' I said.

'Do you – what?' Jackson said.

'The pen thing,' I said. I pointed at Billow's ankle where the same shitty tattoo as Jackson's was showing above the blue and red of his absurd foot.

'The pen thing,' Jackson said. 'Brother Jean wants the pen thing.'

And Billow leant slowly and sorted inside his satchel. 'You want this?' He pulled a pair of compasses out of its top pocket. 'The pen thing.' He fixed me for a long time as if thinking, as if transferring the synaptic trace of his thought into my own. His eyes widening. He grabbed my leg.

I said: *Fuck.*

He forced my hand away and thudded the sharp of the thing, there, into my ankle – one, two, three times. Then he moved his position and whacked in four more blunt holes. A sharp wincing and then he took the marker and squished it into the seven wounds.

They were laughing, and I started laughing. I rose up, I sat up. Stood. Then sat down. A kind of sick feeling in my leg. The rumble of traffic heading back west where we'd left the van with all our gear stacked to its ceiling. Where Spence was sleeping, guarding against men like me banging on the door at four in the morning. An hour before we were due to drive across the state for El Paso.

I got up and fought myself limping with my jacket held to my chest. They watched me stumble.

I heard their voices as I started away. 'Brother Jean. Brother!'

I turned, their faces gaunt blue. The pain in my leg started to home in on something. Something exact but distant.

'It doesn't mean anything, man,' Jackson called. 'If you want to know. It's just something we do. Dots and a bit of pain. Your leg hurts, that's all you got, dude.'

I laughed, finally. They were laughing also. I called out: 'I'll see you fucks in El Paso.'

'And we'll see you south of the border, man,' Billow called. I skipped for acceleration, so I was walking quick in the black cold through the empty quarters of the city, through the unread lexicon of its open spaces: strip mall, parking lot, Denny's, Texaco and carriageway. I walked for an hour, two and then five until dawn. I walked for the sake of walking, for the sensation of movement and air. I walked into the sound of the city waking, the near-empty stir. The great and rising ache. It was with the sun I began to wonder if they meant Mexico, or if they meant somewhere below ground where the dark was sure to blind us and this pain had no reach.

17

May 2019

Bleary, Sonya blows steam off the top of her tea. I'd skyped again at 1 a.m., certain she'd be awake, convinced she'd want this conversation.

'I'm just hanging out on their deck – by the front door,' I say.

'That's a bit creepy.'

'I don't want to wake Juliette.'

'You woke me.'

'It's midday, isn't it?'

'The doctor told me to take it easy,' she smiles.

'Vicki said to send her love.'

She nods, as if calmed by this news. 'Anyway, this is how I confront death: sleeping to midday. You're safe and sound?'

'I believe so.'

We talk and learn the simple things about each other's days. The things we know are far more complex just by the performance of certain vowels and pauses. I tell her I spent the afternoon with Vicki in London where she's teaching American Studies at a campus near the river. Deep in the memory of commerce, guns and destiny.

'Sometimes I think if I blink just right she'll show up and everything'll be fine,' Sonya says.

'She's teaching a paper: The American seventies, its juxtaposition with the eighties. Says the kids just stare blankly as if they're sick and about to lose their eyesight.'

'I stare blankly. Doesn't mean I'm not enraptured by what you're saying.' She laughs a little.

I feel myself slip into sleep as she walks about the house with her iPad and I see the bright of the Wellington day in the windows beyond. She speaks softly and I answer even though I'm drifting off. She puts on music and I sleep to the sound of *Isn't Anything*, which has lately become her favourite LP to lounge to. Bent and blurred guitars, bizarre harmonies and almost perfectly clumsy rhythms. When people ask why I quit music I joke that by the time my frontal cortex finally came of age I was only capable of making sensible decisions in regard to harmony. There no longer seemed a point. And this was perhaps true to an extent. So too was the fact Sonic Youth's *Evol* came out in May 1986 and there didn't seem any further point after that either. The final truth was when the band ended the first time in December 1985 it was the people. It was the way interactions seemed to produce untenable flows of energy which meant I could no longer hear the difference between intent and accident, between anxiety and its source. So I quit and music like My Bloody Valentine took over the world and I felt kinda satisfied. I could never have done it and Sonya sometimes says we should have a band with her singing, but it would be a replica of music like this, and that wouldn't be enough. Now she watches me drift so I'm finally in Morocco, slipping slowly, slowly out of New Zealand time. I sometimes think the only moments I can truly be asleep is when she's watching, her eyes a prayer of a sort, for silence and dreamless nights.

I'm woken at what appears to be midday. The shuffling sound of feet and brush. I sit up and see the back of someone who I take to be the cleaner at the door into the lounge, sweeping up dust and debris. A delicate, learnt hustling. But it's not the cleaner, it's Juliette. I get up, a little less panicked than I expect, and let her come to me. We stand apart for a moment, then embrace with our shoulders touching.

'It's nice to see you,' I tell her, but she doesn't reply in kind.

'Spence said you were arriving last night.'

'I didn't want to wake you.'

She nods at my bare ankles. She grimaces like they were still throbbing thirty-four years later.

'It's summer in North Africa. I'm a shorts-wearer,' I say.

'Sure.'

Then she laughed.

'Spence always said if he had to identify you in a morgue,' she says, 'he'd go straight for your ankles.'

'When's he due?'

'Tonight, tomorrow. We'll see. He's meticulous with plans, appalling at sharing plans. Hungry?' she asks, nodding. Juliette's beautiful in a work shirt and jeans and I always feel a kind of jealousy when around her, that I missed something in my twenties that she got without trial. Something learnt while the redeye of adolescence cooled and that bright sense of competing complexity was usurped by something sober and pragmatic.

We eat olives and nuts, baked chicken and a mixture of vegetables and fruits. We talk, places and the times of various people before we run out and sit in silence until I say: 'How's Celine?'

'Running about somewhere with friends.'

'And she's eight?'

'Time passes,' she says.

And it does, uncomfortably and its raw edges make us twitch. Spence met her a decade ago, and seemingly despite that she's still twenty years younger than the two of us. I was delighted when we first met in 2014. She was light and enervated by something it's hard to name once you've lost or never attained. But then, quickly, I discovered an edge to her I found unnerving. It was a competitiveness in conversation, in

gatherings and restaurant revelry. She questioned everything, nailing comments as nascent racism, then slamming entire cultures for the acts of a few twisted men. She was born in south Wales, grew up in Canada, in Winnipeg. Her accent was constantly breaking down and I never quite knew what I felt about her until on the third to last day at this house in 2014 when we'd argued. It was savage and subjectless. We went at each other, petty and swearing and everything seemed important, but I couldn't tell you why.

After eating we head deep into the house. Multiple layers of cubic forms stacked haphazard against the hill. It's timeworn, but added to in the decades before Spence purchased it from an old family without heirs. I'd visited here with Sonya five years ago, but not seen this part of the house. We'd stayed with Spence, Juliette and their daughter, Celine, travelled with him in his Landcruiser about the country. He showed us Ceuta, where he'd lived when he'd first moved to Africa, the Spanish protectorate on the edge of the Straits of Gibraltar constructed on seven hills in the north, centuries fought over and the site of migration and great battlements and fences at the border sealing off Europe and Africa. Then Rabat, Fes, Casablanca, Dades Valley and the High Atlas. Chefchaouen then Marrakech, where we stayed for a week as he sorted out business. I came to know the city with Juliette and Sonya, the Saadian Tombs, the tanneries, casinos and Jemaa el-Fnaa. The immense square in the teeming night, a cry of melody and smoke. Masses of food stalls and the odd kebab store to the south where espresso stands attracted the addicted and compliant. Within all great cities time and space are compressed, extended; the only calculables are food and its smell. We heard Spence's objection to the place. Its contamination by forced aura. He said he'd come to hate it in the last years, all since it'd become overwhelmed by attempts to separate it from influence and trade. Since its

protection, since UNESCO had announced the square's status as an endangered cultural entity, he'd been overcome by a desire for the square to be swamped by tourism and trampled by whatever imperialisms. He believed the area had become emptied in the act of something raw and continuous. But I'd enjoyed it, returned over and over before we came back to the coast and this house and Juliette and our logic-less dispute.

Juliette mentions the incursions there in the square. Protests and scuffles while robbed men recite the ninety-nine names of Allah, while the French, English and whoever meander.

'I saw on the BBC,' I say. 'Then on a screen at Euro Car.'

'Well, there you go. You know everything.'

We descend narrow stairs into a lit space below the main living areas.

Juliette asks about Sonya and I give the information I have as we enter a room lined with various shelves of unmatched depths. It has a dry, overly clean smell, as if it had been mouldy and some effort had been spent clearing it for purpose and activity. We stop beside one of five old library catalogues. Juliette watches me for a long moment, she opens several of the drawers. Rows and rows of 5x4s, a catalogue of Spencer's enduring work. For a decade he's been working the Mediterranean rim, the Middle East. He journeys in and out of zones inhabited by conflict and destabilization. 'There's an art to horror,' he'd once said. 'It's in pretending to show what you don't know.' He's as famous as Tony when we let Tone be famous, but no one knows Spence's name, just the pictures you see on your phone as you eat your cereal.

'This is wrong,' Juliette says. She turns around, confused, opens several drawers. She's thirty-two at last count, but I still feel her as a twenty-three-year-old. An effect of my age, a degenerative fault in my ability to note change around me. I watch her and try to say her name and age to myself, as if recalculating the world into plausibility.

She pulls out another drawer and stands quiet. Articles and ephemera, posters, flyers. Whole magazines, photographs. I begin flicking through. The ink and crease of old places. Some things are endless it seems, until you get to the end and begin wondering what happened to everything else loose in the memory.

She reaches past. She pulls out the *Sub Pop*. The picture, my face rent, blood and the rest. Nikko beside me. I thank her and she stands still in the room. Spence had told her I was coming, asked that she set aside a few things, but she hadn't. The archive was recent; he'd started it several years ago when things began turning up on eBay. Troves, old articles, pictures, set lists. Searches through Discogs and various auction and memorabilia sites. I wouldn't be interested so much if it weren't for a set of pictures Spence had hinted at when he'd sent through the scans.

We stay down in the room for a time, drawers and drawers.

I find the collection eventually and set them out on the table where Spence and Juliette had done their work.

'This your man, Conrad?' she asks. Her voice without warmth, her question more mocking than lit by intrigue.

Despite this, I nod. The series shows our old guitarist under the weight of mountains and masses of pines in Colorado. Tone's standing cock-hipped with a dozen others, Joan George-Warren and Paloma Mrabet among them. I look through the set, flick at evidence of old things, past nuances of forgotten and remembered. Finally, near the end of the series I'm there, standing with them. It's 1989 and I'm among the three of them near Boulder.

'OK,' I say, 'thank you.'

'I met her once,' Juliette says.

'No you didn't.'

'In the photograph. George-Warren.'

'Bullshit, Juliette.'

'Fuck you, Conrad. I'm not talking to you for amusement, I'm telling you.'

I glare at her for an instant, then let my eyes burn through to the chance details of the basement. The white stone dust hovering near the corners, dried wild flowers in jars repurposed from oil and jam. The relentless geometry of the pure rectangular space. 'OK,' I say as I feel my head fill and weigh. The familiar sense of bare mental materials, of activated thought loaded with physical dimension. A kind of heavy magic of actuated recollection. And I know what that recollection is, its shape and eyes and name.

'Stop being an arsehole,' Juliette says. 'You're always an arsehole. I didn't know who she was.'

'She was a theorist, of a sort,' I say. 'Writer.'

'She came into my shop. Then Spence and me were sorting through these and I saw her.'

I stare, trying hard to not believe her.

'Look at yourself,' she says. 'How's that Angel?'

'I'm always looking at myself. He's alive, sometimes I guess different. Our house is filled with the undead and dying.'

'Well,' Juliette says, the corners of her mouth permanently turned down.

'How long ago you see her?' I ask. 'George-Warren.'

'A year. What's the story, Joan and Spencer?'

'Her and Spencer? She's this woman of grand theories,' I say. 'Spence, I guess, was close to her. She'd this kind of godless fascination with God and gods.'

'I like hearing he was close to someone. Out here it's just us and that's the sound of it.' She nods to the vanishing hush of the sea outside.

'Sure,' I say.

'When did you last see him? Tone I mean.'

'Same time as any one of us last saw him.'

'Angel?'

'Yes, Angel.'

'Then he vanishes?' she asks.

'Vanishing assumes something supernatural. He just slipped out of contact. He didn't like— this wasn't ascension.'

'Fuck you, ascension. You knew what I meant, but you go be a prick about it. Do you want me to say: He went into hiding? Is that better?'

'I don't know if anything's better.'

She sighs. 'Why was Spencer so into this woman?'

And I say I don't know, despite what I believed I understood. The motives and explanations as to Spencer's fixation. His desire for a mechanism to chart the wide spaces of heartbeat and solitude. Its relationship to his mother and father. I don't say any of this to Juliette. It's just my theory, my answer as to why he'd chosen to live out here on the desert's edge before the sea.

She opens another drawer, and we find the past staring bemused back at us. Stages in Boston and Chicago, Burstyn and Calgary. The van and our dumb poses. Dumb boys and dumb gestures. Recording sessions and mountain views. Poses with album covers and girls we didn't know. The office at the Eighty-Eight. The map and me and Finchman so young and serious. The LA sessions he and I took part in during 2004. The album we made with Tone and how that seemed to rule our lives for a year. We didn't tour that album but it was everywhere, TV and radio. Then pictures of the Santa Maria Mountains. A family there so welcoming.

18

The three of us high in these same mountains in south Arizona having dinner with the Seburgs in their house above the desert. Spence, Angel and I. The parental merge of Sonya and Tone. The muted calliopean code of them seated in front of us. The rent ruin of my nose discussed. Angel telling about the gig at the border. A stage two inches off the ground, the hateful convergence of punks and rednecks in El Paso. A bar full of shirtless men muscled and gleaming. A goat there in the audience. Two men holding the animal up so it bleated at the mics. Cabrito in the PA. The strange sight of the crowd hunching down on the floor between songs. Then up, lurching at the first hit. Fists and elbows.

Their dining room was large, matching chairs and a rectangular table made from stained pine. The fireplace and the north massing in the large windows. Paintings and framed prints.

'Have more salad, God knows,' Aroha said.

'Thank you,' we all said at one or another time, multiple times. The Seburgs' home was hewn to the hills, lines matching the run of mountains and ridge that rose out of the desert. It was quiet and spare, but welcoming and loud. They seemed attached to music, a piano, a harpsichord. KEF speakers and Miles Davis, horns and scattered drums. We felt a kind of undeserving peace when visiting, something in the collision of the sentences we spoke which they didn't, and vice versa.

'There's fruit too.'

In El Paso I'd watched a shiny-headed guy grabbing my

bootlaces. I'd kicked him so his face slopped off my foot and I saw his eyes turn upwards in their red recessed sockets. Later I saw him in a tangle with the promoter, an extreme record geek from Round, Round Records down on Gateway. The bouncer flattened my nose when I tried to intercede. I'd jumped off the stage with my guitar above my head and conked some poor soul's head who'd nothing to do with anything. And then God knows what happened next except I'd received several blows to the face. A sense of everything gone wonk. A stunned sustain ringing behind my eyes. I staggered like a dullard with red dripping on my shirt as some snoop flashed a camera. I knew by then that every time I'm photographed it's easiest to just say it's not my blood.

In the after I was laughed at, everything about me, the image of Conrad Welles leaping random into the crowd and swinging his Fender like a loon. But then I'd passed out and they brought me here.

Malcolm and Aroha, looking into my face. The ravelled flow behind my eyes.

We smoked, drank red wine. A night cold and dry from weeks of the early unmelting snow. I took photos of the evening. Half a roll. Aroha asked about her son and shared every detail they had. The gun used, calibre and versions of intent. Three weeks earlier Malcolm had flown up, and found Tone catatonic, then awake, then claiming all was an accident. A trip, a fall, bullet loosed wildly into the evening. There was a long silence after his name was said the final time, an echo of familial distress. Aroha asked then about George-Warren. 'I've read things,' she said. Half her face flared at the mention of Joan's name. 'Tony was talking about her when I called last night.'

Spence started, then stopped.

'I read an interview,' Aroha said. 'She was talking about the most unsavoury things.'

Spence nodded, serious then something altered in him and he smiled. 'Well. Academia is predicated on the world being full of unsavoury things. Disease, crime, religion, reproduction.'

Aroha had a face full of features that seemed on the verge of articulating something we hadn't yet broached. Angled cheekbones that amplified the slightest thought in her eyes. They both seemed distracted as they talked, as if every stated thing led back to trying to understand Tone. 'You confirm my simplest fears, Spencer, thank you.'

'Quite all right.'

'No, I heard her say they're experimenting with all kinds of god-fearing acts, there in Yuma.'

'Perhaps. Depends on what we mean by god-fearing..'

'Religious, doctrinal.'

'Aha.'

The room was soothed by smart Scandinavian lines, arrangements of dried flowers and plants quietly living. It was all softened by intimate décor chosen with precision. I listened to Spence, suddenly aged by the effort of describing Joan George-Warren. He defined what he was trying to write about, her tests on the effect of certain codified practices, doctrinal and sacramental observations. Their effect on the psyche, on the body, whatever. 'It's this longitudinal study of rite,' he said, 'that's what she calls it.' He tried to describe her fascination for the causal flow between enactments of sacred cause and the variances of her own thoughts. For a moment he sounded lithely batty, nearing it and backing off. 'They go looking for the alterations to their behaviour. Then they go looking for changes to their physical wellbeing.' A settled look came over his face, as if this were a bleak edge, a place necessary to sidle up against in order to explicate something that had apparently started as a joke then gained focus, lasering in on an idea and its execution. I thought momentarily of those columns in Columbia, and then stopped. 'It's all mostly fascinating,' he said.

'And we get dragged from camp to camp,' I said.

'Really?'

I nodded for her. For a moment Aroha looked precisely like her daughter, her broad nose, small dark freckles. I felt guilt suddenly, for what had happened to me, for what they didn't know about Sonya.

'You can read what I'm writing,' Spence said. 'When I'm done. Or you can just read my mind.'

'Sounds like madness,' she said.

'It's a kind of madness, yes. Joan would say it's a kind of illness. That's what interests her. She told me that five years back she noticed there was an odd kind of nervous excitement creeping into the colony. A kind of fervour around certain practices one artist up in Colorado was engaged in. Something you might use the word tribal to describe, or cultic. But she hates those terms, what they assume and prejudice. And she wanted to examine it, see if it is a part of all art practice – so.'

'And?'

'If I'm the jury I'm still out.'

'I'm suspecting age is starting to do me in,' Aroha said, frowning, as if with her whole body. 'But so much of what people do just reminds me of what we're explicitly told not to do.'

'Of course. You know they're adapting Mazdayasna death rites? There's faux towers of silence, bodies left to the wildlife till they're bone. There's a sadness in their work. It all seems to mimic religion's more bloody manipulations. They leave out dead animals like they're actual people for the birds and critters and rot. Purification rites and various chants. They try and see how these impact on them as a group. There's a theatre to it she enjoys.' He chewed the inside of his mouth as Aroha leaned in. Her sharp face, eyes asking for phrases she could catch and pry open. 'You know, I think this comes from an understanding of the ecstatic, that it desires to be spread. That there's a danger in its containment, that there's an even greater

danger in its deployment with moral complications attached. She sees violence in this. A bounding of our access to what is rumoured by sect and church to be our special, melancholy admittance to higher life. She wants to know how this endless mourning works.' Spence looked at Aroha. 'It's interesting. But then, sometimes it just seems senselessly crazy. And she knows this, but still keeps a straight face just in case she's doing it in full view of history.'

'You can't be writing about all aspects of it,' Aroha said.

'No.'

'You'd become malformed. History's always been such a boy's toy. Such a thing. You'd become twisted by twisted men.'

'They want to see what effects this has on artistic output. It's an artwork, in other words. That's what she says. I'm writing tangentially about the same thing, about the sanctification of aura, the transfiguration of consciousness to object. It'll kill me for sure.' This was the first time I heard him say this. I felt naked suddenly, and duped. That he'd been thinking about this while we were drunk and damaging guitars. 'There's a kind of violence in this she's interested in.'

'How many shows on a tour like this?' Malcolm asked.

'Thirty-two,' I said. 'But we've lost some, obviously.'

'There's kids in Albuquerque waiting for us to come and save them with punk rock,' Angel said and seemed to immediately regret it.

Malcolm nodded slowly.

'What kind of violence?' Aroha asked.

'It has sacramental uses,' I heard myself say.

We'd cancelled Las Cruces and driven for the mountains at the eastern edge of the Sonoran Desert, critters and roadrunners darting and springing from the verge to nowhere. And there Aroha had her doctor drive up and look at my nose. He'd twisted it this way then stared up past the hairs and snot and right to where my brain starts and said nothing needed

doing unless I wanted it done. I was certain all he could tell by looking at me was simple and plain: I wanted nothing but the sudden appearance our hosts' daughter, naked in my bedroom like nothing had happened and nothing ever would. Then she'd cry and there'd be no reasoning between us but the drama of exhaustion, of time and separation.

I walked the perimeter of their property, waited on the day to pass, for the swelling across my face to reduce and to find a moment to tell Spence we should get back to the schedule. We'd lost three concerts, three shows in the dust on the road back from El Paso. I was concussed and vague, unshaved and bearded. My hair as long as it'd ever been and a headache shook me like a great bell struck continually in a tower overlooking a town deserted but for the elderly and sick. I'd tried to write my article but instead walked out and watched the trees flex with the snow and watched it fall and listened to the soft dull reverberations run through the stands. I watched the eagerness of a squirrel not to be seen and I tried too – not to be seen. Not by my thoughts, not by Sonya, not by the way things seemed to move inside me even after they'd stopped bleeding, not by the thought of Tone roaming the Eighty-Eight with his guitar, turning the building into a massive speaker for the whole town to hear.

I went back into the clearing where the dogs ran without interruption, barking up at the things they imagined were thrown in their direction. Heads tilted to the side watching, teeth snapping at the air, the blue all around them, tails wagging and the hunger of joy in their eyes. I looked out at the desert visible to the north, the mounding and the shape of its surface, the curve and ride and fall. A great museum of time and light. All the little ruts and all the rivulets, the skin of a land rubbed raw, waved, infinitely mixed. It seemed certain to me then that if time had a marker it was most certainly this, the desert and its waves of grain and dune, our eyes the crude guests trying to

make sense of it all. And if time made a noise, it was recorded right there and I just needed the wind or the sun or an idea to play it. Some great stylus left to run on after we'd gone.

I returned to the house; the doors open and a wind on the stairs. Tone was standing facing a large mural of the border-land skies and everything you see when you look out to the south-west from the ridgeline above the gully. The room smelt of pine. He turned, a kind of goofy wet look and I saw his face once more. Eyes, teeth, each crawling out of the hollow of his mouth bordered by a bandage wrapped about his head, under his chin and over his crown.

He said: 'If I look tired it's cos I just drove twenty-six hours.'

'Fuck you.'

Eloquence built up in the capacitance of weeks waiting.

'Yeah, well,' he said.

'Twenty-six hours?'

'I broke some rules. Road rules.'

'Is that a record?' I asked.

'Probably. For me at least. I'm on massive painkillers. Some-what dulled the experience.'

'Jesus, Tone,' I said.

'Jesus me.'

'Look at you.' The bandage compressed his features so he looked shortened somehow in his great height.

'Look at me.'

'It's a fantastic look.'

'If you're a nun,' he said. He squinted in the low sun cutting the trees. A hint of grin. I laughed, a giving in to something I wasn't yet able to call out. 'I did a hundred and thirty in the pan handle. There's a state.'

'What were you driving?' I asked. 'Miles an hour?'

'A Dodge. Ran like a pitbull with crackers in its ass, my guitar on the back seat. You didn't even bother taking my guitar.'

'We have your amps.'

He went to the large fireplace and leant up against the slate. He took up the poker and pretended to stoke the fire which hadn't yet been lit. All heat in the house came in through the vents in the floor. He looked at it as if it were still warm. 'Speed's kind of effortless when you're on your own,' he said.

'Where's Sonya?' I asked.

He looked at me front on, mocking as he put his head on its side.

'Fuck you,' I said. 'I thought she was driving with you.'

'I left her in Phoenix.'

'What's in Phoenix?'

'Her house.'

I swore at him again; it felt like I was completing something each time I cursed. A step towards knowing what I wanted to say.

'She's thinking the same thing,' Tone said. 'She's thinking: *Fuck you, Brother Jean.*'

'And fuck you, Pantagruel.' My name for him which triggered his name for me, which I still own like a pack on a mule. I stared at him and tried to find her in his features. Squinted eyes and tried to see her mouth in the motion of these words being said. Every time she needed to be alone I felt fear unlocking itself and running down the knuckles of my spine. I watched him, determined that he'd make her appear suddenly.

'Where is she?'

'She needed to go home.'

'This is her home.'

'She needed to just go home.'

'—'

'—'

'The kid,' I said. 'The baby?'

He started nodding. That way people nod their heads when the opposite action is required. I started to speak then, but none of it was any use. I wanted to say her name and breathe

on it and hear him say something about her, from her to me, but a shadow went by the window, a mute flash. It was snow falling into the trees from the upper branches, a heavy hush sound and we were both turning, gesturing and pointing to the outside where the limbs shook.

We went through the house in silence, the sense that in an hour it would get dark and it'd be difficult to get back to the property. We put on boots and hats at the rear of the house, gloves and mittens. 'I was lying on the gurney,' he started as we went out the back door. 'The ambulance, whatever it was,' he said. 'I was watching myself leave and I was thinking how when I was small, I'd watch the cowboy shows and see the guys on horses, in the street, in the taverns and bordellos, get shot.' He put a finger behind his bandage and itched his face. 'But I lay on this gurney, you see, with the sense I was shrinking. I lay there, I thought about those men and I was going: *Well, that wasn't so bad.*'

'It wasn't so bad?'

'Yeah,' he said. 'I felt myself getting smaller and smaller, thinking: *That wasn't so bad.* I mean the hardest bit was pulling the trigger.'

'Who was it?'

He looked at me, threw his head around with eyes all squinted and rough-looking. Then he wasn't looking at me. I felt a quick terror run through. That he was about to speak. But he didn't. His mind was in the trees.

I stared at him. 'Do you know who it was?'

'In the van? No.'

'Come on, fuck you.'

'I saw movement,' he said. 'I saw shadows. I saw nothing but shadows.'

'And what?' I asked. I was waiting for his mouth to change its shape, make the words that would say the name of Spence's father, say *Frasier.*

'I shouted at him.'

'And what, he—'

'He swung a hi-hat stand at me. I didn't see his face. He kicked me so I fell out in the snow.'

'When did I wake up?' I asked. *Say Frasier.*

'I can't know that, Brother Jean.'

'Fuck. So, you don't know his name?' I said. *Say it.*

He shook his head. 'But I bet the fucker's got one,' he said. 'Even sick fucks' mothers give out names.'

'Yeah well, fuck. Can I see?' I asked. 'Your face.'

'You want to see my face?'

'Of course I want to see your face.'

We went down away from the house, the interior lights making it appear impossibly empty in the late afternoon. Tone walked delicately in the snow, the stuff that had fallen in the previous hour as we'd talked in the lounge about Sonya and Sonya's condition. The place was empty: Spence and Angel down in Heroica Nogales visiting Angel's cousins and uncle. They'd left me there when I'd said I didn't have my passport. This was a lie. I always had my passport. I just wanted the sense of remoteness to come and drown the loud parts of myself. But then Tone, and we walked east down the drive.

'Why isn't she with you?' I asked again.

'She just wants to be alone, Brother Jean.'

'But I got to see her.' I sounded weary, pitiful.

'You remember all the shit Angel used to nick out of houses?' he asked.

'Of course,' I said.

'Why did you think he did that?'

'The adrenalin.'

'Why do you think he did that?' he said and shook his head for me.

'I don't know, there's excitements when you're an idiot.'

'He liked to take small things. Just irrelevant things.'

'Correct.'

'From someone, anyone,' he said, 'just something small that they wouldn't notice. Then he'd take something else. Something, days or weeks later. Just something small until he was at the point that the victim started to sense something. That he or she knew something was going on, that somehow their life was changing, that what they believed to be there, was no longer there. It wasn't physical theft, rather it was a slow, cruel tinkering of the soul, of the self. Whatever word we use these days.'

'He told you this?' I asked.

'You think he was smart enough to get that part of himself?'

'No.'

'No, no he wasn't,' Tone said slowly. 'Nobody's smart enough to know that part of themselves.'

'And all you saw was a figure in shadow.'

'All I saw.'

During the last of the snowfall we slumped down against a pine that sat on the precipice overlooking the southern flank of the pass we'd stepped up in our boots, his white and leaking and mine black and made for a construction site. We sat near one another, against the fresh smell of pine and snow. I wanted to tell him about the columns in Columbia but stayed silent. Wanted to say what I'd done when all slept but just banged my gloves together. Handfuls fell off the cliff five feet away, a kind of echoing in the trees below. I could sense his face was hurting because he was making involuntary sounds and I could smell snot. I watched him in my periphery, in the storm light in the distance, the way he was looking out to where the overhead wires went swinging in silence down the line, out past the electricity he couldn't see and none of us could see. I leant my face up against his jacket and he put his arm around me.

19

To arrive at Albuquerque I headed us through the Chihuahuan desert, drove us through other kinds of silence away from those wire-festooned hills into the hustle of grit and light. I took us deep into the sand and old rock, the beautiful cruelty of expanse, how it doesn't let you go. The three of us learning to understand one another again in the presence of Tone. He sat beside me in the front. The only one in the vehicle who knew about the back of the van. The only one who seemed innocent, and then – in a moment – seemed quite the opposite. I suspected everyone for an instant, I suspected Tone, for he fired the gun. But he fired the gun that woke me up. I suspected Blair because of what a weasel asshole he was. I suspected faces I had no names for. I suspected Cozen Jantes because wasn't he around? I even suspected Sonya when I had nobody left to suspect, and I suspected her because I missed her to hell and missing someone eventually turns to blame for the most unlikely things. Missed her and missed her brother, even though her brother was in the van driving with us north-east.

And of course it wasn't Tone because I loved Tone. It wasn't most people but not because I loved them but because it could only be one.

I knew Tone because he'd approached me after a Dick Saw show in Phoenix where we'd played with the bedlam and beauty of Mighty Sphincter and JFA. He was mad with ideas, dribbling and naming songs, how they could be combined with certain energies, rhythms and unnameable timbres. Crossing

things like 'Fade to Black' by Junior Achievement with the Soft Boys. The Fall with New Order, who I hated until I was thirty and something happened. And I hated the guy too, I hated Tone until the sun came up, despised the way he knew so much and how none of it made sense until it started to make sense. We found ourselves walking through his neighbourhood in the dawn. I took a photo of him pretending to lean against a cactus. He said: *That'll be the cover of our first single* and I realized then we were in a band suddenly. It was to be called Gun Melic, but never was. We ate breakfast, some haggard burritos and morning beer. We talked until it was all coughed out. The day previous I'd met Sonya and had no idea they were related, this girl and this madman talking physics and math theory and time and suddenly I was in love with two new souls born in the deepest south beyond the border of the maps I knew.

That she wasn't in the van, that I had no contact, that I'd called her in Phoenix from her parents', that she hadn't answered, that when she did finally answer she wouldn't talk – it had to mean one thing, and it was that one thing I couldn't get my head around. It was the baby swelling on her insides. Or maybe not on her insides. Maybe it'd all gone wrong. Or maybe she was miserable for misery's sake, because misery loved her when it found her open and tired and alone, loved to burrow in past the good things and carve a space out beside doubt and despair.

And now we drove with this thick kind of silence about the four of us. Impossible, crawling and hungry and all I wanted was for her to appear suddenly and invite me to sleep. Instead, each time I turned and glanced at Tone I heard the shot and woke again and again. The jolt and body heft and blood and bruising. Every night it happened over and over behind my eyes, hands on my neck, back and shoulder, thumbs pressing into my flesh, the bruises that were still floating in my skin, the broken blood vessels and the faint blue and brown.

'Yo, we fucking eating or what?' Angel shouted out from the back.

'Fucken – chew your shoes.'

To sustain the drive I'd watch the speedometer and count the miles north to the top of New Mexico. Count the miles and the ascension of miles as gas and fume. Count the gallons of fuel. I imagined it seeping, burnt then flushed until it was blue in the atmosphere. I'd counted it and calculated time into dollars and its decimals. The strange conversion like air circling into the stuff of lift and flight, or vapour hitting the cold and turning to rain, ice, then snow and so on, then us huddled in our blankets, fists like meat in the lock-up. In Las Cruces, Spence and Angel cruised the audience to find us a floor to sleep on. A girl who might feed us. Meals meant we didn't talk. Only when we were hungry did we speak, and we spoke about food. Listed the longed-for and imagined. I drove, the form of a wave curling its way north-west. The massaging eddies of asphalt and stone. We peed in truck stops. Stood under columns forty feet high holding neon signage. Great signs stencilled on the sky.

Eat. Food. Gas. Girls. Girls. Girls.

I stood beneath the signs in my jacket and scarf, waiting on the last of us to reappear from the toilets. Walked around in circles trying to stamp out the cold. The sound of heavy wheels, tarmac and slowly reducing rubber beneath thunderheads near bursting on the horizon.

Cheap Drinks! Lousy Food!

Angel and Spence firing bottle rockets at the signs as Tone leant into the roar. The sparkle and crack and the thunder of heavy machinery. I watched Tone jump in the dust trying to catch a plastic bag floated by the wind-pass then drove the van north, this machine in which each of us had at some point fucked. At some point pissed in a cup, come in a sock and stuffed it in a clothes bag and left it waiting for someone

to take it out and put it on over their freezing feet. Sonya has jilled in the back while all slept. Vicki too. The race through boredom is the unfurling of onanistic technique, ruled by the unconscious rubric of the van.

And Tone sat beside me, looking out straight as the van ran at the dawn then daylight horizon. The mask on his face, the kind you use when spraying weeds. Two circular vents either side of his chin, jutting from his cheeks. Something he'd found in his parents' garage. Placed over his bandage and sunglasses, rarely removed since. He looked a mix of Carmelite nun and sci-fi loon, staring at the grey span. And the four of us silent as we drove until we arrived in Albuquerque. Silent. We sound-checked and said all the usual things, ran through half the set till it was perfect, the stunned groove of four who'd never been separated, not by gunfire nor madness.

Five hours, a bucket of fried chicken, a room filling with faces unknown and a set of songs so deeply learnt they mimicked whole selves named in our names, shadowed by our shadows. Watch now: Tone balancing on a chair in the noise.

He stepped up, stood on his amplifier. He trod slowly, careful not to knock off his tuner, spare picks and strings he meticulously laid out during his pre-show routine. He stood still until his balance was there and he could step onto Angel's Ampeg, another two feet up. The room an old vaulted theatre, headroom for this balancing act, for the way he stood arms out. And as he moved, I moved. The two of us edging towards an aural dead spot away from the core of the song as the chords flexed. For the previous three nights we'd played it out over ten minutes, 'Dance Prone'. It sat on three chords, then two, then one, a long drone with Tone and I picking as if in random squirts. But they weren't random, just suggestive of indiscriminate choices. We took our heads away from the beat and played in the same key in an isolated area.

Same theoretical key – which meant anything we liked within parameters dictated by our desire for outcome, yield. This was not noodling, this was us removing *ear* from the piece. This was the eradication of emotional predictability, the dereliction of sentiment. Connection here comes from the interaction of notes, not people. Music talking to music. We were reliant on math, the inherent numbers in music to make the music as we pushed notes out into the crowd. A reassemblage of the ensemble. This was the hardest piece; it took almost no technique, just concentration. Which is a whole other kind of technique.

I hid behind my amp so my guitar was all I could hear. Tone searched for a spot on the stage least contaminated by Spence's kick and hi-hats, the least hit on by the snare, so he could play the music as we'd written it. The key the same, the timing as disengaged as we could make it within limited space. It was our hardest trick and we did it first song. I closed my eyes and held my head down by the strings, I barely touched them but still they rang out, colliding with the bass and snare. I listened for the moment when I was out of the count as Spence and Angel stomped a three-note riff on the same chord in 7/8 time. People danced in a sway. And Tone, Tone stood on Angel's shoulder and stepped up onto of the giant Ampeg rig we transported from town to town, the thing on which Sonya and I placed a mattress when she needed time. Where we went to one another in the silence away from crowds. Where we kissed and fucked and wore the expressions of cum and coming. Tone stood near the roof teetering, swaying as he found his notes in that place – the outside space of the song but right there on top of the music. He stepped further onto the woofer bins and pulled himself up the speakers and then to the top of the PA. That respirator on his face.

I played, picking at and strumming the deserted rhythms. I crawled out from behind my amp into the deep spot where

the music gathered. I watched the audience. The closed eyes and fascinated stares. Each night I saved myself up here, and each night the same faces and each night the song remembered its source of pain and how we tore it apart. How the audience tore it all to pieces. This was the ceremony. Eyes, faces. One woman and then another, mohawked. It was the two chicks from Colorado: Paloma Mrabet and the younger one, Miriam. Mrabet was staring up at Tone balancing, balancing. Paloma with her bottom lip between her teeth, carrying a baby with earmuffs wrapped up tight in what looked like a Pan Am blanket. I watched them until she was dancing, writhing then flexing and jumping with the child as the impossible rhythms jagged from the amps and drums. A falling sound, rising, crashing in red coiling waves, withdrawing in the wreck tussle of recall and havoc. Hiss and hack. Bell sounds and 7-40-7s.

Then as the guitars slowly drifted back to the song, slipped out of the piece's fixation with the non-space, she stopped. The root, the fifth, the ninth and she was still. Tone with the major third and a minor seventh, picking that slowly became strums. A roar out from the haze that became hard, became fists pounding on a table and the boys in the front row standing and jumping and demanding at that instant the song become a song, that the beat resort back to four and four so they could smash each other and throw each other into the quieter crowd behind. And that's what they got. Just me and Tone banging on the power-chord: first, fifth, octave. Fists at our strings, legs apart and hair throwing sweat in the air.

Double strum – halt.

Double strum – halt.

These are war chords. These are the core of punk and you don't forget. You don't forget because the kids are slamming their heads on the hinge of their necks. This is the song remembering itself. This is the moment in the song when it's drawn back in. This is the moment it's no longer free. This is

the moment of recall when something else dies. This is unison and this is the end of freedom and this is when they dance. We stop, sudden. Hard in the middle of the riff and the song we play next isn't ours, it's Warsaw's.

Teck, teck, teck, teck and we watch them all, strutting in line.

We begged for food because we'd no money, like we'd begged for weeks. Asked politely among stands of better-dressed souls. Outside Gallup, Tone let a rocket off in the van. The gunpowder smell, the snooting nose of the thing feeling about among our feet and luggage. The black hiss sound. Up the panel to the roof where it detonated filling our eyes with fine dust of paper ash and chemical. We opened the windows and stamped out the hot spots like cigarettes in the lawn. Angel and Tone were giggling like their names were Gilly and Cat, like they were well aware of their voices, the high-pitched shriek tones, well aware that this was the best moment they'd yet lived – sparks in their hair, teeth in their laughter and the van spilling smoke into December. A minor Armageddon in the days before Christmas and Tone scratching around trying to find another rocket and I remember thinking this, this laughter and tribal urge was evidence of sanity. This was the marker.

20

December 2004

And sanity always prevails, they say. And madness fails. In 2004, Spence, Leo, Tone and I convened at Valley Sound in LA. A studio complex hunched down amidst the cross hatch of street and avenue. The studio walled with shagpile and beer smell. Tone's manager'd heralded me at LAX with a sign saying: *Mister Brother Jean*. This was two months after Tone'd come to visit me in Brooklyn. Leo Brodkey, Spence and I gathered in the strange deadened rooms with Tony Seburg. He had us meet wordlessly at the studio at the same time. He'd sent me demos of the songs and I'd learnt my parts and I'd entered the main studio with everyone sitting with their instruments. The only one not there was Angel, but he was living down in New Orleans by then, deeply careered in his law firm and clear of music. Angus Heigl, LLM. It was a large room famous for its natural short sharp reverb, legendary snare sounds and massive guitars. The guitar tech handed me a Fender almost exactly the same as mine and as I strapped it on without word of introduction or greeting, Tone started playing the first chords to a track called 'Shame Thrower'. We all hit on it, played without pause or error. Then we played it again, and again. No break, no conversation. Just bodies hooking into this great swirling sound. Aside from just that one short visit I hadn't spoken directly to Spence since I visited him in Oregon in 2001. We watched each other, locking into something at the edge of physics and sound. Nodding towards upcoming beats to emphasize, locating the song and hammering it. Sweat and

the odd bit of blood on the pick-guard. Over and over, the groove and punch and finally we all stopped. Tone stood in the room, a weighted smile overcame him.

He came around and hugged each of us, the sagging wet mess of us. My shirt was off and he didn't care, he just held me and began laughing. And finally, dazed, we talked. The four of us. It was giddy talk, excited like we were eighteen and this was the first hit of adventure. It was a dazzling move, having us play like that before we could air our uncertainties, claims of latter-day incompetence, grievances – for surely we had them. Jealousies and things we'd thought in dark hours. Instead we were immediately a band and we talked like a band. Japes ensued, bad jokes and we recorded. Endured epic stretches in the studio, smashing through his songs, making brutal things out of mere chords and notes. Beautiful, aching things that surely nobody would want to buy.

Tone produced it himself and I was in awe of his capacity and knowledge. All the things he now knew by heart. The deep reach of musical complexity I'd never considered. The minutiae of technique and how to make things precise and loose at the same instant. He spoke in a language that was often out of my reach, but Spence seemed to understand it instinctively.

I watched the two of them overdub percussion, tiny things only the subconscious can pick out, but it was the part of the subconscious that made you want to boogie and we felt it in the monitor room as the lights dashed and danced.

It took me days to realize Tone'd met up with Spence before the sessions had started. Tone'd composed twenty-odd tracks at his parents' house in the Santa Maria Mountains the week after visiting me in NYC. He told us how a sandstorm had roared through the desert below as he came up with half the riffs, told us how the whole state seemed lifted from the earth, sucked up to 30,000 feet then dumped back into the plains and

hills and cities. A week later he'd flown to Illinois and played with Spence in his garage. Now the drummer was getting song-writing credits on the album and I was jealous for a moment, but then found I didn't care. I didn't care about anything.

But then Leo. He'd played on every one of Tone's albums, toured with him as his guitarist, but during these sessions he played bass. I asked if he was annoyed not to be playing guitar and he said he was fine with it. That it was his idea that Tone find someone else for the sake of discontinuity. I suddenly felt hollow at that. That my being there wasn't Tone's sudden need for us all to be back together.

But that was my only moment, the only issue during a week of power-chord and re-addressed punk.

Then, with the album done, Tone took us out of the studio for a drive through the massive city. We spent the night sniff-ing shit up off the mixing board then drove the freeways, the weave and snarl of traffic in the ruin of coke and speed. The windows down and the shifting of one vehicle into the place of another and on. The rhythmic shuffle of Buicks and Toy-otas saying something in some language whose meaning is always put off until the last horrifying gasp of each overtaking manoeuvre. Ventura, Hollywood, Harbor and Transit, Century and back around listening to a DAT of the recording.

We drove and laughed and it seemed so easy. The dreamy sense of being twenty, of the age before everything happened. We teased the absent, we poked jokes at Angel for not being there, for not being able to provide his own comeback to the taunts from the shimmer of New Orleans' towers and office blocks. We made jokes about the Louisiana swamplands, about gumbo and words we had no idea the meaning of. We poured through the sprawl, through the suburban mass of palm tree and apartment, low-rise and hazed vistas.

'This is a record, man,' Leo said. 'This is like, this is the record that fucking was invented for. Girls and tits and dicks.'

'Of course it's the fucking record,' Tone said.

'We head up to the Griffin, OK? I want kids fucking in cars listening to this baby.'

This was cocaine talk. Primed by a continual uptake, dust on our unshaven chins.

'One more expressway,' Spence said. 'One more. Where's this anyway? And where the fuck's Disneyland?'

'All around, dude,' Leo said.

We listened to the DAT five times.

'I want to watch women overcome,' Leo said.

'If we don't go to Disneyland right now I'm gonna sue their motherfucking asses,' Spence said.

'I'm talking women. Actual women with grown-up vices.'

It went on.

We drove up through Griffith Park, past the Greek Theatre, looping through the hills, and eventually returned to the complex once the coke had run out. We stood in the centre of the studio, halted by the sudden presence of a sobriety we hadn't expected. We all shifted foot to foot in silence, banged up on the last of the drug as a runner came in with a message for Tone. He stood blurred, then slowly left us. The extraordinary capacity of a studio for silence. Leo, Spence and I waited in the hall on a downward rush. All the good shit running out of us like volts from a dying star. We stood for twenty minutes until we decided to destroy the album – it wasn't any damned good, no damned good. It was broken songs strung by bad harmonies. They tried to distract Sharon, our engineer, with dirty talk while I edged into the tape room. I ran to the hall clutching the two-inch reels by the flanges. Ran through the minor labyrinth, the doors to booths and lackeys and their ability to be in all places and none. Then Tone, the height of him. I felt the heel of his hand in the soft part under my collarbone halting my course out the building.

'The phone,' he said.

'We've got to destroy it, Tone! It's no damn use.'

He stared at me, my sparked eyes, my gallows face. 'Get to the phone. Give those to me and get to the phone.'

I stood still for what seemed minutes, whole snatches of recordable time.

'Good God, man!' I shouted.

'Get to the phone, ass.'

'I got to kill this, Tone.'

'It's, it's my – it's Sonya.'

I walked to the reception, still holding the tapes and Tone organized Rick the receptionist to relieve me of the reels. The phone sat beside a potted yucca plant wounded by the petty stabbings of pens and cigarettes by men like me, like Tone, Spence and Leo.

Sonya, hospital. This was her lone phone call, as she put it.

'They gave me a drip and a phone line,' she said.

'And you call this place? It's run by psychos.'

'They only gave change for one.'

'And you called me?'

'I called my brother. We talked. Now I talk to you.'

'I thought you were in New Zealand,' I said.

'I was seconded to ASU. It's temporary.'

'And now you talk to me.'

'You happen to be there.'

'Dog shit,' I said. 'How long since we spoke?'

'Whatever kind of shit,' she said. 'Fifteen years.'

'Fifteen? Is that it?'

'—'

'You're OK though?' I asked.

'Theoretically.' She sounded starved by each word, as if they were pulling nutrients from her bones.

'Run me through the incident.'

'Accident.'

'Run me through.'

She'd been in a crash, minor enough to save each vehicle, severe enough to put her and the other driver in hospital for the night.

'I woke up in the car, Con, all this broken glass. And then really quickly there were lights and sirens and people talking to me through the whole thing. But then, I don't know,' she said. 'Then it seemed like eternity passed and I was alone for much of it.'

'What's broken?' I asked.

'I don't know. Nothing. They just put me in hospital.'

'Jesus Christ, Sony.'

'Yeah.'

'What's—'

'I don't know,' she said.

'Is there anything I can do?'

'I'm four hours' drive away,' she said. 'So not really.'

'It's amazing to hear your voice.'

She said nothing for a moment. Fifteen years. No, nineteen.

'Maybe they were dealing with the other car,' she said. 'I don't know. But I was alone. Alone in this crushed-up piece of shit and I couldn't stop thinking about you.'

'But you're all right,' I said. 'Physically?'

'I just wanted to talk to you,' she said.

'Thank you,' I said. 'That means a lot.'

'It does mean a lot.'

'It does.'

'Just all these lights and the smell of petrol and I thought of you. Thought about my baby girl. That was all I wanted to think about, my daughter. I had a daughter, like two years ago. But you kept coming to mind and it was pissing me off. But, well. Here you are.'

'What was her name?'

'I never gave her a name.'

Then she told me about her baby daughter. The tot who came along screaming out of her with all the vigour for life in the lounge one Friday when all else were sleeping. A wee love born in Sonya's late thirties I never met, a tragic error of being. Gone, whispering in her ear. She told me how the girl died quietly, a drip in her tiny arm. I could hear Sonya crying. I heard about her first marriage and its wake. I listened to her and I imagined how hard it must have been to dial the studio's number out in California, how hard it must have been to listen to the handset and the signal making its way across the state, clicking and buzzing until it reached another's ear, the blare of her need hinging on wires looped across rooftops, across states, underground, overhead and into a machine whose buttons we'd stubbed out with cigarettes and abused, thrown into the wall when the unwelcome rang in or a chord hit just so and we didn't know why. That she trusted the connection to be made.

I said: 'Sonya?'

And she was there.

She talked on with rhythm and the slight sound of panic.

That night through to morning I sat with Spence on the roof of the studio. The dull sky barely letting the planets and stars come through. He sat there in silence like language had turned deserter, was shot in the back of its head. I told him about Sonya's incident.

'Mmhm,' he said.

'She's under observation.'

'She OK?'

'I mean.'

'You wanna, like –' he was bent over, barely talking – 'head out there? Where's she? Tempe?'

'Yeah, but. No.'

'You head out there and Jesus. You wanna do that?' he asked. 'We'll drive.'

'No, Spence. She was just. She's shattered. Her head's a mess.'

'We'll drive.'

I shook my head. 'She lost a kid. Did you know that?'

'Not the one back in eighty-five?'

'No, this was a living breathing soul. Just a few weeks old.'

'When?'

'Few years ago, two, I think. But I think that's why she called. She said she was trapped inside her car and she kept seeing her girl. Just kept getting flashes of her.'

'Oh, Sonya,' he said.

'She called because – you know how she was pregnant, during that last tour?'

He nodded his head. 'Yeah.'

'Aha. And then Tone. And then. So I guess that's why she called me.'

'Poor Sonya,' he said and I nodded.

'She sounds, she doesn't sound good.'

'She's depressed,' he said.

'I guess.'

'Of course she's depressed,' Spence said and went quiet beneath the muted haze. He did things with his hands, put them palms-out in front of his face as if to calm the coming multitudes. 'You know something, Con? You know, if there's an operation that'd guarantee I'd wake up with no hint of this. No trace of anxiety, dysthymia, any of these cunting states. That I wouldn't ever think about shit again, I'd take it. And if there's this operation with a but in it, and that but is there's a one in three chance I could die, I'd still do it in a heartbeat. I wouldn't think, not of no one. I wouldn't think of anyone. Fuck you. Done.'

I imagined Sonya again, eyes and face alone in that car with hands uncertain what to touch. The ticking sound of the engine, the awful inevitability of her thoughts. How she was waiting on something, a pure, complete logic while nearby her crash twin in the other car threatened dying by the way she screamed out.

'I managed to get the tapes halfway out the building – then the phone,' I said. 'You know, I always wanted to make music that was as confused I was. As fucked. You know? I only know that now. Not *as* confused, that *enacted* how confused I was. Like, I didn't want to make music that sounded like sex; I wanted to make music as an abstract of how confusing sex is. But now, I don't know: this record sounds like rutting and I don't know.'

'Two out of three,' he said. 'Done. I'm there in a surgery gown. I'll supply my own. And she's all right though?'

'What was it like in prison?'

'In prison? I felt like my father. I felt like my dicking, mother-fucking, dribbling old man. Which is ironic.' He arched his head and looked out beyond me to the lights of traffic and living.

We stayed quiet. The slow rocking of us under the always dusky California sky. The two of us paused by the raw of the information shared, all the things we really knew and understood muted by the force of data. The traffic-merge sound, the sound of structured drone, of memories of listening. I imagined thinking of that night in Missouri, sitting at the base of those columns and walking back to the house and what I found still hammered into that mic cable in the kitchen. Then I thought about it proper. I used pills the first time. That was in St Louis after that fuck with the microphone. Little pink tablets that put me into a false sleep. A sleep I wanted to last until I was cold as the snow the yellow-eyed graders would later shunt from the highway. In Columbia it was that knife. But this time I was too overcome with fascination, too surprised at the skin's

unwillingness, then willingness to relent. Too wowed by the sight of something so foreign entering my skin – and how far it could venture. There was only pain for a moment; a blade sharpened for taking muscle off bone and I was easy for it. Then there was no pain – and I stopped.

'Five out of six, I'm there,' Spencer said and put his hands into his thinned-out hair, pulled it up as if to measure its approaching fate, his fate, all of our fates. 'I'll tell you this, Con. Not so long ago I tried whacking myself – twice, two times, right? Once in prison, the other in Mexico in '95 on holiday. Both times, and this is the thing, I was happy. I was – happy. I was at the end of my sentence, getting out in a day and so. I was entirely relieved and excited. Then down in Mexico City I was just so fucking happy, liquid living in Roma. A yellow apartment with a tree out the front and a balcony. There were these nights, whole nights whose length was measured in how many names I magically learnt then lost, there were girls, there was food, exceptional, cheap food and drink and people in vast, endless conversations. Everything around me had resolved into a perfect kinda cadence, right? Harmonious singing, celestial monks and angels. Then, bang. Bottle of Valium and I woke up in hospital completely pissed I was alive, furious at it. No arsehole crying for help, no arsehole bullshit like that. I was furious it didn't take. Then later, a month later, the therapist's saying all this stuff about suicide and happiness. Says this is a phenomenon no one knows or wants to talk about. *People don't kill themselves when they're happy*. Right? But there you are, she'd told me, men and women in our thousands right at the edge of joy shooting ourselves, slitting wrists, chugging pills. Thousands. More.'

'Jesus. Congrats, as always, goes to the masses.'

He gave a half laugh. 'And you don't see this on TV because, because – the thing is, I just didn't want to go back. You have to

be sad to kill yourself, but no. I was happy and didn't want to go back because it's hell back there behind the pills and therapy and good, fighting intentions. Like this perfect progression and it came to its end and – that's it.'

'Like I say: music's only of use when it's broken,' I said. 'Otherwise, what's the point.'

We watched each other for a long time, examining our silence through muscle movement and wrinkle; all those alterations to faces we'd known since elementary school. The intimate things of change we only reluctantly acknowledge. Behind him the perfect lines of the grid and street lighting ran to the north face of the Hollywood Hills, ending in abrupt shadow.

'You want to know the other thing that happened on that tour?' I asked.

'Tone shot his idiot face out. Idiot dumb face because he's as happy as a clam in chowder. According to reliable therapeutic interpretations of my life.'

'Another thing. There was this other thing.'

'—'

'There were multiple things,' I said. 'But specifically one other thing.'

He stayed silent, cold until I started speaking. Till I began talking and he became the first person to hear about the van, what occurred there in Burstyn in '85. He became the first soul since I told Miriam George-Warren something similar. He listened, an appalled glance here and back to my eyes and mouth. Eventually I stopped and made jokes. One about that picture on Leo's fridge with Glen's finger in his butt, another about the irony of Rapeman's *Budd* being my favourite record for about six years, but he didn't laugh. Over the next days he figured out how to reply, half sentences, whispers and the lip sync of silence.

· · ·

The next week I hired a car and drove east out from Tone's apartment near the centre of Korea Town, hunted down Highway 15 through the Moreno Valley, past San Bernardino to Palm Desert. I drove through the wind farms, the beckoning arms waving, waving and the bleak temptation just to head off for Yucca Valley and then Joshua Tree where Leo lived in an ancient trailer home trembling in the heat-warped sand, but I drove on. On and on. At Indio I saw the sign for Exit 145, for Brawley and El Centro, the giant words halting and familiar. I knew they meant the Salton Sea, which I knew meant Yuma. I eyed the signs beneath the raw blue sky and turned. Steered off onto 86 and added an hour to my journey by driving south through the shallow cracked valley to Yuma where the last of the Colorado River ran before ending in the sea.

Eventually I hit 95 and went west until Adair Park Road and all that was familiar was gone. I saw a sign for a pistol club. For a skeet-shooting range. The hills were redder than my memory would allow for, the dirt too. I couldn't find the turn-off, I couldn't see where we had pulled up and parked and stood in the heat and leaked all kinds of fluids as we talked about the heat. I drove on until there, on the wrong side of the road, I saw George-Warren's chapel. I braked and stopped. I wound down the windows. Nothing was in the right place but the sky. Everything backwards, hill and remains.

I stared but didn't get out, I stayed inside the car waiting, expectant of revelation as I lit a cigarette. Vegetation at the edge of a blowout ripped by the decades of wind. The scamper of small animals. Birds circling the butte, a vague mount touched off by a five-fingered cactus. I put the Camry in gear and eased out, certain the earth and sun had it all wrong as the scene rewrote itself on my retinas, on the sky and all else. I drove on until I saw what I came to see, the sign for Mrabet's Pit, as it had become known, both for the physical characteristics of the immense artwork and the cost to the foundation that paid

for it. I drove up into the hills until I found the plateau and car park. I walked until I came to the legend set over the entrance to the viewing platform:

For the Yuma
For the sister
For all Art be Vandalism

Then, at the rail, I saw them: Paloma's Fulgurites. Forty-nine figures, twisted and bent like the dying. Lightning-induced and pained. Large, rent figures, tubes and strange masses formed out of sintered, vitrified, and fused silica-heavy sand. Back in '96, Paloma'd brought in great generators, things of colossal capacitance, sent enormous, induced thunderbolts into the soil, and there the glassed abstracts of the lightning strikes froze and remain. Fifty of them. Bent, rent, cruel, aching.

I stared at them, trying to see them as a whole, as individuals. As human, as something beyond human, an abstraction of abstraction. They were beautiful and hideous, throbbing in the dirt.

There were versions of general and accepted interpretation for the creatures. These held their collective appearance to be dedicatory, a memorial to the victims of nearby massacres, of the Yuma war, of mass scalpings and gun-fought exterminations. But up close and individually they were something other. Something incomplete and distracting. I climbed down the ten-foot wall where the sand and scree had crumbled, and then I stood among them. Beautiful, strange – inhuman, but obviously human because of our desire for humanity. But in truth the only things that seemed to connect them were their proximity and the fact of their materials. Each individual clump of fused silica seemed exclusively formed to represent something utterly unrelated. The only thing to think was that the artwork represented the mechanism of their tortured

construct. They referred only to the way Paloma Mrabet had brought in her massive machinery, humming with enormous voltage and amplitude, the way she'd thrust faux bolts of lightning into the earth, then revealed them to the air by clearing an area of 10,000 square feet. Weeks of spading out the soil and sand, wind and water-blasting so these creatures remained standing, twisting from in the earth. The memorial was the act itself, brutal, agonizing. It was a memory of remembering, a song of the song. She lived in Boulder then, Paloma, with her child. Lived there till she returned to Europe in the 2000s with the kid I'd met in Yuma, the one she took to gigs wearing ear muffs, a babe wrapped in airline blankets. That was when she began painting her murals.

I left after an hour of sitting among them, watching how the sand absorbed the globes of spit I sent to the earth. How they went hard, brittle then returned to dust. I drove then to Sonya, to her house in Tempe, and began this whole exercise of recall and understanding. Though nothing really comes in the order you expect because immediately we found ourselves naked in the middle of her room, slowly trading our awe for things of skin and things it says when lit and shadowed.

She wore several bruises and a bandage around her right thigh. She laughed when it hurt, her whole body jolted like it'd been hit by a joke.

We married three years later in Wellington, New Zealand. It was 2007, the same year Neues Bauen rereleased their two albums and ten years before the band found themselves in a room rehearsing for a single gig – three decades on from our initial demise, the four of us staring at our hands until they began to remember.

21

May 2019

He owns a thick beard now, Finchman, a tan half of dirt and
half of sun. We stand in his lounge and embrace, the rub of
his beard on my neck surprisingly soft. He holds my forearms
for a moment after we disengage. He looks at my face and
eyes, looking for something. His standard greeting for me as if
an inspection of self, to see what things might have changed.
And I give the same look back, just to see, and that's when he
looks away and goes to his wife and kisses her and says things
into her ear. He'd driven from Sfax to Algiers, a hotel along
the quay. Then in and out of the Atlas to Fez, Rabat. Thirty-six
hours in the cab of his Landcruiser. He practised each of the
languages he's become proficient in over the years: French,
Amazigh, Arabic. Fragmented conversations. Then arrived
with impossibly dirty hair. Sweat stained and story-full.

We watch one another as he rests supine on the couch, his
boots off and panting. Pained old knees constantly moaned
about. We watch and don't comment on the strange fact of
us there in Africa, the impossibility of that word. We spend
an hour recalling each other, remembering the old things that
made us friends, the glove-like reference to personage, hidden
in the rhyme and chime of sentence and glance.

'Someone's spotted her,' he says as we go quiet, 'in the
square.'

I look up. 'Paloma? Who?'

'A curator I know.'

'Who?'

'A museum curator from Rabat. He saw her after one of the flash protests. Paloma was walking through the square as the police rushed around questioning every dick with a black shirt on. You heard about the protests?'

'Mmhm.'

'And there's Paloma Mrabet.'

'They sure?'

'As eggs in an omelette.'

I feel the kick of something. A chemical coded rush and my heart quickens as it had in the basement when Juliette had remembered seeing Joan, how she'd said her name and I'd remembered old anger, cold anger like you're drowning. A kind of clear charge as Finchman's wife returns from the kitchen carrying a tray of teas, ducking under the low arched doorway. I find myself nodding, as if guilty of something just acknowledged.

'Do we think it's true?' Juliette asks as she sets the tray down.

The oddness of this sensation. It doesn't shift and it's a kind of fear and I try to ignore it, and then I concentrate on it. Bear down on it to see its coma-coded source.

'I believe so,' Finchman says.

I find myself sighing out, a great lungful of used-up air.

'So you go?' Juliette says. 'And meet him?'

'We go, we go.'

'Be safe,' she says, and I suspect she's almost feigning something. Not concern so much, but perhaps the tenor of concern that seems set there in place of actual interest.

I find my hands cradling my face briefly before I laugh.

'Either you're safe or not safe. It's a subjective thing,' Finchman says. 'I've learnt this by looking at men with guns and just what they mean by the way they hold them.'

'The only thing I've learnt from looking at men with guns is they're assholes,' I say.

Finchman chortles, his arms folded, then laughs proper. 'I'm not anticipating firearms. Just rogue art assistants. Equally dangerous, of course.'

'My first year at college was art history,' Juliette says. 'You can always spot art historians, they sit with their back to the walls. Paranoid, they've a great eye for anyone thinking hurtful thoughts about them.'

We go on joking until we circle back to Paloma and Tone. So often this is our conversation, tenor and pitch and barely a subject of note until it's there, rearing. And this seems to have the effect of calming whatever is plaguing me. Though I'm fairly certain I know the plague in this instance. It's the thought of Paloma after all this time, her eyes and what they'd do to me.

We make plans to leave in the morning, to drive the three hours to the city and book in someplace calm and seedy. We eat, trade old stories against the new. I give him every random detail I have of Sonya. Name doctors and the inner parts of her I'd never heard of until mere months ago. The fact of the Inferior Vena Cava. The presence of the unlikely Pelvis of the Kidneys. I look out above the kite-surfers below as I talk. Watch their battle with the sea, lining up its waves, and find I'm fascinated, the way they jump and turn and swing and land. They lift and sail then fall beneath a heap of cloud crawling in from the Atlantic, a black sack full of violence and electricity.

Finchman, Juliette and I eat dinner with Celine. She's wearing a cat costume, a gift for her eighth birthday from the absent Tony Seburg, honorary uncle conveying gifts via van and courier. She turned the AC all the way up and was rolling around under the table trying to mimic the mewing of a content animal. I turned her and rubbed her belly.

'Uncle Tony says I look like a chipmunk.'

'Uncle Tony doesn't know a cat from a cow,' I say.

'He bought it in *Paris*. He read out the receipt over the phone,' she says. All said in some alliance with Tone, that he did know a cat from a cow.

'He read out the receipt?'

'Not the price. He said: *Cat costume. Ages five to seven.*'

'But you're eight.'

'But I was seven when he bought it.'

'There's no quibbling with you,' I say.

'One day he's buying me a helicopter.'

'He said that?'

She nods, over-nods like she's much younger and still figuring out the mechanics.

'The silly bastard left his address on the courier box,' Finchman says.

'That's how we know he's here?'

'In Morocco? Correct. He's not at the hotel he invoiced it from anymore. But this is a good enough hint, right?'

'It's gravy at best.'

Finchman snorts.

'It'll do,' I say. 'We'll hang out on random street corners shouting song lyrics and watch him come running.'

'Yeah. How's Angel?'

'Well, old Angus Heigl. If when I met him thirty-five years ago you told me he'd be living in my basement for the rest of his life, I'd have asked how the hell do I get out of this one.'

'Right. How is he though?'

'He's costly.'

We clear away dishes. Stand in the kitchen with dishcloths over our shoulders talking as Celine goes sleepy and grizzly. Finchman ghost walks her out of the kitchen, bare heels on his feet and his hands holding her arms like she's a puppet.

'Tell me about Angel,' Juliette says. 'I still have visions of him.'

'You don't want to know.'

'Spencer tells me nothing.'

'Guess he has his reasons.'

'Not really,' she says. 'Tell me, so I know. So I know properly when I ask how he is what I'm really asking about.'

I look at her and see her eyes squint sorrowful and half lit by a sudden nervousness. The same softening I fell for when I first met her in a quiet bar built in a cave full of impossible shades of tanned earth. Gazed blue irises seem to vault the gap between her sudden sincerity and my distaste for such a thing. Both eyes saying they wanted knowledge. Something had put solemnity deep in there and I've no choice but to tell her because she'd been there and there's nothing to do about that fact.

In 2017, during the band's only trip to New Zealand, Angel was caught and damaged for all remaining time. I was living in Wellington with Sonya then, and suddenly became the guy with access to the unknown city. And it was a city. I didn't know it well, just walked at night while Sonya's body slowly learnt her illness, gave instruction on how to be sick. The band had reformed almost mysteriously in 2015. Tone had reinvigorated the record label in 2014 after one of Neues Bauen's songs had been used for a sports-shoe commercial and people wanted to buy it. We played three loose shows in the UK and disbanded for good. Then twenty months later, in 2017, we were invited to play in Wellington at Haven, an arts festival converging international music and dance. We practised for three weeks in New Orleans. Gathered there so Angel could keep working at his law firm during the day. It was fun at first, then the heat and the booze and the realization our bodies didn't know the music anymore. We discovered they'd learnt more conventional routes through to a note's articulation. It takes every part of you to correctly phrase a chord. It's in your stance, it's in the grouping of

muscles, how they force the hand to grip just so, it's in how you imagine yourself fighting, how you imagine yourself running, it's in how high you can jump and just how your knees take the impact, it's in the way you respond to fear and anger and anxiety and that persistent need for sex and how you fuck when you fuck. So we re-learnt these strange old violences like some antediluvian dialect no one knows the meaning of. And we all got sick, paralysed by a strain of flu rummaging through the Lower Garden District where Tone had put us up in a house built sometime in the late years of the previous, previous century.

Then, when it was done, when we knew the songs and we'd each lost ten pounds, we flew to Wellington. Juliette came a few days later with Celine.

And there we practised some more – then a large stage packed with speakers and lighting.

We'd made stipulations:

The venue would not be seated.

There had to be a support band, they had to be local and of our own choosing.

All tickets had to be the same price.

We'd play for as long as we could be fucked to.

We'd play none of Tone's solo material.

And the band we chose to support us were from Wellington. The Slow Learners. They were nineteen, twenty. Had a thing, that small thing that all decent bands have. That slight habit that's impossible to track with the naked eye. A habit they'd built together, a perfected error stamped into technique. All great things are part broken, segmentally cracked.

• • •

We watched them tear raw notes out of the air – then stepped ourselves out into roared applause. I didn't recognize any of it. It was massively warm, nuanced by the cruel and fascinating

acoustics of the warehouse. The click of sticks and the blur of speed and concentration, of always trying to recall what came next. The sweat and cramp and hard edge. I felt us in the pocket, grooved and actual – located in the heave and rip of the song. Applause and shouts. Songs and recognition and callouts. Applause, loud and long. We played songs called 'Pig Rental' and 'Panty Cruise' and people clapped, unmuted by the stupidness of lyric and progression. The songs' violent convulsions of discordance and rhythm quite agreed upon. And the clapping sustained itself through until the next song. 'Radiation Cures'. Something polite in their volume, something known and predicted. The sense then, the knowledge as we played that we'd be doing this again, over and over. Town after town, hotel and pool and rider. We hooked into each song and assaulted them. I found my legs, my stance and attacked the mic. The harder I tried to fuck it all up the greater the echoed response. I swung around and flashed an instant grin at Finchman and he gave the same raucous smile back.

The chairs had been taken out and the crowd danced. We played until we couldn't. Finished with a cover of 'Youth of America' and announced that was it.

We walked off and it was still mid-evening. We dispersed to a bar on Cuba Street, drank and I was surprised when Finchman left for his hotel soon after without Juliette. He said he wanted to check on Celine even though she was with her nanny. Juliette seemed to recognize the cue, that he was fried and wanted solitude. She was drunk by then, butting into conversations then asking what we were talking about. We hung out on the bar's balcony drinking, talking with the girls and guys from the support band. They were most interested in Spence, for Spence was always the most interesting out of all of us if you were a musician. The way he hit, the way he patterned and made a groove out of such small things as the noise Tone and I made in lieu of

melody. One of the kids, a girl with a keen bob, had a theory. It was that he played in time to the vocals, that they were the most in-sync part of the group. The most distant and chiming. When Juliette told them Spence wrote most of the lyrics, they fell over themselves, that they had been right all along.

They sang words to us. The long, held notes on 'Dance Prone's chorus. They joked when they couldn't sustain them through.

Then out on the street we walked to the north towards the waterfront. We were handing around cigarettes, smoking and walking with these guys and girls. And then Tone said hang on, and pushed himself into a shopfront alcove, trying to get his cigarette lit in the wind as a hard gust hit the street. Going: *This is the greatest place on earth.* Laughing.

Two teenage girls stopped and asked for a match.

'Do you even, like, have a cigarette to light?' Juliette asked. She had a small sway on, eyes squeezed by the booze.

'The fuck we do.'

'The fuck you do.'

They were sixteen, seventeen. Quite unaware about the giveaways on their faces, flashing eyes and stupid drunk-kid grins.

'You want one?' Tone asked towards the girls. They hadn't recognized him and he seemed quietly delighted.

'Yeah.'

'Suck my dick and you get the pack,' Juliette said.

'Fucken creeps,' the shorter of the girls said.

'Fuck you guys,' Juliette said.

But kids are quick and the short one snatched the lit cigarette out of Tone's fingers and ran. Tone laughed and Juliette took off after them, comic book, running through the drizzle that began to fall. The guys from the support jogged to keep up with us as we walked in Juliette's direction. There was whooping and jollity riding up the street. Tone and I started walking

in the direction of the shouts and haze down the bustled mall where Juliette had disappeared and Angel had trotted off, looking out for her. Calls from an Irish joint as some team pulled the tide on the big green screen outside. A woman up on her chair yelling at no one who could hear. The ambulatory bluster of groups walking in bulk, loiterers shouting because volume's ambiguous when mixed with drink and night.

Then Angel was calling out from behind us but we ignored him. We'd found ourselves pushing through the night market and the brunt of food smells and it was easier just to keep walking. At the bottom of Cuba Street, where the inelegance of the Michael Fowler Centre sat, we found ourselves in the crowd emptying from its hall where a concert had been in progress until a few minutes earlier. I sat on a bench opposite with Tone and the young woman from the band. Angel appeared suddenly and walked in the direction of some more kids, seventeen, eighteen, wherein Juliette was arguing with the girls toting their shoulder bags and short skirts. Their unremarkable men. Suddenly he had his hands on the shoulder of one of the boys. They were kinda joking, kinda agitated.

Then movement. Then the stiffening of bodies. Fast hands. Then shouting and a punch and Angel fell.

He was on the ground. They were kicking. Girls pulling boys off. Screaming. I upped and ran at them. Young men in Vans kicking Angel's face as he squirmed on the ground. His stomach and ribs. Tone and I arrived at the same moment barging in with elbows and shoulders. Security guards from the large venue doing nothing. Then police. I held the one who'd thrown the first punch, a blond kid laughing saying: 'You a boxer, bro? You box? You want it, bro?' Raising his eyebrows under the melting spume of his pitiful faux-hawk.

'What the fuck?' I said. Any violence I could think of was old, greyed out. For five years we prepped ourselves every

night for this; then it arrived, thirty years too late. These people not yet born the last time I was willing to get a tooth knocked out.

'You a boxer, bro?'

'Fuck. What? No. I'm a fucking sound engineer. Fucking look it up.'

'You American, bro?' He looked around because someone was singing really loud.

'Yes, I'm fucking American.'

'It's all good, bro. It's all good.'

'No, it's not fucking *all good*. Nothing is ever *all good*.'

He couldn't say anything else, his own particular shock. *It's all good, bro.* His own specific haunt from his actions and the predicated words.

I find myself exhaling, sighing and talking. Juliette's mouth gurning regretfully as I speak. 'His brain moved dramatically in his head,' I say. 'Diffuse axonal injury, these are the terms. Permanently damaged.' I feel her look at me but I don't look back, just talk to the sea beyond the kitchen windows. 'It was the repetition, the continuation of kicks after the first punches. There's cognitive, behavioural, and physical disabilities. Though I still take him out sometimes. He has a limp and insists on walking everywhere.'

This is what I tell Juliette and she nods slowly, saddening the room with the smell of wet eyes for a guy living in my basement.

'His parents are both in their late eighties. His siblings don't have the means. So we keep him in our house. We're happy to.'

'I am a guilty person because of this,' she says.

'There are no guilty people in this but the fuckers who did it to him. You're just a woman in the wrong place.'

'But guilt doesn't work like this,' she says. 'Guilt works like higher power.'

'And money's OK?' Finchman asks as he comes back into the room.

'Angel had investments, so it's not all over to Tone, Sonya and me.'

'I hate this. I hate I wasn't there.'

'Who was there and who wasn't only matters to the other side,' I say. 'Do you want to show me the video? I don't want to talk about him anymore.'

Finchman nods and takes out his iPhone, probing the deep reefs of uncharted web. YouTube and Vimeo and the after-effect of Angel does its work with Spence scowling at his phone. Since they started in on him, since the stunned slump of his body merged with the pavement, I've had a terrible new access to data. Mind data. Memory of old things partially unvaulted and a slew of information washed against the glitch and gather of an alluringly lapsed existence. His body buckled, bone twisted, head-shock and his eyes bloodied shut and it'd started: the distant peace of forgotten things slowly loosened, quivered into a new life. The violent rebirth of a partial recall. It felt like a kind of auto-knowledge, systematically available with its vital contents somehow banished in the processes, occupied now by archetype data. I'd watched him in his hospital bed, the hacked, snuffled breathing and I was certain I was recalling the rhythm of a voice and it was her voice. Joan George-Warren's.

'Anyway,' Tone says, 'as I said last week, these keep showing up.' He waggles the phone back and forth like a mirror signalling the far off. 'First one turned up a few months ago, now there's three, I think. Same uploader. Same camera work. This is a Burstyn show, pretty sure.'

Finchman hands over the little machine, lit up. He leans and hits the cast icon and we begin watching it on the large TV set in a niche in the wall. Evidence of our youth, little apologies held captive for years until released into the silence of the two of us.

22

December 1985

We met Joan George-Warren in the pale light outside a bar in the outskirts of the Yuma township. She was there, sudden, taller than she sounded that one time on the phone, lank and made lean by rogue genetics. She was propped up by a walking stick with a hand-worn bulb of wood as its grip. I feared looking at her; I'd never met an author before, imagined something of the medusa in her, something rock-like in my limbs and lungs. There were five men with her, Vicki and another young woman who I recognized immediately from the phone booth in Denver, from the gig in Albuquerque. Miriam George-Warren, her dungarees hiding a kind of private paunch I hadn't noticed back in Colorado. A kind of intent in her glare, too. George-Warren's crowd had met us and fed us cheeseburgers as two men fixed the van and Spence stood outside and watched them and it all seemed so simple. Here was Joan, forty-four now, effusive and seeking out our eyes. Questioning Tone and trying to look in past his mask with sideways glances. She knew people, people in the shape of mythic heroes, grand heroes of album and lore, the people we sought by playing, by driving 10,000 miles, by listening and imitating, she knew. And here she was, ordinary, discussing engines and oil. Intelligent irises and pupils surrounded by a face that knew its possibilities, that its weathering meant little. And there the young woman, Miriam from back in Denver. She was handling an F-1. Wielding it. I went to her and we grinned at each other, not knowing to say how we'd seen each other before.

The incident felt like a secret, silent and shifting. Instead we talked lenses, filmstock. The tech-talk of capture and exposure. Then she was looking up, saying: 'Oh, we're leaving? Are we leaving, Joan?'

Everything so simple.

We drove then in a crude convoy of Winnebago, van and truck to the compound. Dust and exhaust smoke. The film of us saying: *Recently Apocalyptic.*

We found their camp beside a chapel: house trucks and four large tents parked beside a low lurking stage. We pulled up, parked near the edge of the dry fan spread out from the bottom of a wide gully. The whole expanse dotted with trees, thorny and biblical. Which was fun. Then we stood waiting on directions among several tall, creatural sculptures seemingly abandoned to the sun in the middle of the colony. Miriam pointing to the largest of the tents, saying we could sleep there. Several wooden structures sat on the opposite side to the stage, sculptural moulds abandoned to the tinder air. The place smelt of distant death-decay.

'Apologies,' Miriam said. 'We're prepared for earthquakes and plague, but visitors throw us every time.' She was the girl who'd been sitting on Blair's knee a month ago as it snowed in Denver, who'd interrupted my phone call to Sonya. Joan stood beside her, nodding slowly.

'You ever get weather here?' Angel asked.

George-Warren laughed and Miriam said, summoning up some arcane rural accent: 'Ain't had rain here'n so long them trees're out bribing dogs.' She was blue-eyed and sandy like her mother.

Angel laughed. 'How long you been here?' he asked.

'Ah, how long? Joan?'

'You? Two years?' Joan said absently, looking around and finally spotting Spence over by the van.

'But I leave and come back,' Miriam said. 'I've only been

here, like three weeks? I'm supposed to be in Houston, but things change.'

'She's my oldest friend,' Joan said with a laugh, 'so she comes back.'

'I'm a hundred and seven,' Miriam said quietly. I felt a laugh burrow up through me as another woman a few years older than Miriam walked across the compound. She was wearing a Harley-Davidson cap too big for her head and two girls ran around at her feet as she juggled a baby arm to arm, the girls holding the skirts of her dress while she watched us carry our bags. A little dance for the maypole as music bolted across the field. 'How long are they here?' the woman asked, nodding towards us as her face appeared out from under her cap. It was Paloma Mrabet. Her great smile slowly drew itself on her features as she leant against one of the more anthropoid sculptures, immediately draining the figure of its eerie eagerness to be human.

'As long as we let them,' Joan said.

'How long's that?' Miriam asked. She had round, tinted glasses like the kind Albini used to wear. It was hard to tell where her eyes were glancing, if at one of us, or at the nothing beyond the van. We stood with our hands up to our brow-lines. The glare off the land that was, in a much distant past, the salt bottom of the sea. Everything here once witness to the age of vast fish: Eurypterids, Dunkleosteus and Helicoprions.

'How many here now, Joan?' Spence asked the woman as he came back from the van. He wasn't looking at anyone, just staring off to the hills.

'There's twenty-one of us now, Spence,' Joan said.

'We rotate the pillow,' Paloma said.

'Twenty-one? There were forty last year.'

'Inflation,' Paloma said. She was stepping from foot to foot, treading among the children.

'Twenty-two, Spence,' Joan said, 'but I sleep in the chapel.'

She pointed with her stick to the tiny structure beyond the tents.

We were shown to our tent, four cots and a space for our junk.

'This where you and Rhino stayed?' Angel asked.

'When?' Spence asked.

Angel placed his bag on the cot nearest the back and looked at our drummer as Vicki entered. She went directly to Spence and put her arm around his narrow waist. She'd been here four weeks already. The bar was the first we'd seen of her since Denver. Spence left the tent for the van again as Miriam came in, stood quietly with several blankets draped over her forearm.

'What do you do when you're not –' Tone asked the young woman, his voice muffled and mumbled – 'whatever it is you do here.'

Paloma hushed the baby as it began its sudden pleas for the unknown.

'I paint,' Miriam said. 'Sometimes I paint.'

'You should take a look at her paintings,' Vicki said.

'Show them your paintings, Miriam,' Joan said. Her face rutted through, spurning years and decades.

'Yes, sir.' But Miriam remained still, and we all stood there.

'She paints parts of cars, buildings in bad light. There's a diction there,' Joan said.

The girl raised her eyebrows, one of them stayed arched as she bit a part of her lip and then let it fall away. 'There's diction in everything, Joan.'

'We argue about what she paints,' the writer said. She had a laid-back voice, like somewhere in the back of her mind she was continually composing a memoir of her early life. She was straight-out old money, this is what I knew by then, a woman captivated by angles of social exchange and phenomena and

all its manic manifestations. I was amazed to be amongst it, these people who were the source of so much of Spence's talk.

We stood in silence until Paloma Mrabet said: 'You cats, you get around, no?'

She seemed sudden, bordered by babes and various chillins. She was brightly beautified by the sun, her eyes darting as if constantly on the lookout for connections to old memories and new thoughts. I watched her for a time and remembered something Sonya said the first night we met in Phoenix and we were joking and drunk and she'd said when I kept forgetting her name: *You got to practise your memory, Conrad. Otherwise you're of no use to no one.*

In the late afternoon once the heat had eased Tone and I went with Miriam behind the chapel on the far side where another huge tent sat where most of the artists worked but was now empty. Outside there were four awnings, tables spread under the canvas below umber hills in the hardpan. Miriam talked about the weather, the rareness of wind and the chapel.

'Eighteen ninety,' she said as we rounded the little church. 'Built for a family of thirteen.'

'Use it much?' I asked.

'Not so much. We store things on the inside. We pray outside. Which one of you isn't the PhD?'

'Just Spence's the PhD. And Vicki.' I pointed back behind the chapel where they sat with Joan and Paloma as the baby discussed its place in the world with gurgles and the odd pitched scream. 'Were you here when he came through last time?'

'The shorter one? No, I was up in Colorado. Spence, he's the shorter one, right?'

'He's not short, just shorter,' I said. I found myself enjoying watching her, the body movements and deflections in her voice.

'No, he's short,' she said.

'Jesus was five foot one,' I say. 'That's short.'

'Really. You know this?'

'It was the average height for Galileans during the Roman occupancy.'

'How tall are you?'

'I'm also average height, but not very religious.'

She grunted a small laugh. We watched Tone walk around the chapel. She called to him: 'The door's just around the other side. It's not locked. Or if it's locked, I don't know.'

He disappeared. I heard a door open and close, a creaking that seemed peculiar to the desert, the way sound rolled off without echo.

'How's one hundred and seven?' I asked.

'So, so. I still struggle with long division,' she said plainly, then laughed at herself and I joined her. She had generous eyes, wide and asking, the type you wanted to trip into and lie resting awhile. 'I'm going to ask. What's up with the dude's face?' She looked back in the direction of the chapel. It was barely eight yards long, three across. A broom cupboard with a single stained-glass window among the standard panes.

'Wound,' I said.

'What kind of wound?'

'Skiing.'

'That's not true.' Then, a pause: 'Is it?' She looked concerned for a moment, she glanced at the chapel. Her wide face frowned and I felt bad for lying.

'Worse,' I said.

She shivered. And though she was nineteen or twenty it seemed a young-person motion, practised, understood and executed. She found an empty bottle of bourbon under a tarpaulin, sand coming from its neck.

'You want to get drunk?' she asked. 'I mean, we can just get drunk and whatever.' She laughed again, threw the bottle in

the dirt. She stood still, something squinted in her expression, the hunt for the right word perhaps. The word that separated her from others, the others who she knew weren't capable of such and such thought.

'He shot himself.'

'The fuck he did,' she said.

'The fuck he did, yeah. Through the cheek.'

'What kinda idiot? The fuck he . . .'

I felt the urge to laugh or cough hard. Something heading up my body. I watched her moving things about on the table, the grim life of squeezed-out paint tubes, of pencil nubs and hardened oils.

'We don't know. Six weeks ago.'

'I've got a good mind to ask,' she said. She looked at me close. A long silence.

'We don't know exactly what he did,' I said. 'Or why.'

'Jesus.' A small pulse in her neck.

We stood paused, waiting on the thought before the word. The linkages, ideas viaducted from theory to thought.

'He want to kill himself?'

I shook my head. 'He baulks at any suggestion he'd wanted to put it through his skull. So no. I get the feeling he just wanted to – God – fire the gun. That's all.'

'__'

Her feet in sandals, crossed over and then not.

'__'

I watched her for a long time. Felt the shadows forming from our legs. We talked on, joking, then not joking. Something easy and I liked the way she moved, the practical sense of her small, rounded body. I felt like I could touch her arm and she'd smile. Felt like I could ask personal questions and I'd learn something about myself. She told me how Joan'd come here first as a student, saw the chapel and found it so infinitesimal, so cloaked by its necessity she thought it the holiest

site she'd ever come across. She bought the plot of land, lived in a caravan during the summer when the temperatures killed everything not endemic to the area. Miriam'd visited during one of those summers when she was a girl and walked the hills with Joan, stood over the great gullies and ravines and listened to the wind. That was when it came to her, that there was something beyond the simplicity of her eye and she wanted to draw.

'So I started painting eventually. But I'm not convinced I have it right.'

I watched her, imagined her in another time, a future time potent with some kind of intellectual affluence that comes with being good at life. At being good at one complex issue few others show competence in. I imagined her changing something vital in the breath of a thought. I said: 'I'm going to tell you something.'

'Yeah?' Light flinted, glanced off her glasses, a kind of nerve-flash in the corner of her vision.

'This isn't good news,' I said.

'What's good news? Tell me that.' She laughed out a small *huh.*

'This is, this is something that happened to me.'

Her face shifted its muscles to say she was listening and capable of listening seriously. It all said it was OK. All said we were in the golden hour of new rapport. Trust perspicuous, soft and simple, held there by attraction and, by association, becomes the thing we mistake for profound connection.

'You mightn't feel so good about it,' I said. I looked back at the chapel.

'Yeah, well. Fuck.'

'We'd been up in Burstyn. That's where we're from,' I said. 'We'd played a gig. I'd taken our gear out of the van once we'd got back from our show. This is the night Tone did it. The night he shot himself.'

'How long ago?'

'Feels like a month.'

'Feels?' she said.

'I don't have our tour book. That's Spence's thing. Seven weeks maybe. He watches the diary for movements, change. I just drive; I get us there. Here. It was just after Halloween.'

'So nearly two months.'

'Sounds right.'

She laughed. Some nascent ESP telling us we need to find amusement in something before I said what I had to say. She asked: 'So. So something is going to happen?'

'Something is going to happen. Something had already happened,' I said. 'We'd done an afternoon show in Burstyn. Just a show. Kids and noise. I'm not keen on daytime shows. There's always something left over that shouldn't be seen in the sunlight. Anyway, a band, especially our band, can spend days not really speaking, and then we split until it's Tuesday and practice. That's what we did. We dumped the gear and ignored each other. I'd gone down to the rehearsal space, humping amps and guitars. I was drunk on some cheap lightning. I just had the urge to get messed. Everyone was just milling around. My girlfriend wasn't talking. And Vicki, she came down to the practice room with me, helping lug stuff. Sometimes I just wanted to lug gear. Sometimes, sometimes. Being in a band's like moving house every day.'

'Vicki's spent most of her time at the bar,' Miriam said, 'since she got here.'

'Yeah . . .'

'—'

'She's a guitar player,' I said. 'She's extremely good. She plays in my other band.'

'Who's that?'

'The Ruths. Spence's mum's name, cos we were all in love with her, before she died. Spence wrote "Radiation Cures" for

her and I'm the one who has to sing it every night. But Vic can play the drums. Can belt the skins off them.' I told Miriam how we'd sat and drank whisky. How I'd plinked on my guitar and Vicki'd sat behind the kit and we'd shared the bottle. How she started banging. 'She started playing. I plugged in. Just like feedback and volume. We drank. We didn't really say anything. It was hard, physical. I tuned a guitar to some chord and set it feeding back and grabbed another and played over the top. Then Vicki was screaming as she hit, yelling at the microphone as I wanged out over the feedback. Smashing the cymbals and shouting, screaming, thumping the life out. Then Spence's father, he came in. This grand asshole of a man. He stood there for a moment and I couldn't tell if he was pissed or whether he wanted to ask me a question. He shouted out something, trying to get us to stop, but we ignored him. He left eventually and I put my weight on the guitar and bent the neck and the pulse of all this noise, the hammering out-of-tune-ness. It got really hot in that room. Eventually I'd my shirt off. Vicki was just in her bra. We weren't interested in each other's bodies, just this noise. But maybe it was the fear of stopping what we were doing and staring at each other. Maybe that was a part of it, why we kept playing. Just the idea of sitting there looking at each other, half-naked and see-through. We didn't want that. So, we went on and on. Maybe two hours.'

'Ain't no rock and roll party without tits,' Miriam said, staring back. 'Texas teaches us shit like this. What's his name?'

'Who?'

'Spence's father?'

'Frasier Finchman.'

Miriam nodded slowly, as if she'd heard rumour of the man.

'He's always trying to get his son to do shit. Anyway, and then my girlfriend came in,' I said.

'Of course, of course she did.'

'Vicki and me all pasty and damp. Me just banging this

guitar. She left and I was suddenly very empty. The heat drained out of me. Vicki stopped. I lay on the floor a minute. Then I went after my girlfriend. And that's it, all I remember. I put my shirt on and went up the stairs. There was a dozen or so people there. It's not a good crowd Tone keeps. He likes certain vices. Certain vices like certain clientele. All a bunch of crude mothers. Anyway, I found Sonya on the fire escape. There were these kids in the block. They were setting off firecrackers. They were yelling and shouting, you know, in all feigned-up fear. It was freezing out. Deadly cold. I was dripping and I could feel the stuff go hard on my skin as I tried to talk.'

'To her?'

'Yeah. But she wasn't interested in talking to me. Instead she's smoking pot and I never smoke pot. It doesn't work for me. But I smoked and. And that's it,' I said.

'Not: *That's it.*'

'I smoke pot and drink and I pass out. I got nothing against pot, but for me: no. I lose track,' I said. 'I pass out and I can hear, but my body – it's like my spine's been severed cos I can't feel a thing but I can hear just fine. Which makes me think it's my fault. Makes me think back to all the things I did that day and what I should have done differently.'

'You're telling a story,' she said, prompting.

'It gets broken,' I said.

'It starts up again, right?'

I walked around the table, picking up pieces of dried paint. I stood opposite her and glanced once more back at the chapel. 'It starts again, hours later.' I blew air out my mouth so my lips trembled. 'I woke up. I woke up sharp, but not able to move. All the time in between dumped out. A weight on me and I couldn't move. I was in the van. The back of the van. This is what I remember: and there's a fucker on me. I couldn't move. I could hear shouting. People yelling and my pants torn, they'd fallen and were around my shins. The burning pain of this

– this fucker. People yelling and this fucker's weight on me, holding me firm so my face is in this bag of clothes we drag around. And you don't want to know what's in that bag. What shit goes on from town to town.'

'Oh—'

'Just like, this fucker,' I said. I tried to hold myself still.

'Do you know who he was? I mean, do you know, know?'

I shook my head. 'No.'

'And he raped you—' she said.

'—'

'We don't have to use that word if you don't want.' Her eyes were wet, she glanced at my fingers and I realized my hands were shaking.

'We don't know what some words mean until they're acted out,' I said. 'Sonya had some pot and I smoked it. But I can't handle it. I smoke it, I get drunk and I pass out in the back of the van. And sometimes when I pass out I can hear everything, every movement and sound, but I can't move or see.'

Miriam nodded slowly, her fingers near my arm, about to reach and touch. But she recalled it, eased it back to her side as if any move she made would bring back the sensation of everything, all the hard parts of him making me bleed, his fingers digging into my neck, his elbows knocking me sideways.

'What happens – what happens now?' she asked.

'This happens now,' I said. 'Just this. And then. Phoenix for two gigs, then west coast.'

'And you're in Yuma.'

'I'm like, fuck,' I said. 'I'm in Yuma. Eight weeks. And—'

She looked up at me, her eyes half-squinted, a question then nothing. Then she slowly stopped watching, a correction of movement. Her gaze down towards the trestle tables.

'Show me your work,' I said. 'Anything.'

She nodded and started moving tentatively, touching things she didn't want to touch.

'I mean, this happened,' I said. 'It happened and I didn't have to do that. I didn't have to tell you that.'

'It's OK,' she said softly. She showed me her art, holding up things and shrugging. Joan George-Warren was right: parts of cars. The corner of a building. 'You were around?' she asked.

'When?'

'When he shot himself?'

'I mean. This is what woke me,' I said. I told her the known sequence, the assumed relationship of events. I felt ourselves look up into one another's eyes, and then to the mountains. The silent structure of the hills, the way they were built out of a makeshift logic of upheaval and erosion. She held up another picture in a series. The trunk of a tree just above where it enters the earth. Partial things, edges, borders and detailed like they were still life.

'What do we talk about?' she asked.

'I haven't said any of this, not to anyone. You're the first.'

'And you're on tour.'

I nodded. 'I woke up and then. I woke up. This thing—' I said. 'Then the gunshot once more. That was him taking out his face. I've slunk into arbitrary suspicions. Tried to imagine eyes. Tried to imagine a face that could do this. Suspicions of other's motives.'

'Who knows?' she asked.

'Tony,' I said. 'But he doesn't know who.'

The way her paintings seemed to be looking around corners. The eye hidden from the subject. The desire to be unseen, but conspicuous at the same time.

I asked: 'How'd you end up here?'

'Little me? The first time I drove from Houston with a map on my lap. I drove through the night, I drove without sleep. I pissed in a takeout box. Which is disgusting. I'm a little surprised at myself in a hurry.' She looked at me until I was gauging something.

'And Joan, she's your mother?' I asked.

'She's my mama,' she said. She'd a small laugh, one that lasted longer than it should.

'You're her oldest friend,' I said.

'Just something she likes to say. I was five when I figured out she was my mom. She was just this woman and she'd play with me on her lap at my uncle and aunt's. She was what? Twenty-five. I was seven when her first book came out. A party at my uncle's until someone discovered what the book was about.'

'Which book was that?' I asked.

'*No Relief for the Dying.*'

'Aha.' This was the book Spence had read passages out of when I was thirteen and I'd listened, fascinated.

She stood paused. 'OK, so these here,' she said. 'These are of the chapel. I stand over there and examine its outline first thing in the morning. I hate taking photos, but I take them and then I've a reference. Joan gave me a camera. Something about young women and cameras that makes me a little nauseous. Like it's an art form we're allowed to indulge in – it's –' she shifted the paintings, a thin line of exterior wall taking up no more than a tenth of the page – 'it's vital to get the light right,' she said. 'Otherwise it's just a line.'

'It's always just a line,' I said.

'Yes, but it's this line,' she said. 'I'm after this line and not others, and why is it specifically this line. On and on.'

'—'

She bit her lip, said: 'It's like only true borders – this is what I say to Joan, and she doesn't disagree because she's a bitch sometimes – I say the only true borders are the arguments we have when we talk about shit. The only true borders are the shit we talk when bored because that's when we should be thinking: *Oh God, I know nothing.*' She watched me. 'The issue with making art in a desert is that meaning

is amplified out here. Everything takes on greater force in its
sheer isolation.'

'—'

'Does she – does Sonya have any idea?'

I shook my head.

'But you've told me,' she said.

'I've told you,' I said. I felt a saddening hunt through my
body. I looked back over at the chapel and felt like lying down.
'I thought for weeks, or I tried to think for weeks, that it was
a prank. That it was just a joke played on me. *Ha ha.* And
that's it. I need to convince myself of things. But it was never
a prank. It was the actual. Thing. Something happening again
and again in my head so sometimes I've no idea of its actual
origin. But I know.'

'You can tell me. You can say what you need to tell me.'
She took my hand in hers, it was small and felt like cotton. But
then her eyes narrowed and I realized something, that she'd
said this because it felt like the thing she believed she had to
say. I realized too, that we were breaking this thing, this bloom
of friendship. That's what we were doing, sacrificing it for the
sake of sacrifice. I held her hand and waited until I felt her
muscles loosen and I let go. 'We don't have any reason not to
share these things,' she said. Her tongue caught on her palette
when saying her 't's, producing a clicking sound.

I nodded, slowly. I said: 'Things, things are difficult.'

'Are you together?'

'She's, and this is the thing. She's pregnant. Pregnant and I
keep thinking how maybe when I fell asleep she was pregnant.
When the fucker came into the van, she was pregnant. This
terrifies me.'

'Jesus. But you're together?'

'Aha.' I looked around, trying to shake the thought of Sonya,
of her on the balcony the last time everything was fine. 'Where
in Texas you from?'

'Houston,' she said. 'Sometimes Austin.'

'Houston.'

She nodded and said it was just for a short time. She was in Madison before that, where her aunt and uncle on her mother's side now lived. They'd brought her up. She explained how she'd a job out in east Texas in a record shop. A life talking about drugs and music. Taking drugs and obsessing on music. 'When we weren't listening to music we talked about music, and when we weren't talking about it, we were talking about how we were always talking about it.'

'When did you live in Madison?'

'Never,' she said. 'Folks moved there when I was eighteen and I moved with them for about a month. I visit, get in at night, hang out in the house, eat their food. Leave before the sun cracks. Don't ask me about Madison. Paloma and me, we were both adopted out.'

I nodded, laughed for the first time since she'd said *Long division*. She picked up a photograph from among the tubes of paint. It was of hills, from within the hills. She said: 'I sometimes just want to blow these things up so they're the size of the actual thing, you know? Then I could really paint them.'

'Paint what?' Tone asked across the tables as he came near. I didn't recognize his voice, like he'd made his way here out of some complicated system of tunnels in the hills. He pulled the mask off for a moment and put his hand across his forehead to collect some sweat from his brow where it was leeching into the bandage. He flicked his hand and sent the fluid onto the plants at the base of the chapel. Miriam held up the photo. He approached and took it from her, looking closely. 'What's all that shit in there?' he asked.

'In the chapel?' Miriam asked.

'Correct.'

'Drafts.'

'In the boxes?'

'Yeah.'

'I just spent twenty minutes, reading,' he said.

'I'm not sure there's an open invite on reading,' Miriam said.

'Yeah, but what's the point of leaving the door unlocked.' Tone described the chapel, a tiny altar, a chalice and a cot in the corner. The cartons, waxed archive storage boxes.

'It's all a draft,' Miriam said. 'Drafts. Joan's book.'

'The book of Joan.'

'It's called *The Permanence of Suspicion.* She's finished it eight times. It goes on. She carted half those boxes from Texas.'

'All the things that come from Texas,' Tone said.

'Yeah,' she said. She laughed, but it sounded guilty, unintended. 'Yeah.' She looked at Tone, then shifted back to me. I tried to imagine her for a moment as the girl in Billow and Jackson's report from down in Houston. The girl molested in Madison. I tried to imagine her as anything other than honeyed by the sun. I tried to imagine her running with them on the highway and the proximity of the vehicles knocking them all sideways.

'You read any of it?'

She shook her head. She said: 'Joan doesn't let that happen.' Then she screwed up her face. She looked away, suddenly stubborn. Angry, like all this had disrupted her thoughts. I looked back at her paintings. I looked over them again and again. Something distant, remote. And it was a remoteness that was terrifying because it demanded you didn't think of yourself as the objective, but rather lost, mislaid, oddly omitted from her world. 'The thing about Joan,' she said, 'is she hears things. She hears voices and she's not supposed to hear voices. That's why she's so interested in societal processes. She thinks it's all a version of the various cognitive illnesses we cart around. The world, she says when she's mad and drinking, the world's half mapped by science, half by lunacy.'

'Well it's, it's certainly half insane in there,' Tone said.

'That's what happens when you pry into things representing difference, Tony.'

'What happens?'

'You just see madness before you can see anything else.'

I stood, rocking back and forth. Eventually I pulled up the cuff of my jeans to show a bit of ankle. I put my leg straight out to reveal the red risen dots of the mildly infected tattoos. 'You've seen this before?' I asked.

23

Tone, Angel and I ate out in the dark, arc lights, jackets buttoned to chins and my hair waving in the breeze. Bread and vegetable soup amidst the gathering dew. Spence had gone to his cot to read. People from the bar, from the desert, had arrived full of stories. A school teacher and a doctor. Just people who wanted and needed conversation. We dipped and drank as the sky turned a shade of penicillium blue. We traded words as Angel played Tone's guitar and joke songs made their way around the circle. Miriam placed herself beside me in a pair of moccasins and went quiet, twitching her feet. George-Warren spoke and gave lessons in bird control. She pointed them out in the distance, the airflows, the rise of wide-winged beasts. I turned to Miriam so our faces were just inches apart.

'They get in our trash,' she said quietly.

'We fire buckshot,' Joan said. 'It's the noise. Seems to know the perfect sound on the perfect day.'

'And you know the perfect day?' Tone asked.

'Every day's the perfect day,' she smiled, giving the sense these were eventful moments we were engaged in, true and hallowed. She seemed to have the gift of tonality over logic, each one of us affected by her rhythm and pace. Earlier we'd watched as they spoke the precision words of an unnamed sacrament, laying out the carcasses of roadkill and carrion at their tower of silence. It was still, eerie and educated; the Warrenites dedicated and solemnly inward. We'd watched in

voluminous peace as buzzards began doing their work. 'I'm looking forward to this all being done,' she said. 'I want to sit in a cool room with a typewriter and imagine all the world's pasts coming down in the rain. Imagine me, an old woman listening out for lightning.'

The birds lifted into the hills as four separate conversations ranging under the awning. Vicki and Angel talking with an engineer borrowed from the bar, an irrigation specialist with heavy glasses and a goatee. A man charged with the eternal difficulties of steering water from the Gila River to the canal that was built at the end of the nineteenth century. Elsewhere, Paloma engaged Tone in ghost stories as the birds hovered, eyeing proceedings. I now understood something about these two young women – they were both adopted out and both had returned to Joan at different times. There was something present and foreign about them. It wasn't Paloma's descent out of Morocco, nor was it anything about the fact of Miriam's gently thick features. It was as if they existed in a plane of scattered isolation, as if there they'd come to know a dialect only they knew how to decipher. I watched them talk with their hands, with the minute muscles in their faces, across the gathering. Paloma reaching and touching the red beads of an earring hanging from large lobes, the way her mouth changed its shape at the mention of facts.

Joan spoke about Afghanistan, Rajasthan and Nepal, the borders of places that never had borders. Cyprus and Africa. Jemaa el-Fnaa in Marrakech. That was the first time I learnt about the great square. She described the place, the prodigious longing of its name.

'It means, I believe, "the mosque at the end of the world". Or it means many other things. It's big, an expansive open area near the centre of the medina. Maybe two hundred yards by two hundred. I might be underestimating; when you go it's fully populated; it's hard to gauge size and distance. It's

a thousand years old. People've been going there for all these centuries to buy and sell. To communicate stories. Which I guess is to remind one another of shared human excesses and all our agonies. To sing, heal. It's full of food stalls and dancers, sellers and singers. Magicians and snake charmers and pedlars of all sorts. But it's the music, musicians in a forced life as storytellers. I go there and I feel like one of the Barbary macaques taught to juggle.' She described its odd sense of near-excavated permanence, that everything within its bounds would be there forever. The magnificence of memory played out every night through song and its hypnotic grind. George-Warren talked on in gradual, worn phrases. Rich-voiced, chafed by the local dialect. I watched them all talk, back and forth. Narrative rhythms in the light off the sacred fire still burning in the shelter ten yards to the east. Joan remained striking, cheeks sunken by the sun and wind, by eventual thoughts produced by the same elements. 'What's your plan after this?' she asked us all.

'Ah – we're heading to Phoenix,' Angel said. 'Then California.'

'Phoenix?' Joan asked. 'You're playing the party?'

'I believe so,' Tone said and glanced at me. I nodded. We'd been invited to play at her party after our all-agers organized for the afternoon.

'Good. Good, good,' Joan said. 'Fine aša to you. Will and freewill.' She made a hand gesture that gave the impression of ancient rite, but I suspected by way of her smile it was invented on the spot.

'Why's everyone always so hepped up about free will?' Paloma said. 'It's an appalling habit. We're at our best doing nothing.'

'I'm all for doing nothing,' Angel said. 'That and hot wings.'

Joan lapsed into a quiet series of smiles. ╱

'No really. You ever notice,' Paloma said, 'how so many of the things we do out of habit are the re-enactment of events other people, not us, believe are evidence of a higher truth?

Higher being, beings. Even if we don't think we have belief, we act them out. Imitate various codes without any idea. No idea.'

'This is why we have sweet-chilli sauce,' Angel said.

'Is that what I'm saying?' Paloma said. She laughed. 'There's something invitingly vicious in this. In all acts of imitation, there's something hard and violent. Yes?'

'Well,' Joan said.

'That's what we've been learning about ourselves out here, yes Joan?' Paloma said.

Miriam started laughing and stopped. I found myself drawn to her simply, my face lit by some blood-rush and warmth. 'It's like we don't know when to shut up, more like. Joan sometimes wonders if we should be jailed for what we're doing here,' she said. She laughed and Paloma went on.

'All of this is just bad habits and bad habits are the world's great governing gadgets.'

'Gadgets,' I said.

'This is how we monetize revelry. We create a moral shell about the ecstatic. This is what we call religion,' she said. 'This is what Joan says. It's an actionable offence. We should all be jailed up.'

'Do I?' Joan said and laughed.

'Or not jailed. Something else.'

'Well, in jail we just learn another kind of life and live it,' Joan said.

'That's what I was saying. Let's do something else. That's my thought,' Paloma said.

'What's your thought?' Spence asked.

'Let's set evil motherfucks in an interim space, yes? Somewhere where they're forced to relive the act of the world knowing the shitness of what they did, over, over. That's my vision for future penal living.'

'This is something else we do here,' Miriam said at me.

'Reimagine various hells. Get us in the mood for prayer. Next thing we're shaving our heads.'

She and I sat quietly amidst the diminishing round and round of conversation. She shuffled close, some word or other. We thought of the things shared earlier. We thought because we were near each other and there was little choice but disclosing these things.

'There's swarms of kids lining up for them,' Miriam'd said back at her studio, nodding at my tattoo. 'You can only give one if yours originated from a few, specific people. The original bozos who started this thing.'

I did something with my face, unsure if it made me look foolish or shrewd.

'The guys that gave me this in Texas,' I said. 'They told me about a girl. One particular girl.'

'It's raining girls in Texas,' she said. 'During certain seasons.'

'They didn't give a name, but—'

She shrugged, said: 'I started this thing with these guys.'

'You?' Tone'd said.

'They call it the *Spurn Germ*. Which is a Germs thing, right? That's where I got it from. I was attracted to people attracted to ideas which promise promise. I was seventeen. So. Anyway,' she said, 'you're part of the tribe now.' She frowned, undid the straps of her dungarees and tied them about her waist. We found ourselves seated in the dirt examining the seven dots on my ankle.

'Spurn-Cock?' I asked.

'Yaha,' she said. 'I started it in Phoenix. Then Texas.'

'Why the dots?' Tone asked.

Miriam turned to him. 'Take that thing off your face,' she said. 'You're making the paints dry up.'

He pulled up his mask up so the respirators sat atop his forehead and he was just bandages.

'Why the dots?' he asked.

'Don't know. I was obsessed with the implications of certain numbers,' she said and shrugged like she'd never intended it to be something she'd have to explain. 'I was obsessed with seven. I did my boyfriend's ankle when he was passed out. I was going out with that guy Leo for a bit. Just a couple of days when he was here with his band. He was friends with Cozen Jantes of Cock.'

'Leo,' Tone said.

'I was seventeen,' she said. 'We thought it'd be hilarious if such a shit band got their own little culty tat.'

'Why seven?'

'Because it's the number,' she said. 'This is the thing, it's the number we all think of when we want to invent or imply a random sequence. Three also, but mostly seven. Statistics bear this out. Random's just this word we use for our inability to predict or account for outcomes.'

'You made the sculpture in Colorado,' I said.

'There's lots of sculptures in Colorado,' she said.

'At the place in the hills,' I said.

'Yeah,' she laughed.

'You and Paloma?'

'Aha. You meet Paloma there? I love that woman. Even beyond our half-sister-ness.'

'When did you first meet her?' I asked.

'Paloma? Near enough to a year ago. Mother Joan. She got around, my mother did. A woman with an impulsive womb. Quick to find adopting parents in my aunt and uncle. But Paloma,' she said, 'when she was a kid she was a terror, a vandal. Rushing around Marrakech with a little crowbar, smashing windows and spray-painting stupid sayings. All twelve-year-olds should be revolutionaries, otherwise what's the point?'

'What were you doing at twelve?'

'Mucking with horses. Then I discovered the number seven

and began putting it into skin. It's about making something arbitrary into something permanent.'

'Got mine in Houston,' I said.

'Houston.' She poked at my ankle. It was quickly apparent she wasn't interested in where I'd received the dots, the lineage of the tattoo. Just a mild amusement it'd made it this far back to her.

'Seven,' Tone said.

'Why do we all choose this number?' Miriam asked. 'Why do we choose the same number as everyone else and think it's the number no one else will think of?' she asked. 'This is my only contribution to the world of thought.'

'It's a conspiracy of sameness,' Tone said.

'Mm, yeah. Maybe,' she said.

'*Everyone desires the same desires as everyone else.* I just read that in there,' he said and nodded back at the chapel. 'They secretly want everything to match. It's a reflection of a belief faith is unchanging, whereas it's always changing. Your mother's words.' He stood then in the long afternoon shadows. 'They fear the implications of randomness,' he said.

'You read that in there?' she asked.

Tone shrugged. He stayed watching over us, lingering like he was about to say something else. But he began slowly wandering off, headed in the direction of the tent where we were all staying. Miriam and I sat waiting for the next thing. For the words.

'Such a shame,' she says. 'His other cheek looks so promising.' She laughed, a little nervously. 'What are you going to do about what happened?'

'What?' I said.

She nodded at me.

'To me?'

She nodded again. She seemed tired suddenly. I had a sense then that all this talk wasn't usual for her, that her normal

state of interaction was stillness and quiet away from people. I stared for a long time.

'I can't say,' I said eventually. Which sounded weak, which sounded forced.

'You can come back here when it's done. When your tour's done. You can come back here and rest up and think. There are some here who might be able to help. I can only imagine and hope to say the right words. But there are others here.'

'I have a girlfriend. Sometimes I swear I don't have a girl-friend. But I have a girlfriend.'

'Yes,' she said.

The last desert light started to ebb into the recess of the hills. She watched me, the widening of her pupils in a kind of race to sum me up, to form some kind of judgement that would place me in the correct shelf in the right library of dubious men. Bookish, childish, quiet-ish. Ssh, ssh, ssh. But she wasn't judging, not in that way. She was watching my eyes watch her, she was watching for her own movements. The twist of her hips, the shift of her breast when she reached to touch her neck.

Finally.

'And that's not what's going on here,' she said. 'Is that what's going on? That's not what's going on in this conversation. I'm not looking to have you, not looking to get on you, Conrad. I watch your lips, but I'm not looking to – if that's what's making you say that.'

'Maybe.'

'Maybe.'

'—'

'And maybe before,' she said. 'Jesus. Maybe before you told me what happened. Maybe then I wanted to see what would happen if you were tempted.'

'That's a word.'

'Drawn,' she said softly. 'But I'm not doing any of this.'

'We're not doing any of this.'

She was so close now, though neither of us had moved.

'You'll go and jerk off,' she said. 'But none of this is going to happen. None of it. But you'll go and jerk off. You can imagine me watching, but none of this is going to happen.'

'I'm not going to jerk off.'

'Fuck, and fuck you. We're in a desert and you can jerk off anywhere.'

'Show me,' I said. And then quickly realized what I had said, what it meant. That I couldn't take it back. There was something I suddenly believed was extant between us, hovering and alert.

'Show you?' Miriam said. 'I'm not going to show you nothing.' She seemed to shake. 'Fuck you. And nobody's gunna watch anyone jerk off. You don't know a damned thing, Conrad. Not a damned thing.'

Then all impossibly still. The wind rippled, circling sand about our feet. Her feet, the toes and wide ankles. Her calves disappearing into her dungarees. I had the brief thought I should try and really hit on her, hard and vulgar. That I should gnarl any confidence she might've had in me, just so this couldn't continue. That we'd swat the other away. Instead she said: 'There's something I need to tell you, Conrad, about Paloma. Paloma and those Rhinosaur guys.'

24

June 2019

Finchman and I leave late the following afternoon. I drive us up into the hills away from the Atlantic, into the desert from Essaouira. We'd spent the morning there among the fishing boats, blue and rank and high beside markets with Celine and Juliette. Then we'd headed away from the coast and the great walls of the medina, the same place Sonya and I'd ignored for the entire day we spent in that ancient town five years earlier. She'd said it'd looked like a prison for lost souls and refused to enter its walls. Instead, we'd walked about the rocks beneath its ramparts, jumping stone to medieval stone and realizing the only thing we knew of the whole city was Orson Welles and his chromatically brutal *Othello*. He'd infamously shot parts of the film there in spurts during the late forties and fifties. It was stark, torn, filled with hard lines cutting askance the screen. After walking the broken shoreline Sonya and I had realized neither of us could recall the film, only the way we couldn't stop looking at the walls of the fort and wondering if we'd really seen them before or if they were something Welles had built on a lot in Rome.

And now as we drive I realize the video that'd appeared out of Finchman's phone'd had a similar effect. Imagine the abstract of the four of us emerging on the wall in his house, the TV in a niche specially designed for the screen suddenly animating old doubts as to whether any of this story could be verified, via linear thought or other. There stood men with instruments, exaggerated to blocks of grey and black. Men

in the air, throwing themselves about, kicking. The show in Burstyn, the afternoon before all this began to be told and there it was, being told once again.

We'd watched and Finchman's eyes had clung to the screen, squinting. An image of Tone bent over, of me bent over. The illusion of randomized notes among a ragged set of images, the hue and cry of destabilized harmonics. The thing Tone did sometimes, the thing where he walked closer and near the edge of the stage, guitar into people's faces. Not a pose, not playing to them, just in their proximity, right on top of them as if they were absent, ghosts, and he could play right through them. His fist strumming up close to their mouths and noses and eyes, strings virtually against their cheeks. Inches till millimetres till they back away and he stayed put, playing in their space.

And my body remembered the difficulty of it all.

The instant recall of the room. The people and names. The odour and reek. All before Tone, all before the van and the shots and everything else. All before I put that stupid tattoo on my ankle.

I'd glimpsed Sonya off to the side by Tone's speakers. Twenty pixels accenting her face. I'd tried for further glimpses of her as the camera panned and caught the room, a glimpse of her shape, a hint to whether she knew then about the form of us in her belly. The tiny twist of humanness shaping into possibility.

We watched Tone climbing on top of the amplifiers, myself disappearing out of sight. The way we barely touched the strings, the way the notes entered the room, at first dissonant and unconnected. Outsiders, frowned at and peculiar. I'd watched Finchman watching. Looking for some evidence of what came after. Some clue to everyone's movements that day. Everyone in that room. Some pointer that said this video knew by its very existence the precise unfurling of events.

'How do you listen to this?' Juliette'd asked during the build and climb of 'Pig Rental'. 'How do you work yourself into listening to this?'

'Practice,' Finchman'd said. 'Practice and patience. And then – you're gifted a new language.'

'What an arrogant prick thing to say, to think.'

They'd argued and I'd found myself standing next to him, then going down onto my haunches saying: 'Is that the fucker?'

'Oh. Yeah. That's the – that's the fucker. Juliette, that guy. You see the pudgy guy in the leather jacket. The black jacket.'

'That's him,' I said.

'Brother Jean beat the shit out of him a few weeks later.'

It was Blair. A bearer of strange things, of Sonya's voice, of Boulder when there was no Boulder. There was a girl beside him, long hair and slightly thick. Miriam, it was Miriam.

'Good God,' I'd heard myself say. It seemed impossible she was there, but it all seemed impossible, every face and eye and note.

'Who's that?' Finchman asks.

'You remember her. You have to remember her.'

'God. OK. Is that?'

'Miriam George-Warren. You remember.'

He nodded slowly, as if the name gave definition to the image. Brought the pixels to life and he remembered and we both remembered.

'Oh God,' he said. I watched. There was little recognizable about her, except for the fact it was just her.

We'd watched on till I realized I'd been waiting for a whole half-hour for Tone to make his leap, his jump from the top of his stack onto the jumble of steel and brass and wood and skin of Spence's drums. And he did, eventually. The crash and bang and it seemed so strange no one was laughing. Everything went still.

'Who's uploading this?' I'd asked.

'I don't know.'

Then, finally, the band crashed through the remaining set, and then into the outro: Tone, Angel and I, the three of us up on the stage deep in the harmonic feedback and howl through to the end. The rise and shriek, the blister and rumble as we crammed our headstocks into the speaker bins, let the sound run through the necks of our machines and into the strings and into the pickups and around and around, the churn and hiss. Sound remembering sound. Spencer had absented the drums, of course, walked into the crowd to observe as he did at the end of every set. He stood with his arms folded and waited in the roar as Tone gauged the audience bathing in harmony when harmony is allowed its own freedom of thought. I was crouched by my amp as Tone stood in the middle of the stage, glaring out into the audience, his guitar tuned to an open chord and singing the entire harmonic range of 'Dance Prone'. A whole minute of Tone, just staring inside this beautiful noise. And as I'd watched I'd silently begged the cameraperson to turn and scan the audience standing in the room. To just show me who was there.

We'd watched until Tony turned away from the onlookers and the widescreen began cursing itself with lines, the disintegration of the original helical scan, a VHS rescued from a shoe box in a garage and somehow marked *Rare* in the title when in fact it was no longer rare but eternally replicable.

I'd gazed out then, at the kite-surfers; the way they'd swung in the air and flew on under the heft and heave of the sable sky and I'd realized I was expecting light. I was expecting thunder and blaze. Lightning flashing in, turning on them, turning them into fiery ash and bone.

And now we drive and the sky turns to honey. We don't talk about it, just head on. Nico's *Marble Index* out of the stereo and we ride east in the lights coming off trucks and cars. Bursts of

horizontal light, dust held in the rays as if drawn there and never to be let go.

It's a twenty-minute walk into the square from our hotel, to Jemaa el-Fnaa. The lanes and smoke and stores in the night. The various compulsions and deals you feel yourself making as you stare and walk. The understandings you make with the surrounds, individuals and groups, that we're supposed to come here and see, hear, listen, eat. Buy and buy and buy. But I've come here to think, because that seems to be the square's role when you've no desire to eat or listen. So many great cities are so eager to be the sights and howls they're rumoured to be. So much so it's impossible to see without giving up something of yourself. Drummers hammer and all the smoke flows into the sky as a television crew film a blonde woman in travel gear, all windswept awe and heat-kissed in the evening. The sounds, Gnawa and the ever-telling of sagas rolling through the evening. The hundreds and thousands of goods lining street and souk, alleys and walls, the sense you can't buy anything without buying it all.

I've come here to think because I need to think. There seems to be a kind of narrowing, not of people, but of event, of their detachment from the now as if now were a state hypnotized by the things we believed existed in place of the past. Time, dates, people and the structure of their accounts of living.

I head by the newscaster, nod a smile her way. In weeks, or months, or even hours she'll be on the BBC explaining how this is the exact spectacle of the square: its repetitions daily; its minute fluctuations constant. Voices, sounds, gestures, an event of public sense. *All come here to listen*, she'll say. *To taste, smell, see and touch.* A physical space, sheltering impalpable custom, oral and sweeping. Such romance and I'm here because I sense the opposite. I sense remoteness and despair. I

sense the conclusion of illusion and its hold on fact. I'm here because Joan was the first to say its name. And without this the place would mean nothing, another kind of nothing. I expect Miriam to appear, agile amongst the tourists. A real ghost with real grievances.

Finchman refuses to take photos of this place, he refuses to photograph anything he has seen before on paper or screen.

I stand by glistening groups listening to the healing ritual of the Gnawa in song. Story told and told and we hear it as something so close to rock 'n' roll it's impossible not to sit and listen because even though something is missing, something remains. I place dirhams in a can and walk among the hordes.

I'm here because two hours earlier my old drummer and I had waited in the lobby of Royal Mansour to meet his contact. The curator who'd told Finchman he'd seen Paloma a few weeks earlier. We sat in soft, gorgeous seating below massive vaulted ceilings. We'd dressed in suits, prim things, light and expensive. The man had appeared after just a few minutes. He sat quietly, apologizing for the surrounds.

'I'm here on business,' he'd said, 'which is not my own.' He shook his head in a manner we were supposed to take as appeasing. His name was Ibrahim Yusuf. Finchman had met him years earlier in Ceuta when he first moved to Africa. Ibrahim was the one who'd made the joke that Spence was too afraid to enter Africa proper, that Ceuta was just a halfway house for interlopers and criminals. I liked him immediately.

After various pleasantries the curator told us he'd heard Paloma was in the desert, in the south of Morocco. The border lands disputed and lined with mines.

'But no,' Ibrahim was saying. 'Since then, I've heard three things about her location. But now I've learnt she's up in the Atlas.'

'Which Atlas?' Finchman had asked.

'I don't know. Pick one. They're planning something large, improbable.'

'What kind of improbable?' I asked.

'The scale-of-death kind,' he said and laughed. 'No, I am only guessing. I love her work, the tranquillity, ferocity. I love this, I'm moved by massive things. Professionally, I like my art intelligent and small, but a secret part of me is sucked in by scale. I'm tugged at by subtleties which aren't subtle, but I still use that word, what is it about this?'

'We enjoy magnitude because we can't imagine it,' Finchman said.

'Yes, perhaps.'

'We find it easier to imagine ourselves in awe of the colossal, so we dip in. We're scared of small things, what they hide.'

'And what do they hide, Spencer?'

'The potential of illusion,' Finchman said, then looked uncertain.

'The potential of illusion,' Ibrahim parried back.

'Thus the square. We can't resist it because it's there and unimaginable, we love imagining the unimaginable. We go there because it's in the guide books.'

'But you know about the square? You know what's been happening in the square?'

Finchman nodded.

'This is the most peaceful place on earth, until it's not.'

He told us how under the square there are holding cells, dungeons which were until recently used by the government for torture and the inducement of human suffering. 'They stopped but who knows, they can start again at any moment.'

Now I stand amidst the music and listen to chimed rhythms, the improvised chorale of unnamed instruments and their synced owners. It all sounds improvised, but this is a mechanism of trance, practised across peaked centuries. The circle of

song in the rain of healing karkaba. I turn slowly. The voices and chants sung by thousand-year-old men. Whispered pleas, murmurs to the one Lord.

'This is a land preyed upon by God,' Ibrahim had said.

Finchman had nodded, uncertain.

'We're a haunted people. Memories of God. Memories of warring for God. Be careful, is something I say.'

He was a curator from Rabat. He knew Paloma, had known her since she'd put out her sketch book on Gnawa in the late 1990s.

'She's been here,' he'd said. 'This hotel, months ago. Then not.'

I find myself walking the stairs to a restaurant gazing down on the stream and clutter, the smoke and shouts. The nervousness that I might crash into this newly forged version of Paloma, the one offered by the man. The older version, chain-smoking and full of slow talk, of familiarity with this part of the world. But then again, I've no idea what she looks like now. No idea.

'And what is it of Paloma?' Ibrahim had asked. 'Why do you need her?'

'We find Paloma, we find my wife's brother,' I'd said.

He'd nodded slowly, thoughtfully. 'I work for the museum,' he'd said. 'This should be easy. This is Africa after all, gentlemen, this is the site of the first thought. All questions have their answers here if you think hard enough.' It sounded like something he might say to twitchy tourists at his museum, eager men and women hoping for the transcending voice of the all-knowing continent. 'I've connections. I ask questions.'

Now I watch the flow and creep of souls in the square and think how we all long for the safety of galleries and museums. We travel to foreign climes, inhabit their cities and we head to their museums. We long for the confirmation of something within us. I wonder quietly if we go to such places for the

proof of something permanent about ourselves. Here we stroll
on into Jemaa el-Fnaa, ready to commune with agelessness, its
manufacture in the blaze and heat. I wonder if it's the illusion
of a seemingly open production of civilization, a sense of raw
creation, the manufacture of a supposed pre-existing self. A
kind of bullshit we tell ourselves to convince the mind that
all pasts are permanent. I assume this was something Joan
George-Warren once said, written in some book I'd long ago
read. In the great cities, in the places full of myth and the
inordinate romantic spree, we head to the museums, the very
places we never think to venture into in our own hometowns.

I take a picture and send it to Angel, the square and my face
in the corner of the image.

I watch a neon-lit drone lift from a patch of the square.
Children gazing upwards, index fingers tracing the sky.

I've come here to think while I wait on Finchman. To try
and see the people we used to be. I've tried many times to
comprehend the computations of Tone's mind as he came
to the moment, the absolute instant when he shot himself.
What were the shapes of his thoughts, what squally patterns?
I'd visited Vicki in London on my way here as if to get some
answers, her office near the Thames, crates repurposed into
bookshelves, vases and artworks hung on the brick walls.
She'd the nervous aftershock of four double-shot espressos,
grabbing my shoulders eagerly after we'd hugged, then smiling
it all away. Elegant green glasses catching her eyes, making her
soul almost physical. She'd rebooted our friendship in early
1990, started writing letters to me in Ohio, intelligent missives
from as far away as Adelaide and Lima. Back and forth; a
caring monologue between two almost fictional characters. By
the new century it seemed we hadn't known one another in the
old life, as if we'd discovered new people within a new lan-
guage. And this seemed pleasingly prescient as she elucidated
various new facts of memory as we sat in that office wasting

her lunch hour. It was what we always talked about. Memories have corporeal form, she'd told me, constellation-like presence in the brain when fired. Synapse and neurones erupting in seemingly mappable and theoretically repeatable sparks. She showed me a thick tome nicked from the other side of science. Bunching colours, solar-lit MRI scans portraying brains at the full hilt of ecstatic revelry. Men coming. Women coming. The star-danced neural patterning loosened by each excitement, drink and prayer. Jesus freaks, alcoholics and the ill. *If we could replicate this, don't you think we could know the meaning of thought? We could do away with all the ploys of narrative. What a dream.* She'd sounded so sweet saying this it killed me. I'd felt a gradual love for her over the years, something out beyond that old sexed-up *what if.* An unpained tenderness that knew itself as delicate, faithful to something built by ourselves, a rare apparition of what we liked about the world.

I eat, drink two cans of beer, and think. Read an abandoned *Guardian Weekly*, an article on the Temple of Bel in Palmyra, Syria. Destroyed. I see the word *Anastylosis*. I read how a French company is busy digitally scanning rubble so they might join it all up once more out of the dispersion of stone, dust and sand.

What a dream, she'd said. Her two children in pictures on her desk looking like grown-ups. *These are the true ghosts of recollection, Con. The true museum of human endeavour.*

Which told me nothing about Tone's state of mind but convinced me his actions knew more than he was ever willing to say, or knew how to.

I walk the extent of the square, the hawkers and leather and trinkets and mint tea vendors. Snake charmers and juicers and coffee-ripped wanderers. The whole swath of invisible identities. I watch and listen and something has me think that maybe Finchman was right. Something of the raw, the tide of

consistent change is evaporated in the knowledge the space has been shielded against invisible forces. The entire intangible space of song and story, the past and historical enactment. Makes me think it's a bit-part Beale Street in Memphis. The Graben, Vienna. It's the French Quarter minus the French, Times Square without junkies, porn and the mire. It's Hilly Kristal shifting CBGB's to Las Vegas, urinals and all. The *telling* defended by decree, the ancient stories, their projection and expression stalled by the intent to hold them in place. I walk through stores of hats, fedoras and toy giraffes. Baskets of bread and fruit. Stalls of oils and lotions. I sit with the Imazighen and listen. The shimmer and bass. The call and chant and chime. Tourists dance and fall back. I want to join in, take up the guitar-like instrument and twang along. My eyes rolling back, singing, mimicking my own fascination for foreignness, its righteous exoticization. I feel obliged to move but I want to listen and see, hear and clap.

'One hundred fifty-five,' Finchman'd said while we'd watched the video. 'That's how many shows we played.'

'So why this one?' I'd asked.

'Yes. That's the question.'

I walk alongside the Gnaoua dancers back around to the mosque where Finchman had entered earlier with the curator to pray, then the rows of horses decorated and waiting for tourists. I walk back into the square, certain there's something I'm meant to see. I move among the horses. Carts and drivers. I feel the air's fingers in my skin, everything sweating, every pore opening to the scene, letting it all out so it roams my body and clothes. I walk ten metres to a stall and purchase water from the man there. He's grilling several sausages, they bounce on the hotplate and I ask if they're ready. We speak with our fingers. I eat from a small bowl. Alternate the food and the drink. Tip some of the water on my face. Above, wires run across the square, shipping electricity from building to building, feeding

lights and fans. They feed phones, they feed burners, they feed the radios and their musical hearts. I leave the man and find myself paused beside the cameraperson, trying to think how men and women of his ilk feel about their specific contribution to permanence. I believed I'd never see an image of Miriam, never have anything but my own replays of face and arm and leg and guilt. But now there were as many inseparable versions as who would care to look.

I take another photo and send it to Angel, certain it will annoy and confuse the rational parts of him held on to by his old mind's desire to remain a mind. I find myself standing beside the film crew once more, sound and action.

'We go again?' the producer says.

I watch the cameraperson hoist his large digital device to his shoulder.

The presenter seems distracted, looking out over past the camera.

I turn too, once I notice others doing the same.

Movement.

A shift in the crowd, something feels remote, stirred.

'Doug?' the producer says to the cameraperson, nodding back over to the east.

The sudden jerk in the regular flow of tourist and punter.

'You get that will you, good lad.'

Stillness, then running, shouting. *Oi, fuck out my way!* Screaming. And others screaming in the distance. I stand on my toes. The cameraperson starts to run towards them. I start to run also and we're hurrying against the tide. Men and women pushing past me, shoulders knocking me sideways. People on the ground. Others pausing to pick them up. The producer trying to get her cameraperson to get a shot up over the crowd to tell her what's going on. Folk elbowing the other, swearing and panicked. But the melee spreads and thins and I see them then. Men in black pants and shirts, they're among

239

the Gnawa, the song circles. Men pushing over amplifiers and taking instruments out of their hands. There's shouting and old men standing in their path, silence in their faces. The black-clad elbowing and kicking, rushing on, crashing into the next group, kicking over bowls full of dirhams, thrown in there by seekers and drunks. I find them running at me. Fifteen, twenty of them, lurching from group to group, kicking and shouting.

I try to get out of the way, move quickly without running or showing fear. I want to stay near the response, the anger and brawling. Gnawa grabbing at the black balaclavas trying to reveal the faces. I step in beside the cameraperson and three of the insurgents are shunted my way by the crowd. They stumble and regain their footing. Two run off, but the third stays standing in front of me in his balaclava, eyes shielded by sunglasses. White-framed Prada, the kind only owned by souls hunting out the dark.

'Pantagruel,' I say.

'—'

'The fuck, Tone?'

'Don't,' he says.

'What the fuck?'

But then he's running as the police come, he's sprinting to a black van thirty metres to the north, its door open and rushing them out of there, tyre squeal and gearshift.

'You fucking ass,' I say to their noise, to their exhaust and acceleration into the rushed screaming streets.

25

December 1985

The last time I saw Miriam in Yuma she was down at South 5th Street outside Nichols Lock & Key and Post Office. She was crouched outside, sorting through a wad of mail. I was looking to gas up the van before turning and heading across to Phoenix via Highway 8. I went to hit the horn and only connected with the hard part of the steering wheel. She didn't look up. I didn't think anything of it; we'd said we'd see one another at Joan's Christmas party in the hills above Phoenix. She'd watch us play and there'd be some strange conclusion as we ignored one another in the aftereffect of the noise.

During the previous night, while all else'd slept, we'd walked a half a mile to the far edge of the compound where they stored paper and glass for recycling, near to their mock Tower of Silence, the source of all the smell where roadrunners picked at decaying leftovers and rotten carcasses. There we'd thrown bottles at a hunk of rock jutting out from the hill in the dark. We couldn't see the face of it; I'd just been told it was there. A large piece of limestone that had fallen out of the cliff like the worn expression of a doomed president cornered in the red hills. We threw until our arms hurt. We threw and rarely hit anything and cursed the silence as the bottles fell in the sand. Then began swearing at the pain in our arms. I could hear her smiling as she chanted annoyances and *fuck yous* to the murk.

Later we went to her tent. I'd told her I needed to write up that week's highlights for the tour diary and she told me I could use her desk. She cleared it off and sat on her bed and

read as I wrote up Albuquerque and my broken nose. She had me read out the odd piece from the typewriter, laughed in the correct places. She went quiet when I read back the descriptions of the gigs, the carnage and crowds. I wrote on, tapped and reached in with my pen to correct mistakes. She fell asleep, then woke. She said she liked the sound of the typewriter, that it reminded her of a stream. Later I heard the sound of her lighter catching and flinting out on the porch where she went to smoke. I watched her balance a book between her knees. The pages fanning out from the spine. A rare night drizzle then, it ticked into the tent from a hole in the canvas the size of my little finger. I saw the seven dots on her ankles, the tattoo of that number she claimed stood in for not so much the random but for all we construct as the indiscriminate and haphazard. *There's no such thing as random, and there's no determined events*, she'd told me, *just a kind of nervousness for spectacles we can't control or account for.* There was water between her toes as she arched one leg over the other trying to find the gap.

I continued to write.

I could smell the cream she used on her hands.

Time.

Then she was someplace near, stepping on the particle-board floor. The padded sounds under the tent. She was behind me, I felt her put a finger through my dank hair above my ear, tucking it to the curve. I didn't stop writing, just kept tapping and felt the tendons running up my neck. She had a comb, scissors. Tines running through and the sensation of her snipping. Hair fell on my shoulders and down the open shirt collar. Sounds and voices, whispers. She blew the stuff from my neck. Pulled the shirt down my shoulders and continued to cut. I pushed out of the shirt and let it fall into the space between my waist and the back of the chair. Her finger over my brow, the shallow breathing almost not breathing at all.

Then she was gone. My hands stopped typing. The quiet grew till its sides touched the canvas walls. Something told me she was in the bathroom. A door open. A wind-shift among the paper. Sheets moved on the desk. Then her fingers again. Wet warm and the smell of soap. Soap on my cheeks. There was a glint, a catch of light, metal against skin. I closed my eyes. It was a straight razor, ebony handle. The minute vibrations in the noise on my skin. Her breast touched my shoulder. It was cool and I felt a shiver run down my chest to my groin. She took seconds out to consider each glide of the blade, lingering over each follicle. The touch remained fresh, present.

'You don't stop,' she said. 'Keep writing.'

My hands moved back to the keys and her hair lingered on my chest as she bent over, I could see down to the white of her paunchy belly below her breasts as her T-shirt hung forward. There were stretch marks scratched in loose lines. I blew on her skin, watched goose bumps rise. She went back to the scissors. I put my hand out behind her back and let it fall to the fan of her hips.

She smelt of salt. Then she smelt of wet hair.

I found the gap in the side of her overalls and put my hands through and under the top of her underwear. The room seemed to change its shape several times. I felt her squat, felt her crotch take the weight of her on the stone shape of my knee.

I moved my hand up inside her shirt to her breast, the soft rounded mass and hard nipple. We stayed that way, moving slowly until her hand touched my cock and everything seemed to waver.

I felt her move, shifting up and away.

'We should get you out of the camp,' she said.

'What?'

'The bar's still open.' She looked flushed and her eyes seemed a different shade of blue. Her face pink amidst the smell of her, the cadence of late-night sweat and tang. I wanted

243

to bury my head in her. I wanted her to take a step forward and unclip her dungarees from her shoulders and let them all fall so the smell of her could have a sight to match as she pulled away her shirt.

'Come back,' I said.

She moved further away. 'We'll go to the bar.'

'I'll need to change my shirt,' I said.

'Change your shirt. Then we're going.'

I stood. I rinsed myself at the sink fed by an orange plastic tank. I had a blue T-shirt from the bag in the van. She was standing at the door. I could sense her there. I didn't turn. She emerged in the periphery of the mirror but I didn't let my eyes focus on her.

'You haven't finished yet,' I said. There were patches of stubble on my chin, hunks of hair sticking out from my head. I wanted to turn and find her naked, dungarees about her ankles. The map of her hair below her belly. Weighted breasts and her yielding belly. I wanted her but stayed at the basin with handfuls of water knowing she was still and clothed.

She shrugged at me. 'We'll find a professional.'

I still didn't turn. My hair was cut in chunks, some near to the scalp. I looked deranged and eager. She tapped the canvas by the door with a fingernail. I held the shirt at my waist and turned as she pulled her hair back and then let it go. She stood still for what seemed like hours, desperate periods of time in which thought was endless and endlessly unravelling. Then, in a suddenly real instant, she removed her dungarees and it all seemed to happen so quick. Her T-shirt and panties and she was naked. The full form of her and I was hard, erect and that's all there seemed about me until she was looking. Her eyes not on mine, not on my mouth or body or legs or cock, not at the gammy scarring under my ribs, but at the remains of bruises just above my collarbone, how faint they were now but still complaint to force and excess, even after seven weeks. And

she stared at them and came in close. She moved as if she were fully clothed, her eyes on the light discolouration. Her nudity suddenly irrelevant. She took the T-shirt out of my hands, lifted it over my head and pulled it down and it seemed then neither of us were naked, just another kind of bare.

In the morning we drove out as Spurn-Cock drove in, Cozen and Leo in the front seats, waving loons cruising past the sculptures, those tall moulded structures bowing solemnly in the morning sun. Then down on that little Yuma street I saw her. She was wearing the same dungarees and T-shirt and all I recall thinking was the next time I'd see her she'd be someone else.

26

June 2019

There are times when I'm away and we skype. We talk and
stare at one another, and after a time Sonya or I will let the
call run on when we were away from the computer, let it tick
through the night as we go about our business, listening from
the other side of the world. TV, dinner, dishes. Calls to others.
This way we are privy to the universe of ourselves. Here in
Marrakech I lean in at the screen. We try to hear one another,
concentrating. Her face in Wellington and me a half mile from
the square. I can see the things of our bedroom; keys in a
copper bowl, a collection of smiling Buddhas left over from
some previous journey and the book I was reading before I left.
I'm listening to her, to her and all the music ringing in from the
square 400 yards to the north from which I'd walked slowly
back after running into Tone. The clatter of remote rhythms,
of signatures and tablature. Little symphonies, an echoic hum.
Polyrhythmic runs Elvin Ray Jones might've imagined in his
deep sleep, the phase of bass and bells. Song into song and out
into the night. This was what Steve Reich was talking about in
the sixties when he discovered tape loops. This is what he was
talking about when he wrote his thing for eighteen musicians.
The trick of time and how to distort it.

I blink and open my eyes and she's drifted off.

I watch her as she sleeps 12,000 kilometres away and I
read the Barry Hannah paperback I picked up in the sec-
ond-hand tourist bookstore. I went running after the van and
Tony Seburg and found myself panting and wet surrounded

by confusion and things I didn't know. I'd walked until I was inside the bookstore staring at familiar names and jackets. I bought five books I already owned.

I can't wake her, because to wake her would mean lying to her. To wake her would mean, *Yeah, I've just been out walking.* Lying, saying I was just strolling in the square and the whole place was all quite as one expects: massive, heaving, trying. The truth was I'd purposefully gotten lost after Tone'd crashed the square with his pals, hoping for something. A clue as to what it'd all been about. The truth was I found a second-hand bookshop deep in the souk, stayed there an entire hour before returning and finding her on the screen.

There's a mosquito somewhere in my room, coming in near across our range of hearing. I sit up and watch her. Sometimes she pants and then halts and begins again, to breathe softly. But then, as always, an intruding thought. I think how most people, that they die in their sleep. I think: Fuck sleep. *Fuck sleep.* I've so many things to tell her.

We're old enough now to know that we have secrets that are only worth dust, but still, we like to keep them. I want to tell her that she was once in Boulder, that I've heard her sing in Boulder. I want to tell her about Blair and his studio in the wastes of south-east Chicago. I want to tell her about the senseless tattoo that she's prodded at and teased so many times, trying to make the ink shift its place into something more pleasing, less wracked by its imitation of permanence.

She breathes and breathes on.

I wait until the mosquito has come past one more time then clap my hands on its body. Sonya grunts.

She says, kind of stretched and scratched: 'Hey, bunny. What're you reading?'

'Go back to sleep, baby.'

'Hey, darling.'

'Sleep, honey.'

'Hey. What you reading?' she yawns. 'If you can't tell me, turn your light off then, huh.'

'Barry Hannah,' I say. I let my glasses slide to the end of my nose. 'Sone, did you ever do some recording with Blair?'

'Who?'

'Blair Potaski. In Boulder.'

'Fat Blair?' I can see on the screen the way she enjoys saying *Fat*. Her lips pursed just a little.

'Fat Blair,' I say.

'Aha. Yeah, I think so.'

'Where?'

'I think Arizona.'

'Where in Arizona?'

'He turned up, I think. Then my brother with some tapes, some studio down in Tempe. Why?'

'I was on that recording, Sony.'

'Right.' She seems to rouse. 'On it, how?'

'Don't you think that's interesting?'

'I'm going back to sleep.'

'But don't you think, hold on, don't you think? That that's interesting?'

'Maybe the morning will find it interesting. Once I know what I'm having for breakfast.'

'I was in Boulder, and I did this recording. I don't remember being in Boulder. I don't remember doing this recording. But we're both on there.'

She props herself up on the massed array of pillows.

'Who else was on the recording?' I ask. 'Cos it had Tone, me and Leo.'

She blinks like she's confused. Then waits a moment. 'Just Tone and me. And Blair on the boards. A studio down in Tempe.' She shuts her eyes, then opens them again. 'Why're you asking now?'

'Go back to sleep. Doesn't matter.'

'No, why now?' She stares, fully awake, trying to see what's got me backing off. Puffiness about her eye sockets.

'I was in Boulder, but I've no memory of it,' I say.

'OK. Maybe, like they say: *Two cans in Colorado is worth six in the rest of the world.*'

'And we're both on the recording, Sony.'

'Tony came to my house,' she says. 'Drove me to the studio.'

'Drove you. That's it.'

The music from the square grew, widened. Wind-shift, perhaps, or some lighter air. A whole museum of sound shifting and strange.

She sighs. 'You know what I'm doing now? I'm thinking about Vicki,' she says.

'She rang,' I tell her.

'How'd she get to be so much smarter than us?'

'I don't know. But why'd you think I was in a band with her?'

'She was telling me a while back,' Sonya says. 'She said how all memories, they're always on the go. That they're always subject to incessant adjustment.'

'I think we know this,' I say.

'We don't ever notice that a memory's altered, cos it always looks the same to us. It all looks real, even though it's quite changed. It's just a trick of the light, except the light's synaptic and the shadow play's the whole world from before.'

'Really?'

'She said while we were yabbering. The good news about all this is that memory can't ever signify reality, not with any degree of precision. It's ridiculous, but I find this such a relief.'

'There it is. I'm not arguing.'

'You never argue, that's your problem.'

'How can that be a problem?'

'—'

'I miss Vicki,' I say. 'I imagine her sitting in front of her classes. Teaching this history, and this ancient thing and I'm thinking about her students, going: *You lucky fucks.*'

Sonya nods and seems to loom on the screen. 'I always imagine she's just everywhere,' she says. 'That she's just going to be here, there.' Sonya blows a jet of air out between her lips. 'I don't know what I sang,' she says. 'I just sang. But I've never been to Boulder.'

The retreat and rhyme of sound and shouts from the square, crystal noise and a whole hazed distance. I get the feeling she's lying. I sense she's uncertain and lying.

'Honey, you look nervous. What you nervous for?' she asks. 'I've known you longer than your mother. You don't get nervous.'

'—'

'Honey?'

'Don't know. Maybe for the some-fucker-who-doesn't-know-he's-about-to-die,' I say.

'Huh.'

'You know?'

'*My* some-fucker.'

'Aha. Kenny. I'm thinking: *How's Kenny Kidney?*'

'Kenny Kidney.'

'Sure.'

We've tried to give it words, names: The Sucker, The Organ, The Meat. Nothing's caught. Tried to imagine a kind, eased death for some poor bastard.

I say at her, ask: 'Sony? If thought and memory, if they were physical, what would they look like? Right now?'

'Right now?'

I nod.

'The lot of them,' she says quickly, 'everyone who's got to go to get this done. Everyone who has to die for me to have a chance.'

'Yeah. OK,' I say.

She picks up her laptop. 'I do searches for people, Con, you know? People about to –' and she gives the knife across the throat sign – 'people about to quit. About to meet their doom.'

'Any luck?'

'No. Google hasn't figured that one out yet.'

'No, they have,' I say. 'They've got an algorithm, but aren't sharing.'

She smiles.

The odd silence of a rain-harassed roof. I listen, trying to hear if it's hers or mine.

'Sonya,' I say eventually, 'I know where your brother is.'

27

And her brother, her brother on that final day, he stood on the stage in Phoenix so utterly present, so defiantly there on the verge of *now*, leaning his ear against the roar, against the noise and great light of us in flight. Guitars, bass and the collision hit of the snare and kick, the burn of hi-hats. This was the last day and this was the song recalling itself, remembering and summoning itself. This was the hidden empiricism of performance, blur and pain, muscle and noise. It was flash and nerve twitch, body recall, instinct and adrenal efflux. It was the fight through the drug hit and drunk. It was the fight through bad lighting, through appalling monitors run by madmen. Through divers shouldering their way into the afternoon wreckage at the VFW on 2nd Street. Our name stencilled there on a shirt as a body leapt back off the boards into the loose chant of the crowd.

Riff, hook and feedback.

The next song. The next.

Feedback screech and crowd scream. The punch and glide, the pounding absolute of song into song, no intro or pause. Count off and how did we remember every note and word when so much else vanished?

Song ten.

I broke a string at the end of 'Radiation Cures' and Tone and Spence and Angel went into an improvisation. Heavy, slow, grinding. Spare then dense. Volume then silence, then volume. I tuned as they played and this improvisation would appear on

Tone's first album two years later. Written there in Phoenix as
I fixed my broken string.

'Pig Rental'.

'Shocked and Poor'.

'Pink Ships'.

The song names listed on paper torn from a diary. It'll later
be nicked off the stage and pinned to a teenager's wall. Stared
at years later when he returns from college, no knowledge that
the most famous piece played that night wasn't even thought
of when the list was made.

'Green'.

'Red'.

Then the rhythmic hustle of a voice, of another voice,
shouting my name.

'Brother Jean!'

I kept banging on the guitar, not taking my eyes from the
frets.

'Brother Jean!'

But I knew the voice. I remember remembering her voice.
Sonya, she was there, finally. She sounded invisible but clear.
She was there screaming my three syllables like she wanted
to die on the end of my name, impaled and writhing. *Brother
Jean!* I saw her at the near-blind edge of my eyesight. She was
suddenly bald, screaming from the side of the stage, dancing in
a red kilt as I yelled words into the room and the room fought.

She was shouting. She was giggling, dancing, everything
up and down. Everything rushed through me. Everything
vanished.

Sonya with her head shaved clean. She looked extraordi-
nary. Her eyes like cats', taking up half her face and no hair
around to contain them. I ran at her, wanging on the guitar
in rock pose: there's no other way to play sometimes, and
sometimes there's no other option to stand but with feet apart,
snarling. The things we did with our mouths, yawned like

253

terror, stretched open like knives were stuck in our backs. Why did this look, this body joy seem to resemble something so close to pain?

I went into the tight picking against Tone's. So pretty, major thirds and ninths and octaves. Two rhythms against the other collecting into a string of notes and chords bickering and fighting to be the one beautiful thing in the room. I was just inches from her face; I leant across and licked her cheek. I didn't know what else to do. I tasted the make-up and sweat and fell out of the song for a moment. She was smiling like the music was suddenly so far away, grinning so hard her face was about to fall off and the band lifted the song, lifted it off the floor, some beast pushing up from its knees. I stayed watching her until Angel was beside me, jumping, banging his back into my own.

I leapt backwards in a kind of mental pogo. Missed him and fell. Struggled to stand. Sonya was yelling and I felt something sharp on my lower back and I thought: *Glass*. I thought: *Fuck, glass*, that I'd landed on a broken bottle and it'd gone deep inside. I rolled and sprung to my knees. There was a face with a pen, leaning over the monitors trying to write on my skin. Jabbing at the small of my back, scribbling. It was goddamn Paloma. I rolled and tried to stand but couldn't. I turned and saw Tone as I tried to get the chords back. Tone off the stage in the audience clambering up a curtain. His guitar hanging off his back ringing feedback. The string sound beautiful and random in the song. Beat and bass and the trance of two notes or three as he climbed in the dervish.

And I was falling again so I was on my side playing my basic crib of notes. Tone climbing the wall on a huge drape. I hacked at my chords as I lay there, Paloma reaching with her pen once more, arms pushing out of her army jacket.

'What the fuck,' I yelled, but she didn't respond.

I stood finally. Blood, there was blood again on the

pick-guard, so I must have dropped my pick and I shouted something else at Paloma but it was lost. I must have dropped my pick and used my fist. Ah, and then the whole curtain was coming down with Tone and his mask as we kept at it, this hypno-beat and the merge of time and people and words and pain. A falling streaming gold mess of net curtain fabric. He cascaded into the pit. The crowd caught him, they held him above their heads and handed him back to the stage with this fabric tucked into his jeans. He dragged it so amps fell and it was just Angel and Spence in on a strict beat. I stumbled and fell again. Jammed the head stock of my guitar into the gap between the speakers and the amp head. The drone vibrations running direct from my speaker to my fretboard to my strings to my pickup. I sat with the guitar above me, bending the neck and lifting the two amp-heads. Angel's eyes closed. I watched him in the howl. He'd synced in, a perfect monster of red hair and thick arms. He stayed in that click with Spence till Tone and I were ready, the two of us falling into the rest of the song, the final beats played out staccato, ten times over, heads banging. The dance of dance and Tone in the centre of it, beautiful movement. The grand stampede for the end.

Then out the back. Sonya & Brother Jean.

We tussled, kissed faces, mouths and tongue after the show. Delicate, hard and she bit my lip and ear. Hands in what was left of our hair and legs lifted, ragdoll embrace. Everything had rushed through me and vanished. We cried, snot and the way she wiped it on my jeans and I put my hands under the soft cotton of her T-shirt. Words, words like baby, like *Oh baby*, like baby talk and we didn't care about the way we could have fucked right there and then and how everyone saw our faces all wet with tongue, tears and sweat. So many moments, we knew, to wash away.

Later we watched as the people filed out. Sonya smiling out past them into the crowd beyond. A girl stumbling and her boy pulling her up from her knees. They laughed and raised mock fists as they fell into the rest of the audience walking out into the early evening.

Sonya looked small, her features saddened. We watched each other. She took my hand and put it on her head and rubbed it, the soft seal feel, the clumps she'd somehow missed, but what the hey.

'I love your hair,' I said.

'I love yours,' she said, though that wasn't what she meant to say. She looked at my hair half cut and moved her mouth as if she knew the right words but they were blocked by some other thought.

We both began walking out of the room. The two of us bright as if nothing else had happened in the world and we were the light that all woke to.

'How many days you think about me thinking about you?' she asked.

'Every Sunday and Tuesday. Most Tuesdays,' I said.

'How many hours.'

'Eighty-seven,' I said.

'Which means you missed me.'

'I've lost twenty pounds.'

'It was worth it then,' she said.

'We haven't eaten. Not really.'

She jogged on the spot in the glow outside the hall as we waited to cross the road. The slow cruise of a Saturday afternoon, cowboys and their redneck sweethearts all blossomed, they shouted at us because I'm a faggot and Sonya's a fat dyke. Every second car and someone's got something to say, someone's loading up and making their fist and forefingers into a pistol aimed right into the heart of us.

'You look so sweet and handsome,' she said.

'Come on.'

'I did you a favour. Or, Spence did you a favour. One of us.' She pulled my hand up to kiss. That was when I first remembered to look, to scan the crowds for Paloma. 'I didn't take the money box,' she said as I flitted my eyes about the crowd. 'Spence forgot it. Something was forgotten. I put it in the bag and put it my own bag, I took it. Which made no sense.' She stopped for a moment and looked me up and down. 'But you look so eatable – so.'

'Jesus says, *Fuck You*,' I said. It was a line from a Rhinosaur song, deployed at will.

She laughed, said something else and I pretended not to hear her. She looked up the road, past the cars slowing for a red light further down the street.

'You missed my voice, right?' she asked. 'You missed my eyes?'

'Yes,' I said.

'You missed touching me. You missed feeling you had the right to touch me – and touching me.'

'I missed saying the things I sense you haven't heard before,' I said. I sounded like an asshole and the guilt started then, silent but nervous and I looked again for Paloma and realized I was looking for Miriam as a truck came by, rumbling through the shortest day of the year. A quiet monadic guilt of immediate and forceful growth, a kind of psychic tumour burrowing up from the base of the brain stem.

'What parts?' she asked. 'Detail the parts.' She watched the traffic again, the lone drivers headed for the all-night video store, then back at me. Her huge brown eyes asking things, telling.

I leant into her. We kissed, the warmth of that. Cars honked to our left and we broke and looked: nothing but the regular honk for a girl, a set of girls. We whispered at each other, watching our mouths for the secret things not said in words. We'd spoken for an hour on the phone when I'd first got

to Yuma. She told me a hundred things. Told me how her neighbour had been playing music all night, keeping her up. I joked, saying nations had gone to war over bad music, sent whole armies to battle symphonies and rogue song-cycles. Blood across deserts. She laughed but I was frightened there was something else, some other emotive force at play, hidden by the phone line.

'It was a Ruger,' she said suddenly on the street. 'A Bearcat.'

'What?'

'Tone's fucking gun.'

'Where?' I asked. 'Where'd he get it?'

'What?'

'The pistol. Whatever else you call it,' I said. 'Pistolero.'

'You find them in pawn shops,' she said. 'Some greasy-haired loafer charging you whatever comes to mind.'

She settled into a hundred-yard stare out into the street.

She told me about the money, suddenly and strangely. She fell into me so the warmth of her breast was against my chest. She stayed stiff as if watching someone read her poems aloud among strangers. Two kids sidled past, one of them started shouting lyrics at me. The words from one of Spence's songs. They yelled them like I'd written them first and had an idea what they meant. I quickly looked for Paloma again, for Miriam, for one means two. Then. Then. I realized what we were talking about.

'Did you?' I asked.

'Did I? Yeah, I did. I made an appointment. Some shitshow clinic. I picked up my phone and made a call.'

'You should've said, I would've found the money someplace.'

'You're so, so kind, Conrad. What a sweetie. You would've found the money?'

'What am I supposed to say?'

'You say: *Darling.* You say: *Love.* You say: *I'm sorry love I wasn't there. I wish I was there.* You say that. *Love.*'

'Of course I wish I was there.'

'But you weren't and you've no idea what happened. You've no idea.'

Then I did that small thing some men do when feeling shameful, I shook my head and stared out past her shoulders like I knew things, like I owned the territory bordered beyond her thoughts.

We jogged across the road and it was cold suddenly in the hit off a breeze. But I didn't feel anything, wouldn't feel anything until the adrenalin had slipped my veins and my body finally stopped playing. The volume was turned off half an hour ago, my guitars were in their cases and my cables correctly coiled, but the rhythmic edge of it remained. A hum like the thick cables shipping great volts across the countryside. I was also, guiltily, thinking of Miriam. How she'd said I could go back there, to Yuma once everything was done. How impossible that was now we'd seen one another naked. The guilt of it, its translucence and fact. And the guilt of thinking of that escape and Sonya right beside me in the sudden worked cold.

'I'm sorry,' I said, unconvincing and too quick.

Sonya looked around, avoiding my sightline, said: 'There should be a fucking library. A gun library, full of the fucking things. You take out a forty-five and walk around with it for a week. Any crimes are the city's responsibility.'

'You say this?' I said.

'And I'd lend you my fucking card,' she said. 'Then you can blow my goddamned brains out for me.' She laughed then, exhausted. Done.

We were at the door to the bar and we went in. She watched me sit, as if there was something in my movements that would allow her to understand me more than if she were just listening.

She pulled out a roll of twenty-dollar bills. 'This is what's left. It's most of what I took.'

'Most of it.'

'I bought moisturizer. I bought some food and paid for Tone's gas on the way down here. That's about all I paid for.'

And then the sense I knew what I didn't know.

Two kids stood in the window as we drank. We downed two whiskies with Miller Lights. I watched them as Sonya talked. I didn't know if she was angry at herself or me. All I had was the sense it was neither of us. I sat silent and ignorant. She knew something about us I didn't. A common thing I hadn't yet understood. I could see the boys' breath on the window. Then one was knocking on the glass with a dime. His friend had his dick out and was pointing it at me, swinging this thing around. His T-shirt a screen print of the *Peace & Hate* single – a silhouette of a man hammering a nail into his nose. He was one of the kids who'd been up and stage diving. I smiled at him and flicked the bird. The boys were about fifteen and they wanted to make my evening by showing off genitalia. Then, as he started to pee, a shadow blocked out the light behind them. It was Tone, he went past and they must have noticed my gaze jumping because their eyes lifted from the glass and turned. I was no longer important. A man with a respiratory mask and a guitar case pushing by meant I no longer existed. I stood and watched him enter the bar. He showed his ID to the doorman and I shifted around to Sonya's side of the table.

'Now,' he said, but didn't say anything else.

The barmaid came by and picked up Sonya's empty glass. She gazed at Tone's mask, a kind of: *My old man'll put a bullet through you if you even think about looking at my ass.* She nodded at me and glanced at my beer. She called me *Honey Love.*

'You get all the sweet things, huh?' Sonya said when the waitress had gone. She smelt a little of beer and BO.

· · ·

Some black-jeaned figures gave us a snarl as they walked in. Four of them watching us. It was Typocaust. Blair and Amerighi.

'The fuck,' I said.

'They're playing George-Warren's party,' Sonya said. She turned and looked at the boys. Then something broke because she smiled, laughed as they all, in delightful synchronicity, gave her a middle finger, then waved. They were suddenly those impossibly sweet kids. She hadn't been at the Garage, hadn't experienced the full wattage of their annoyance.

'We don't have to worry about a thing,' she said. But I wasn't listening, then I was because she repeated the words. *We don't have to worry about a thing.*

Tone and I watched his sister. Then we watched Typocaust for a moment, awful replicas of ourselves calling out for beer with their fake IDs. I found myself holding Sonya's hand with some determination. It was soft, as if moonlit. She undid my shirt buttons, then did them up again, then started over, undoing them all and buttoning them up. She stared at me, kissed my mouth and stood.

'We don't have to worry,' she said. 'It took care of itself. Like it knew.'

'Christ, Sony.' I felt something pour from the rear of my head, a lightshow shimmer of nerve endings and scalp. 'Sone?'

'I'll see you at the party. I got to go to my boys. You know where you're going?'

'What do you mean?'

She kissed me and went past the band, watching them watch her as if recalling the time and the time before that. Blair shouted something at her. She ignored him and ran into Vicki and Spence coming through the door. Vicki and Sonya embraced in the way girls know how to embrace, the way their bodies seemed to fit. Sonya left after a couple of words. Tone watched her head out. His eyes lingering on her back and the

blue and red kilt, and then on the idea of her walking that remained.

He glanced over his shoulder in the direction of Spence and Vicki as Sonya went past the kids outside and I wondered if Tone knew the way I was looking at him – how I was a kind of phantom, jealous for what he saw while he watched her leave: her back and so little else.

'Tone,' I said. 'There's something I got to tell you.'

'Mate, I'm sick of hearing things people think I got to hear,' he said.

I shook my head at him. I gritted my teeth and instead of telling him I unravelled my scarf and pulled my undershirt down. I pointed at the last browned-off remnants of the bruises. I told him about Miriam, and the way her face had changed, the way her body had become something else when she looked at their dye-like presence under my skin when she saw. The deep indelicate markings of gripped fingers, of involuntary seizure by hands steadied by cold, violent resolution.

'Well, fuck,' he said.

'Well, fuck,' I said.

'OK,' he said and I stood.

'You know what this means?' I asked.

'Miriam? I believe I know what it means.' His eyes blinked, their familiar glare narrowed and flinched, latching on to the same thought I'd had for days: she'd seen the same rough digital patterning before; she'd seen and read the markings like a kind of possessed Braille. I looked at him and felt his stare full of fear, as if saying all intelligible histories were bent, and not only bent but corrupted by the transient decay of passed voices, dead voices and the presence of what we know through sudden torment.

I stepped out then and went after Sonya, all around me people hurrying in the full night.

• • •

I followed her the two blocks to her apartment on Richmond Ave. I watched her body and back, the determination to get out of the dark and into her room. Pot plants to water and coffee cups to arrange, her roommate's cat to grab up in a quiet bluster of babying sound and nuzzle. She pushed on from street light to street light and I was certain I knew what it all meant, Miriam's body reaction in Yuma. The abruptness of her sudden determination to clothe me and reduce my presence there to that of a mere sound beside her in the bed, bodiless and sympathetic only to the mysterious softness of sleep. I watched my girlfriend, the easy intention and pace and I was certain some vastly angered thing had happened upon Miriam, an event matched by the hatred in the back of the van in Burstyn. Sonya didn't turn until she was at her door. She didn't speak until we were both standing in her room, clothes on the floor, bed a tangle of dirty sheets and blanket.

'Don't look at me,' she said softly.

'What am I looking at?'

'Don't look at me,' she said again, and I looked at her.

I thought silence would win out here.

'Life's just pricks and dicks,' she said. 'Or am I talking about the other thing. Am I talking about death? I don't know what I'm talking about.'

The room felt so full of her. Things she brought back from Burstyn. Plants in pots and posters. Things of mine: a typewriter and tape deck. She talked and talked on and each word seemed multiplied by the possibility of the last. I sighed.

'Don't make that sound,' she said. 'You don't have the right to make that sound.' Thought, then: 'I didn't want a baby. I just wanted some control of the process. You know, Con? Or maybe I did want a baby. Whose fucken right is it anyway, to have a baby?'

'You don't have to say what happened,' I said – and they sounded like the worst words, the weakest.

'I'll tell you what happened,' she said and her body seemed to fail a little, she slumped so she was sitting on the bed. She waved me over and I lay next to her. She pulled my arms around her, I slid myself so her ass sat snug against me. She held my hand against her left breast and began.

'It started on a Tuesday three weeks after Tone was let out. Started with massive, blood-like cramping,' she said. 'It was about three in the afternoon and I was there with Tony and he was wandering the halls playing his guitar and this vicious fist came up through me and I tried to sit and couldn't sit. I lay down and got up and shouted, but he didn't hear me. But it wasn't a shout you want people to hear. Just this shout and I went to the bathroom. I went into the last cubicle and there was no pain after that. Just the sensation of organ loss. Which isn't the right word, but I don't know the right word. There was blood, a fair amount of it and I went through a roll of toilet paper. Then I made coffee and poured gin and went to my brother and kissed his good cheek and he wondered what that was all about and – that was – that's it. The next day I cancelled the appointment at the clinic because I didn't need it anymore. Hence, you get your money back. That's it.'

But it wasn't it, she talked on and when she started to repeat herself I let her, and when she started to say words that no longer seemed to connect to other words I put my hand on her cheek and felt her jaw open and close. She stopped then, turned, put my index finger in her mouth. Her tongue soft and everywhere.

'I hate you, Con,' she said.

28

Then we were in the hills. Joan George-Warren's party in her grand ol' home gazing down into the Valley of the Sun where Arizona spread its millions. The place vast, full of ceilings and abandoned rooms, titanic cupboards and wardrobes. A Queen Anne, built during World War I for a mining magnate. The home constructed out of multiple towers, angles and gables. A baronial monstrosity of fanciful detail and grandeur. The whole startled thing generated by the combined mass, roofed by a mix of angles and surfaces: it wasn't huge, but seemed huge. Obscure rooms and the ballroom where we played. There was even a giant mirror on the south wall so all of it danced in doubling strides. Joan's house, bought for near nothing during the housing slump in late '79.

It was 22 December. Halfway to summer and half of the souls sober, half of them from a crowd that phased in and out of another art colony camped in the foothills out east. Hairdressers and waiters, scene kids and record-store dudes. The sculptors and painters who camped in the desert, firing paint from an air-cannon onto giant canvases. The room crammed with such things as their work and conversation. Large paintings, burnt landscapes. Serigraphs and the large picturesque of the entrance to the Honanki dwelling, the over-exaggerated cliffs of its surrounds. Then the skate-punk kids breaking into scuffles, minor punches as if it were all a necessary act to stake claim on the atmosphere.

Five bands before us: Sun City Girls, Spurn-Cock, JFA,

Sonya's unnamed posse and Typocaust. The latter had played to no one first thing and Blair and Amerighi were in a race to drunkenness. They put themselves in people's faces, lingering on the wrong side of abuse as Blair staggered by, riddled with unexplained grievances. People were doing their best to ignore him when Sonya arrived on stage with her bandmates. Two guitars, Nikko on bass, and a drummer.

I watched her tune, string to string. Watched her strum airily, the song somewhere inside the simple harmony and rhythm of those first few strokes. She played over by her amp. Nikko with his bass high up, a little melody, then the kick and snare and low hum of the lead guitar. The song hovered, rising like starlings, the way they group and mass and flow. She sang, because she could sing. Slightly flat and warm, high like the bassist out of Galaxie 500 a few years later.

People stood and watched, the folded arms, heads tilted in the ringing harmonics. Blair teetered in his vague dance, arms out like a loon. Music is so simple and all it takes is an accent here, a trembling finger there and it's suddenly perplexingly complex.

I watched Blair stumble in his angled dance, swaying from foot to foot, then halted in the middle of the floor like he'd been hit, as if frozen by some distant and now near thought. He talked to himself, swatting invisible souls out of the way. He had *Nig-Heist* stencilled on his jacket, a kind of joke because he'd told me back in Denver how much he hated joke bands. Soon he started shouting, shouting out during the quiet part of the song, like there was an emergency nearby. At first, I thought he was in a kind of heat, and it'd wear off soon enough – but then I saw him snarl and turn his mouth into a *fuck*. He threw his plastic cup at the stage so the punch they were serving danced up as it hit the mic stand and the air was momentarily full of vodka and cranberry juice.

Sonya continued to sing, wrangling a chorus out of her

same two chords. It was her band, though all the music seemed to rumble out a place I hadn't had access to. Deep sound blessed with tambourine and drones. Blair was yelling: *Fucken bitches.* He spat and the wad stuck on the front of Sonya's kilt. She ignored him, singing through the spray and shouts. I started moving towards him, ready to headlock him and drag him out by his neck, but Amerighi got to him first. Took Blair's arm and guided him off. Sonya caught my eye and I saw a micro shake of her head, like she knew. But then took it to mean stay put, that this was the music and this was the song and people will do what they will with it.

I watched the audience float into the bowed space of the dance floor. A mislaid girl and gal holding hands to the side underneath the room-long mirror. Strewn make-up. T-shirts for Black Flag, stencils for Minutemen, Meat Puppets, Millions of Dead Cops, Sun City Girls, Spurn-Cock – words that seemed part of some mock language, the Lapine of desert-land punk. A sculpture of a six-foot Gautam Buddha under construction across the back of the dancefloor, sheeted and draped against the dust, figures moving transiently past openings in the blue fabric. How clearly I saw them, three or four kid-punks making out in the skirts of this thing, making the work seem a failure, a dereliction in the abandonment of idea.

I saw Tone talking with Joan, animated, heads down, serious gabbing at the makeshift bar. I saw Bern exiting in and out of a door where some drank a crude mescaline mix drained from a peyote somewhere in the Chihuahuan Desert. I nodded but he didn't recognize me among the half dozen walking by who thought it was a masquerade, masks hiding their features. I walked until I saw Paloma, bottle-feeding the baby. Miriam's sister with this tiny less-than-one-year-old with a beanie over industrial earmuffs. I remembered what Miriam had said after we'd spent time in the wrack of dirt and sand. How she seemed to trust me despite giving her every reason

not to. She'd told me how in the months after she'd stopped seeing Leo at the start of '84, he'd slept with Paloma when his band went through to Yuma with Spence. I believed she was telling me it was Leo's kid, his and Paloma's. I look around for her, scared and thrilled that she might be there someplace. That she'd hear Sonya sing and know things about me nobody else does.

Blair was shouting again, despite people yelling at him: *Hey, shut-the-fuck-up!* He went on shouting: *Eat my balls. Eat my motherfuckin'-sick-bitch-balls*, as Amerighi dragged him to the side. A JFA skater-kid ran past and pulled Blair's jacket from his shoulders so it went up over his head and stayed there. Blair shoved his drummer off, corrected his jacket and went back to the middle. There he stood, shouting.

And Spence stepped forward as I started forward, stepped into Blair's face. Spence tripped and Blair lunged at him. Then our drummer had him by the hair and was dragging him through the audience in this grand old house. People staring, fascinated but on their tiptoes in case this scene came too close. Then Blair swung his boot out, kicking Spence's feet and they went to ground, the both of them. Angel ran to the scuffle, pulling Blair off. Spence told him to fuck off. Blair shouted also. Spence started in on Blair's kidneys. His fist balled into something I hadn't seen on him before.

Grunts and *Fuuucks*.

The song ended. People on the edge of applause and Tone was still speaking to Joan because Joan was at the bar and they were clapping because others were clapping but really they were just talking and Spence had Blair by the neck, kind of a harmless throttle, and the shitter was wincing nonetheless and then they stopped. They fell off each other, panting, blood out of noses. I eyed the room once more. The engineer with his head down over the mixing desk, soloing channels for his headphones and looking at the equalizers and gains and

memorizing what he'd done. People clapping, then turning to each other to talk. I had the odd sense then of emptiness, that nothing had happened. None of this. That there'd been no fight. No Blair and his idiocy. No tour. No gun. No Sonya lying in the bathroom with blood on her fingers and a towel between her legs. No blood-hurt of a miscarriage at the Eighty-Eight sixteen days earlier. No words shared with Miriam and no Miriam. No blood and broken skin, torn haemorrhoids and bleeding shits. There was only Sonya on stage and us standing there and Tone talking with Joan and Angel and Spence just being Angel and Spence.

And it was all as if nothing had happened in the back of the van but sleep. Nothing as Sonya played on.

Nothing till a flash of leather, a sudden and fresh noise. My head jerked up. I looked up because Blair was jumping, leaping so his jacket was floating in the air. A black cape in slow motion as he ran and went at Spence. Then Spence's fist in Blair's hair. The two of them, knuckles cracking on broken skin.

I ran, I went close and tried to put myself in front of Blair. I was willing to hit him or use my forehead as a ram if it came to it. I got an elbow in there and I felt his chin crack on the tip and he grunted but went madder, he bit at my arm and jumped up and over my shoulder as Tone ran from Joan to separate us. I caught Blair as he lunged at Tone's face, his mask. *Bitch*, he shouted. I could feel him pulling himself over me and then I heard Tone shouting. I felt Blair kicking and then stop. I flung around so Tone was right there in front of me. His respiratory mask was off and he was shouting. The crowd started to clap for the end of the song and the end of the set. Sonya's band only had five tunes and this was it. Hands slapping like a kind of rain falling through the room. Sonya put her guitar down and started from the stage towards me, could see her through

Blair's long hair hanging in my face. I swung him around so his legs went out. I saw Tone start to hunt for his mask, saw the site of his wound as his bandages spun off. Sonya stood erect in front of us all like she knew where this ended.

And I thought it was at an end too as I pushed Blair off me. I watched him crawl up onto his haunches. He looked half conscious. Looked like he might stand until Spence went at him. Went at him with his boot and collected him on the chin and how Blair fell backwards. How he watched as Spence stood over him, used his fist to muck his face and then, then, that was the end because Spence stood in the centre of the room and felt the arms of others as they dragged him away, screaming. I went to him and put my arm around him and glanced to the side of the room, Miriam stood paused at the door, watching.

29

I walked stupid and dazed about the party. Blair's blood
smeared on my arms and face. I hadn't sought a restroom
or water; I wanted people to know this was another's blood.
How, I wasn't sure, but I desired the sight of me, for it to
breach some kind of boundary, the way it smeared and spoke
an unidentifiable anger. I went through a kitchen area, the
light off, just a vague illumination from the hall outside
revealing the hidden movement of smoke. I dripped on the
floor. Panted gravelly. A breeze ached into the room from the
cracked sash window. Then the flare and catch, the flicker of
Joan George-Warren leaning on her cane. She appeared behind
a cigarette, thinned and narrowed by event and circumstance,
by some unseen crescendo of conspiracies dreamt up by time
in the dark.

We stood in silence, the kind that feels borrowed from other
hours and minutes, another moment when all around you are
people for whom comfort comes easily. I guessed she'd come
into the room to cordon herself off from the party, I gathered
this from the way she looked up at me as I stepped back, sur-
prised at her sudden appearance behind the cigarette. I'd seen
her ten minutes earlier talking with Tone after he'd wrapped
the bandages back around his head, their faces close and con-
centrated. Here she was stooped, trying not to see me, as if not
seeing would allow a degree of invisibility. But I was there,
and she was there.

And she spoke finally. 'It's always something, isn't it?' she

said. 'Watching people. It's something.' She gave a slight roll to her right shoulder up near her ear, all to imply movement: the punch-up and fight.

I leant my head into a nod. I was still run through with brio from the encounter. A part of me wanted to go back out and find Blair, to resume the fight, to fucken nail him and hurt my hand on his face. But Sonya had shouted at me as I left with Spence. She dragged me from the room until Vicki found us and they went off together.

'Makes you feel raw, linked. Puts you outside, doesn't it?' Joan said.

'What?'

'Makes you feel connected to something. Makes you feel like a true outsider.'

'Does it?'

'And then, by way of proximity, an insider.'

I'd also wanted to find a room where I could stare down the noise of the party and meditate on the remaining image of Tone's face. Look at the quivering memory of it over and again. The view of his gored cheek that kept entering then slipping. Instead I'd crashed into Cozen Jantes and he'd pushed me up against a wall, this leery grin on his face. He smelt of eighty cans of beer. *The fuck you going?* he'd said, then shoved me and walked off.

'Why're you in here?' I asked Joan.

I wanted to see it again, replay it. Examine it for proof of something, of rare knowledge.

'Violence speaks to our expectations of the world,' Joan said. She sounded resigned to this thought and flattened by its source. 'I don't want to believe it, but it seems to be proved over and over.'

'Sorry?'

'It's the—' and Joan flinched as Nikko made some exploratory hits on his kick and snare in the main room.

'That's just Nikko,' I said. He'd swapped his bass for drums and Spurn-Cock were about to start.

'It speaks to the way you've been primed. The way you expect the world to behave. We expect violence as a natural response.'

Joan passed a bottle of whisky. The room smelt stiff with its malts and cigarette smoke. We stood quiet, the party elsewhere. I'd wanted a room where I could re-examine, recall the gore and look in close at his stitches and the seep. I wanted to see his face, hold it in front of me and look hard at the ruin of it. Instead: Joan and this silence.

Bada, bada, bada, bada in the ballroom. Kick drum, snare.

'Where's she?' I heard myself ask.

'What?'

'Where is she? Miriam.'

'She's here.'

'Where?'

Joan shifted her position as another body entered the room, two bodies. Paloma and the little one. The Moroccan left the door open to the hall so light gloomed into the space. Features and mouths slowly becoming visible. Joan kept her eyes on blackened glass behind me. She stayed that way until the baby shifted her attention, stretching its mini arms and feet. Paloma held the thing under its rump so it was up near her face. Then asked: 'You get it?'

It took a moment for me to realize she was addressing me and not her mother.

'You get it? The tattoo?' she asked. 'That ankle thing. Most of you boys get it.'

I couldn't answer, I just looked at the baby, Joan's grandkid, a daughter and niece. The many titles of a child without words of their own.

'Most guys, you guys,' she said, 'you either want her or, whatever. Bang. You're limping around.' Her eyes remained on

the child, she didn't look up. 'Most of you guys just want her, and that's it. Her and it.'

'I got mine in Houston.'

'Houston? What about it?'

'Two dudes,' I said, 'they got theirs from her. There's a lineage.' I sounded cold and young, like I'd slipped back to an age where I believed sarcasm sounded wise.

She murmured something and I noticed Joan staring at me. Her eyes scanning the movements of my face. The cues of muscle reflex and deft giveaways. She turned away from me and looked at her eldest daughter. Paloma was rail thin, a different form to Miriam, singular with narrow eyes.

'What are you doing when you get a tattoo?' Paloma asked.

'What?'

'What are you doing? When you get a tattoo.' She forced these last words out, agitated, like she knew my answer before I did. But I didn't care, I didn't want to answer, I just kept looking at the baby. I examined its features, the reddened cheeks and softly distorted mouth.

'You're not doing nothing,' I said.

'When are you due on stage?' Joan asked.

I took the whisky off her. I shook my head and drank. I shrugged as if compliant with some part of her that was also uncertain. 'We're idiots with guitars. We're always playing somewhere. Where is she?'

Paloma looked up at me. 'What happens when you get a tattoo?'

'Sorry?' I said.

'What happens?'

'Pain.'

'Pain, yes. And what comes after?' she asked.

'Regret.'

'No. What comes after?'

I stared at her. 'The desire to do it again.'

'The desire to repeat the process,' she said, 'because there's something edifying in pain.'

'No there isn't.'

'There's vast history of celebrating pain with the simulation of pain,' she said. 'Speaks to the higher gods. Billions putting in a request for protection from death by mimicking the pain of others, or themselves. Just look at you guys, in your leather and bleeding guitars.'

I shook my head at her, mumbling. 'There's nothing good in pain.'

'Pain is, and pain always is,' she said. 'We put this nonsense under our skin and it's the perfect simulation, yes? The perfect mirroring of pain because it's neither on the surface nor under it. It's neither of these things. It's inside the surface. Inside. Secret and public to the entire world.'

I eyed her with what felt like exquisite disdain, my face disjointed by drink.

'You know Miriam, her thing about the number seven, Conrad. She adores numbers because there's such small room for interpretation. And when there's little, little space, there's less likelihood of pain. And she has pain. I tell you.'

'Where's she?'

Joan opened the fridge and took out a bottle of vodka without looking. She nodded at me to drink the whisky. A sudden stark reek of rotted vegetables and milk voyaged the tiles and hit.

'It's something, isn't it?' Joan said. 'Watching people fight. It makes you forget things, doesn't it? Or remember. Depends on the fight. Makes you feel isolated from outside pressures.'

I shook my head. 'What the fuck's it to do with me?'

'What happens when you get a tattoo?' Paloma asked again.

'Pain and the desire for pain,' I said quickly. I stared at her.

'She told me what happened to you, Conrad,' Joan said.

I shrugged. I held my shoulders up near my ears and then

felt a heat grow in my body. A maddened flush, all sudden and angry and it pushed through into my face.

'I need to feed her,' Paloma said.

I felt my body sway. A kind of ceremonial swagger lit by the whisky and the tight proximity of the room. By this new fury, rogue and pulsing. I stared at her, hard like my face was about break. I knew then why we used music in the deployment of rage and wrath, nothing less complex than the endless plight of harmony and its ruins would do.

Paloma almost smiled as she saw me tilt, an ironic lifting of facial muscles. But it wasn't a smile, that would've been a version of cruelty. Instead it was something sympathetic, in the same phatic family as rapport and empathy. She looked at Joan, then at me. It wasn't a smile but some practised drama of eye muscles and pupil saying they shared complex things. 'Shut the door, Joan,' she said gently. 'There's a draught.'

Joan went to the door.

'Miriam said she didn't know what to do with your information. So she told me too,' Paloma said. The baby burped. A rude annoyed bubble full of foreign fluids talking back to themselves. 'She didn't know what to do.'

'Why the hell are you telling me?' I said. My body full of anger, full of what they knew about me. I felt the sudden risk and distance of having a shared story, a story shared. Anger, yes, but fear too.

'She said you weren't awake when it happened. You were asleep, and you don't have any words for it. She didn't have any words for what happened to her either, but she didn't tell you this.'

'Her? What happened to her?' I felt the air shift once more. The door opening. 'What happened to Miriam?' I asked, my face strained by a whole new fear that I knew precisely what had happened to her. 'Where is she?'

But then Blair, bloodied Blair suddenly standing in the

middle of the room. Blair. He'd come in and stood in the dark. Joan cracked the fridge once more and reached in. The stink again rolled across the room. Blair had a brandy glass, over-sized and brimmed with hard fluid. He was waving it slowly around as Spurn-Cock burst through a song out in the ballroom. Hard riffs and grunted howls. It was a cover of the Minutemen's 'Nature Without Man'.

'Where is she?' I asked. I drank again.

'Shut the door, Blair,' Joan said. 'There's a draught.'

'She's here. She's dancing to rock 'n' roll music,' Paloma said. 'Isn't that what you do at parties?'

'Where is she?' Blair mimicked. He laughed in that goon way, his face smeared and swollen from where Spence'd beaten him. 'Where's wheresy?'

'Fuck off, Blair,' I said.

Blood smeared on his chin and neck. The same stuff as on me. 'Where's she?' he said, drunk and blurred by the dual concussions of violence and alcohol.

'Fuck off,' I said, I sounded stiff, like my muscles and bones were forming into one hard shell. 'I fucken kill this cunt, I swear, if he comes any closer.' I felt the room closing. I traced a line to the hall, the way I'd dip and weave if I had to get out of there, because I had to get out of there. I had to find Miriam. I had to find Sonya and Miriam, but that didn't seem possible. I mapped how I was going to crack his chin, how I'd duck Paloma's attempts to grab me.

Joan put her head in her hands for a long few seconds. Then looked at my boots. 'Everyone wants the same right to violence as everyone else,' she said. 'This is the sickness. All as if it makes us somehow forget. Makes us forget all the near, real pain.'

'Who's she with?' I asked. My voice static.

She looked past my shoulder once more and into the cold glass where another Joan stood looking into the room where

everyone was watching, staring at the other version of her, waiting for words. Waiting for her to say her daughter's name again and understand its meaning when its source was so absent.

'She's with your Tone,' Joan said, taking the infant from her daughter.

She moved towards me. The baby smelt of milk and warm lanolin. Joan's limp and how she shuffled, saying words, saying phrases and names like things mislaid. Event and a name. The soft syllables of a name.

30

June 2019

Now Finchman and I watch the band in its last moments on stage as Juliette puts Celine to bed. For this is also the last of it – it's surprising how watchable it is. The final moments before we went separate ways, before Tone became famous and we sank, before Spence quit his PhD and took up a job in the archaeology department, before he started to fall apart, before he spent time inside in '98, before Angel went to work for his first law firm, before he was attacked, before Sonya finished her doctorate, before she married her first husband and watched that all dissipate into shouts, hitting and distemper, before I began to recall that moment in the kitchen as Angel lay in hospital.

We gaze at the screen, how simple this particular narrative seems. Figures on a stage. One shot. Appalling resolution and none of that seems to matter, because we know the names and we're fascinated by the sheer existence of these images and sounds.

There's no actual base memory of this. There's only recall of a dark drunk. Of the room with Joan and Paloma and the whisky. Nerves that weren't nerves but something other. Now there's also the thought of Tone, what he'd said about performance, about the forced trauma we put on ourselves and I wonder how right he was. Brain sectors implicated in the response to stress. The amygdala, hippocampus, the prefrontal cortex under ferocious pressures. Then the rapid increase of cortisol and norepinephrine, the post-trauma responses to

subsequent stressors and how brain-sick that makes you. The inhibition of recall and extreme unreliability of what we do recall. There's George-Warren and there's Paloma talking. There's her voice, her face as she came to me and the sense of what she was saying, but there are no words because then we were playing and how drunk? And look, there we are. A band setting up their gear. The remembered ritual of certain acts and somewhere in that brain of mine I know and here I don't know anything but what I'm watching. I feel no reasonable excuse for not knowing what Joan said. There's just a whisky miasma, stage fog and the silent space unbordered and expansive, and then there's us on the rostrum ready to throw ourselves into the air and scream at the great unknown and I'm thinking about what Tone had said. I'm thinking of Miriam with just two hours left to live. Blair all blood and nonsensical. Sonya and the baby and the dead baby. The rage through the haunt of decolorated things.

It's us with our backs to the audience tuning and listening to the conversations between friends and the rest of the crowd. The camera somewhere to the right – my eyes never seem to hit the lens front on. They seem to be averting any looks, any faces. The room full of men caught in the light of other men.

I watch myself on the stage, organizing my pedals and cables. My shirt is done up wrong, buttons and holes out of alignment. The sleeves are torn from where Blair grabbed me, trying to protect himself. My movements slurred.

'This is Fountain Mont?' Spence asks, suddenly realizing. 'This is the last show?'

I nod for him. We'd driven the roads back from Marrakech. Now we're three days on from Tone, from his apparitish arrival out of the bruising torrent of black-clad runners in the square. We'd spent multiple hours hunting him, seeking out people in masks, any masks. Nobody wanted to speak. We'd searched stalls and stores, run through alleys, made assumptions based

on nothing and followed them through to the deep place of their natural voids. We'd sought out the man at the hotel, but he'd gone. We returned to Tafedna and found Juliette in her bathrobe watching the huge television, this video blurred and streamed. *There's another film of you guys*, she'd said. *Another gig.*

Now I'm on the screen, hard eyes and thin, hair cut like a lunatic. I'm stalking something, nerves or pure anger. A concentrated look. Drunk, eyes turned inside out. I tap a pedal and the whole screen is filled with feedback and my shoulders seem to relax. I turn and look at Spence on the riser behind the drums.

'One, two, three,' the other Spence in this room says.

And, yes.

The count off: wood on wood. *Teck, teck, teck, teck.* I put myself in the air, Angel slinks down then leaps so we land on the beat, the camera shuddering at the noise out of the PA. I stalk, rapid shifts in direction, leap, throwing the neck of the guitar down on each beat. I scan the screen looking for Joan and Miriam. I imagine each word Joan'd said and how each word, each letter and sentence is an eruption of synapse and neuron, a galaxy-like burst and how many millions of things have to go just right to say the same word twice. God, it's a wonder we remember anything. I hunt for a hint of whoever was behind the camera, whoever shot the show. Whoever uploaded it. On the screen I nod hard on the beat, harder till my neck is a fulcrum. Then I'm in the air, crashing on the beat till I'm at the mic screeching an incoherent verse. Drunk. Spit on my chin as I scream, eyes wide and such a pale pair of cheeks, such a look of deathly concentration.

'This is "Pink Ships",' Spence says to Juliette standing at the door, or perhaps to both of us.

'What's pink ships?' Juliette asks.

'Pills,' I say.

Then in on the next.

The sound of chords torn off strings. The rip and tear of frayed notes. Kids blur. We shift in and out of A. The riff for 'Dance Prone', sliding it up a notch and back, almost swing and completely dissonant against the kick and bass. We go for repetition, trying to summon something, some effect or intrusion on what passed moments before. I recall the act of playing so easily: under my skin I dance and strum. Then for two, then three minutes and on. Five minutes, the same chord. The notes gather in chemical code. Branching, linking, talking, shadowing. Each instant the instant before and the instant to come. We drift in and out of the song's consciousness. It's knowing and unknowing. Finally, Tone makes the third change. I throw myself.

Fury and wrath. Wrath and fury and the dance.

The vital sign of a song is the persuasion to dance. Its life is elbows and fists and feet and words shouted by the crowd. Song is the space between the audience and strings, between their eyes and ears and skin.

We finish, bang. In another life there's smoke and lightning.

Angel says into the mic: *This is fucked. You're all fucked and disgusting.*

There's cheers. Whoops and on the table in front of me my phone thrums and rings with Vicki's name on the screen and that, that seems barely possible. I let it run on to my answerphone because I remember nothing of this. It all seems a corruption of another's memory, embellished and the colours painted in.

'It's watchable,' Finchman says. 'F-fifty minutes?'

'Aha,' his wife says and comes and sits.

'I remember nothing of this,' I say.

'All I remember,' Finchman says, 'is Cozen Jantes telling me about D. Boon. Just before we went on he told me he was dead. That's all I remember.'

'Don't know when I found out,' I say, and then I remember Jantes shoving me against the wall and maybe that was when, maybe he was trying to tell me and had nothing but a shove and a curse.

The next song. The next. And then I do remember. I remember but it's all caught up. I remember Angel telling me. Angel saying Boon had died that afternoon, but I only see him telling me this information in the big room at the Eighty-Eight, the same room as where he'd told me Finchman's mother had died a year earlier.

'You ever figure it out?' Finchman asks. 'Who did it to you?'

'I never figured nothing out, man,' I say.

'Who did what to you?' Juliette asks.

'Nothing,' I say, and unlike saying nothing in the standard universe where nothingness implies another kind of presence, this nothing signifies the forgotten, the truly forgotten. The words Joan shared with me in that kitchen because she'd spoken and all I hear now of that room is the sound of Spurn-Cock thrashing their songs in an extreme exchange of imitative noise as her mouth moved and I moved slowly after she'd said what she'd said out of the room towards the stage. That was the moment I knew who and what had happened to me. The moment I knew Miriam had been assaulted by the same person in another town in another room. And then it all vanished.

'Where's Sonya in this?' Juliette asks as soon as my silence diminishes. She's over by the window, closing the curtains against the arrival of all the evening sea fog and breeze and I remember: Sonya wasn't there watching, she was out in another room, pissed at me and pained by something that couldn't be shaken by a word. Vicki with her, calming and all else as Sonya yelled out her own brand of fury.

'I've no idea where she was,' I say.

Then Spence, the Spence on the screen's going: *one, two – one, two.* His sticks smashing into cymbals on the first beat and

we're off again. His teeth showing white. This is a good band, a band of effect and song. I watch, nervous that someone is going to come and demand we do it all over again.

We bang out the chorus till its last little hook and it's a pop song: by the time we switch the B minor to a D major we're FM on a Saturday night, we're the lights in your eyes. This is 'Radiation Cures'. We sing in harmony, three of us, and I see mouths shouting the chorus from the crowd. I sing and watch faces and bodies looking up from the black room. My movements tempered by the whisky. Stumbling but somehow my hands are coherent.

The camera pans to the audience. Then it comes back to me and I'm staring hard, right at the camera. Right into the lens and I'm furious as I bang at the guitar. My wrist and hand strumming from a foot above the fretboard. Then the camera pans away, slips to the mirror on the opposite wall. The first face I see is Paloma. Then Cozen Jantes. Her deft and wide eyes and Jantes beside her. Paloma behind the camera, the young woman and the baby in her backpack. And then Miriam because she's right next to her, the two of them caught in the same frame with Jantes.

'Miriam George-Warren,' I say.

Then another ding from my phone and Vicki's decided to write. Her name and the letters that follow.

'This is it,' Juliette says. 'This is the bit. Look at how drunk you are. What do you do after the end?'

'What bit?' I say. Paloma and Miriam. Suddenly I'm certain it was Paloma who put this up on YouTube. Some kind of statement only someone vastly smarter than me could unpick.

'This is the bit. What you do, Conrad, at the end?'

Tone is near the edge of the stage, doing that thing he did, body up against the crowd like it wasn't there. He's lifted his guitar high above his shoulder, waiting for the pulse, the brute moment when we throw our bodies at the chord, the whole

weight of us thrust forward, down on the beat. And the beat predicts movement. The fight and thrash of boys tossing their bodies into shapes and signs. I spot Jantes moving through to the front where his sweet drummer, Nikko, stands banging his head.

'Is that? Who's that?' Finchman asks. 'I used to have a memory of all this.'

'No, no,' Juliette says. 'Wait.'

'Is there much more of this?' Finchman says.

'Not much.'

'How m-much longer?'

I pick up my guitar so I have it by the neck, the strap off. Noise and the way it seems to eclipse the image on the screen.

'A minute or so,' Juliette says.

I bang the guitar into the amplifier head, five, six times. Then squat. The Jazzmaster dangling in the strap as Spence jumps out from behind his drums like he always did and slips into the thick heaving crowd beside Jantes and Nikko. Then I stand, start swinging the guitar about until I'm in a tussle with Tone. We tangle our guitars, grinding the necks and pickups. I lift the whole howling mess of us so he's up on my shoulders, his feet in the air above. We grind the necks of the guitars. The two of us coated in sweat and the sound of strings distorted and electric. I heave him around, four legs, four arms. A doomed arachnid hunting a last meal amidst the feedback and drone. He falls off me and I stop. All my movements halted by something. I stand in the centre of the stage. Then I start. I move.

'What do you do?' Juliette asks. 'This is what—'

I start out from the stage.

'See? What the fuck?' Juliette says.

'How much more?' Finchman asks.

I lift the guitar, threatening, wielded.

'Fuck. What do you do, you asshole?' Juliette whispers.

But the video doesn't carry on. It dilutes into horizontal

lines, crippled and white and the world returns to rumour and hearsay. A black screen and Finchman's laughing, saying: 'What the fuck?'

But despite this, I carry the movement through for all. The weight of the guitar in my hands as I lift it through shoulder height and swing like I did that time in El Paso when my nose was broke and I swam in the crowd among random bodies. I swing it out in an arc, out from my body, out from all of us shouting at me from this far side, from the boards rigged in Fountain Mont, from the border of the stage, out through the paused air, the screen, our ceased voices hung like shot, out through the sullied helical scan captured, incarcerated on a server somewhere in St Ghislain, Belgium. Out into the room on the west coast of North Africa where we all sit, watching and Finchman saying: 'Who'd you whack?'

'No idea,' I say.

And then he starts chuckling and I feel my chest cavity shrink and I can't remember for a moment what it's like, any of this, to breathe and not to breathe, to remember and not remember.

31

And what do I remember? What do I assume I remember? Hands grabbing and dragging me, Nikko pulling me up off the floor as I fell between the legs of the meshed crowd. I remember that and I remember screaming and Sonya suddenly appearing in the room with Vicki and moving me out of the area before we bled everywhere. I was ripped drunk, tripping on my feet and how she hadn't seen any of this disaster. There was a band on the stage as we hustled. A group of ghouls full of mock chants going: *Zanna-zu, zanna-zu. Oo oo oo. Zanna-zu, zanna-zu. Oo oo oo.* Ten minutes, twenty. Parlous repetition. Two drummers, bass and keyboards and the singer nailing rats to the front of the stage when he wasn't singing, banging three-inch suckers right through their skulls. They were ridiculous and terrifying and this seems to be the stuff of memory.

And I remember Sonya and I hustling down off the hill, wrapped in blankets she'd stolen from one of the grand rooms. We were running, stopping at corners to catch breath as we jogged down between properties, a shortcut that severed a mile off the road's meander south then back north and rejoined at a hairpin where this path came out between two large cacti. Everything felt distanced, lessoned by the primacy of the December air. Sonya hailed a taxi as it headed in the direction of the van and I've no memory of knowing who I'd hit, or why. I know we'd been told to park down off the hill because there was so little room up at the house but in this there's no sensation other than blood-thick rage. Sonya hailed the

cab because I started dry-retching, all bent over, crippled and horizontal. The car a slow-moving Ford with a driver so near sleep it looked like he might drown in it all. He was barely in charge, the machine swaying between lanes as it went west down East Oak.

Sonya shut her eyes.

I said: 'Open them.'

She said: 'No. No, no. I'm not watching anything, not anymore.' She put her head into arms folded on my lap. Rage, as if rage were tearing up every last thing. Throwing them in my face like confetti, like this were some black wedding.

'Open them.'

'You think you could find me a dog after this is done, or steal one? I'm like, so goddamned blind and it's – I'm not watching anymore.'

The driver oblivious to our commentary, his radio singing cheap country, songs born in a room where people get paid to imagine what it's like to be miserable.

'Narrate for me,' she said.

'What?'

'You tell me the story of how we get the fuck from here to there cos I don't know anymore.' She lifted her head, shut eyes streaming with black eyeliner and just the sense that my guitar had landed blows. How Joan'd put her hand over my mouth and pulled me away. How I tasted it. The weight of the guitar.

'I'm going to vomit,' I said.

'Just tell me, just concentrate on telling me.'

I described the route for her, the corners the driver almost missed, a woman on the street walking slow from the hills. A bag of garbage spilling all its interest into the road. A bus stop with a kid sleeping under his jacket. A cactus hit by a car. A bookshop. A pickup for sale. A single-storey city of hard stucco, of four-by-fours, trucks and cars. A desert dorp whose

ghosts ride in air-con vapour, whose water flows from conflu-
ences set deep in other states, cascading down, down until its
river's named by other names and flushed to sea at the edge of
another country.

'Fire hydrant,' I said. 'Dog sniffing fire hydrant.'

The low roof of a roadside bar, the squabble and yells
among the trucks outside. I wanted to join them and fight. A
couple hailing our taxi like we were invisible. And perhaps we
were; Sonya with her eyes closed and me leading her through
with words when all I wanted to do was fight. The way I'd
gone at the crowd, I still wanted to scrap. The way I swung
my guitar at the air and clocked some fucker because I knew
in that moment. I knew it was the fucker who'd fucked me,
a creep just standing in the audience staring. I knew because
Joan had told me in the kitchen. She knew. Someone had told
her or she just knew, but nobody just knows. Then Sonya
shouting, screaming at me as she ran into the room from the
hall where'd she'd been with Vicki and yanked me away, quite
unaware I'd hit someone, equally unaware I'd lost the eyes and
name of who. The gait, step and voice vanished in an instant,
or a string of instants each warring against time. Or I knew
utterly and this knowing was deferred, lost later in carefully
constructed conflagration, the entire complex of chemical code
abandoning me in the rushed will of heat and spark – this
shelled story all I've been left to navigate by.

'Walmart,' I said. 'Shopping trolley. Car in the car park.
Dollar tree. Plastic bags caught in fence. McDonald's, but it's
not open. Empty, empty.'

'Empty, empty,' she said and then – suddenly – I saw him,
Tone walking hunched between cars. His head sweat-wet like
he'd been running. I opened my mouth to say *Stop*, but then
shut up. I didn't describe him. Sonya kept her eyes shut and
we drove past and I said the words of other things. He was
wearing Spence's great shearling coat. His arms about himself,

warming himself with himself as if holding himself in order to move himself.

I described everything that wasn't him until we arrived at the van parked outside the Bullet House, a place of punk parties and hard living where I'd left the van. I looked back as Sonya sorted the change for the driver. Tone 200 yards over her shoulder. I watched as he pulled the jacket up to cover his head with one hand, the other against his torso as if holding something in.

'Close your eyes,' I told her as she stepped from the street side of the taxi. I moved her into the van. We sat, cold and silent. I pulled off my coat and put it over her shoulders in the back. I waited for the door to be torn open once more, for her to open her eyes and see what she would see when she saw her brother. What words they might say.

Instead, she opened them and asked: 'Who wrote that?'

'What?'

'On your back, above your jeans.'

'What?'

'Lemme see,' she said and turned me over.

'It says: *Fuck off.*'

'No. No it says –' and she started prodding my back.

'What?'

'Who wrote this?'

'What?'

I instantly thought of the boys in Houston, Jackson and Billow. The two of them sitting under their light and the smell of Billow's foot. The compass and ink. I hoped that somehow they'd left a message. Something else from Miriam where I could never read. A secret in indelible blue that said none of this ever happened.

'It's a phone number,' she said and I remembered Paloma, Paloma with her pen.

'What area code?'

She said nothing, then snickered, still looking at the digits. 'Ah. You smudged it.'

'Tell me.' I tried to recall the number on the payphone in Yuma where I'd called Sonya before heading to the compound, the first few digits at least.

'Why?'

'I want to hear you read the numbers.'

'You want to call it?'

'I just want to hear what they are, before they wash off.'

'When did you last shower?'

'I just want to hear them read out.'

'Why? You won't remember them,' she said.

'I just want to hear them read out.'

'So, what the fuck? You'll shower and they'll be gone. No one knows.'

'Read them.'

I wanted to hear, I wanted Sonya to say those numbers, an address mapped in wire, coded in volts. A marker deep in the telephonic. I wanted to imagine Sonya reading a last coded message from a girl who'd something to tell me, something she knew not how to say. But then the doors creaked, they opened and all location was summoned back to that stinking van. Tone and the way he stood there holding the thing. The way he stood, the baby squirming under his coat. The strange quietness of a child in revolt, bottle at its mouth and the continual rush of violence, the guitar, its weight and then this, a child staring right at us and I can only see the child. I try to see whose head I'd cracked and see only the child.

'Oh, Tony,' Sonya said and then we were all silent, trying to understand, trying to know what to do. She took the baby and told us to drive, one of us. I hauled him into the van by the jacket. He felt strangely light as I lugged him in. His sister was crying at him. *What the fuck, Tony? What the fucking fuck?* I drove back to the party, drunk in corners. I shouted at Tone the

entire journey. Deliberate words. *Whose fucking baby? Whose fucking— Tone?*

Sonya telling me to hush.

'Whose baby, Tone?'

We passed a cache of punkers running down off the hill. Stupid jackets and larrikin shouts. I swung the wheel in an effort to miss them and skidded the tyres in the gravel.

'Whose goddamned baby?' I'd said. But I knew whose baby.

'Just a baby,' he said.

I drove up and into the stretch leading to the property. The lurking building on the hill. A mass of people shouting. Sonya had me head around the back where we'd earlier parked and loaded in the gear. I left Tone in the back and went in, huddling through the kitchen, looking for Miriam's sister.

I banged through into the hall, the two of us searching for Joan George-Warren or anyone. Hunched groupings of party-stoned stragglers. Faces in shouting make-up, bodies pushing into the main room, bodies huddled at the house's many markers of taste and congregation, grandfather clock, a broken-legged sofa, two couples there searching their bodies for evidence of attraction, a delicately, painfully painted mannequin gazing through us all. Then in the anteroom. Paloma standing with her mother and Miriam. Five or six others. The serious gaze of drawing together a posse. Sonya went towards them, saying: 'Who the fuck brings a goddamned baby to a gig?' She walked into the circle, into the centre and held out the child. 'This yours?' she said to the lot of them.

It took a strangely long time for Miriam to move her arms, to pull the child into her breast and hold it close. The child's reddened head matching the lettering of her Redd Kross T-shirt.

'Where'd you find her?' Paloma said.

'In the bushes,' Sonya improvised.

'Bushes,' Miriam repeated, then looked at me as if I were

utterly foreign. I stared at her rocking the baby, not under-
standing something.

'You found her in the bushes?' Paloma said.

'In the bushes, in the rushes. Isn't that where you find
babies?' Sonya said. They were looking at her hair, the impro-
vised skinhead that came that morning. She was half criminal
just by having done this to herself. 'Next time you bring a baby
to a punk rock show, strap it down.'

'Yo. The fuck!' It was Cozen Jantes. He was coming towards
me across the hall. 'The fuck Brother Jean.'

We started moving out of the circle. I glanced back, but
no one was looking at us but Cozen cursing away. There was
blood on his fingers, up his forearm. He pointed the red hand
my way, twisting it like it really was busted. 'You fucken
pitiful pissants.' Paloma had the baby now and was cooing
at it. Cozen was drunk-shouting and Miriam started walking,
out towards the exit and the dark and Cozen with his bloody
hands and I hoped suddenly, turned to him ready to become
the flying end of a burning spear – then I stopped hoping for
anything because he wasn't there.

We ran back to the van and found Angel standing out-
side. Sonya was sobbing and Angel was trying to get her to
stop. 'What the fuck has happened to you people?' she was
crying. 'What the fuck's going on.' They fell into each other, her
crying and Angel delicate and whispering. We opened up the
doors and as we went to shut them up them four others called
out from the dark and stopped the door from sliding to. Nikko
and Leo pushed into the back with a couple of stragglers. One
of them Cozen Jantes and I smelt the lot of them, beer, pot and
fading stage stink.

I was too hazed, too drunk, but drove. I wanted to head us out of
there, out of the hills, out of Phoenix, out of state, out of the south

and out of the west, head north to the snow and watch all of us freeze. I ripped out the clutch and spun the wheels. Tone in the passenger seat, Sonya between us. I was sweating, dripping. The lights cut and the engine lost power then kicked in again. I punched the dashboard, accelerated and tugged the wheel so the tyres shot up screeds of gravel in the dark. The Modern Lovers playing on the stereo from earlier and nobody thought to hit the eject button and let silence intercede. The headlights raced through the cactus and scrub and I went through the gears, double-clutching and pouring us down off the mountain. Everyone silent, everyone watching the road, tightly concentrated on the corners and how I sped out of them.

'Just, faster,' Sonya said.

'I'm driving,' I said.

'Just get me the fuck out of here,' she said between the seats.

'Where's Spence?' Angel asked.

'Don't know,' I said. 'Where's Vicki?'

'Who'd you whack, Con?' Angel asked.

'You whacking someone?' Sonya asked.

'Dunno,' I said.

'Tone?' Sonya said, turning to her brother. 'What happened?'

'I was still playing; I don't know what the fuck Brother Jean's doing.'

I changed down for the hairpin, let the engine draw momentum from the ride, then slammed my foot on the accelerator to tear us out of the tight corner. The sound of the revs, the feel of the camber and the gravel clanging on the undercarriage.

Tree shadows and moonlight. Cassette music.

Clutch and revs.

Then Tone, half a word: 'Wa—'

Light, light and – flash. A pale flash. A flash, then its thud. I was still accelerating as I felt it, the hit. A thud and the face. And then a second noise and I was breaking, my foot on the centre

pedal and the body hitting, the bang, the hit against the right side of the van and it fell off the fender, rag-dolled and broke.

'The fuck,' Tone shouted.

'Oh God,' Sonya stammered.

'That's—'

'Con.'

And they were shouting at me to stop, just to stop. But I'd stopped already, I'd stopped the van, my foot still jammed against the brake. The thud and flash and then the face.

'Oh God, oh God,' Sonya said. 'Oh God. Oh God.'

White flash. My chest full of beating and air then no air at all. Jantes was there shouting. Tone was getting out, stepping down and I was trying to get out but I couldn't get my hands off the wheel. I was panting and Sonya was saying words but I didn't recognize the language. Then people, people running and shouting, a man pointing, instructing, shouting and I couldn't hear anything – just the flash, the jacket and a face and the way she'd stepped, the way she'd moved and stepped. The way she'd stepped and I braked and she'd stepped and there was light.

Sonya and I, in the days after. Hushed hours in her room in Phoenix. We'd repaired there once I'd been let out.

I was starved for two nights in a cell for wearing a leather jacket with the badges Miriam had given Tone and me before we left Yuma. They read: *Cops! Millions of! Dead!*

I'd run in the dark after I'd hit her, down off the hill away from the scene. Was picked up at 3 p.m. the next day near Piestewa Peak Park, six miles from the van. Two officers slamming my head on the bonnet.

I made two three-hour statements.

Each time they'd said her name, said *Miriam*, I'd have a great and widening sensation that she was alive. A kind of beating awareness, that I was there for other reasons.

And then I'd remember I'd killed her.

Hours in Sonya's room describing things, remembering things. We cried – and then I didn't cry. My mind hardened. Her breath smelt like she had a cold.

In the cell they woke me every twenty minutes, banging on the bars with night sticks.

They sent in a cookie with a cup of tepid tea.

And then at 6 a.m. on the third day I was released. No charges. No court.

I'd had one thought as I walked in the dawn, that Joan'd had some other kind of justice in mind for me. That she'd managed to get me off and return me to Yuma, imprison me while stoking the fire she'd stolen from Iran for the occasion of the death of her daughter.

Sony and I argued.

We sent flowers to the house with a hopeful note.

We lay in her bed. She understood something had changed, that something vast and vital had altered. I felt her compliance with something, how she understood that others knew, that they had the data marking myself that she didn't. That one of those people was dead. She knew there were unnameable things and we lay near naked in the silence.

'And you fucked her?' Sonya said eventually. 'In a tent. In the desert.'

'There was no fucking. Not like you think.'

'How delicately romantic, Con. How – and Con, were there camels outside the tent? Were there, like, dromedaries making dromedary noises as you fucked her nice tight –? Huh? Were there lions in the distance? Tribesmen singing tribesmen songs.'

'—'

'You did fuck her. What'd she taste like?'

'She cut my hair.'

'She cut your hair?'

'She listened to me and then she cut my hair.'

'So why the—'

'—'

'Why Con?'

'I thought I was in love. For ten minutes.'

'Jesus fucking Christ,' she said, mocking now, glaring. 'This is Conrad Welles. This is Brother Jean. *Where am I?* he says. *What do I want to eat? Who do I love?*' Mocking, pinching lines from others: books, films, songs, potent rejoinders and glaring into some fictional place where my face was supposed to rest. She finished and I watched the muscle under her left eye flicker and twitch until something else stopped and some pained article of evidence seemed suddenly admitted.

'Something, another thing – this other thing, it happened to her,' I said. My voice, its contents surprising me. The strange precision of knowledge then, that I'd known what'd happened to Miriam. It had been coming at me, staring down the straights since Yuma, since we'd been naked in that tent, naked and she'd eyed my bruises, those slowly dying evidences, and it'd been filling me like a cockcrow dawn, the battlement of colour and light rushing and fighting to expose the hardness of land and the faces among the rot of rock and all the eyes, the mouths and words and the secret join between mouth and word.

'Something happened to her, what?' Sonya was trembling, her sentences shaking.

'—'

'Snake,' she said and that was us, done.

She wore her bra and that was all. Two people in a room. Watch them, how gorgeous they were in their misery. Watch them, then watch me, Conrad Welles, trying not to look around for his underwear, trying not to say any of this was anything by covering himself up.

32

June 2019

These were our dead. The dead and the unremembered and remembered, which seem at times to amount to the same thing. The word only gets said once when you're young. Can only be said once as there's no possible repetition of the things that are only stated in such muscled gestures.

'Only youth understands youth,' Sonya said last night from our couch in Wellington. Angel was there with her, staring at her iPad. 'Is that what I mean?' she's asked to no one, as if such questions meant the vanishing of all queries.

I'd described for her the video on YouTube, then scrutinized her and Angel watching it on our big screen in the lounge, the many windowed room on the top floor with its grand view of the ferocious Pacific. She also feared guilt, the anonymous terror of physical memory that came with indisputable image, the strange tactile fact of pixel and light. We've asked questions over the years, we've sworn we've known the answers, then asked them again. We've tried to understand Miriam's death as suicide, as hit and run, as something I did. We've looked for intent, asked if I turned the wheel. Atomized the moment, searched my eyes for evidence. Asked if she put herself in the lights of the first passing vehicle, if we were the first passing vehicle. We've asked if Miriam knew it was us. We've asked and had no answers because we no longer know the dialect of youth because it's hidden, obscured by time and age and other languages bright and clear for their capacity in repetition.

· · ·

I'd left Tafedna the next morning. Drove and flew, found myself in a town called Marlova where a twisting river bent like a harelip on the broad black coast of Andalusia. To the west stood fortifications, ancient and Roman, Moorish, Berber and word-worn by people like me trying to give it meaning. Me in my tan and black fedora watching and rewatching the video at any spare moment. I'd hired a car and found my way here. And here's a waterside studio, several hours after dawn and how hot it can get just like that. Windless and a whiteish blue. I'd arrived here in the car and asked for Blair at the studio's reception and waited until he appeared. And he did. A thick head of still-brown hair and he'd said: 'Look at this bitch in his little rental. Look at this old-time dude in his hat.'

I said something forgettable in return and he took me through the complex's narrow halls. We talked studio talk, drank coffee and ate pastries in the kitchen all decked in wall hangings from across the Gibraltar Strait, rugs and electric fans exciting air through the room. He was on his third coffee and we realized things would be simpler if we traded up to something harder.

Now we stare out over the water. He's wearing his ancient *Peace & Hate* T-shirt, eyes deep in their sockets. We tap at the arrays of effect pedals set at our feet. Many of them labelled with obscure names: *Bloom*; *Cantaloupe*. I'm not even playing yet one of them sends line fuzz into a rhythmic jaunt athwart the river, a step filter on a delay on a reverb on a phaser. The remote harmonies dream-driven, the remorse of a music we've never thought of previously.

He's trim now, Blair. I'd expected a blimp, but here he's thin-limbed.

'Sit closer,' he says. 'I can hear what you're going to play before you play it if you sit real close.'

I shuffle on the rough wood of the deck but don't move any closer. We've stolen every pedal board in the studio and

brought them out here. Phasers, delays, filters, distortions of a ridiculous complexity. Digital processors that could fly you to Pluto and back and here we use them to make noise, to disguise how bad we really are at subtlety. Tube screamer, Big Muff. Compressors and envelope filters, tremolo and Super Fuzz. Brand names never seen before. A shop in Boise Idaho, two men, a soldering iron, a bench and bucket of capacitors.

'What happened to your other boys?' I ask. 'Amerighi and those guys?'

He ignores me, stoned and bleak. Vicki'd told me he was here. That's what her call was all about. The phone thrumming on the table as Neuse Bauen shrieked all distorted on the television in Tafedna. She'd seen him briefly in London. He'd come upon her in a cafe and sat with her, a man talking. It was fifteen minutes before she knew who he was. When I didn't answer her call she'd emailed, told me he'd like to see me if I was in Spain. So I left Morocco and flew.

I look at Blair now, he's thin, yes, but his face hangs, the skin and muscle susceptible to time and its weight. He's aged, pale and the body left behind since all the volume evaporated seems uncomfortable and he shifts constantly as if still getting used to the fact of visible bones.

And I fear him, just a little.

'Who's going to sing?' I ask. We're kind of nervous, kind of laughing. Or it's me who's laughing because I feared singing more than anything or near anything.

Blair says: 'This is a theory of strings and electricity. Singing's nonsense.'

I start playing the Gretsch I've chosen from a rack of vintage guitars, each one tuned and tightened daily by a guitar tech with an awful penchant for playing the same blues riff over and over. I bounce my pick on the bottom notes and ring the high. Blair eases into a serious shitting look, his mouth agape. He starts to play tones next to my notes, not on top of, but beside.

I watch him, suddenly amazed I'm here. That it's his form and not another's standing in for my memory of him. He's blurry, as if mixed in with dreams and other night-time trances. The come and go of old hauntings and apparitions of psychic sensation and physical affect. Nikko's here, too, somewhere. The reason Blair had taken on the gig. The drummer had become sought after, convivial to whatever styles of whatever rock and so easy to get a good drum sound out of his unassuming phrasing. But it's the band's day off and it's just us two.

Throughout the previous night my entire sleep had been tampered with by the scenes in that old Queen Anne. Of Miriam. Of the me onstage. Of that video Juliette, Finchman and I'd watched, and it won't let go. The evidences of an unremembered self. Video and sound. The weight of the guitar, the size of it in my hands. How it kept coming back, its heft. The way I'd lifted it. The weight and feel of the thing, the way I'd had to counteract its bulk with my hips and feet.

Blair says, 'Let's just –' and we play on.

Six amplifiers. The roar out into the still air. Deep inside the building machinery churns over the sound coming from the amplifiers, miked with condensers that cost three grand each, layering it into binary code where it all might sleep. We shadow one another, slower and slowly out of sync, and then into keyless drones. I open my eyes and watch some sort of waterfowl run on the dark river then slowly lift, dragging a foot in the last moment before it's entirely in flight.

Blair strums furiously, a strange haze rising from his amplifier as I find myself plucking chords echoing Big Star's 'Kanga Roo'. I imagine the whole world swooning, collapsing in time to the violence of feedback and its imitating swathes of silence.

I'd tried to sleep but again and again I'd lifted the guitar, swung it and – how the fucker'd staggered back at Fountain Mont. The fucker's feet splaying. The Fender, the way I flicked the strap off, hefted it, brought it down. The sunburst arc of

Jazzmaster and steel strings. How the fuck's legs'd splayed, feet
sliding outwards on the redwood floor. The way the hit shock
jolted back through my hands, my forearms, and he fell. That
was my night over and over. Certain that I knew for that single
moment in Fountain Mont who'd fucked me. Knew it in that
one moment then lost it as I'd collected the fucker. Or I lost
it later and I don't know when. And now I only know by the
uninterpretable shock up through my arms; a strange kind of
forced language without faces or names or words.

We tune as we play, Blair and I, lower, lower. The long-
wave frequency of sustained notes. The collision of wave upon
wave is harmony, chords whose beats bang once every few
instants, and what's between the instants I can't say. This is the
music from before seconds, before the words. Blair looks like
he's taking a dump when he closes his eyes and strums. The
volume immense. I can feel it through the floor of the deck.
This is the sound that turns desert into dunes. A rhythm hit-
ting slower than the pulse of your heart – *Whyump! Whyump!*
The music seems beatless, it seems outside of time, it seems to
be inventing time, telling the fucker how to be. I look around
for Spence, hoping he'll come and find us here and add some
rhythm to all this, shunt his kick drum and pound some
borrowed phrase on his snare and hats. I look for Nikko, but
Nikko's not there.

'This is C sharp, this is the key of C sharp,' Blair announces
as his ear tells him something unknown to the both of us.

He dribbles on his shirt and my underwear is slightly wet
where I've eased out a little squirt of pee in a momentary lapse.
A phenomenon rock musicians know and rarely talk about. I
once shat on a stage in Boston. My trousers were tucked into
my boots and the diarrhoea settled there at the bottom of the
cuff. It was cold by the time we came offstage. Other times too.
We played City Gardens in 1984, where Sonya picked glass
from the back of my head, the Knitting Factory and Pittsburgh

so ruined by flu I recall nothing of the entire week. Another night when we drove through a storm, stopped for the full moon and made a snowman. We backed up and then drove at the thing, smashing a headlight. Then during the summer in that same state Spence took acid and climbed the Kinzua Viaduct. This was something they used to call the *eighth wonder of the world*. And though he eventually stood on the rail tracks above, for months afterwards all I could think of was him falling. All I could see was his body limp and tumbling.

A sensation that had its own reoccurrence in the front room of our house in Oberlin in 2000. That was where was I living when I learnt Finchman incurred a stretch in prison. A single-storey complex on the outside of an unnamed Illinois town. Walls and steel doors and I'd imagined the same thing again, Finchman falling, caught behind endless bars flashing by as he tried to grab at one then another. Two and a half years for aggravated assault, but no one counted it. He'd attacked his father, beaten him so severely he had to be hospitalized up on Corking Road after the man had told him he loved him, loved his mother, and that this was their fault. Frasier had put both of Finchman's dogs down, shot them between the eyes when Spence was out of town. Said they'd shat on his Cassina sofa and torn up priceless first editions. They were old, he said, the dogs. Finchman broke his eye socket, jaw and five teeth. Class 4 Felony.

God, how the fucker's legs went out when the guitar hit, eyes squinted then opened as he went to the floor. His hand reaching as he staggered. Blood. The opening of skin.

But it always comes back to how we know and Blair strums and I'd agreed to do this, play and record because he said it'd be fun. I inspect Blair's eyes on the odd occasion they open, just in case they open.

I'd got the fucker on the join between bones. Blood. The cold realization that the cranium has many bones and Finchman

had so damaged his father the old man'd had to retire. But such is life when you kill a man's dog.

'And the thing about C sharp,' Blair says, 'is as a key it's impossible to remember where to put your fingers, so you end up just strangling the bitch.'

And then, finally, we aren't playing anymore, Blair and I. I don't notice the quiet but sound has stopped coming out of our amplifiers and I watch him, his mouth closing and then opening and then the words. I don't know how long we've been sitting in stillness but Blair is speaking suddenly, saying: 'I saw Tone, you know, back about six months. I was in Croatia. He's hanging out at a spa.'

'Nice for him,' I say.

'Nice for him. He told me what happened to Angel.'

'Well. Angel's everyone's problem these-a-days.'

'Too bad,' he says. 'I liked Angel's playing.'

'He can still play but just doesn't remember anything.'

'Fuck all that. I talked to Tone. Like for hours, in Dubrovnik.'

I make some noise as Blair shifts himself on the deck.

'People, you remember?' he says suddenly. 'People were milling round. You remember? Lots of folk.'

'Sorry, Blair?'

'This is what I told Tony because for some reason we started talking about it. Lots of folk. I didn't know anyone cos I was from out of town. I'd had my face punched in by the security at your gig, you remember that? That's the thing, I was from out of town and I had my face busted for getting up onstage. So I was like: *Fuck all you guys.* Just a bunch of oily punks hanging around. Studded belts and bad taste. I liked punk when I was ten and it was all PVC and random shaving. Then: *C'mon, idiots.*' He leans back, the guitar still in his hands. 'Fucken dick-breeders. But I was hunting around for Tone.'

I stare at him, then through him, then out across the river where birds are milling in the black trees. 'That was you who got punched in the head,' I stated, bland and plain. 'I remember being vaguely pleased about it.'

'Anyway, Tone'd said come by, cos my face was all mucked up,' Blair says, 'so I brought the band over.'

I put the Gretsch down on the deck. This thing's worth five grand and here I am, drunk, coked and covered in piss. I pick it up again because it's still making sounds and then Blair's giving my shoulder a light shove with his thumb. Says: 'This was Burstyn, right fuck-o? At the Eighty-Eight.'

'You know why I came here?' I ask him.

'You're playing games in Morocco. You're thinking: *Andalusian sherry.*'

'You know why?' I say.

'You came about Boulder,' he says.

'Yes.'

'Boulder.'

'Yes.'

I'd told him first thing. As soon as we'd stopped saying hello and giving over general *fuck-yous*, I told him I wanted to know about Boulder because it seemed caught in all this, all memory and non-memory, seemingly summoned to ruin whatever chances we had at getting on with it all.

'Well, in Boulder we recorded songs, Conrad. We went out in my brother's pick-up and got drunk at George-Warren's camp. Yada yada. Then you and Tone tried to hit each other. We recorded songs. But I'm talking about the Eighty-Eight, fuck-o. I don't care about Boulder.'

'I don't need to hear about the Eighty-Eight,' I say.

'But that's what we're going to do, OK? I was there, so, we talk about it.'

'A lot of people were there, dude,' I say.

'Dude. How old are you now?'

'I'm fifty-five.'

'What you do for a job?'

'For a job? I used to move furniture around. It's a mystic experience. Now I'm doing sound systems, have a PA company.'

He looks at me, then away.

'Wish furniture was still my job. I don't even know your last name, Blair. I think I owned one of your records, but I don't know your last name.' I do, it's Potaski. 'How old are you?'

'Fifty-two.'

'I assumed you were still eighteen.'

'Ian MacKay's still eighteen. I'm fifty-two. I argue about it with my dead parents, but there I am.'

I undo the strap on the guitar again and lie it down on the deck.

'But the thing is, see,' he says, 'we'd shown up at the warehouse hoping to crash the night.'

'Just fuck off with that.'

'I didn't spot anyone I knew,' he says. 'I was hunting around for Tone but couldn't find him. This was after your all-agers gig, you hear. Hours later.'

'—'

'I saw your van, opened it up and saw you sleeping. I shouted at you, because you know, I was a shit and I tried to wake you but you were gone. So I abandoned you. I mean I tried to wake you because it was an ass thing to do and I was fully into being an ass.'

'I was there,' I say, 'I know what happened. Tell me about Boulder.'

He shuts up for a moment. I punch a pedal beside him on and off. A squawk of feedback. Birds bursting from the grey. The weaponized noise of a guitar in the still.

'The world's full of fuckers, Brother Jean,' he says. 'Evil fuckers and they think everything they touch is theirs.'

I hit the pedal again. On and off. The sound of music.

'I know who the guy was,' he says.

I hit it again. The echo smashing into the trees disturbing birds there. 'Do you think I want you to tell me? Do you think you know me well enough?'

'But I know.'

'I thought it was you,' I say. 'Remember Denver and what a prick you were? I thought it was you.'

'Me? Fuck. Jesus. Me?' he says. 'That's a giant cock of a joke.'

'I tried to make you fit,' I say. 'Tried to squeeze you in there. Still do sometimes.'

'It's a name,' he says. 'I just say it and then it's over.'

'But I know enough already,' I say. 'I don't know who did it, but he's right there. But – but he's not there.'

He grunts. 'You figure it out, or?'

'Couple of days ago. Just now. Last night. I'm always figuring it out. I don't need you telling me. I don't need another version. I can feel him there. And that's close enough to be real.'

'So you know.'

'I whacked the fucker with my guitar in Phoenix. I don't know who, I don't know his name. I just know what his head feels like on the end of my guitar. That's the state of my memory. That's enough. I don't care anymore. What I care about is Boulder.'

'PTSD,' he says.

'What?'

'PTSD. You know but you're scared of knowing, so you don't know. There's a great deal of fear in knowing. Conrad, all I remember about Phoenix is getting the shit kicked out of me by Spencer. Then you were swinging your guitar, swinging indiscriminately. This is the cultural memory. Alt rockers in Phoenix, Arizona. Brother Jean loses his stupid rag, swings indiscriminately.'

I stare at him for a long time.

'Tell me about Boulder.'

'You played your guitar in Boulder,' he says. 'You played OK. Everyone played OK. We'd a barbecue each night. I did a good job, you were average. Played average but you were a

fucking mess. I brought in meat and watched you guys burn it. I bought magazines for you all to read while you shat.'

'We played OK? Just OK.'

'There was drinking,' he says. 'You were acting like insanity was your new best pal – you weren't all there, Conrad. You disappeared from the studio for hours at a time. Then came back drunk and talking like it was some other time. That you were in Burstyn.'

'What you talking about?'

'That's all. You were just acting like your head was gone and I don't know.'

'There's more. Obviously more. You're a son-of-a-bitch, Blair. Paloma was there, wasn't she?'

'Well, this is the thing, Conrad. I came back to the van and opened the door and someone was there. I'd opened the side door, not the back. I stood there trying to make out what he was doing.'

'I know what he was doing,' I say. 'But you think I want you to tell me? Sonya was in Boulder, right?'

'So, I shouted out,' he says, ignoring me, 'and then the back door opened and it was Tone and the guy fucking you ran out. Tone had that gun. Whatever, fucking Nancy pistol. He fired it in the air. He fired the thing. Bang, like three times. Bang, bang, bang. And then once more and the guy ran out. I went through the van shouting at the fucker behind you and you were bent over. And Tone was shouting at the fucker, firing that fucking gun in the air. You started coughing and, I don't know.'

'You son-of-a-bitch,' I say.

'You started coughing. Coughing.' Blair raises up, stretches. He stands straight, alerted by this desire to tell, by the hard rod in his back we call intent. Then says: 'Tone just stood there, stayed in place. It was dark and it took a moment for me to see what was going on. But I know and I've known for years and I've told not a soul, Conrad. Not a soul. But I don't want this information in my head. So here I am.'

'Fuck off.' I stand. I lean near him and push.

'But this is the end,' he says. 'He was standing there and he shot himself.'

'—'

'This is the end, dude.'

I shove him again.

'This is what happened to you.'

I sock him in the chest.

He shoves. He pushes me so I fall backwards off the deck and onto the riverbank. He steps off and joins me in the damp earth. We stagger like old men trying to dance once more.

'And you know,' Blair shouts, 'you know why I tried to rip Tone's mask off in Phoenix, you dumb tool? Why I tore it off?'

I step back. A discarded bike at our feet, I stumble over it into the near river mud.

'Because I was giving him shit about not telling you and how he could let that fucker stay on the tour with you,' he says. 'That he must have known, and what a pussy thing to do, fucking shoot yourself and let him ride in the van with you across country. And then show up in Yuma, and she's there. You know that? Huh? He always knew who was in the van. We talked in Croatia.' He heaves himself up from the mud and stands on the deck, disgusted by the smell on him.

'Fuck off. What was it in Boulder?'

'You want to know about Boulder, you stupid fuck? That's between you and your wife.'

'You're an asshole, Potaski.' I step back onto the deck, throw a roundhouse and catch his chin, clip it so it feels like I've taken a knuckle off. He falls among the equipment and microphones. The heel of his wrist waking up pedals and agitating the air, waves finding strings, and they all start to moan, to call and hum so everything's agog and shaking, the deck, the wood, the air thickened with electricity so birds scoot from the water.

'What did Tone say?' I shout as the noise diminishes, caught by unseen spaces.

Blair just stares at me. He punches the pedal once more. On. Then off. We glance up as the fowls alight the water, returning from the noise of the first report.

'Let me tell you a story, Conrad. Let me tell you another story.'

33

'There was that party in Madison,' Blair says. 'You were there, Spence, Cozen, Tone. Nikko was there, and the Rhinosaur guys. You remember the party because you were there. Because it was two days before what happened in Burstyn.'

'I know the party.'

'Good. So you know. I hated parties, I still do. I was bored and wanted to get to the place we were crashing but my drummer had the keys, so. I looked all around the house shouting abuse. I found some stairs to the second level where I thought he might be. Then the third floor, up the wide staircase and there were only a couple of rooms and they were empty. There was a small, one-man set of stairs, almost a ladder. I climbed up and found myself going through a door and standing on a flat section of roof. The view spreading out, the prairies in front of me. I kept staring. The dark acres of crops and field and I hated it all. But, whatever, I didn't want to go anywhere else, I realized. Just wanted to stand there and stare into this void of voids and wait for it to become something else. I didn't really have friends, Conrad. I just had my band and that's something completely different.

'But anyway, eventually I stood and went back down the ladder. Down to the second floor where all the lights had been switched off. I noticed a door I hadn't been through previously and was about to walk past but stopped. I heard a grunt, a man-noise which could have been a laugh or the back end of a cough. I put my shoulder against the door and lifted the handle

and shoved lightly. The light on, kinda bright and it took me a second to make it out. The clenched rumps of two men. Cozen Jantes with that faltering dick-hard grin saying: *Any second now.* The puckering of glutes and shimmer of small fat deposits. I caught his profile wanging his hard dick on the face of a woman on the bed. It was Jantes, waggling and in that cum-now face. He turned to me and raised his eyebrows, you know, a shitfucked grin. He put his dick in the woman's mouth and she grunted, an unambiguous noise of complaint or whatever. The other rump was just a rump. A bald ass pumping. It belonged to the brother of the guy whose house it was. Just this double sex act no one ever sees but I caught it. I caught it and Jesus. The black hair and dicks and tits. Cozen Jantes and some other asshole. So – I shut the door and walked the hall to the staircase. I ran down, trying not to lose my balance and fall. And then the face, Conrad. The hair. The light hair and bangs. The features. The girl's face. I walked to the ground floor, and the face. Just the reoccurrence of the face as I went down the stairs. I saw the face, and how hadn't I seen the face while I was standing there? How hadn't I seen her eyes? I paused on the stairs, I turned. I thought, *Fuck!* Spence came up the stairs, then, pushing past me and he had no idea who I was and I moved out of his way and just saw her eyes. The eyebrows and the mouth, the cheekbones surrounded by crudely cut hair. It was Miriam, Conrad. I didn't see her eyes because her eyes weren't open, they were shut. I started back up and I stopped, I stopped because her eyes didn't open. Jesus, it was Miriam. Miriam's, and I stopped. I did nothing. I stopped and went back down the stairs. I stood still. How drunk was she? I didn't know. Or I did know. And I did naught. Absolutely zero.'

'Fuck you.'

'I know.'

'Fuck you. What kind of cunt does this, does nothing?'

Blair stands, mud slew and raspy-voiced all of a sudden.

He goes around the dozen or so amplifiers we've set up and switches them off.

'This is fucked.'

'I know.'

He stares at me, his face still. Empty, exhausted. '"Deny Everything",' he says. 'You remember that? You'd play the Circle Jerks in your room and you'd play "Deny Everything" three times over before you let the rest of the record play out. Thirty seconds and some things got to be played over and over. That's the thing, man. How many times did you have to listen to the same thing until you got it? Anyway. That was Miriam. And you want to know about Boulder? Well, it was some strange shit, Conrad.'

I feel my face tighten as some part of me tries to force memory, extend nothing into the realm of explicable thought. Instead all I feel is the hard, savage restlessness of my body and how it shakes, how it vibrates like steel struck over and over.

'God, that girl,' I say.

'So you think you had it rough?'

I shake my head. There's silence. The counting off of the crowded seconds. Cozen Jantes. Jantes.

'But that wasn't all, was it,' I say. 'That's not all that happened to her, is it?'

He shakes his head. 'I always wanted to be a better human than this,' he says. 'I always thought there was a part in me that knew how to work a normal job, pay normal taxes, eat pasta without getting so fucking fat that . . .'

We are silent for a long period after he finishes. There's another name to be said, another face to junk and I need time.

Eventually I ask: 'Why do I remember Burstyn and nothing in Boulder? There's no recall of going to Colorado. Just your fucked-in-the-head garage. I want to hear someone explain to me.'

'Because, Conrad, Tone made sure you remembered Burstyn. Pow. Bang. Every time you think of him you remember. He told me in Dubrovnik, man. Told me everything.' He shifts, realigns himself in the sun, the heart-stop heat and the sense he wants to establish what it is we're trying to understand by ordering his limbs in a precise manner. He talks then, gabs about Croatia, describes the bar where they met. A stone-walled place dictated to by *Thrones* fans and their rented ecstasy. 'I'd never seen the TV show and nor had he, but after a few drinks we went out and followed the throng. It was winter but still there they were, guided through the streets, officials ushering us through the medieval stone, the melancholy granite walls, never before breached. We found ourselves on cold stone stairs in the old town. Women weeping, others clapping in time to unheard music savouring the site of simulated slaughter and humiliation. Camera-crazy idiots filling the entirety of digital space with a hundred shots of the same frame. We found ourselves wandering upwards, eventually coming upon the Minčeta Tower where the wind bit and we froze. But however cold, we stayed there, looking out over the city towards the Adriatic imagining tides of ancient war machines, armadas full of olive oil and slaves. That was when he started speaking, telling me the shape of what occurred with you and Miriam. It felt like we had to be there in that exact spot for him to tell me, standing at the peak of this beautiful site all world heritage and overrun by experts in TV marathon and hotdog-eating competitions. Each stunned by their part in the renewing of the world.'

'How long have you felt a need to tell me this?' I ask.

Blair shakes his head. 'He told me you yourself had pretty much worked out what'd happened to Miriam. He told me you realized in Yuma, saw how she'd recognized something. The grip marks near your neck and collarbone, the intensity of them. Tone said he added it up, all the way back in eighty-five.

Somehow made a correct guess, that it was the same guy and he knew who that guy was because he saw you in the back of the van. The poor girl was raped in Yuma twenty months before you showed up there. Then, seven weeks before you got all cosy in Arizona, she was assaulted in Madison by two shitheads and I did nothing about it. That's her history. Predators understand what allows them to be predators, the smallest displays of hesitation and—'

'And what about you?'

'Me? I don't know what any of this makes me. I hide in dark rooms listening for answers in the crackle. My ear has become extraordinarily well attuned to disappointment.'

I shake my wrist and put pressure where the skin has split away from the knuckle to stop the bleeding. I watch Blair coil guitar leads, then the XLRs. That time-honoured method. Over, under. I've fired roadies for not knowing how to correctly coil a lead. He takes the mics from the stands and puts them in their little road cases.

'I thought guys like you travel with your own mics,' I say.

'Yeah. Well, this isn't my gig. The producer had a bunch he wanted me to use that he'd brought over from London. Whatever. She was gone, Conrad, rudely drunk. But that's no reason. Cozen had his hands on her all night till I wasn't looking and fuck. And before that, Yuma. And between you and her: I don't know what the two of you make me.'

I feel a new and instant kind of depression, the kind shaped by the fact it took thirty years for this information to hit. By the fact that it knew its own contours, the relief of years, of the wane and wax, of the continual and actual and brutal presence.

'You know, she was about the only person who'd ever been nice to me?' Blair says. 'She took me all over the show. The only person until later. And then—'

'And then.'

'And then. God, you know? I didn't do anything. I try to ask why.'

'I don't know, Blair.'

'I was a fan,' he says. 'Fans trust people because we like their records. And then the stupid shit in Boulder in eighty-nine,' Blair says. 'The stupid fucking shit.' He looks so irredeemably sad. Bleak and dusty, like he's come in out of the hills, years in the hills and years bent over the same idea. 'You remember?'

I shake my head.

'You remember Boulder.'

I feel a new kind of illness in my gut.

'You remember. This isn't a question,' he says. Indeed, it was an instruction.

'Don't be a shit.'

He wipes at the mixed blood and sweat from where I collected him. 'You went off. You disappeared after the recording.'

'Paloma was there,' I say suddenly. 'I've seen photos at Spencer's house.'

'Correct – in Boulder,' Blair says. 'She lived there for years.'

'I've seen a picture.'

'We went to a bar and you disappeared. You went off and we spent a night looking for you. Then figured you'd gone back to wherever you were living, or whatever.'

'Ohio.'

'Ohio, OK. We thought you'd gone to Ohio. But then you returned five, six days later.'

'Bullshit.'

'I've no good reason to bullshit.'

'How the fuck is it, that I don't remember?' I ask. Then the words are gaseous, hissing, vapour-like before vanishing, before becoming what comes next, before all fails and falls. I think of myself after what happened with Miriam. The amount of drinking, the amount of forced drinking and hard drinking, how I stockpiled devices designed to freeze each assembling

thought. Drugs, sex, sex like a tool and drugs like all light flickering on to off for all time.

He shrugs. 'Violence does strange things. That's all I've learnt. You were covered in dirt. And then—'

'What *then*?'

'Leo. Leo found you and pulled you out of the ranger's office after you'd gone missing in the hills. A whole week of you missing.'

'What ranger's office?'

'He drove you to Vicki's in Cheyenne. Shot you up with whatever. She was there awhile and you were there till you went back to, what? Ohio? Who the hell lives in Ohio?'

'What the fuck, Blair?'

He continues packing up gear in silence. There seems no more talk left and I help, coiling the leads and moving amplifiers.

Then I ask suddenly: 'Do we have the right to try and understand what she went through? I don't mean right. I mean do we have the right to try and explain to each other? I don't feel like I do.'

He shakes his head and keeps packing. 'That's what I asked Tone in Croatia, dude, the two of us surrounded by hundreds of hunters. All I have is data, Conrad. I don't know what rights we have to data. But I know the problem comes when we try to give it narrative. That's when I know we're in trouble. All I know is the self-same ass who fucked her in Yuma was the same asshole who got you in Burstyn. This is the end of the data trail.'

'There's no such thing as just data,' I say.

I let him tell me everything. Name, the whole act in Illinois. The name and person and event. He talks and packs the ridiculous effects boards, each with dozens of processors doing impossible things to the sound. The name and the intimate retelling of the name. Then he describes Boulder, the whole

twelve days. How Sonya was there, how she was there and others were there.

'I used to know it was him,' I say, oddly confident once he stops speaking and the name of the fucker who'd hurt Miriam and I sat in the air and in our bodies, all at once compact and solid, at once vapour and fluid, breathed and tasted.

'I know,' he says.

'I used to know. But I don't know when I stopped knowing.' I sit, quiet in the wreckage of my astonishment at this sudden knowledge of myself. That the mind is capable of letting this memory go unpractised and unlearnt for decades. I knew as we'd walked off that Phoenix hillside, just don't remember knowing.

Blair looks at me for a time, then back at the XLRs and puts them down and picks up mics and cradles them gently. 'Well,' he says.

'I used to know.'

'This is the deep illness, right? Deep and certain about itself.'

'I used to know,' I say slowly, the words an old kind of march. 'I used to know—' and I say it on and on, as if practising the key phrase of another language, the apparatus of thought and memory of another people embedded in the mind by one key line. I remember the whole scene in Boulder, how simple and complex. And I remember then that the recording is still running. I think how Angel'd said once how it takes up the same amount of memory recording nothing as it does an orchestra. I pick up the Gretsch then and strum, just in case someone else is listening.

34

July 1989

I woke in a park in south-west Boulder. This is what I know now. I wasn't in a bed, wasn't in the house down near the university I'd followed the straggled woman to. This is what I know. There were tents and it was pre-dawn cold a mile up above sea level, mist swirling and my breath doing the same as the dew began to rise. I heard myself say: *Fuck.* I jumped up, legs skidding on the grass. I started punching my limbs as I stood trying to get warm blood inside by banging the muscles under the light jacket and jeans. I tried to understand where I was. Tents and an RV. It was a holiday park. I felt and found my wallet, cigarettes and lighter. My shoelaces were untied and my socks discarded someplace. I tried to remember how I'd got there. I was freezing. I kicked one foot against the other as I lit a cigarette.

Fuck.

She'd said her name was Chancy and I left with her because. Just because. Followed her from the bar through the shadows pushing down from the Flatirons. Followed as she trailed her way through the university district that emptied out into shitty housing. The street narrowing and she took the occasional glance back at me. I neither quickened my pace nor slowed. And neither did she. She was narrow, a leafless trunk that had never found its shape nor girth. Or it had, but had been taken away from her by drink, by needles and lighters and the burnt bowls of spoons. We went through streets like this. One by

one, the gap between us ten yards and then more, then less. Then, a large house behind a convenience store. Paint-flecked weatherboard and flies, the fence graffitied in elegant murals of famous faces and bold, hard reds. Chancy shifted boxes of rotted produce and made a path for herself and us both beside the fence. She paused at her door and produced her key. She unlocked it and looked back at me. The oddity of her face among that hair, the tangle of bangs and bob.

'It's, ah. It's OK. If you want.'

I went in after her. The house was dark, and music was playing in some place deeper in the house. As she turned on the hall lights I could see it was older than any place I had previously spent the night. And I don't mean in years, but in decay. The wallpaper was drooping from the ancient sack lining. The carpet was torn and the place smelt of dog. She turned in to the first door on the right. It didn't seem to close properly, she waited until I was in the room before wedging a piece of wood at the foot of the door and it stayed shut but it made no difference, I could still hear the music and the odd voice.

'Now we're here, daddy, we're alone,' Chancy said and immediately took off her jacket and pulled down her skirt so it was her skinny legs and underwear. She pulled off her jumper, her T-shirt. Ribs and breasts. She wore no bra and she stripped off her underwear and got into the covers and said: 'Now what're you gonna do?'

I followed suit. My jacket, jeans and boxers. I stood naked before the bed, cold and uncertain. I stood quite unsure whether I was going to continue. I felt meaty, like the sweat I'd dragged from the stage was flecked with blood and urine.

'Just,' she started and sat up. She leant forward and took my damp penis and put it in her mouth. I stood there watching her working the flaccid thing into some awful shape. I pushed it forward so it was easier for her. She moved her head back

and forward as it filled and went ridged. Then she looked up and smiled at me. The room smelt of pasta, of that cheese you put on the stuff. I couldn't think of the right word. She said: 'Come on,' and opened the covers so I could see her bony torso reach and arch. The black hair and jutting hip bones. I got in. I was lying beside her, passive and unanchored by decision. She came to me, slid on a condom and guided herself so I was inside her. We rutted like that, on our side.

'What's your name?' she asked. 'What's it—' Every time she tried to speak her sentences were interrupted by a measure of grunted pleasure. Heaves and calls, this near splenetic grin like I was the greatest lay, the best fucking fuck-machine. But I wasn't. I did little, just let her do whatever felt good on the inside and lay there, a drunk settled in my limbs. 'What's your – ah – oomph.' Questions which meant my arms could have been anyone's arms, anyone's. 'What's your name?'

Afterwards I lay still. Her skinny chest on my own. She smoked and I took a drag. There were posters on her wall. B-movies and hardcore troopers. Agnostic Front. DOA. Cro-Mags.

'I don't fuck just every screwball guitar banger,' she said, noticing my gaze. 'Just the jocks who follow me home. Just sometimes.'

'How long were you married?' I asked; it seemed like knowledge I suddenly had.

'Too long,' she said. She didn't ask how I knew. And I didn't know. I just felt like guessing at facts.

And then, again, again. Her hands on my belly. Her mouth. She looked a little like Sonya, her hair just a little like Sonya's and that's why I followed. She went down on me once more. This time the whole way and I came in her mouth. That hard subsequent cum, seconded from a later time, urgent and almost pained.

'Thanks,' I said.

'Oh – it's my pleasure,' she said and it might well have

been for all I knew. There was movement then, out in the hall. Scrabbling noises. I looked around for my pants, an instinctual panic. I felt a massive wave of drunkenness, nausea and spin.

'Just my roommates,' she said. 'They're always coming home.'

Then I woke in the holiday park. Children waking early and whispering but they were really shouting because they just don't know and I woke and I'd got there somehow.

Because.

Because we'd played, because Paloma. Because Paloma was domiciled in Boulder. Because Blair's studio. Because she'd been hanging at the studio and she said she had to see us to hear us, that the music was empty without seeing. Paloma. That she knew a bar. Because we took the gear, borrowed gear. Because Tone and Leo. Because Paloma had been at Blair's studio and convinced us it was a good idea. Because she was a person of idea and vision and I was shocked to see her. Felt myself glow in a stolen light, that I was obvious and vile. She'd come into the studio with Tone wearing an Adidas tracksuit top and black cotton pants. They held hands for long periods and I thought they were an item, as if some skewed devotion had overcome them. That in the aftermath of Miriam some deep knowing had shepherded out any ill-wrought feeling and become a new kind of tenderness. He'd attended the funeral and had stayed in Yuma for three months after Miriam's death and maybe. But that was three and a half years earlier. And she ignored me. She didn't say my name or look my way.

She lit candles in the studio, gifting it a pale, votive glow.

And me, she ignored. I wasn't there, a ghost of skin, bone and shadowy effect.

And she convinced Tone to play the songs aloud in a space where she'd be able to hear them.

A dust-filled bar with a vocal PA and thirty who seemed to know our names. Because that and because Sonya. Sonya was at the bar. Because she was there and she'd been at the studio that afternoon, because we'd tried to catch each other looking for the other's eyes as we played the songs Tone had written and knew he was missing something and had dragged me down from Oberlin to fill in the gaps. Her brother's songs and we had a drummer borrowed from a local band and he improvised the best he could. I watched her in the black and white of my periphery. Leo forced us to play things from Neues Bauen. Started playing riffs he was never a part of and the drummer seemed to know their rhythm and whether that was because he'd heard them a hundred times or because what he played was deeply implied by the harmony I don't know. I've never known. He had us eventually in the harmonic sprawl of 'Dance Prone'. The rise and heft of feedback and randomized chordings, within the fact of vast volume. He had Tone and I chiming our guitars and we watched as people who didn't know suddenly knew and they came to the centre of the room and they began to sway and the body movements were the same, the whole ballet of it, of punk's kind violence, its love of its hatred of hate. The cavort and head movements, the strange knowledge extant in that minor college radio hit, dorm room singalong and they seemed to know and I couldn't tell you the words, couldn't recall them as it was Tone who sang now and his sister danced in the room with Paloma Mrabet.

'It's been a time,' I said to Sonya afterwards.

'Is that what you say?'

'What you expect?' I asked at her. She'd come and leant on the bar beside me and I'd bought her a beer and we hung within a proximity I can't quite recall in any other language than that of bodies. Bodies and how they move so anomalously, daring us towards interpretation and question.

She shrugged. 'Other kinds of niceties maybe.'

'Other niceties,' I repeated at her.

'Boy, do I miss them,' she said, flat and just a little too loud. Her clothes sat on her like her clothes always seemed to sit on her.

'What you doing here?'

'I'm here to see Tone before I move back to New Zealand.'

'Moving back?'

'Been gone long enough for it to intrigue me again.'

I nodded. 'Three and a half years, or am I missing some months?'

'What?'

'Since we saw each other.'

She snorted. 'What? Like I begin to miss things when numbers start coming up. Is that what you mean?' She sounded approximately sarcastic, lightly mocking and this excited some minor adrenal event to rush about my chest, knocking on doors.

'Your little house in Phoenix.'

She nodded slowly and looked down at the bar. 'Let's just be in the same room and people can say to themselves: *Well ain't that nice. Conrad and Sonya talking like old times.*'

'Ain't it nice,' I said and she looked up, over the top of my head into the crowd. She'd arrived in Boulder three days earlier with her boyfriend, a man named Roy. He was in tech, computers and code. Sonya and I had managed just a couple of nods, a couple of short shouldery clinches like she gave to Tone and Leo. 'I got something to tell you.'

'No, you don't, Con. You just have things you want to try and say. These are different to actual things.'

'Why'd you come and stand here if you didn't want to hear me say things?'

'It's been more than three years. I thought: *Well—*'

'You thought—'

'You looked like you were about to come and—'

'Come and what?'

'Say the shit you want to say. You've always had a sense for the sentimental.' She looked around at the silhouetted figures caught by the stage lights, she stared as if expecting them to step into the real light of the room and rescue her from the inevitable.

'A sense of the sentimental?'

'There're things you want to say. I smell them on you,' she said.

I started laughing, surprising myself.

'Say what you want to say,' she said. She seemed nervous all of a sudden and she kept looking into the room.

'There're words that keep forming.'

'Say them.'

'They say: *I want Sonya.*'

'Con—'

'Right since I saw you – back at the studio, soon as you walked in this room.'

'Con.'

'I – this is what they say – love you. I imagine you saying this back to me. I imagine us alone, naked, parts of us fucking before we fuck. I imagine us with our mouths open, slack-jawed. Three words. There's no point in us not using them.'

'Idiot.'

'It's a long-held-on-to truth. I'm sick of truth not being said.'

She pulled up her hair so I could see the pale brown of her neck hidden from the summer by the length of her tresses. 'You feel this, you feel like it might even be true,' she says. 'And it might be true, but hell, Con.'

'There's no point in loving anyone else.'

'Don't. You sound pathetic.'

'Sure. I'm good with pathetic.'

'How long you been saving that one up? Weeks, days? Or years?'

'Roy seems a nice guy.'

'He's anything but a nice guy.'

'Well, leave him then. Screw him, and leave.'

'I enjoy his not-niceness. I am attracted to his bullishness. He has many *nesses*. They're repulsive but he makes up for it in a world-weariness that's certain about itself.'

'I. Love. You. You came over here to hear me say this.'

'This isn't relevant, Conrad. How could this be relevant?'

'It's always been relevant.'

She sighed, as if summoning up another time, another season. 'How have you been, Con? I worry about you sometimes. That's as close to thinking about love I get. Worry.'

'Don't be a bitch.'

'Oh, me and being a bitch – we go way back. All the way back to you killing a girl and we all killed a girl—'

'Fuck off, Sonya.'

'Oh sure, Con. Let's just get on. Let's just make sure we move on and: *What was her name again?* You fuck some girl and then kill her.'

'I never fucked her.'

'Well, whatever.'

'Well, whatever,' I said back at her. 'I want to make sure we know what we're doing when we say the words we're supposed to say.'

'Say what?'

'I love you.'

'I love you too, Con. But that's not relevant anymore.'

'See.'

'Fuck off, Conrad.'

'Where's Roy?'

'He had to drive back to wherever it is we live now. I'm staying with Paloma.'

. . .

Then Chancy. Her house and how pitiful I was and how giving
she was. Then I woke in the RV park. I walked then ran. *God.* I
felt vomit come into my mouth and I coughed it into the grass.
I found myself running into the street. A rasping thirst in my
throat. I smelt myself. I stank of someone else and whisky. I
smelt of stale cum and girl cum. *Jesus.* I remembered the smell
of her room and her body all elbows against mine. *Fuck.* I
ran, ran until I saw a supermarket and I slowed down because
there were people suddenly, people and cars. I was relieved,
somehow. Relieved because cars seemed to mean things were
back to normal which meant none of what'd happened was
real because mothers and their fresh clean children don't roam
that world in station wagons. They don't park and step out in
a biosphere of hatred and everything else with such ease and
elegance.

I'd woken up in the park. But I must have left, I must have
left her house. I walked through the supermarket. Through
the elegant rows of produce and how organized everyone and
everything seemed, how perfectly timed all this was, how per-
fect it was that each soul was here at this moment and at the
next moment gone, vanished to their home and replaced by
the next shopper and the next and how delicate it all seemed.
I was asked to leave by the security guard and I walked. I
walked because we'd fucked rudely, horribly and the smell
of her room and I'd heard voices and felt my body under the
sheets, the strange terrain of skin and muscle, how it was all
going cold. The voice. The sound of a voice. Then: *Just my
roommates*, Chancy'd said.

'I don't know how many, yes,' the voice had said out in the
hall, muted by wall and door. 'We live here but it's – uck – all
a kind of meeky hell. So we love it,' and the voice had turned
to laughter.

Another voice. 'How many?'

Then more laughter, because I didn't hear words for a time. Instead I heard the sound of sentences, their intonation and I remembered hearing Tone claim once that it's timbre that triggers recall, not melody nor harmony, it's the combined noise of scrap and hit and ring. And it was Paloma Mrabet, Miriam's sister, as if she routinely appeared in houses like those claiming to live a life among people like Chancy and the people Chancy'd named in the rooms down the hall.

'Oh Lord?' I heard Paloma say. 'How many? I've no idea. I live here and forget to count. I've no idea. We're talking junkies and porn addicts. I give a fake name.' Laughter. 'I dream of a life where we swap names every week. This would make things bearable, yes?'

And then the other laugh and I felt my legs tighten – it was as if Sonya knew her laugh would be heard and felt because my body seemed to twist. It was Sonya and beside me Chancy put her fingers into her hair and tried to sperate the knots that clumped at the back. 'You wanna cuppa coffee?' she asked, her face wan and measuring. I felt my features, the shape of them harden against the sound of her.

I heard my name. Heard Sonya swear at its sudden noise in the hall.

'Let's go out into the kitchen,' Chancy said, almost sweet-sounding. I put my hand over her mouth and felt her teeth nibble at the pads beneath my fingers like it was a game. She tussled and separated and she laughed like I meant it all to be funny. She reached and grabbed a cigarette and lit it and once she had ash she tapped it into the palm of her hand and blew it on my chest and traced her finger through it. 'I'm hungry, daddy. You know what I am in real life, daddy? In real life I'm a chef. I can make anything out of nothing.'

But I wasn't listening to her. I was listening to the hall, the two women.

Paloma. Sonya.

Paloma was asking and Sonya was just saying. I took the cigarette from Chancy and drew up the smoke and held it in my lungs as if that would make everything silent. I listened and Chancy was giggling. And I swear Paloma began saying, describing secret things, an ease and flow undoing everything I'd kept tight. I swear I heard her say my name and then a silence. A learnt silence, or a silence in which things are learnt. And I listened, the rank walls holding nothing back. The words slipping easily through and how Sonya was in the hall just inches from my head and how Chancy kept tapping the ash off onto my chest and how it singed the hair and I woke up in the park and the air curling around me like the dumbed-out contrails of the thought I could escape all and I walked. I climbed out her window and walked and woke in the park.

Then from the supermarket I went out into the morning and found Baseline Road and made my way west towards the edge of the city where the street twisted and ended at the head of the trails into Gregory Canyon and I walked. I walked until I saw signs for Green Mountain and I thought: *Yes.* And I walked and climbed till I was out of sight. I climbed in the thinning air and hit the height of the ridgeline and I turned so all I could see were the Rocky Mountains and how beyond were desert, desert, mountain then desert then ocean. *But by then who cares?* I thought. By then it's all the same, the same steel-blue sky, the same incalculable wait for the end. And I'd walked because Chancy had gotten out of bed and trailed a sheet across the floor to the door and I'd jerked up. I'd pushed up from the bed and hunted for my shoes as she made for the door and opened it and I ran, went through her window and sprinted then jogged then walked until everything vanished in the hills behind a wall of self-sure terror at what the world can know so simply.

35

June 2019

Sonya told us to find him, Spencer and I, to look for Tone in
these other desert hills, umber and wracked. To head inland
and meet with Aderfi, the man Ibrahim Yusuf had tracked
down in order to look for her brother. All so I can drag him
back. Put Tone on a plane and have his kidney checked and
clocked against her own. I drive from Blair's studio east to
Málaga. Fly to Marrakech via Madrid surrounded by the drunk
and sunburnt. Two men in oversized football shirts in the vast
ruin of holiday and despair fill the seats beside me. They've
been on the cans since before security and are full of piss and
bad jokes. I find myself drifting into the flight, the mesmeric
sway and give of falling and not falling. I ask questions, I ask
at what point did I forget about Boulder? When and why did I
forget? Ask if it occurred at the moment I began walking blind
into the mountains, lost myself in the gullies where I was
bluffed-in and half insane, starving myself, terrified. I ask if it
was when I heard Sonya and Paloma in the hall and believed
what I erroneously believed, that they'd said my name and I
believed they said Miriam's and I believed it was stated there
and then the fact of our common experience and the horror of
that, the unseeing terror and following rage and descent as I
climbed those hills. Or was it when Leo picked me up from the
ranger's office five days later and drove me north to Cheyenne
and I spent a week there with Vicki, drunk and stoned?

And at what moment did I forget what Joan George-Warren
had told me in that kitchen? Was it when I smashed my way

through our set, or was it when I leapt into the crowd and swung my guitar in a rage, drunken and vicious? Or did I never forget and it's another word I need to use? A word like diminish. Like ebb, lessen or reduce.

The aircraft angles through the magnificent clouds in off the Atlantic and we glide into the white above Gibraltar. I look out the window without answers, briefly stare and see the southern extent of Hercules' pillars, the hefty granite of Jebel Musa jutting out from the northern tip of Africa. And there at the foot of the mountains rests the city of Ceuta I'd visited with Sonya and Finchman five years ago. A fort town famously built on seven hills, the fortifications rising and falling away with our wing-tilt. Seven hills and you know what that means. It means the people in me bulge. Tone, Sonya, Spencer, Angel, et al. All missing at one point or another, thought dead, thought alive and hiding. They gawk back at me and bulge. Blair, Billow, Jackson, Joan George-Warren, Paloma and Miriam. They bulge and gawk, come and go and it's Miriam who stays, only Miriam. A young woman in dungarees making sounds, noises as if talking through some cognitive uplink I'd never had access to before. It all echoes like an old conversation, one we've been having for years, but it is in fact quite new. We get on just fine until I accidentally close my eyes and she sees what I see when I blink, who I see. All the people in me and that one person and I feel her, the immediacy and weight of her rage and I feel her, the rigid ripples of anger running up my spine and materializing in the smallest of pricks, like light heckling the back of my neck as the aircraft bangs on the surface of the air rising off the continent, rattling the wings and shaking the men beside me into laughter.

I tell her how it seems now, how it all seems I've become this improbable migrant, a man who'd run himself aground in all those great cities and islands and continents and hemispheres he'd once mocked himself for hungering to view up close. I

tell her I've somehow come home because there in the air was suddenly home, held by the trust we put in the pilot to resist the plane's persistent desire to throw itself to the surface of the earth in a roar of smoke and flame. I tell her that all I see when I look below is that face, sized out of the ageing angles of the city and its seven hills. I speak and I'm numbed, dumbed out as the clouds. Clouds and their swirl and I'm expectant of calamity each time we smash on through their great, empty expanse.

I'm met by Aderfi outside Marrakech's new airport, he's a bearded man with a sign bearing my name. He looks at the cut on my lip as I shake his hand and I mumble clichés about the other guy. But the other guy's Blair and Blair's fine, he's tracking an album with Nikko and he's free from the words that have haunted him for years upon years. Free as the damned air that somehow didn't let go of us as we glided across Morocco, didn't dump us into the earth as I realize some part of me had hoped. The Moroccan gets me to put my backpack in the rear of the van among supplies and boxes of spray-paint. Twenty, twenty-five boxes looking for the hoodlum element.

His van's black, clutch-less and rushed by aircon. He drives south of the city to the luxury development at Les Jardins de l'Atlas where Finchman'd spent the night after driving up from Tafedna. Aderfi speaks with a receptionist as I wait on my old drummer and I watch wakeboarders on a man-made lake on the other side of the building. French tourists running past in swimsuits, cluttered glee in defiance of the African desert. The scape of near-dead earth and the ruined rock I'd wanted the plane to throw itself into, burst into an orb of billowing death-smoke, all so our private memoirs were nothing but the chemical vapour of vanishing souls.

'Yo. How's Blair? How fat's that fucker now?' These are the first words I hear from Finchman as he comes down the hall from his room. He's wearing the same clothes he wore on his

arrival from Tunis those weeks before. Dusted cap and boots. His skin carrying all the familiar marks of war photographer and desert dweller, sun damage and squint lines. He's smiling through his beard.

'He's just the same,' I say, lying.

He puts his arms around me and his beard crudely kisses my cheek. I smell the rough stink of him and a simple and ancient fondness takes over. I've so much to tell the man. So many coarse facts I want to make into lies. Because lying is inevitable now, just as the end of every thought you once trusted is inevitable.

Out in the car park, Aderfi pauses the van beside a man who's waved us down. They speak softly and calmly and Aderfi hands over several notes as I sit in the back watching the moment, waiting on the truth that anger always believes it knows and if it doesn't know, trumps in its pure enervated fury. They shake hands, a brief, coded exchange. Aderfi turns to us before we pull out onto the highway, he says: 'He's African, this man. So, very poor.'

The man in the car park wears sports shoes, a tidy shirt. I watch him, then watch Finchman watch him.

'Where in Africa?' Spence asks.

'South, past the Sahara. Where do you live, Spencer?' Aderfi asks.

'Africa,' I say for him.

Finchman looks back at me.

'Africa,' I say again.

He stares at me. One eyelid seems to fail and he's squinting as if I know something, what the word really means beyond what the Romans came up with for the continent.

Aderfi laughs, strangely mid-ranged for a large soul. 'You know, it's an outsider word, this Africa. Difficult to know what people mean by it.'

'Yes, but so is America, and look at us spouting it every opportunity,' I say, still looking at Finchman.

'I live in Tafedna,' he says and somehow that makes my heart race, as if I suddenly need to get back there. That I have to do something there among his collection of photos and old articles. Destroy them perhaps, burn it all. Watch as his house falls from the side of the hill in a hiss of smoke and stone, collapsing, and there are no words to be said, just the sombre sorting-through and just the things insurance will replace when everything is gone.

It's forty-eight centigrade outside, a number of mythic proportions and somehow we drive through it, heat, wave and particle up into the Ourika. The river cutting through the loose red-rocked foothills of the Middle Atlas. Aderfi points out houses and shacks, Berber tribesmen and on up past the orchards and the fruit stalls. The trees hanging their arms across the road. He points to the turn-off, a small sign advertising a ski field. Then the river, the restaurants on its bed. For miles it seems, tables and chairs and waiters feeding men and women in travel attire among the boulders on the bed of the river. At Setti-Fatma, Aderfi stops and has us out among the mingle of vans and their occupants. Travel pants and day-packs. Fanny-packs and money belts poking out. Aderfi heads up the road with instructions to wait. Ten minutes and he returns. A guide at his side nodding and shaking our hands.

'We go,' the man says, and we follow. Aderfi taking out his phone and dialling. The serious voice of connection. 'Paloma,' he says, nodding to us. Then nodding again, that it was OK, to go and return.

The guide leads us across one of dozens of bridges slung over the river and we follow, up behind the restaurants and gift shops where men are bent over their saws and brushes. We pass day-trippers – Moroccan, English, French, Egyptian

– skipping up rocks and pulling one another through the river and up and up. Finchman grunting with the pain in his knees. Hunters with ancient rifles returning from the hills, 10,000 times oiled. Antelopes and goats. One waterfall and then another. A ladder amidst falling water. Our guide saying: 'The highest, the last. We meet them. Then I go and they take you.' The deep pool at the base of a grand cascade. Swimmers bathing and diving. The shouts of the water-mad. Everyone resorts to splashing and howls. He moves quickly, turning every few seconds to make sure we're with him.

Up. The crowds gone. The single-file path beside the canyon below as we climb above the sixth fall. The view widening to the hard peaks of the Atlas. Mountains pushing through the vista so we all stop and stare. The compulsion to consider size and distance. Beyond the hills the Sahara where the snakes riddle the desert. Here the final waterfall. Another pool and we stand beside it, white stones arranged in a circle, or the part of a circle. Our guide says to wait and he leaves, descending the trail and it's just the two of us.

Finchman and I sit upon the rocks as the light starts to lower into the hills across the valley, there the village sits and Aderfi waits and our guide is now sipping his drink. The nerveless blackening of the hills. Behind us it's all aglow and it's hard to tell how much longer we should wait.

Finchman watches me, his glossy head and pale eyes.

We smoke cigarettes, handing a bottle of water back and forth as if it were wine, or something harder. Several of the houses below appear to start fires in their ovens simultaneously, smoke rising and catching the upward breeze, bending towards the peaks out of sight behind the valley where we believe Tone to be waiting.

'What do you say to Angel?' Finchman asks. 'When he asks about the band?'

'I say we're still playing. That seems to make him happy.'

'I send him books.'

'I know,' I say. 'I pick them up at the gate.'

'How is he, really?'

'I fix his Wi-Fi and he makes me watch *High Maintenance* webisodes and we laugh but I'm fairly sure he doesn't know why. There are levels of competence we're still figuring out. We discuss the state of his bathroom and leave it at that. I bring him his mail.'

'He sends me photos of his shelves,' Finchman says. 'Hardbacks. I don't fuck around with paperbacks. Burn them if I'm ever forced to buy the things. Set off alarms all across Europe. In Slovenia they send whole brigades of fire appliances because I'm burning a book in a sink. It's everyone's favourite hotel, and there I am.'

'I pick them up at the mailbox,' I say again. 'He can't read.'

'I know, but reading isn't their full purpose, is it?'

'Not all of it.'

'It's the spines on the shelf,' he says.

I shrug.

'Without books we'd just stare at walls and try to imagine what other people think.'

'Is that why you send them, Spence? So he can imagine how other people think?'

'I send them because I want some part of his life to be a part of mine.'

'There's an admission,' I say.

He stares at me, trying to get under my eyes concentrating on the ground in front. 'What did you think Aderfi meant by Africa being an outsiders' word?'

'Just that,' I say.

'It can't be just that.' He looks at me, still trying to find my eyes.

'He means Africa's the word the world likes to hide behind. It's the term the world uses when aligning itself in language

and tries to get its head around all the fucking horrendous things done here. He means for us to fuck off.'

'Bullshit.'

'Think of all the things done here,' I say. 'You can say bullshit, but you're just bullshitting yourself. What are you doing living here, if not hiding?'

He goes quiet, looking up at the waterfall. 'I'm sorry,' he says, surprising me, as if there were no space for real apologies but he desired to try them on anyway. 'I don't know what I'm saying.'

'No, you don't,' I say.

'I'm improvising.'

'Improvise away,' I say.

'I send Angel books so I can be a part,' he says. 'So, I'm not apart.'

The light on the hill opposite shifts, its colours take on shadow and the day dies down. Old western, the ballistic reds and yellows of desert mountains.

'I think he means we're supposed to be careful up here,' he says.

'Bullshit. You should call your wife and tell her you're here,' I say. 'Maybe you'll extract some sympathy.'

'You should be calling your wife. She's all alone, except for Angel.'

'Call your own wife. Tell her some things, Spence. Tell her some things.'

'Calm down.'

'Call Juliette.'

'Hey,' he says, sharp, shorting the conversation.

'Call her.'

'Juliette,' he says, then waits for a moment. 'Well, my wife's busy with the house. She renovates, Con. She attacks the bathroom, she does it with vigour. Juliette hammers out a new bedroom without telling me. Our wives are secret people, Brother Jean.'

'Aderfi meant Tone doesn't want to be located, you dumb fuck,' I say. 'That's what he meant. He means we can't actually find him. Mountains are the place where memory goes to get fucked.'

On the hill opposite are the multiple clusters of houses. The squared-off roofs, each slowly stepping up the hill. Something of the longed-for archetype we cross rivers and deserts and seas to mark on a map, hopeful of ruins.

'Fuck this,' he says. 'Shall I head up and look for them?'

I look into the hills.

'Shall I?' he asks again.

'How's Celine?'

'She's gorgeous, stunning.'

'What's it like, Spence?' I say. 'Having a kid?'

'Raising a kid? I don't know, Con. You know? It's to enact the parts of you that lie deep and dormant.' He looks abysmally sad all of a sudden. 'How much more light do you think?'

'Half an hour,' I say.

'I go for ten minutes, and if I find him . . .'

I point at his knees. He nods and shrugs.

'I do this every day; the complaints are just a part of my general living.'

'Idiot,' I say.

'And you wait, huh?'

'I wait. It's OK.'

'It's OK,' he says.

'It's OK. And then you fall,' I say.

'Sorry?'

'Then you fall.'

'Con?'

'You hit your head on the way down,' I say. 'It cracks and you buckle and twist.'

'What's this?'

'What's this? What is this?'

'So, I stay here then,' he says.

'You stay.'

'—'

'—'

'Con. What is this? Tell me what this is.'

'—'

We hold the silence, the two of us, him standing beneath the spray and me staring across to a dried riverbed curving towards us on the far side of the valley, a bend on the berm of the ridge, distant and permanently dry despite the drowned gurgling of the cascade.

36

Moments of clarity are rare now and full of sky. Full of blue
that goes black and I scan this place for connection, holding
the phone up like an idiot desperate for meaning in the sky. I
watch the little light indicators and hope for a sign. For years I
expected Sonya to call. To burst out of silence and be sudden
and true on the end of the line. I imagined at thirty her calling
and saying something, that I would recognize her voice, face
and mouth. Then, a decade later, she sang to me in South Deer-
ing with Blair bursting to tell me what seemed plain knowledge
to everyone but me. At forty-two she called across the desert to
LA from the border lands. Arizona, where the only true borders
are maintained by deserts, mountains, river and road. But then
again, the only true borders are set by language and voice if I
were ever to believe Miriam. The only true borders are those of
taste and food and drink, that was what Angel said before he
was wasted after our final gig in 2017. Mugged in Wellington,
never to leave the city again. He lost his life in New Orleans for
one gig on the other side of the world. Lost decades of accrued
knowledge and people, lost emotive understanding and the
intellectual bearing of the man he'd become. And I'd gained all
this, these names and places. And now it seems the only true
borders are those of tremor and pulsation, of music and drum,
of string and song. Of the clothes we wore and fought over. Of
skin and violence. The only true borders are love and hatred.
The only true borders are drawn on a desert by camel train and
foot. The only true borders are bedroom doors and the posters

hung therein where betwixt roam the living and their queries of gods and bullies, rogue questions about where they begin and where they stop. And here I am, the thing in between, perched on a rock above the pool of the last waterfall. And here Finchman sits below, listening to the footsteps and the scrap and hustle of many in the dark.

'You doing OK?' I ask once she answers and finds a place in the house to talk.

'I'm – everything's OK. I've a nurse with vials and a wheelchair.'

'How are you? You sound like you're breathing all funny.'

'Mm. I'm OK,' she says.

'You all right?' I ask. 'How are you feeling?'

'You located my brother?'

'Yeah. I can hear them all; they're up above,' I say.

'Where are you?' she asks.

'Up at the last waterfall.'

'I can't hear anything waterfally.'

'It's just a trickle,' I say.

She's quiet. 'How many?'

'I don't know. Finchman's here,' I say. 'He's threatening to go looking for them.'

'Christ, Con, I tell you. I'm tired.'

'Yeah,' I say. 'How are you feeling?'

'OK. Tired.'

'How are you doing?' I ask. I wait and listen as she considers her options.

'OK.' Then she paused. 'You know, darling. You know that sound of the city, of streets? The early morning. The not-quite-empty sound of the city?'

'Yeah, sure.'

'You know. Before all the cars come. Right after you've done what you've done. And the evening has stopped having a middle, right before the workers come.'

'I know,' I say, smiling into the phone.

'The hum, that hum sound,' she says, 'streets and the sound of a city holding back until the people. And you realize you're just waiting on the people, that sound? You know that sound?'

I say I do.

'That's how I feel.'

I listen to her breathing, the faint patter of music in the background from our lounge. Guitars and muted drums flown across the globe to be here. It feels odd that they're also there on the phone, lingering in the audio stream; to hear her voice seems the rhyme of the everyday. Even her breathing seems customary across the expanse. She'd decided she'd never been to Boulder – and perhaps that's how she keeps what happened to me at bay. I know she knows something happened. It's as obvious as wind change, as the gradual snake of a river from its old bed to new. A kind of future shock of the self – and who recalls what was there before?

'How long you been waiting?' she asks.

'Two hours.'

'Two hours?'

'Yeah.'

'He's coming soon though, right?' she says.

We say nothing more for the moment and I imagine her smiling, peaceful for a time. I listen and I'm amazed to hear her talk. I know now she once lied to me and I don't care. She lied to me about Boulder, that I was there, that she was there. And I know about Boulder. I know she spent a night with Paloma. A single night of bodies and sex she'd never have again, a night of deep strangeness with the sister of the woman I'd killed with her in the van beside me. I know she lied. But I don't care. She lied because she'd panicked for a single moment, and stuck with the lie when she understood I'd no means of challenging her. And I don't care.

'They're here,' Finchman says, calling out.

I look at him as I listen to Sonya walking about the house. The lounge, kitchen, stairs. I think about her keeping Boulder out of reach. Think about her mind in that moment. Her panicked response, to deny and lie. For me to ask so suddenly after three decades – she made the decision to deny and lie. And I don't mind, I don't care. I'd walked in the mountains there for five days without food and something in me vanished. Something near to vital left among the catamount mounds, abandoned below the glinted rock faces and ever-deepening gullies. Hunger and body pain and great skies of blue then black and star-studded. I love the idea of her in any place. I love that she can't tell me about Paloma. Secrets make the world alert and constantly awakening.

'There's maybe ten of them,' Finchman says.

The unnamed voices juggling in the hills. Then silence, from me, from Finchman and the phone. We sit in the chill, the cost of cellular silence oddly the same as spoken words. Economy is time multiplied by whatever. I'll never tell her what happened, not unless she can promise she won't die in the aftermath. You can't trust other people's secrets not to inflame and take over in fatally wounding ways. I swap hands and put the phone back to my mouth.

'You remember Blair?' I ask Sonya. 'Out of Typocaust.'

'Blair. Of course. Why?'

'I saw him in Marlova.'

'Marlova.'

'I thought he'd have things to tell me,' I say.

'Did you say hello from me?'

'Of course, hon. And Nikko was there.'

'Où est Tony? Est-il avec vous?' Finchman calls in French.

'What? What's happening?' Sonya says.

'Hold on.' I swipe the screen and turn the camera on.

'Honey?' Sonya's saying.

'Hang on,' I say. 'Can you see?'

'What?'

'Can you see?' A jumble of people stepping down. I capture the sky and the mountains, the hard rock, the faces of men who've been in these hills for months.

'Is he there?' Sonya says from the phone. 'You're so far away,' she says. She's laughing in that way she laughs.

I pan and I keep panning until Sonya sees what I see.

'He's not there,' she says.

'I know.'

'Who's there?'

'Just men,' I say.

Just men, men in jeans and T-shirts, in sandals and sneakers. Finchman among them.

'Where's my brother, Con?'

'I don't know. But Sony,' I say, 'I saw Blair and I was so relieved to see Nikko.'

'Why?'

'Hang on,' I say.

The two men talking with Finchman. They nod together and both point. Finchman's laughing with one of them, turning with his whole body to look around. He nods at me and he stares at the camera, his eyes made small. He comes stepping over the rocks, ankles bending and shoes slipping. He's pointing upwards towards the crags above, grey and pink and a bored-out peach evening light.

One of the group shouts: 'We climb. Not so far, but far enough, yes?'

'Yes,' I say back. 'I got to tell you something,' I say into the phone.

'Con?' Sonya says.

'Hon. We have to climb. He's up ahead. But I got to tell you something.'

'Be careful, darling.'

'Yes,' I say.

'Follow Spence,' she says.

'But I have to tell you something.'

'Just follow Spence,' she said. 'Be careful.'

I don't reply. I realize I've nothing I want to tell her, just that I'd seen Nikko and he hadn't recognized me and I was so happy for him suddenly. I start moving upwards, up and away from the tourist trail we'd come in on. I've no desire to let her know she lied. There's far more impossible events happening in my head and I follow on behind the last feet. He didn't recognize me and I was so happy and I follow Finchman one man ahead. His new boots and Sonya in my shirt pocket listening to our exertions and grunts. Finchman looks back down at me, making sure I'm OK. I nod at him and he nods back, oblivious to the way he is suddenly falling in my mind, over and over. He's laughing and oblivious to how in my imagination he's tripping, quite unaware of the brief shout from his mouth as he falls, oblivious to the way he stumbles. Oblivious as he buckles against the boulders in my head again and again. His skull cracking. Oblivion and oblivion. He mouths something to me, or speaks, but I neither hear nor see what it is he's saying. Then he signals with his hand, opening it and closing it like a duck's mouth and I realize he wants me to speak, but I don't. He wants me to speak to these men and listen, but I don't. I let him keep signalling into the air, for it's silent in the air cos there's only him falling in my mind. Fall, Spence, you fuck. Fall and fall and again. Trip on your new boots, Spence, over and again so you grunt and go down, down.

37

Tone has his tent up near the lower wall where they light their fires, away from the rock face, for the rock face is where the students, volunteers and artists do the work. It's a cliff that leans outwards from the vertical, tilting over the camp, protecting the fire from the wind that comes from the west and skips over the little town of twenty or so tents. There's a continual drape of smoke obscuring anything on the wall that might give a hint to the actual painting, its colour and magnitude. It's a heavy dark. We'd walked by the light of our phones, tripping and never falling, not in that way I desired. Each path and turn had the potential for the fucker to fall, but he kept walking upright, easy does it, and I learnt a new kind of fury watching his footing, sure and steady. We come into the clearing of tents and ropes, I hear a brief soundtrack. It's something after us, something mathy like Don Caballero, Mountain Eater or something older like Bitch Magnet. Tone always liked things before we knew about them and he's the first person I mark on arrival. Tony Seburg standing by the fire. He comes over to greet us, offering cigarettes. His beard has gone, his hair neatly cut and parted like he's last lost member on *Die Mensch-Maschine*. Immaculate and ordered. None of us have seen him since we all sat outside Angel's room in the hospital two years ago, too shattered to go in and look Angel in the eye as his brain struggled to recall who he was.

'What is this place?' I ask.

'This is. This is where— What do you know? Like, about it?'

He asks these questions, gesturing with some part of his body to the steepled rock and the white and blue and indigo domes of tents. Tone has been here for some months and decked his quarters in rugs and bookshelves. A desk and a lamp.

'Just rumour.'

'How'd you learn about it?' he asks as he comes forward and I realize we're going to embrace.

'About the camp?'

'Yeah.' He stares deep at me, a kind of deafening glare as he puts his arms around me then steps back. There's no evidence of disbelief in his look, that our appearance here has taken him by surprise. I feel suspect suddenly, that our arrival here was his plan.

Finchman tells Tone about the man in Marrakech, the curator from the museum and Tone stands nodding, a slight hint of concern.

'Where's everyone from?' I ask.

'They come from universities and all over for Paloma. You can ask them, they'll tell you whatever.' Tone speaks slowly, glancing around at the dark surrounding the camp, the way it clings to the air. He twitches his head like a sparrow at seed; I read this as a kind of knowing, a kind of prediction that everyone knows, all and all, and I've been reduced to a coming moment when I have to tell Finchman that I know who he is.

And I walk behind him as Tone takes us around the tents, the groups of young men and women talking, clipped and serious exchanges. Introductions and offers of coffee. The sudden sense we're there for reasons none of us know about.

Tone gives a little speech. He tells us about plans for the place, logistics and so on. 'It's a meticulous operation,' he says. 'Nothing improvised, except when lives are at risk and things need to happen quickly. There's a bible we follow. Written in blood. Plastic blinders.'

We sit under this sky, now battle-weary black. Ten students appear out of the crack in the cliff. They immediately start in on a bong. The deep-sighed smell of hashish. The men serious-looking but joking in their T-shirts and jeans. Introductions and handshakes. Rough hands of various sizes. They speak mainly French. A couple in Arabic. We listen to the glistening jokes. I have the sense Tone isn't anyone specific here, that his role is rudimentary. The sanitary officer, or some such. I also seek out evidence of my suspicions, that Joan has been here. Her speech and body amidst the wafting smoke.

'Did they locate me through the old phone?' Tone asks. 'I used it once when I first got here. I was looking up football scores and realized I could be found by satellite, that helicopters were on their way. It's all the hash they smoke around here, it makes me paranoid.'

'Someone spotted you on the paths,' Finchman says. 'Didn't think you smoked.'

'I don't, but paranoia is a catching thing. The amount of money we spend to pay off the locals, the police, to keep this thing quiet, you'd think I'd have conquered it by now.'

Finchman laughs. I stare at him for an instant. The same face and eyes. The same voice. The same curdled humour in his laugh. The moment I saw him at Jardins de l'Atlas after arriving from Potaski's studio with Aderfi I felt nothing. He was just Spence. The same features and ageing. The same clothes as three days before. The same small joy I felt in him when he saw me. I have to hack out a new version of him, shape him. I try to see his face in shadow and see nothing.

'Some tourist saw you on the paths,' he says. 'That's all.'

Tone squints at me until I squint back. He shakes his head and whatever it is behind his eyes goes. 'A tourist,' he said. 'I guess that's what I've been reduced to, right? The only people who can see me are folk skipping on the paths in travel wear and two-hundred-dollar boots—'

'How'd you get here?' Finchman interrupts.

'Otherwise I'm invisible, impalpable,' he says, then looks at Finchman. 'You really want to know how I got here?'

Finchman shrugs and he sits still among the young men and women. The artists and volunteers who come here to work with Paloma Mrabet. I expect hatred, for it to glow in their mouths as they talk but they're as friendly as pups and there's something that rages afresh and alone in my gut. I want to run but there's only darkness and bluff and who would I run to? I came here for Tone but Tone's still in the distance. He's wearing his large coat, wrapped like a beggar's blanket. He was wearing it in Wellington when Angel was mugged and really the only difference I can detect between then and now is that he has a cough, something I've noticed on a few of his fellow camp dwellers. Kind of rough and raking. He starts talking, describes his communications with Mrabet over the years. How they'd merged their discussions into a trust of various secrets of whereabouts and intent. Then the camp fire flickers up, bursting light on the wall. And I see it for the first time in the retreat of shadows: evidence of a colossal mural-like arrangement, a work in slow stealing progress on the side of the cliff, clawing its way into the pitch above. Tone tells how after Angel, he could no longer face the kind of crowds he needed to be around to make the music he makes.

'I could never understand,' he says, 'why people want to be in a crowd one hundred metres from the band. I never understood how they could even claim they went to see such and such and the such and suches. But they go and I'm not convinced I know why, and it feels dangerous not to know why.'

I watch Finchman bobble his head at Tone.

'Music has ambition, I think. But it's reduced by projection, it becomes pitiful and pitiless and it can't continue in that format. There's no way for the music to continue on except as a reduction.' He stops, points at the rock faces. 'This work, this

is clandestine. It's not meant to be seen until after we leave. That is how music will be for me in the future.'

I take him in, expecting him to talk on. To make an apology of a kind, that he's never contacted Sonya. Instead he just looks at Finchman and says: 'Every time I think about Angel, every time I think of him on the pavement and those fuckers kicking I realize that despite everything, despite being able to go on stage and have people a hundred metres away dancing along, despite this I can't stop something so simple as my friend getting mugged on a well-lit street surrounded by people. This power is pretty useless in the end, huh?'

Early the next morning I watch several students come out of their tents. All dressed similarly. Jeans and the same T-shirt with this inscription in yellow on black: رادجلا. They set their abseiling gear, the nuts, hexes and spring-loaded camming devices. They step into their harnesses and climbing shoes. I watch Finchman talk with them and how he nods intently, ignorant of all that's occurring to him in my mind. They each inspect the other's readiness. They stand in a circle, put their hands in the middle and shout: *Hoah!* Then they disappear behind the wall, the hour's trek and climb before they can rappel down, hang there before the rock and begin their work. Finchman stands staring and I too stand looking up some thirty metres away until my neck begins to ache. The wall and then the way it steeples into a crag, grows thinner and finally peaks. Tone stands beside me, saying how awe is always the newcomer's curse.

During the afternoon with the sun stretching across the ridges, Tone introduces us to a team of riggers about to head up to the staging area where the painters rappel onto the cliff face. Finchman asks if he can climb with them and leaves with his camera and lens to explore. Once he's gone Tone and I walk. Up higher into the Atlas on the other side of the valley. The

crooked trails and stunned rock faces. The extended views, higher until he sits in a squat with his back against smooth stone, his lungs struggling with the thinned air. I watch him call Sonya on my phone. The smile that only comes when he talks to his sister. The stupid things they say to each other. I hear him make promises of a blood sample and a trip home.

Afterwards he asks about Angel. 'I sometimes google you,' he says, 'but only come across things about me, which is—'

'He's OK. And not OK. Alive, talking, but confused.'

Tone stares up at me.

'He's in pain a lot of the time but seems to get through it.'

'It takes great discipline to maintain pain at a constant level,' he says.

'I know this, yes.'

The mountains out in front of us, the hard shank of uplifted rock shaped by squall and water. Tone says he'd been to Bali for a time, the north coast and mountains. South India. Turkey, Hungary and the Balkans. Then he'd headed to Settled City, as they call it.

'I saw Potaski,' I say.

'Yes.'

'He told me things that've been on his mind for years.'

'Dear Potaski.'

'All those old things. Isn't that the thing with old things? We try to forget. But that doesn't happen, does it?'

'No.'

'You should've talked earlier to your sister, Tone. She's more important than any of this.'

'This is me apologizing,' he says. 'To you and her.'

'What is?'

'This work. This whole thing.'

'Jesus says fuck—'

'I'm sorry I haven't been around,' he says, 'for her and everything.'

'We've done plenty without you, Tone,' I say. 'Whole lives.'

He nods slowly. He examines my movements again, says: 'I just realized it was just another thing that has happened when we're all together. It's just this thing we shouldn't do. Not anymore. All the people and the things that have happened when we're together. And I realized. Fuck it.'

'What?'

'I realize I knew,' he says. 'That somehow I knew that what happened to you in '85 was my fault. And I think, I think what happened to Angel is my fault. And then Miriam. Everything happens when we're all together. I'd had Aderfi drive me halfway to Tafedna, I tried to visit you. But then we were in the middle of nowhere, between two towns. There was a mass of people, delirium and chanting. We were stuck and we had to wait until something passed. And I wasn't sure what it was, but something did pass. And I told Aderfi to turn and head back.'

'Did she kill herself?' I ask. 'Miriam.'

'Sorry?'

'Miriam. Did she kill herself?'

'Miriam? Jesus. You ask this now?'

'Did she kill herself? The question comes and goes. It's like a pike twisted in my gut.'

'She jumped in front of the van is what I saw,' he says. 'It's thirty-four years.'

'So.'

He sighs. 'I watched her walking, then she skipped and ran at us.'

'—'

'—'

'Whatever way, I killed her.'

He nods. I watch his eyebrows for a hint of something that would reverse this statement, deny it with a new fact. Instead he asks: 'Why's all this come back?'

I shrug at him and we sit in silence. I wait for Tone to look

at me. To say something else. But he says nothing and it's me who changes subject. It comes with one simple word – oddly weak, peculiarly ancient and I say it.

'Finchman.'

'Finchman,' he replies.

'You always knew,' I say.

Tone does nothing, then shakes his head.

'You always knew it was him,' I say. 'It's been a fact in your head always. You knew. You always knew.'

'Did Blair tell you that?'

'No. But you always knew,' I say. 'I just know this because I know.'

He blows air out between his lips.

'I threw Spence off the cliff thirty times on the way up here,' I say. 'Just – over and over in my head. Watched him fall till there was nothing left of him to fall.'

'He's been through hell.'

'I imagine Spence in pain. In deep pain. And Jesus, he pretends he doesn't know.'

'He's always been in pain, Conrad.'

'Deep pain. The kind that leaves scarred tissue deep and rubbing against the ends of every goddamned nerve.'

'Yep,' he says.

'You know every second person in the 2000s was diagnosed as manic. It was the role of psychiatry in the 2000s, to diagnose everyone as bipolar. It's bullshit. He's something far worse.'

'—'

'I imagine this for him. Every nerve in his body, each time he moves or talks or thinks, every nerve is rubbed raw. Each time he has a thought there's deep, clambering pain. I use the word deep and I mean *deep*. Right, delving, in there.'

'I never knew how to say anything.'

'And each nerve is like a hard nub. A little peak of flesh and thought, and that thought is him knowing, the precise point

of knowing that I know.' I pause and stare my whole face into Tone's. 'So much force goes into this exact point. That's what I've learnt, Tony. Years. Centuries of effort and war and pain and arguments, illness, death and hurt. This all goes into this one pinprick of a moment we call knowledge. This is what I want for him. The end point of knowing. The cusp of it, the lance, whatever. How much pain that induces.'

We watch as several little redstarts land in the rocky out-crop opposite. Jam their beaks into the crevices. Tone puts his arm around my shoulder like we're kids once more. I pull up my shirt to show where I inserted the boning knife into the space below my ribs in '85 thinking it'd be the end, but was instead transfixed at the sight of it and stared until it was out.

'OK,' he says. 'OK. When?' But he doesn't want an answer, I can tell by the way he stares, looking for his own memories of pain.

'I think about what you guys have been doing, down in the square,' I say.

'We only did it three times. It was an empty gesture.'

'That's why I brought him up here. I'm all about empty gestures.'

'We thought it meant something,' Tone says. 'People came to us wanting to know what it was behind it. Paloma talks for hours. She's a very smart woman, extremely. It wasn't her idea though. It was Caroline's. Cultural protectionism, she claimed, is the worst form of cultural appropriation. Which – I don't know. But Paloma ultimately saw it as empty. And so it was.'

'Who's Caroline?'

'Paloma's daughter, adopted daughter. Her niece.'

I stare at him, 'Tone,' I say. 'Spence was looking out the window as we drove up here and I was watching him and I was – I was many things but I was so angry, so angry he was no longer going to be there. I mean he was my friend. He helped me when I needed help. I was so angry suddenly. He was no longer going to be a presence. A presence of amity. Who I went through

everything with. He was gone. And I was so angry at him for this. He's vanished. I watched him as we drove up and I was thinking, how did he do it? What has him do it? And then there's Miriam in Yuma. How is this a thing? What gets him to the point that he thinks he can do this? Was he just fooling around? Did he think it was funny? And now, now what has he got, Tone? He's not a chance at love. Not a chance. Soon as he knows I know, he won't be able to let anyone love him again. And I'm frightened, Tone. I can hurt him, tell Juliette and Celine, but I know he can hurt me again. It's – it's just so easy to hurt me again.'

Tone kisses my temple. 'You know about his mum?'

'I loved Ruth.'

'Joan told me everything Ruth did,' he says.

'What? She did? What'd Ruth do?'

He frowns at the sky off behind my right ear. 'Spencer called Yuma and told Joan everything that'd happened to them a long time ago. I guess eighteen years back he told her. Once he got out of prison he called down to Yuma. She knew about what'd happened to Miriam because I'd told her in 1985, at the Christmas party, but then he called in 2001 and spilled his guts. That she didn't kill him or something, well—' Tone puts his hand through his hair.

'What'd Ruth do?'

'It's not what she did. What Frasier did.'

'What'd she do?'

Tone removes his flask from his jacket, slipping it from the folds like a secret. It's military grade grey, sucking in the sun. He seems to shake his head as he tips the bottle into his mouth. A whatever afternoon pick-me-up, sweet and zinged with a hint of booze. He offers it, looking up at me. I stay still, watch the little canteen until he pockets it and the air suddenly stinks of its hard contents. I'm blurry, as if I'd drunk it all, suddenly buzzed and half-high. But I'm blurry too because of the drifty look in his eyes. I ask him again what Ruth had done and once

more he shakes his head. I feel movement inside me, a kind of twisting like there's an unmapped organ there, one of doubt and self only accessible by following other's silences to their ends.

'What she do?'

'She was, she,' he says and again goes quiet. His mouth twitchy as if he's lining up sentences, lining them up like they're books to be shelved, their order specified by cold, numeric command – and then he's forced by instinct to take them away again because this isn't it. He pushes himself so his back slides up the rock wall. A jittery moment of aching legs and selfless determination, all as if he'd sat down so he'd have this moment of effort and strain to rival the things he knew he'd have to say. 'Almost in self-defence I'm thinking, from that cunt of a father is how he remembered it.'

'What are you talking about?'

'They'd cower, her with Spence in the bathroom which, you remember, was the only room that locked in their house. She'd hold him and keep him close. Black eyes for them both. And she would hold him and kiss him and sing to him. Hold him and hold. She wanted nearness, I guess and . . .' He pushes his hands against the rock behind him and makes to start walking, for us to head on into the higher hills, but stops.

'What about them?'

'You know what a cunt that father was? Years of this. Of being near to something.'

'To what?'

'The two of them. Years of his father. Of shouting and kicking. His father used to kick his mother as she lay on the ground holding him. And they'd hide and at some point, she used to. She'd kiss him and hold him to take away the fright. She used to hold him and hug him until him holding her was something else. And he eventually used his hands to – and she, she didn't. He touched her, hands under her clothes and she. Ruth eventually became soft to it. And it became this, this thing.'

'Soft to it? She became *soft* to it? What bullshit. Ruth – she didn't do nothing,' I say. 'Finchman is a lying cunt.'

'This is what he told Joan. We're talking years, slowly over years.'

'And you think he was telling the truth? Fuck you, he doesn't tell the truth. And you tell me? You tell me?'

Tone just looks blindly at me, his face caught between expressions, between sayings spelt out in any language other than English. Behind him the rock is turning skin-red with the sun angling through the hills. He talks on and no matter what version of events he offers I don't believe him. Not about Ruth. I only believe in the outcome, the final state of event. The source of everything is always the product of others' determination to be beyond knowledge, a seer of inverse divination.

'He's a liar, and he's a liar to suit his own ends.'

'He's a liar and rapist,' Tone says.

'I'll kill him.'

'But this happened. This is a fucked love.'

'You can't use the word *love*,' I say. 'Jesus. He raped, Tony. God knows how many others.'

'That's what he did. I'm just saying, with his mum and dad things turned into the impossible things. I'm just saying these are the circumstances.'

'I still don't believe you. God knows how many others. His mother.'

'I don't want to tell you this. I never wanted to tell anyone this.'

'What a cunt of a thing to put on her, Tone.'

'I'm just saying there's difficulty in knowing how he got to this point.'

'You think I need complexity pointed out to me?'

'No,' he says.

We sit in silence. Clouds cover the sun then run on. Occasionally we see through to the far side of the Atlas boundary,

the valley where Marrakech sits in smoke. I see Ruth, I see her face and the calm and urgency and I imagine her son lying about her. And I see Tone believing him because what else do you have when the world you've created has become so abstract there's only a desire to destroy it all.

Time.

And time.

I think of George-Warren and Paloma. I think quietly of the two of them in that kitchen and the things I couldn't know. I imagine them still there waiting for me and I suddenly understand why they'd loomed so in that room. What their anger had spelt. I'd put on Miriam the whole narrative of my own shit, leant on her to give it some account and size and shared acreage. The girl'd been raped in Madison by Cozen Jantes, by the worst of fuckers, she'd been raped by Spencer Finchman in Yuma and there I was in the desert, telling her all about it. Explaining just how it was. And then I killed her, and intent — hers, anyone's — seemed irrelevant.

'Miriam, she told me the baby was Leo's,' I say. 'Leo and Paloma's.'

'Really?'

'But it was Miriam's, right? Miriam and Spencer's?'

'Why do you think I stole the little thing?'

'Jesus says, *Fuck you*.'

Tone looks past me into the hills and when he sees what he wants to see, shakes his head.

'The fucken— He know that kid exists?' I ask.

'That kid's here. She's thirty-four,' he says.

'She's here?'

'Caroline,' he says.

'Good lord. What's left, Tone? Which one the fuck's Caroline?'

He's still for a long moment, so still the air around us gets busy with other things, shifts of breeze, the scurry of a small lizard, feet tapping on stone and my mind's replaying

every image of every face I've seen on arrival, scanning then searching for Caroline. I start to ask but he's speaking —

'You want to know why I shot myself?'

'I know why you shot yourself. I've known this. I have knowledge, believe me.'

'What, then?' he asks.

'You felt the urge to shoot this fuck coming out of the back of the van. You felt how easy it would've been to fire and watch the fucker fall over, gasping. Right? After all, Tone, you'd seen him raping your friend.'

'I didn't know it was you then.'

'*Raping your friend*, because you knew it was me. You'd watched him in the van. You saw enough to see it was Finchman. You knew it was Finchman. Then you traded that thought for one that said: *How easy, how simple it would be to shoot myself. How easy that would be.* And the effect would've been the same. Gore and mess and rupture. You thought, *It has to come.* The bullet has to be fired, otherwise what was the point? You knew who it was and you couldn't shoot him.'

'—'

'The whole horrible act of knowing,' I say. 'The precise point of knowing, the event of it, right there at gunpoint. And this means, it means you always knew it was Finchman, Tony. Always. There's no bullshitting around it. Why shoot yourself for anyone else? The gun existed. It has presence, it has to go off.'

'—'

'You had to fire.'

'I had to fire.'

I feel him watch me, trying to say the words that come next. Eventually he asks: 'What do we do with him?'

I shake my head. 'Why'd you keep him around all these years, Tone? Why did you put me in the same places with him?'

'Because, I don't know.'

'Why?'

'Because—'

'Why?'

'Because – and I've thought about this – forgiveness is about locating a place for people in your life, however distant. That's why I kept him around. Forgiveness is about finding a place for people in the structure of thoughts that make up your life, or heart, whatever. It's about keeping them there so you can control that part of your—'

'Fuck forgiveness. Fuck it, Tony. I've only just learnt about the fucker. Forgiveness isn't on my agenda. I'll never see him again after this. Nothing near. Nothing.'

'What do we do with him?' he asks.

'I don't know. Show me the paintings, Tone,' I say.

'Yeah. Let's.'

But we stay seated, something yet unsaid. What to do with Finchman? What to do with Spence Finchman back over the valley at the wall where that morning we woke and saw the painting. The size of it. The huge stretches of pigment and shape. The abseiling ropes dangling off the top of the cliff. The sense that you couldn't see it from this close. The explosions of colour at the bottom where the workers had dropped their cans and they'd erupted, flung pigment in all directions. Gold to flint the khaki massif, charcoal, onyx, taupe and versions of grey for the shadows. The sense you had to climb to see.

We sit in a pause, somewhat meticulous, as if time is only something we volunteered to take part in. I watch Ruth wandering about in my memory, delicate in the kitchen. I watch Tone twisting in the gravel outside the Eighty-Eight.

'I think I believed that if I pulled the trigger something would change,' he says suddenly.

'Bullshit.'

'I think I thought all of it, every moment up until that

point, it would change. Wham. And the future too. Wham. Everything's different. But nothing changed,' he says.

'Everything changed. Tell me how it didn't? Tell me various evidences of this. I'm still in the back of the van, Tony. Still there. Miriam's in Madison still being raped by Jantes. She's still in Yuma being raped by Finchman. These things – they're prevalent. And Ruth. Jesus, Ruth.'

'Yeah,' he says softly.

'I'm still there. Waking to this, over and over – it's a simple, simple ruin.'

Tone looks at his fingers, the nails he bites. 'Maybe I did it because I thought I could outdo all of this – time, whatever. I do it again and again in my head. If I pulled this trigger everything would change its shape, none of what happened would've happened. That if I pulled the trigger and the sound, the sound and the force and the intent. That the intent alone would split time and everything would return. Maybe I did it because—' He signals around.

'But it happened. It's always happening,' I say.

'Sound and force and intent,' he says.

'It's always happening.'

'It's the closest experience I have, the closest to the instant,' he says.

'It's always happening,' I say.

'And I got to go home,' he says. 'Right?

'You got to see your sister, Pantagruel.'

We walk then, head to the viewing area. Another hour's climb in the hills until we see it. Paloma's shadows painted on the rock. Blackened Buddhas caught in time.

38

At seventeen we craved velocity. Volume and haste. Massive, thickening waves of decibel and speed. Then at twenty, we desired something else, we wanted noise. Violent surges of the stuff. The heave and threat. The sense you were in the centre of a great tearing, that all spoken things were being shredded in a magnificent and vicious insurrection. Where, in reality, we were just listening to a seven-inch, standing in a room with our friends, one of whom turns out to be, not the thing being torn, not the ruptured waves, but the actual tear. The actual mutilation of something incomplete and shimmering.

The last time I let Spencer near me we're all in the audience beside Paloma at the firepit as she oversees her foreman, a Tunisian woman named Star, giving instructions for the day's work. A pep talk. Star gabbing in French about the Buddhas, the absent Buddhas of Paloma's work. Aderfi interpreting as we stand among the workers and discarded cans of paint. The foreman's given a speech like this every morning, low-voiced, massive hair. And Finchman, he's being shown how to check the other artists' harnesses as she speaks and everyone moves in a little closer. I listen to Aderfi relaying, saying: 'This is our interest, everyone. Yes?'

Nods and the odd callout.

'We stare, yes. We stare with resolve.' He laughs at his words, or the sound of the words, or the specific translation of

the words and how they've come out – then looks serious once more. 'History is the act of looking. OK?'

The young souls around me yell out, trying to get Aderfi to finish by not finishing at all. Scattered laughter.

He looks at the foremen for reassurance and receives a short nod. 'She says this is, this the vocabulary of history,' he says, plain-faced.

'Dance for us,' a woman yells.

'If I dance, you'll all fall off the mountain.'

The woman laughs. She has a soft, round face like her mother. Tone'd introduced me to her earlier. She's short and stocky, some kind of muscled intent under her singlet either born with or born here under the iron skies. This is Caroline and I'm nervous around her like she might recognize me as some murderous prick or worse.

'Ah, yes. No.' Aderfi looks confused for a moment as Star seems to repeat herself. 'They're destroyed, these, ah. You rebuild, but that's not the truth.'

'Fuck,' Finchman mumbles.

'So this is our attempt to look, yes?'

The group whoops. There's some uneven hand claps. Sporadic applause for some element of his wording I'm not picking up on. Or not for his wording; perhaps there's an unspoken in-joke I'm not hearing. Or maybe, it's even beyond this, it's for the original words spoken by the foreman whose French I can't translate. Slapping hands and quite quickly the noise of it turns into something else. A rhythmic chatter of fingers and palms talking among themselves. I sense an inward slackening and find myself drifting with their enthusiasm. I don't put my hands together but I feel a curing sense of ragtime in their irreversible noise. Woollen hats and bare chests, beards and girls in makeup because *what-the-hell*. A whole rogue people lit upon the world.

'We paint, we paint!' Aderfi says, laughing. He's improvising,

I suspect, because of the way he looks back at Star, confused. Because these are grand statements – then so small.

Everyone laughs and shouts the words back at him.

'The past's the shape we see when imagining what has, ah, vanished. This is history, so we paint.'

Paloma comes forward to tap him on the back.

I feel a genteel kindness in his translation, as if he only wanted good deeds possible from his words. Caroline goes to him after he has finished and puts an arm around his stoutish middle and they walk away like that, talking and bragging some kind of intent in their own language of movement.

Afterwards I find a few seconds in which Paloma is alone outside her tent. She's talking to herself, flicking through images on her iPad. The architect trying for a mental glimpse of the entirety of her creation. The explicit indicator of the thing the work knows, the thing that she didn't know before she began and discovered in the process. I introduce myself. She nods slowly.

'I'm Tone's friend,' I find myself saying.

'Yes you are.'

'I was around in '85.'

'Nineteen eighty-five,' she says. 'I do remember. Or, I have the image of remembering.'

I nod, an almost bow. 'I last saw you in nineteen eighty-nine.'

'I know when I last saw you. I was neither kind nor not kind.'

'There was no reason to be kind,' I say.

'There was plenty of reasons,' she says. 'To be kind and to remember.'

'Were there?' I say. And I say this despite the fact she once filmed me, rolling in the zoom. Despite the fact I've been watched, according to YouTube, 45,000 times. Recalled in the dismal lives of old punker dreams. Despite the fact I killed her half-sister when Paloma was twenty-four years old.

'But I like to remember. Makes me feel more responsible to everything that's going on here.'

I pull up my trouser leg, reveal the old tattoos.

She leans in closely, goes down onto her haunches.

'That's some time ago.'

I say it was. I find myself lying. I say: 'I got this from your sister. From Miriam. You remember?' And I ask as a test, I realize. I want to see if she remembers our conversation in the kitchen in the Arizona hills. A test for the sake of my memory, of hers, of the world's.

She nods at my ankle, looks up, then down again. 'Sure.'

'In Yuma.'

'My sister. I remember her well,' she says, whimsical, like there is a joke about to be posited. 'Do you remember her?'

'Me?'

'Yes,' she says.

'I remember her so well it kills me.'

'Because she didn't do this,' she says and pulls herself up. 'This is someone else's work.'

We stand quietly.

'Houston,' I say.

'There we go. Houston.' I expect her to admonish me. I expect her to say Jackson's and Billow's names. To say they'd done something extraordinary with their lives. Instead she just shrugs. 'It made it into so many places, it's so silly. You know the thing she loved to say?' Paloma says. 'The thing I remember her saying: *Every occurrence, it leads to now, every event. Then ding, here.* It was just this thing she made up. She said it always made her wonder how haphazard things really were because the instant, it always felt so perfect to her. Which, you know, she's a kid. We were kids. But it was a statement that lurked. Especially after what happened to the two of you. What happened to her.'

I don't say anything. Instead she just looks at me until she's

satisfied she knows what I'm thinking. And I stay still looking at her, knowing that she's playing with me, just a little.

'And Joan was here?' I ask.

'Joan, yes. She's always been here,' Paloma laughs. But then her face goes quiet and she looks in close, the compression of her brow into evidence of thought. 'The oldest form of violence, you know what this is, huh?' she asks. 'It's the retention of the world around us. The oldest form of violence. Every time we think, *Ah yes*, we wipe out what was there before. It's the first act of language. Annihilation. What was that song you used to sing?'

'What song?

'The dance one.'

'Yes.'

'And people always danced to it, yes.'

'Correct.'

'It's like you say its name and all movement – vanishes.'

I smile for her and she enjoys this and puts her hand on my forearm. We stay that way, as if some thought we'd had has finally been completed. I try to summon some kind of jealousy for the night she spent with Sonya thirty years ago and only find myself looking up at her giant work wondering how she thought this could be done.

She says: 'I was angry, yes. At everyone in that van. At you. Tony and everyone. And then, I'm no good at anger. I do this and it becomes something else. Instead of anger I leave America. Too much ill-directed violence.'

'Did you tell Sonya what happened to me?'

'Me? To you?' Paloma asks. 'Oh no. I just liked her legs, very much.'

I stay still, then a smile.

'I told Sonya forgiveness isn't an event, but rather it's a lifestyle change.' Then she coughs. 'We seek vengeance, yes?'

I nod.

'Then we're all trying to avoid the terror it leaves behind in its wake. What I'm trying to do here isn't about remembering something forgotten, Conrad, it's about how forgetting is a process of replacement, yes? Of gradually possessed time.' She puts her arm on my shoulder, resting it there. It feels foreign and heavy, strange and calming as if the weight is coming from my shoulders and her arm is made simply of air.

39

We take the road down into the city, the desert drift and vague skylines. The twelve of us in silence, bar instructions for the instant and its contents, the moment we'll exit the van, the strategy of disruption and disturbance, of regroup and escape. Sharp phrases, and instructions of formation and precision. Military words. We pause in Sidi Bouzguia, drink from vacuum-insulated water bottles, each of us gazing into our phones until the late afternoon when we eat. Then we pull out, drive Rue d'Ourika, turn left and right in the dusk. The spangled decorative lights hung across road for blocks as if the entire city is under the false rule of festival and rave. Then Aderfi gives a signal and one of the artists pulls curtains across the windows and we're in the dark, blanked by dusty cotton. We know we're nearing the square by the sound of bass, of hip-hop and its marvellous thump. The tiny snare clips and colossal bottom-end phasing as we draw closer to the outlying bars. I feel the rise of blood, the heat of it in my hands, neck and face. My mouth dried out, my tongue like sandpaper. We slip on balaclavas so we can't tell who is who, except for one. All the same colour, except one.

Aderfi yells from the front. One hundred. Seventy, fifty. I can feel the van slowing. The easing of pace and ride as we come upon Moulay Ismail near the carousel, the horses and tourists. We're at walking speed, just easing on the south side of the square. I can smell it suddenly, the severe odour of food and smoke.

'Go,' Aderfi says suddenly, the van still moving. 'Go, go, go.'

The doors pull open and the whole sure suddenness of the square moving slowly past. Light and teeming thousands. I feel a hand grab at the back of my trouser belt and lift and thrust me forward. I fall out into it. I'm running, the entire brigade of us sprinting into the centre of Jemaa el-Fnaa, pushing through tourists. The combined black of us shifting crowds out of our way. The sounds of them all, the shouts and screams and pure running fright. It takes just seconds for us to get to the first song circle.

The first there shoves over the young musician on the bass, pushes him off his crate as the others kick in the speakers and I find the bowl for the loose dirhams and knock it out of the kid's hands who's been collecting on the part of the Gnawa. And then I steady him because I've knocked him and that's not what this is about, but God knows what this is really about. I watch the Settled City artists, how careful they are not to hurt anyone, just equipment and the whole enormous visage and act and summoning song, of the practised recall. Of lyrical revenge and reportage, of ancient tales and their deep, deep ache. One of our men is knocked to the ground and set upon by the band whose circle we've invaded and turned into this strange melee.

I'm pulled away, but I look back and see our man getting up and stumbling towards where Aderfi dropped us off.

We run on, up the west side then head east through the centre of the food stalls. I haven't run like this for years, but it seems easy, simple. Legs, arms, hips. We kick in two more groups before turning back south. Men screaming in our faces, wide-open mouths. I'm tripped up by an obese tourist, soused and deliberately running into our path. His mouth's full of kebab, lettuce and lamb down his soccer shirt. I manage to regain my balance and run on as Tone grabs my elbow. I know it's him because of his white Prada, and the way he says, 'Head left, go left.'

I see two of our men breaking the neck of the bass-like instrument, the strings flinging in the air. I see two more tearing the chimes out of hands of old men. It's awful.

'Run,' Tone says.

The whole thing is awful and I'm trying to understand why Tony ever thought this was a significant protest, because that's what he'd called it, a protest. A disruption of memorialization.

I sprint, turning in a wide arc until I see them, the police, officers of the Sûreté Nationale. They're rushing out of an alley, five, then seven, eight of them.

'Go left,' Tone shouts in my ear over all the sound and movement. We veer left and the officers pull to our right beside a juice vendor. Three of our guys head with Finchman – his blue balaclava, trimmed with red – right into the path of the police.

'Take off your mask,' Tone says as we merge with stunned onlookers, pushing through until we're in a shoe shop. I pull the balaclava up off my face, strip my black top off. The owner yelling at us. We head back out into the throng where I watch as Finchman finds himself on his own, slowly surrounded by the police. The others slipping out into the crowd.

I hear Finchman shout, he calls out for Tony.

'Stay quiet,' Tone says into my ear.

'The fuck's going on?' Finchman shouts, but his voice is lost in the yells echoing around us. He sounds distant as I move closer inside the crowd, inside the shifting silences they create as they stare with wanting eyes. He sounds mutely foreign and small.

The first officer heads to Finchman's right and cuts him off.

The large soused tourist steps out of the crowd, pointing his finger, the same man who'd tried to trip me. Now he's cursing in something northern.

'Tone?' Finchman yells.

The Englishman throws his kebab and it bursts on Spence's

shirt front. He tries to run, tries to find a way into the crowd, but the police move in.

'Hey, cunt!' the man in the soccer shirt yells. 'You fookin come here, you come here and—'

The rest of his speech is lost because Finchman runs at him, tries to push through his arms as the soused fucker takes a swing at him.

Then the first officer throws his baton, collecting the side of Finchman's head. I watch, he staggers, a kind of *ahh* noise and the tall man kicks out his legs. Blood then, blood flashed across his face. Then another guard using his boots, kicking the side of Finchman's head and I watch it twist, his neck extending in strange ways. Immediately his mouth is red, his hand going up to find the source, to plug it while his other arm reaches up in protection. His eyes go so wide, wrenched open in distress response. They kick him so he lands on his chin and I hear its knock, its hollow sound and those around me murmur. This is what money can bring. I can't see his eyes, they've become slitted. I feel my heart hammer. His hands coated in blood held up over his head, his knees hooked up to cover his belly. The crowd around us, a circle leaning in and not able to back off, hands over eyes as the guards lift him and throw him back into the tiles.

I start towards him as two more tourists join in. Large men, American, Australian, and then a small Frenchman. This is supposed to stop, or it's supposed to go on and I'm supposed to watch. But it has to stop because I want none of it. They go again until the whole area seems red though the red is black in the evening and eventually Tone has me by the arm, pulling me until I've no choice but to leave, to hustle out of the square because that was the deal he'd made. This was what money could buy, that this would happen and we could look away. But I look back and Tone looks back till Finchman sees me, catches me and all the voices diminish,

all the shouting shrinks to a hole and all light seems to fall, defiantly, through.

We head left onto a darkening street, bars up above, shouts and oblivious music. Tone takes me into a series of alleys, stepping me past piles of garbage. We head on for twenty, twenty-five minutes. I feel myself shouting, but I'm saying nothing. My throat raw from silence. Archways and the illusion of labyrinth. Left, right, a series of doglegs and kids kicking a soccer ball and shouting: *Cheat.* Kids everywhere in the world dancing about a ball shouting *Cheat!* Blocks of housing and small squares full of smoke and stacks of water bottles and I keep turning, expecting the police, but the police only had one target. Finally Tone has us at a heavy wooden door at the end of the alley. He knocks twice, four times. A young woman answers and hurries us. It's Caroline, pale hair and make-up. We walk through a dimly lit hall, the here-and-there decorations from the world and country. Stairs winding up the side of the riad's lightwell and I suddenly know where I am. The odd clarity of space and personage. I see her before my eyes find her. She's almost as exact in my mind as the old woman present in the large room lying on a couch, a book at her side and smoking.

'You sent flowers, didn't you?' she asks. Slim shoulders and hollow breast.

'I imagine they're dead by now,' I say.

She gives a large, living smile. We had, Sonya and I had sent flowers and a Rilke poem to the house in Arizona.

'How long you been here?' I ask. I'm sweating, smell of rank clothes and firepit smoke.

'A decade?' Joan turns to Tone. 'Many years.'

I nod and reply and everything coming from my mouth feels out of time, narrowed by the compression of years, by our rush through the square, by the sight of Finchman bent

and hunched. I stand quiet, unsteady with the adrenal heat of glimpsed violence, of true actuated violence. I find myself trying to recall how many times I've meandered into these streets looking for someone I thought was Tony. How many times I got that wrong and bought something for the shelf, a vase or dish, some arrangement of meat I'd never tasted before. Joan moves uncomfortably and I see how old she is now, the gap at the base of her throat deep, like breathing has carved much of her away. She speaks with her hands, telling me to come and sit near her. I do. She smells like desert dirt and sun. The wide land where she'd buried her daughter under lifting skies.

'Here,' Caroline says. She passes towels and we wipe ourselves down. Her presence makes me feel jealous and nervous.

We address the immediate. Our physical states. Our need to hydrate and settle heart rates and organize the scratching skipping events from the square. All like we are the winners of some battle we've never heard of, crying for pity. Police action, smoke and that drunk in the soccer shirt, the mauled white of his shirt and maybe Spence might've got himself out the square if the man hadn't grabbed him as he'd tried to force his way through.

I wipe my face until I stop sweating, talk until I've stopped talking.

'You found the videos?' Caroline asks after time spent in silence.

I nod. I really don't want to look at her, not yet. 'We saw the footage. Interpreted it various ways,' I say.

'Finchman found the videos,' Tone says. I look at Joan hoping for some ironic indicator to what this was all about. Instead I catch Tone's eye and see for the first time how his posture is unsettled, his good cheek twitching and he can't decide to sit or step foot to foot.

'Video. Still sounds like a new word to me,' Joan says. 'It can't be, I understand, but still.'

'What will they do with him?'

Joan looks past me. She squints as if looking at the reflection of her thoughts at the end of the room. 'You know, first time I saw Spencer,' she says, 'his ache was almost luminous. I asked Miriam to spend time with him.' She puts up her hands in mock surrender. 'It's taken me thirty-four years to give in to this. I haven't named the taste yet.'

'Parts of me want him staved in,' I say. 'Parts want him active, free, just knowing I know.'

'Parts of me don't know what I want,' Joan says. 'I'm suspect of them, fearful that they are the most honest.'

'What'll they do with him?' Tone asks.

'They'll lock him up until someone realizes he hasn't done anything.'

Nobody says anything for a time. The riad full of old smells and versions of stressed silence as if somewhere within its walls torture's being played out by the willing and mad.

'I've imagined every iteration of everything for him until death,' I say out of the quiet.

'And of course.'

'Everyone dead.'

Tone won't sit and he exhales a long sigh. 'It wasn't supposed to be like that,' he says, nodding back over his shoulder.

'Like what?' Joan says.

'Like that. They were supposed to just – remove him.'

'We don't get to choose, Tony. We don't say: *Just this much. Just apply this much hurt.*'

'They take him away,' Tone says. 'That was the idea.'

'*That was the idea.*'

'Yes.'

'When was the last time you had an idea that actually cleanly and clearly related to the physical, Tony?' She stares at

him. A stillness, a hard passage of moments and seconds until – 'Sometimes I don't even think the physical exists except in the things we do out of habit. Same with any idea I might have. I fear so many of our thoughts, they're there just to conceal ourselves from the physicality of life.'

'Bullshit,' Tone says.

'How many of our daily routines are just re-enactments of old violence, just there to ward off violence against ourselves? I could tell you, then you'd have multiply it by the speed of light.' She sounds as if she is in mild pain suddenly, discomforted by some internal yank.

'Bullshit.'

'Bullshit and dogshit,' she says and goes on and Tone interrupts and she goes on and I find myself nodding, happy to listen to her. To hear her talk and try and get to a place none of us really want to acknowledge. It's the process, of course, the act that's the result, not the end.

And I fear the end. I always fear the end because that's when you have to look people in the eye. Joan talks and asks questions. Replies to them herself. 'How many of our unremarkable everyday acts are essentially re-enacting violence?' she asks. 'How many of our impulses?'

'Bullshit.'

'Bullshit,' she repeats, her grained face considering the word, then dismissing it like ash tipped off her cigarette. She talks and I think how we say we oppose everything, but we don't; we're always letting it in. All of it. Violence and what comes with it. Learnt and celebrated violence. How it's all made permissible because we disguise it so well. Listen to symphonies, look at great frescoes and imagine how this isn't so. People obsessing, people dying for these. We're always letting it in. It's everywhere. Sacred action and imitation. We keep carnage close. Keep it in habits we believe will bring peace. This is how we share the religious experience. We do

it through routine, make it a part of our standard operations. 'But here we are still,' she says, as if finishing my thought, 'waiting on it.'

'On death and doom,' I say.

'If you like.'

For a long time we sit and the conversation moves between practical things and the everyday. Joan still-faced, listening to my answers to her questions about my life. I slowly learn how Tone'd asked Joan to bribe the police and make this happen. Hear about her reticence.

'I don't put stock in reprisal,' she says. 'But once in my mind I couldn't move it.'

'I've always been sorry about her, Joan,' I say.

'Of course you have.'

'I imagine her friendship sometimes. That it exists, present and reciprocated.'

'And instead you have Spencer Finchman. And instead we have blood-letting revenge,' she says and seems to regret saying this for a moment and waves her hand as if to fan the words away like the attentions of the disturbed. I expect Joan to make another comment about our habits, how the living only exist because they're part of a line of signification we haven't yet snapped in two. But instead she says: 'I didn't know anything had happened to her, not until she was four months pregnant. Then I made the guess. She never told anyone who did it. She never knew who did it. She never spoke about it until it was too late.'

'Everything always feels too late,' I say.

Joan nodded. 'If we're allowed one thing in life to regret, I have that one thing,' she says, her hand up to her face, shadowing the left side as if trying to separate her memory from what she was about to say. She tells us how she told Miriam who the father of her child was while we played drunk in the hills above Phoenix. 'He was onstage,' she says, 'and I told her it

was Spencer Finchman. She didn't react and I shouldn't have told her because when someone doesn't react, you know something far deeper is happening. That's my one allowed regret. I hate it – and maybe I don't regret it. Maybe it's something far greater than regret. Tone had approached me and told me what had happened, that he knew Spencer was the one, that Spencer had done what he'd done to her.'

'I don't know what to say about that,' I say and turn and look at Tone, who's suddenly pale, eyes buried in misery.

'All I know,' Tone says softly, 'is if you don't regret at least a quarter of your decisions you're liable to be found out as insane.'

Joan covers her whole face, then drops her hands to her lap. I look around at the framed photos on the wall and try to spot her in the group pictures of souls staged like a repertory cast, each in distant third person. I can't evade a feeling of mild shock when I see her with short hair, oddly weighty in a time I can't label with any precision. 'He found you in the van, Conrad,' she says suddenly, her eyes white and dulled with cataracts. 'Spencer made confessions. Confided and divulged this to me, how many years later? He was out of prison and he called me on the phone. He came to find you where Tony lived. He wanted to talk to you, but you were with Vicki. He said his father'd been drinking. His father was that kind of pathetic bastard. All he knew was what he could blame on others. And how old was Spencer then?'

'We were twenty-three. Maybe he was twenty-four.'

'His father'd come and grabbed him from your warehouse while you and Vicki were playing. He took him back to the house and locked him in a closet.'

'Bullshit.'

'I have no reason to bullshit. His father threatened him with expulsion from the university, then said he was going to burn the house down.'

'—'

'The whole house.'

I fall silent, the room too and the only movement seems to be the reflected evening light falling through the centre of the house. Beams just feet away.

'How'd he get out?'

'Oh – his father started crying and apologizing like a child. Spence went looking for you, found you, just wanted to smoke a cigarette with you. Explained this to me after he got out. He called me collect from Oregon,' she says, stops and goes on. She tells me he'd wanted connection. That that was his belief. He wanted peace. Something palliative, quietening. An element of humanness. Tells me that he'd found me fast asleep. Cold. That I slept through everything. He talked, she tells me, he lay down to be next to me. He tried to wake me up, by talking then by nuzzling, and when that didn't happen he tried shaking me. 'You were comatose, correct?'

I nod.

She tells me it was a hunt for affection, for something tender. She talks until she goes still and all I hear in the silent space is Ruth's name. The horrible wrenched thought that he'd done the same thing to his mother.

'Why'd he tell you?'

'Guilt, I can't imagine. And I can't imagine any of this, it breaks my heart. Partly because I can't follow the entire psychopathology, but I know he didn't wake up that morning saying: *I'm going to do this thing.*' She wipes at her wet mouth, coughs and spits into a tissue. 'There's no validation of intent, just a means to discernment. And not for his sake, but for yours. Hold on to your hatred. Sometimes it's all you've got.'

'What about Miriam?' I ask gently. Gently, although something inside me is snarling, daring itself to shout and scream at the woman in front of me. Tear something from her, but something else keeps me calm and I can only think it's Miriam.

'I wouldn't let him tell me. She was asleep, stoned and whacked out on a handful of Valium I'd given her. That's all I know. What a mother does, what a mother believes is the right measure ends up killing her a thousand times.'

'But we're talking the same thing?'

'Nothing is the same.' She glances at Caroline. Small and listening like she knows everything and more and is there for Joan's sake and nothing we say is new to her. 'Listen – I say all this,' Joan says, 'but it doesn't mean I understand. This a form of hatred confused with love by some dislocated part of a consciousness ruled by misfiring synapse and nerve junctions. Am I right? I don't know.' She describes the neural physics, verb and noun. 'I know the Latin. I know the this and that, the compromised nature of the connect zinging between the amygdala and the ventromedial prefrontal cortex. Technicians in white coats observing this in brain imaging. But that's not enough. I can't know what happened to you and my daughter. Sympathy leads to weeping and pain, but it doesn't endure. Not like what you had.'

I shake my head and feel the night heat of the room. The way it makes each thought feel delusional and somehow ancient. She talks on, I listen, rebut on occasion, but rebuttals don't matter. I watch her body act out her words. I become convinced, then uncertain. I slowly learn she's always having this conversation, with whoever's set of ears happen to fall upon her words.

'I've tried my entire life to understand this movement, this transition from love to violence,' she says. 'I doubt I ever will. You know what I've learnt? I realized I was just trying to discover the gap between the ecstatic and horror. You know what we learnt about that?'

'There's no such thing.'

She nods. 'There's only an inbuilt desire to separate affection and hatred. That's it. And the thing about desire is it's

unmappable. It has no chart.' She laughs at that, not because it's funny, but because it seems there's nothing left to say. She watches me then, sad eyes for so many vanished things. 'We don't need history, Conrad, not anymore. That's the word you want to forget if you want to know how all this came to be. You need the one that takes over and sits in its place.'

'There isn't one. I've looked. Plenty of bottles can attest to this.'

'I don't know, I just pray there is something. We want a word that has no linear capacity. Nothing like it because that whole thing is owned by men and I swear they own its structures and they're never guilty. Men are never guilty. And I don't mean real men, I mean men in capitals. They go to prison, but they are never guilty. The word I want is without walls. One that would make it impossible to mix up power, plot and past things. You need something that recalls all things at one moment. Every bisecting point in time and theories and thought produced by time. I pray we'll learn this word before we die. My only real prayer is for empathy.'

'My grandmother is always saying this,' Caroline says, '*before you die.*'

'I'm an old woman. I say what comes to mind after all these years.'

Caroline stands. '*Years* has a different meaning now,' she says. 'We stop counting, right, Joan.' She smiles, leaves and returns moments later.

She has a small cake she sets down on a miniature table, her hair lit by the thinning ray of bold beaming light falling like the rarest rain. I know who she is. I don't need to be told. I know her mother. I know her father. I know her father is currently bleeding in a cell and this light in her hair isn't close to a halo. She sits beside her grandmother and slices up the cake and I think of Angel, how it's the one thing he's got left. A baker's obsession and how unbearably sad he makes me

sometimes. She talks with Tony. There's no indication from her that points to locatable sentiment about her biological father, just data and practical outcome. They seem to know exactly how the plan came together to get Finchman cornered in the square, though I'm uncertain whether there was a precise plan, or in recalling the event its precision came together in a way that represented intent. All I know is twenty months before I met Miriam she'd met Finchman. That she was stripped while she slept in a drugged sleep, that – on and on – and she'd had a daughter and then, then I'd killed her.

And then Spence had Celine.

Which doesn't seem fair to anyone, until you think of Celine in her cat costume and wonder what thin things have protected her all these years.

Then Sonya'd had one kid.

I'd had none and Leo Brodkey, he'd had five.

Vicki two.

The on and on of all this living and I find myself wondering sadly about Leo, how he'd rescued me from Boulder, Colorado. That false peace as we drove towards Cheyenne, an exact peace, perfect, and how I spent a week on it with Leo and Vicki, the two of them in love for five stoned nights, drifting out of dreams until dreams gave into sleep and I don't know what was sleep or waking. How the last time I saw Leo was in LA, 2004. The last time counted. Four of us in a studio, perfectly exact in that ecstatic outpour of song and drug of song. That was the valediction, the last time: he and his brother went and died in 2010. Ice. Wheels. A tour, a bridge and the way water turns hard on such surfaces and how tyres don't always hold, no matter how hard we grip the wheel. One of their songs strums through my body as Joan talks, an unlicensed stream, blue and echoic out my memory. She speaks about the conclusions she came to about her camps back thirty years, how they'd never completed themselves, how they'd only

suggested and never stated. She speaks and I imagine the ice splintering beneath Leo's tyres as the remembered song runs hard in my body with Joan talking on.

'You know I used to be interested in religion,' she says, 'till I realized God's just this great brain-splintering rendering of all the hearts of all the souls who'd own the word. Exploit it. That's what I learnt. And love's just the same till you try to do something about it.'

I look at her with something matching hatred, something envious and wanting.

We leave the next morning. Tone and I walking through the deserted square where there are only cleaners and the odd sun-stunned tourist wondering what the fuss is all about. We'd left when Joan seemed done with talking, done with seeking her daughter. All as if she'd completed the great task of her. I'd felt stomach-less, terrified by the thing I eventually discovered, the element of Miriam's story Joan'd never been told. But I couldn't talk about Cozen Jantes and Madison. I couldn't tell Miriam's story to yet another without something vital breaking and then everything breaking because I knew I had no right to make comparisons of experience because in the end that is all we have. I thought about Cozen in that ballroom shouting at me and her and Paloma and baby Caroline and how we just left her and how she went out into the dark, all of us watching. I feared all this could happen again and again if no one told Joan about Madison, and I didn't tell her.

And now Tone and I, we head north through Jemaa el-Fnaa. Eyes on us, sensed eyes, eyes slowly turning us into silence under the run of the sun's course through the square, that great sweating space from which Spencer had vanished, sucked up into the city like those 10,000 always singing songs.

40

February 2020

And home and there's something comforting in the three of us gathered here now. That we're here and there are three. Tone, Sonya and I. That number, simple, pleasant, cold. Three and a half when you include Angel – and of course we include Angel to make it four. Tone comes around once a week, leaves the rented fisherman's hut out beyond the red rocks on Wellington's south coast, drives his Land Rover along the devastation of shore and sea to the southern suburbs where he's guided by ridgeline to our house. He brings takeaways and a bottle of something and talks with Angel, time dedicated to repetition and calculated lying. Tone tells him stories, fills in the years Angel keeps losing. They don't talk in time. Not days or weeks. Numbers aren't something they want to offer, because they're too abstract when considered against what's been taken away.

Sonya loves having him here, her brother, her line to so many undescribed things. They talk for hours. Old family stories. They talk about pets, dogs and cats once adored and then cast off when their time was up. A certain matter-of-fact-ness of discarded love. It's the act of the words and it's the fact of the words, but it's the fact of something else too, something dared and prized.

This afternoon we took Angel to Tone's shack where the smash of ocean and rock make such a noise and it's kind of terrifying when the Pacific's all worked up, but today it was calm and the fur seals left over from last season's haul-out lounged on the rocks just forty metres from the hut. Angel seemed to

catch something when he saw these blubbered pinnipeds, their wide mouths full of fangs, roaring and strings of saliva. He went running at them in the shingle, shouting and falling over and then he was covered in sea foam as they boomed and ran agitated into the sea. Sonya wrapped him in a blanket and manoeuvred his huge form close to the fire flickering in Tone's old hut painted in the worst primary colours decades earlier and we listened to him quiver and try to explain to us what the hell the seals were telling him. Because that's what it was all about apparently, the seals were trying to speak. We got tea into him, a bar of chocolate and he slept eventually and we felt guilty in the way we laughed, but we did, softly among all the old paintings and posters leaning in from the walls. The place was full of memorabilia, junk assaulting the wit's ends, stuff lying in the hall like the owner was always about to move.

Angel slept heavily on the floor, snoring, and Tone laughed, saying: 'I don't know about any of you guys, I really don't, but gravity sure is strong in this one.' Angel grunted and I felt an awful sadness suddenly.

We were quiet for a long time, sitting silent under a blue-painted double-hung window. Then Sonya said, all hugged up beside me: 'You remember that time?'

'I remember too many times,' I said.

'You remember? Where were we?'

'When?' I asked.

'And we hid all of Angel's clothes. He was running around.'

'God. When?'

'When?' Tone asked.

'You and Spencer stole his jeans and shirt and all he had was this ridiculous towel. This little motel towel we'd pinched in Trenton.'

'We were in Boston,' I said.

'Yeah. And you'd nicked his clothes and he was running around,' she said.

'Yeah. Why?'

She went silent again. Each time she stopped speaking the sound of the sea grew in our ears, the roar and retreat, and it seemed like the only way to quieten it down was tell something about Angel.

'You remember what you did with his pants?' she asked.

'No idea,' I said.

'You remember the name of the motel?'

'We hid them in the back of the TV,' I said.

'You remember the name of the motel?' she asked.

'It was a Motel 6.'

'That's it. I was trying to remember.'

I said nothing for a moment.

'Or maybe a Super 8, one of those.'

'I'm trying to remember what he wore,' she said as it began raining.

'Who?' I asked.

'Angel.'

'He had on his little towel.'

'We couldn't find his trousers because we were drunk on tequila and couldn't remember where we'd put them and you had to play a show at the Channel.'

'I don't know.'

'Something from the bag,' Tone said.

'The bag,' she said.

'The bag.'

'The clothes bag. The stink of that thing,' Sonya said, laughing.

'Enough to kill a man,' her brother said.

'Seems impossible I remember it,' she said. 'What was it made of?'

'Most things are impossible if you think about it,' Tone said. 'But here we are.'

I stared at him, watched him as if he were the rain falling

outside, close enough to touch but so far away. 'Here we are,' I said.

Then Sonya was speaking softly. 'You know, I thought I saw her this morning.'

'Who?'

'I thought I saw Juliette.'

'Juliette?'

'Yeah. I thought I saw her and – and I suddenly remembered Angel and his towel. I was at the supermarket and I was just getting fruit and I thought I saw her talking with some woman, Juliette, and I thought of Angel.'

'Really?'

'Yeah. And—' She started crying then, her face quickly wet. She fell into me and I held her and she smelt of tears and snot and then she was trying to laugh her way out of it all. The tremor of her and I kissed her head and she kept on, a bleak wash of jerking, tearing, weeping. Just a giving in when there seemed like nothing else.

'Hey, hey,' the voice beside the fire started. It was Angel. 'Hey, hey,' he said. 'It's all OK. My jeans are just up there.' And he pointed to where Tone had hung them above the fireplace beside the replica rifle that'd come with the hut.

'Shut up, Angel,' Tone said, and I felt an awful silence in my chest.

'Yeah, shut up, Angel,' Sonya said and she was laughing then and Angel was laughing and he stood up naked in the room. The blanket falling on the ground and he started dancing like a bear, slow and laughing like he did when we watched old episodes of *Taxi* or *Cheers*. They were both smiling up at him and I felt I knew nothing all of a sudden, not of what makes us human when so much has been sucked out and so much remains. All I knew was the fate of that bag, how it'd lived in the back of the van for years, how I'd held on to that piece of junk until I gave it away to a young family desperately

trying to move towns after their third kid came along and they just couldn't hold on in Oberlin for another year because they feared another year meant another human to care for and that was just too much, so they moved in my old van, taking with them whatever hope.

In the evening, as Tone was making dinner and Angel was properly awake, I showed our fallen bass player the images from the Atlas, the multitudes of pictures taken of Paloma's cliff-face epic. The great empty alcoves snapped crudely from across the valley where I'd stood with Tone nine months earlier. How enormous they were, far larger than they appeared to be when standing below. The shadows lining the two niches where the Buddhas once stood. Angel swished through them, commenting now and then. Their height a precise replica of the originals in the Afghan mountains. Fifty-three metres. Immense and higher than I could get a sense of when standing beneath. The precise shape of the Buddhas' empty niches in Bamiyan. Enormous, deeply shadowed by hundreds of versions of black then grey. I couldn't stop taking pictures when we'd stood on the hill gazing. A stream of them, the absent Buddhas and the false depth of the alcoves. The precise surface details of the Bamiyan sandstone, colour and contour. Beautiful, threatening and the sense of great servitude. Tone explained the whole piece as he cut up potatoes, the intent, the paint, the art. It was Paloma's retort and response to the UN in the Afghan mountains, he said. Their scrupulous processes of reconstructing the cracked Buddhas in Bamiyan. Gangs of workers manning scaffolding. Archaeologists out of Berlin and Stanford mumbling amidst the debris matching stone with stone as Afghans starved, as the poor suffered in drought and crop failure.

Every time I think about that I feel the worst regret, and I quickly realize it's that Sonya wasn't there to see the niches reveal themselves. Nine months ago, Tone walked me to a

small platform on the side of the ridge. There wasn't room to move, there was only below and outwards. I'd stared and looked away, glanced back and each time I saw something different, in its size, in the depth of black, the shadow and the shape. Each time I saw a different component. The queer dance of pigments mimicking shadows. The way I stood back and kept trying to see, kept trying to trick my marvel into knowing this was just the product of thought and volition. But, that's never quite true. Art's always been the product of observation. Prior to this it's just men and women on a cliff, just craft on a grand stage until – eyes and eyes seeing and linking and I wished for Sonya's eyes to be among them, there within that instant of knowing what hasn't ever been known.

We ate, a stew Tone'd developed over the years, and eventually we headed home. I spent two hours with Angel in the basement flat while Sonya read upstairs. We watched TV until midnight, we laughed and then he was falling asleep and I heard the sound of movement in the storeys above. It was Sonya. Footsteps. She was walking about, her nightie and bare feet, high arches and then, of course, music. I headed outside and now, right now I sit under the stars and their various constellations. The air strangely still, moist with the aura of late February. Music reaches through the night and the lights are flicking on then off. I sit still. The double strum of some post-punk masterwork coming from our stupidly expensive speakers upstairs. The high bass. And the chorus. I sit on the deck chairs and listen. It's Rhinosaur. I can only really hear the bass but I know the guitar so well it rings clear in my head. God, I tried to hate Rhinosaur when I first heard them. Hate them. It was the girls in black eye make-up and the boys so earnest. The airy pop and forged misery. It took me one show to understand how great they were. I was brilliant at hating many things, but so poor with others.

Double strum.

And the next song and it's their last single and I try to get to the door before it starts proper, that chromatic descent to the first hit and the gentle chording. I go to the front entrance. I look through the door's window. My wife's dancing, invisible to the world. Throwing shapes at the dark and catching her breath by the stairs, singing under her breath a combination of words. The lyrics and all the rest. How these are just the words and how long they've hung in the airwaves. I open the door a fraction and the music hits and I can't hold back from watching her. Her arms out and then in as she flings herself, turning and singing.

This is the dance.

Consoling and tender.

And in this way Sonya keeps Spence here also, for it was him on the drums playing out from the speakers in the house. She's dancing and I think of the Finchman in the studio three decades before playing on that same Rhino record. He isn't credited on *This is the Sun*. He's just a rumour keeping time on a timeless album and I watch Sonya through the windows in our front door mouthing and dancing on the beat. Her eyes closed, the rise and fall of the skirt she must have put on when we got home. She sometimes likes to get dressed up for the times she's alone in the house, a special get-up for Sonya. I watch and watch, her mouth and closed eyes. I feel the shape of her mouth as she sings, the way it opens, closes and she could be saying anything, the words Leo once wrote and sang in a studio in Chicago, or her own mystic lyrics. Whatever way I'm somehow hopeful for the future, what we can make for ourselves, but I'm also trying to keep myself from falling apart, physically, logically. I look back at the thirty-five years and am amazed I'm still intact.

Sonya sends Finchman books, magazines and cigarettes. He dies there eventually, in my mind. In prison. Losing all ability

to reason. But he's out in seven months and that's the end of it. It's simple, he'll be out and history will begin again.

I rang Juliette back in Marrakech before I left to tell her about her husband, that he'd been arrested. Some kind of disconnected satisfaction hearing her voice break. I had her on the other end of the phone crying and I thought, *How is any of this worth it?*

I've called her back every week since, to see if she needs anything, to offer whatever comes to mind and maybe that's the difference, listening to Juliette's measured torment. After all, she's lived with the man for a decade and surely she knows something because we don't get well so easily and the body remembers in the things it does and says. Unless you're Sonya, and you're suddenly lit with life, brandishing it and throwing shadows on the walls that seem to fall away so easily.

And what does Sonya think? She talks about the politics of it, she talks about bringing Finchman and his family to New Zealand when he's out and it puts me on the verge of saying, of telling everything. But I always pull back, as if I've been given a vision from a long way off of life crashing again and again, decimated by figures merging with the dark. I think about telling but it seems foolish now because I returned with Tone and returned with nothing. He wasn't a match, he was never going to be a match for her dying kidney because that would have been too clean, too simple.

But there were always others. And one came along, a thirty-four-year-old woman killed on her bicycle, crushed by a man in a rage, driving insane after leaving his wife for no reason but for the inanity of his own drunkenness. Everything in the poor dead woman lined up and Sonya has her second life and why would I tell her about Spencer? Why would this be the start of our next shot at living?

I watch her dance and there's nothing that can ruin it if I stay silent.

She told me about the gun when I moved to New Zealand in '07. She'd bought the Bearcat second-hand in Madison after she heard what happened to the girl up there. To Miriam, as it turned out. *This is fear*, she said on that first night. *Fear's the infringement on the right I have* not *to bear arms. I despise how there is so little choice in what we fear.* She put her eyes on me then. Soft, the gentleness of offered alms. A look linking all her internal negotiations with mine, her judgements and sympathetic beliefs, deliberations and brain-bled loves. Glances like the caresses and taps and embraces that followed, the things that protected us, kept us from the remains of our lives that liked the savagery of certain exchanges, the red-white flashes of brutality we liked our music to mimic and offer.

I listen to it and long for it and long for her and I watch my girl now and know she's amazed too, that we've survived. I'm just happy to stand near her and watch her dance, the charmed act of poise, of balance held by song and physical shift. I moved to her country to know something of her, but I'll never know, and neither will you – not of me, of her, just the mechanisms of how we know and learn, that's all. I watch her mouthing the words like they're the names of all who've been through it, an inventory of all we've been, all who've parted ways with the world for us to be here. The two of us either side of the door. God, I love her and it's the names and the songs they take with them, pulling them out of the air, the names of everyone who's been hurt, the frail and confined, the sought-after and sorted through, how they'll say when asked, how they'll say the only true border is memory, how the only true border is time.

I turn and leave the song to run on, Sonya within its special chaos. I walk the short path to the steps, head past Angel's studio and there at the letterbox I turn right. The road shapes beneath pine and ponga down along the inside of the hill,

curving in and out of the line of the ridge before rising and finding Farnam Street, I cross the road to the small children's play park. A young couple, teenaged and sitting still in the swings quietly inhaling vape fume, secret and perfect. I find the path that leads down to the golf course. The green-grey under the moonlight. I slip many times. Go down the incline then steeply up until a new bush-clad path. I walk among beehives and sleeping horses. Then a ridge and it's dusky and black and I fall often, blood on my knees under torn jeans. Up, down, the dark everywhere. Idea and retention fluctuate against each other as I head on, the details falling off me like water. Nothing seems to happen, all seems vanishing though soon enough I've walked many miles and I'm standing at the edge of the coast, houses suddenly behind me. The sweeping majority of the earth is buckling under the weight of the oceans and there I am. The water massed and black, a vast other world of wave and inverted life. It's cold at first touch, permanent and soon everywhere. Tussling, certain of what it wants.

Acknowledgements

An almighty thank you to Creative New Zealand and the Todd Corporation who funded the writing of this novel – it wouldn't have been completed without their openhanded assistance. Colossal appreciation and credit goes to Anna Jean Hughes who edited this thing – thank you for pushing and asking and engaging and taking it further. Thank you to everyone at Picador UK for your perseverance and patience – Paul, Grace and Charlie. Thanks to Fergus and Ashleigh at VUP in NZ. Cheers to Fraser Crichton and Ashleigh for fine edits. Ta to the excellent Caspian Dennis and Andy Kifer. Thank you to Michael Hugill, Mitch Marks, Kiran Dass, Rose Collins, Laura Southgate, Alec Niedenthal, Carl Shuker, Rayne Atwell, Hannah Uprichard, Clare Moleta and everyone who engaged with me on the web, shared stories, dates and names – especially Warren and Robin. Thank you to Rim Boukdir in Morocco. Gratitude to John Douglas for the loan of his library, Instagram handle and general John-ness. Big nods to those of yore – Charles, Paddy, Sharon, Ben, Deli, Matt, Angela, Andrew, Andrew, Rob, Jeremy and Brendan. Thank you to Dean Roberts for conversations near the end and Jon Fine for conversations near the start. Grateful appreciation to Paul Douglas and Rosy Parlane for data on the last day. And thank you to Laura, who is always there – like magic.